NOBLE DREAMS

Wicked Pleasures

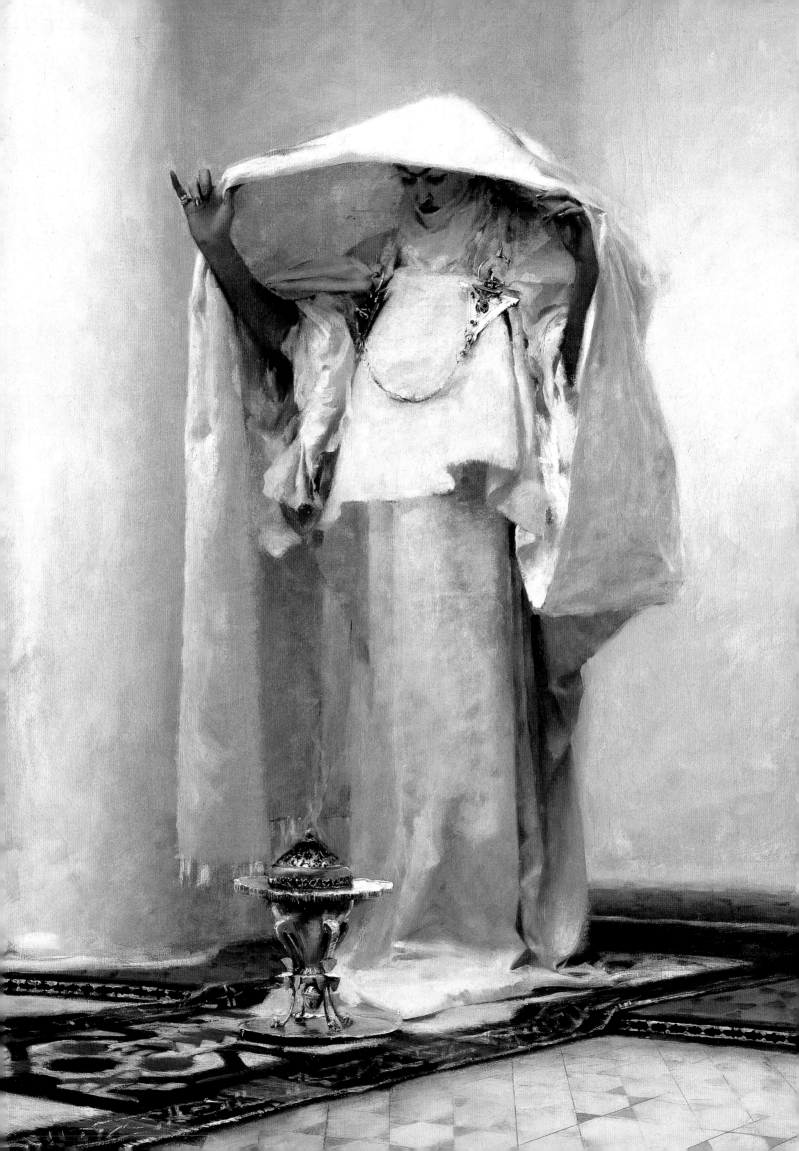

NOBLE DREAMS

Wicked Pleasures

ORIENTALISM IN AMERICA, 1870-1930

HOLLY EDWARDS

WITH ESSAYS BY BRIAN T. ALLEN, STEVEN C. CATON,
ZEYNEP ÇELIK, AND OLEG GRABAR

PRINCETON UNIVERSITY PRESS IN ASSOCIATION WITH THE

STERLING AND FRANCINE CLARK ART INSTITUTE

Published on the occasion of the exhibition
Noble Dreams, Wicked Pleasures:
Orientalism in America, 1870–1930

Sterling and Francine Clark Art Institute
Williamstown, Massachusetts
6 June–4 September 2000

The Walters Art Gallery
Baltimore, Maryland
1 October–10 December 2000

Mint Museum of Art
Charlotte, North Carolina
3 February–23 April 2001

Published by Princeton University Press in
association with the Sterling and Francine
Clark Art Institute

Princeton University Press
41 William Street
Princeton, New Jersey 08540
In the United Kingdom:
Princeton University Press
3 Market Place
Woodstock, Oxfordshire OX20 1SY

Sterling and Francine Clark Art Institute
225 South Street
Williamstown, Massachusetts 01267

JACKET/COVER ILLUSTRATIONS: *(front)* Frederick Arthur Bridgman, *The Siesta,* 1878 (detail of cat. no. 6);
(back) Fatima Cigarettes Advertising Sign, 1890–1920 (cat. no. 53)
FRONTISPIECE: John Singer Sargent, *Fumée d'ambre gris (Ambergris Smoke),* 1880 (detail of cat. no. 9)
PAGE xiv: Edwin Lord Weeks, *Interior of the Mosque at Cordova,* 1880s (detail of cat. no. 10)
PAGES 118–19: Robert Swain Gifford, *An Arab Fountain (Near Cairo),* 1876 (detail of cat. no. 22)

Designed by Diane Gottardi
Layout and typesetting by Bessas & Ackerman
Color separations and printing by Graphicom

Printed and bound in Italy
(Cloth) 10 9 8 7 6 5 4 3 2 1
(Paper) 10 9 8 7 6 5 4 3 2 1

LIBRARY OF CONGRESS CATALOGING-IN-PUBLICATION DATA

Edwards, Holly.
 Noble dreams, wicked pleasures : orientalism in America, 1870–1930 / Holly Edwards ; with essays
by Brian T. Allen ... [et al.].
 p. cm.
 Published on the occasion of an exhibition held at the Sterling and Francine Clark Art Institute,
Williamstown, Mass., June 6–Sept. 4, 2000, the Walters Art Gallery, Baltimore, Md., Oct. 1–Dec. 10,
2000, and the Mint Museum of Art, Charlotte, N.C., Feb. 3–Apr. 23, 2001.
 Includes bibliographical references and index.
 ISBN 0-691-05003-1 (alk. paper)—ISBN 0-691-05004-X (pbk. : alk. paper)
 1. Arts, American—Exhibitions. 2. Arts, Modern—19th century—United States—Exhibitions.
3. Arts, Modern—20th century—United States—Exhibitions. 4. Orientalism in art—United
States—Exhibitions. I. Allen, Brian T. II. Sterling and Francine Clark Art Institute. III. Walters
Art Gallery (Baltimore, Md.). IV. Mint Museum of Art. V. Title.
NX503.7 .E355 2000
704.9′4995—dc21 00-036685

Contents

Lenders to the Exhibition

Ace Architects, Oakland, California

Alexander Gallery, New York

Amon Carter Museum, Fort Worth, Texas

Archives and Special Collections, Williams College, Williamstown, Massachusetts

Brooklyn Museum of Art

Chapin Library of Rare Books, Williams College, Williamstown, Massachusetts

Margaret B. Caldwell and Carlo Florentino

Cincinnati Art Museum

Elizabeth Cumbler

Bram and Sandra Dijkstra

The Detroit Institute of Arts

Duke Homestead and Tobacco Museum, Durham, North Carolina / North Carolina Historic Sites, Raleigh

Farnsworth Art Museum, Rockland, Maine

Fine Arts Museums of San Francisco

Fort Ticonderoga, Ticonderoga, New York

Frances Lehman Loeb Art Gallery, Vassar College, Poughkeepsie, New York

Emily Irving

The John and Mable Ringling Museum of Art, The State Art Museum of Florida, Sarasota

Kennedy Galleries, New York

Livingston Masonic Library, New York

Los Angeles County Museum of Art

Lowell Thomas Archives, Marist College, Poughkeepsie, New York

Mead Art Museum, Amherst College, Amherst, Massachusetts

The Metropolitan Museum of Art, New York

Mint Museum of Art, Charlotte, North Carolina

Museum of Our National Heritage, Lexington, Massachusetts

Museum of the City of New York

National Museum of American Art, Smithsonian Institution, Washington, D.C.

National Portrait Gallery, Smithsonian Institution, Washington, D.C.

The Nelson-Atkins Museum of Art, Kansas City, Missouri

The New York Public Library, Astor, Lenox and Tilden Foundations

The New York Public Library for the Performing Arts

Olana State Historic Site, Hudson, New York

Old Dartmouth Historical Society—New Bedford Whaling Museum, New Bedford, Massachusetts

Pennsylvania Academy of the Fine Arts, Philadelphia

The Preservation Society of Newport County, Newport, Rhode Island

Sandy Schreier

Shubert Archive, New York

Shelburne Museum, Inc., Shelburne, Vermont

Sterling and Francine Clark Art Institute, Williamstown, Massachusetts

The Toledo Museum of Art

University of Minnesota Libraries, Twin Cities

The Walters Art Gallery, Baltimore

Private collections

MICHAEL CONFORTI

*Sterling and Francine Clark
Art Institute*

The exceptional collection of nineteenth-century portraits, cityscapes, and land-scapes at the Sterling and Francine Clark Art Institute includes a surprising number of works depicting the Near East. Two such paintings in particular, Jean-Léon Gérôme's *The Snake Charmer* (c. 1880) and John Singer Sargent's *Fumée d'ambre gris* (1880), have become icons of French and American Orientalist painting, and their presence within the same collection has raised questions about the differences as well as the similarities between French and American treatments of the Near East. Gérôme helped fashion the taste for Orientalist painting in the academic style, and his American students were among the chief proponents of Orientalism in the United States. Many other American artists, including Sargent, traveled extensively in the Near East, and their collective observations led to a sumptuous visual feast of painting and decorative arts in the late nineteenth and early twentieth centuries.

Holly Edwards, guest curator of the exhibition, has taken up the task of exploring the complex cross-currents among French, American, and Near Eastern cultures. She has undertaken this challenge with energy, imagination, and scholarly incisiveness, and her research has revealed that American Orientalism itself was multifaceted and evolved substantially and variously over time. In the 1870s, the great American land-scapists Frederic Church and Sanford Gifford treated Near Eastern subjects with an evocative reverence and an aesthetic grace. By 1900, Orientalist themes were becoming common in the emerging advertising and mass entertainment industries, and by the 1920s Orientalist imagery had been appropriated for use in film posters, cigarette packs, popular music, fraternal organizations, and fashion. The common thread was consumer interest in the Orient as exotic and, often, erotic.

This exhibition is exceptional in many respects. It provides a critical look at American culture and its attitudes toward the Near East by scholars who are by and large not American art specialists, but who are trained instead in Islamic art, in archi-tecture, and in anthropology. Many of the artists represented in the show have not been considered for decades, and the mixture of paintings from the late nineteenth century with advertising ephemera, film, and decorative arts from the twentieth century extends this examination beyond the traditional preserve of the art museum. A number of exhibitions have brought together the exotic imagery of the Near East, but none seems to have approached the subject with an attempt to cross so many boundaries between high and low art.

I would like to thank Holly Edwards and her fellow authors Brian Allen, Steven Caton, Zeynep Çelik, and Oleg Grabar for their work on the catalogue. The entire staff of the Clark has shown great dedication to the complexities of mounting an exhi-bition of this kind, and the generosity of many lenders as well as the commitment of the Walters Art Gallery in Baltimore and the Mint Museum of Art in Charlotte have combined to ensure the project's success. I thank them all for their vision and effort.

Curator's Preface

HOLLY EDWARDS

\mathcal{I} am an Islamic art historian by training. The roots of my academic identity lie somewhere in the legions of travelers, writers, artists, and thinkers of the nineteenth century who were intrigued by what they called "the Orient" and sought to understand it better. With this exhibition, then, I am effectively delving into my own scholarly ancestry. Perhaps as a result of that affiliation, I bring to these earlier Orientalists a respectful consideration. I have not glossed over their foibles and limitations, but rather I have sought to understand them better, as products of a particular era, in part so that I might undertake my own work of cross-cultural perception and representation in a more self-conscious manner.

Very early in the research process, a colleague asked if I would not be wiser to write a book about the subject first, since it had not been previously explored in any detail, and then perhaps consider the possibility of an exhibition. The exigencies of mounting a museum show compounded with the challenges of a largely uncharted subject seemed to her an unlikely recipe for curatorial success. My response then, as it is now, was that the evidence must be found and collectively appreciated before the definitive book can even be considered. Thus I began what has been essentially an archaeological process: unearthing the material evidence of American Orientalism, evaluating those finds, and correlating them with cultural, historical, and art historical trends. From the outset, it was clear that time was a critical factor in Orientalism, both as an agent of change and as a factor of perspective. What was true in 1870 had evolved somewhat by 1890 and changed radically by 1925. Furthermore, I became convinced that Orientalism is best considered a symptom, a representation, or a therapeutic response to changing circumstances rather than a static intellectual stance or a monolithic phenomenon.

Having gathered abundant material and formulated a flexible model of Orientalism, however, I faced a major quandary—what could legitimately be left out? Whole categories of seemingly relevant evidence began to appear peripheral to or qualitatively different from the main strands of American Orientalism. Representations of Ancient Egypt, India, Tibet, and even Persia were difficult to incorporate into the exhibition without losing conceptual clarity. Each of these regions and cultural traditions invoked different and tangential questions. In light of this, I defined the "Orient" of this exhibition as it was most often conceived in the later nineteenth century—the accessible but still exotic regions bordering the Mediterranean Sea, including the Levant and North Africa. This area, I would argue, enjoyed a conceptual integrity in popular awareness that warrants careful consideration.

Having narrowed the field with geographical and chronological limits, however, I was still left with an unruly corpus of material. It did not conform to convenient analytical categories and it persistently disregarded the boundaries of my own intellectual comfort. Furthermore, it fell into unwieldy clusters of evidence rather than a neat line, and it got very tangled up with mass culture. In order to wrestle such disparate

materials into an organic whole, it has been critical to focus consistently on the over arching theme of the show and not the dynamics of any one medium or category of evidence. My intention has not been to do a definitive study of Orientalist painting, a detailed analysis of Orientalizing decorative arts, or a comprehensive study of advertising imagery. I have also made no pretense of including "Oriental" voices or art forms. Initially, I was tempted to try this approach, because I believe that, ultimately, Orientalism should be addressed in holistic ways, concentrating on the exact interfaces of exchange between interested parties. I do not believe, however, that our collective understanding of American Orientalism has reached that level of refinement. In the interim, the diverse and wide-ranging essays included in this catalogue represent some of the methods and questions that are currently being explored in this area.

Oleg Grabar, drawing upon a magisterial career in Islamic art, identifies some of the basic variables by which Americans look at "the Orient." Brian Allen, a historian of American art, addresses the ideological character of American paintings of the Orient. Zeynep Çelik, an architectural historian and expert on World's Fairs, introduces Ottoman voices that were collectively silenced by circumstances surrounding the World's Columbian Exposition of 1893. Steven Caton, an anthropologist and author of a recent book on Lawrence of Arabia, analyzes how images of the sheik were constructed with reference to political events and filmmaking. To complement these tightly focused essays, I have presented an overview of the exhibition as the visual evidence of multi-vocalic and evolving Orientalisms in the United States. Indeed, I see this exhibition as an opportunity to link previously discontinuous areas of academic inquiry: the study of Orientalism and the study of American material culture. In presuming to begin this process, I should explain some of my choices.

Painting is perhaps the one subset of visual Orientalism that has inspired sustained art historical comment. For obvious reasons, I have emphasized the preeminent artists of the Orientalist genre, such as Frederick Bridgman, Edwin Lord Weeks, Frederic Church, and Louis Comfort Tiffany, but I have also chosen to spotlight two lesser-known Orientalists, R. Swain Gifford and Ella Pell, for whom we have extensive and heretofore largely untapped archival materials. I did this in order to expand and ventilate our thinking about the myriad ways that individual artists engaged with the Orient and rendered it in paint. I have also included works by some of the luminaries of the late nineteenth century who painted Orientalist images during careers that were centered elsewhere—for example, Sanford Gifford and William Merritt Chase— to suggest how Orientalism might factor into an artist's growth. Perhaps we will begin to see all of these artists in new ways and reconsider our canons one more time.

The decorative arts represented in the exhibition comprise a group of superior pieces which seemed to suggest how the Aesthetic Movement intersected with Orientalism. I included them with the conviction that acts of artistic homage or appropriation can reveal underlying attitudes of cross-cultural perception and representation. A detailed exploration of formal questions, however, would be tangential to the topic at hand and could easily sustain an independent exhibition with a different structure than the present one.

In the case of those materials that are often called "ephemera," the largest handicap that I faced was one of basic documentation. Some of the objects in this show have never been catalogued before, much less subjected to scholarly analysis. By situating these works in a larger cultural context, I hope to inspire other scholars to explore the rich potential that they offer.

As a result of the disparate character of the materials in this exhibition and the unevenness of current scholarship, the catalogue entries vary widely in scope and style. In writing about unique works like paintings, I have sought to emphasize how each piece pertains to the question of Orientalism, often at the expense of more traditional art historical documentation. I have tried, along the way, to alert the reader to key sources by which to supplement this narrowly focused presentation. The mass-produced materials, which are less well-studied and require different methodologies, have been grouped according to themes that are intended to complement the introductory essay. By adjusting the format in this manner, I hope to italicize the ways that mechanically reproduced imagery can reflect as well as shape popular culture, and to underscore how Orientalism functioned in that context—as sales pitch, as vicarious experience, or as education.

In adopting these strategies and aspiring to these goals, I have wandered cavalierly from American painting to decorative arts, from advertising to movies. This was a deliberate effort to situate the issue in the realm of material culture, beyond the confines of specific academic disciplines or particular methodologies, in the hope of bringing nuance and greater scope to the discourse of Orientalism. Along the way, it occurred to me that my peregrinations had an Orientalist character, for it has been titillating and refreshing to dabble in other, albeit American, cultures. Ultimately, however, I see this exhibition and catalogue as an initial effort to move beyond traditional boundaries and to explore new terrain, and I invite others to extend the conversation with further insights.

Acknowledgments

This exhibition would not have been possible without the contributions of many people. In particular, a group of students in the Sterling and Francine Clark Graduate Program in the History of Art helped me to explore the nature of American Orientalism with rigor as well as creativity: Silvina Fernandez-Duque, Emine Fetvaci, Kyle Johnson, Ann Musser, Jungha Oh, and Isabel Taube. They made the process challenging, productive, and very enjoyable, and I cite many of their insights in this catalogue. After the seminar ended, Emine Fetvaci acted as curatorial assistant for various components of the exhibition, for which I am very grateful. To all of the students in that class, I dedicate this catalogue.

Conversations with colleagues have been an important part in the protracted process of refining my thoughts on American Orientalism, shaping them for an exhibition, and getting them down on paper. I am particularly grateful for advice and input from Gerald Ackerman, Esin Atil, Deb Brothers, Steve Caton, John Davis, William Darrow, Darby English, Oleg Grabar, Michael Ann Holly, Renata Holod, Richard Murray, Christopher Noey, and Caroline Williams, who acted as advisors or readers at various stages of the project. I am deeply indebted to Marc Simpson, who served, sometimes officially and sometimes unofficially, as editor and curatorial advisor throughout the implementation of the exhibition. With consummate tact, he saved me from missteps in fact, taste, and judgment, and suggested numerous ways to enhance the content and character of the show.

The other contributors to the catalogue—Oleg Grabar, Brian Allen, Zeynep Çelik, and Steve Caton—have been stimulating collaborators, bringing a truly interdisciplinary character to the project with their diverse insights. Caroline Milbank deserves an ovation for overseeing the fashion component of the exhibition with expertise and efficiency. Thanks to her, this very important aspect of American Orientalism has been represented in this exhibition with some extraordinary works of art. She in turn wishes to acknowledge the help that she received from Janet Zapata, Flora Miller Biddle, and Penny Proddow.

As is the case in any loan exhibition, people at many different institutions have faciliated the inclusion of important materials, and I am grateful for their contributions. Certain individuals had a formative impact on the exhibition: Karen Zukowski, Evelyn Trebilcock, and James Ryan of Olana and John Lovell and Ann Cassidy of the New York State Bureau of Historic Sites have made possible a complex loan of materials from Olana that add immensely to the integrity and scope of the show. Karen Zukowski, in particular, was a generous and expert collaborator on the presentation of Frederic Church as Orientalist. William Moore, in his past capacity as director of the Livingston Library, Grand Masonic Lodge of New York, played a crucial role in my understanding of the history of Freemasonry and the Shrine and made critical suggestions about what to include in the exhibition. Celeste Penny has been a wonder-

ful collaborator on all things related to R. Swain Gifford as well as ambergris. Along with Richard Kugler, Judy Lund, and Mary Jean Blasdale, she made it possible to bring Gifford the attention that he deserves. Elizabeth Broun facilitated the inclusion of materials that would have been otherwise inaccessible due to renovation of the National Museum of American Art, and Richard Murray and Virginia Mecklenburg were helpful interlocutors. Barbara Gallati of the Brooklyn Museum was particularly helpful with regard to Orientalist painting and the inclusion of key works in the show. Members of the curatorial staff of the Metropolitan Museum of Art, including Barbara Weinberg, John Howat, Francis Safford, and Stefano Carboni, were generous with their time and very helpful with their expertise. Alice Frelinghuysen was very supportive in the efforts to represent Louis Comfort Tiffany in this exhibition. Meg Caldwell was very generous and enterprising in regard to the exhibition of furniture. Margaret Conrads was helpful facilitating the inclusion of Frederic Church's *Jerusalem from the Mount of Olives.* Judy Goffman of American Illustrators Gallery enabled the inclusion of Maxfield Parrish collections for the show. We are grateful to Vance Jordan for advice on Orientalist painting and Frederick D. Hill and James Berry Hill of Berry-Hill Galleries for advice and access to important paintings. Robert Volz, Wayne Hammond, and Sylvia Brown of Williams College were constructive and accommodating about the use of their materials in the exhibition. Anita Ellis facilitated the inclusion of the Alhambra vase in the exhibition. Sylvia Yount of the Pennsylvania Academy of the Fine Arts made it possible to include a work by Henry O. Tanner, an important figure in American Orientalism. I am indebted to Christopher Fox of Fort Ticonderoga for providing access to the Ella Pell materials and making it possible for me to study her diary at length. I would like to thank James Yarnall of the La Farge Catalogue Raisonné, Inc., and Paul Miller of the Preservation Society of Newport County for facilitating the inclusion of La Farge. Dale Coats of the Duke Homestead State Historic Site lent expertise and support regarding tobacco materials in the exhibition. I would like to thank Beverly Cox of the National Portrait Gallery and Pam Belanger of the Farnsworth Library for facilitating the inclusion of works from their collections. Ellery Kurtz of Spanierman Gallery facilitated the loan of important paintings in this exhibition. Michael Borgi provided important access to Orientalist paintings. I am grateful to Rebecca Lawton and Francesca Consagra of the Frances Lehman Loeb Gallery, Vassar College, for perspective on Pell materials and other contributions. Claire Keith of Marist College was helpful on matters relating to Lowell Thomas and T. E. Lawrence. Rick Stewart of the Amon Carter Museum provided helpful suggestions regarding the inclusion of Russell and Remington in the show. John Hamilton and Maureen Harper of the Museum of Our National Heritage were helpful with regard to Shriner materials. Lance Brockman introduced me to the Twin Cities Scenic Collection and related matters. Stuart Feld of Hirschl and Adler Gallery has been instrumental in facilitating the inclusion of Millet in the show.

This exhibition was made possible by the skill and dedication of the staff of the Sterling and Francine Clark Art Institute. I would like to thank Michael Conforti for his willingness to undertake an exhibition that departed in many ways from the Clark Art Institute's traditions and collections. Once convinced of the merit of the show, he encouraged me to push it to its maximum potential, sponsoring the inclusion of media as diverse as painting, fashion, and film. I am grateful for his conviction and support. Richard Rand was consistently helpful about catalogue and exhibition matters, setting high standards regarding content and aesthetic considerations. The

registrars, Martha Asher and Mattie Kelley, dealt with diverse and complicated loans with aplomb and efficiency. Jana Stone expertly initiated the publication process of this catalogue. I am particularly grateful to Brian O'Grady, who took the project over in addition to his many other responsibilities and brought it to fruition with skill, tact, and an unwavering sense of priorities. Dawn Lampron was a critical member of the team, coordinating the visual component of the catalogue and regularly creating order out of chaos. Alexis Goodin contributed help with the catalogue, along with Jordan Love. Nicholas O'Donnell was the ideal curatorial assistant for whom no research issue was too thorny or obscure.

I would also like to thank Clifford La Fontaine for the enthusiasm, conviction, and taste that he brought to the design of the show. Paul Dion, William Powers, John Ladd, and Harry Blake implemented his designs well. Merry Armata and Michael Agee handled extensive photography requests, with contributions by Ralph Lieberman. I would like to thank Susan Roeper and the library staff, and Sharon Clark and the docents. I am grateful for the contributions of Steve Satullo and Ronna Tulgan, who generated outreach programs to complement the exhibition. It was a great pleasure to work with Susan Branch-Smith and Sharon Clark of Spicer Productions on the video component of the exhibition.

Since the exhibition was mounted at three venues, it effectively enjoyed three different incarnations. Gary Vikan, director of the Walters Art Gallery, welcomed the show and suggested enterprising ways to enhance its significance. Members of the staff, William Johnston, Shreve Simpson, and Susan Wallace, were wonderful collaborators, and John Klink installed the exhibition in a space that is quite different than that of the Clark Art Institute. I had discussed this exhibition extensively with Todd Smith prior to his joining the staff at the Mint Museum, so it is a pleasure that his institution agreed to host it when my research came to fruition. I would like to thank director Bruce Evans for his support in this process, and Kurt Warnke for his exhibition design.

I would like to thank Patricia Fidler, Curtis Scott, Ken Wong, Kate Zanzucchi, and Sarah Henry of Princeton University Press for making this book what it is. They addressed the myriad logistics of catalogue publication with expertise, efficiency, and calm. It was a pleasure to work with them. The book's elegant design was provided by Diane Gottardi and implemented by Jo Ellen Ackerman. The index was prepared by Kathleen Friello.

I must make special mention of Brian Allen of the Clark Art Institute. He orchestrated the logistical aspects of the exhibition and contributed an essay to the catalogue. Moreover, he acted as sounding board and facilitator throughout the process with grace and tremendous organizational skill.

Finally, I wish to thank Betsy Chadwick and Dorie Burr for their continuous support and encouragement. I am indebted to my son Nick, whose technical expertise and moral support were crucial to the completion of the catalogue. I am grateful to my daughter Melody, who consistently reminded me of the really important things in life. And for my husband, David, the collaborator who contributed at every stage of the process but whose name appears nowhere on the title page, words of gratitude seem entirely inadequate.

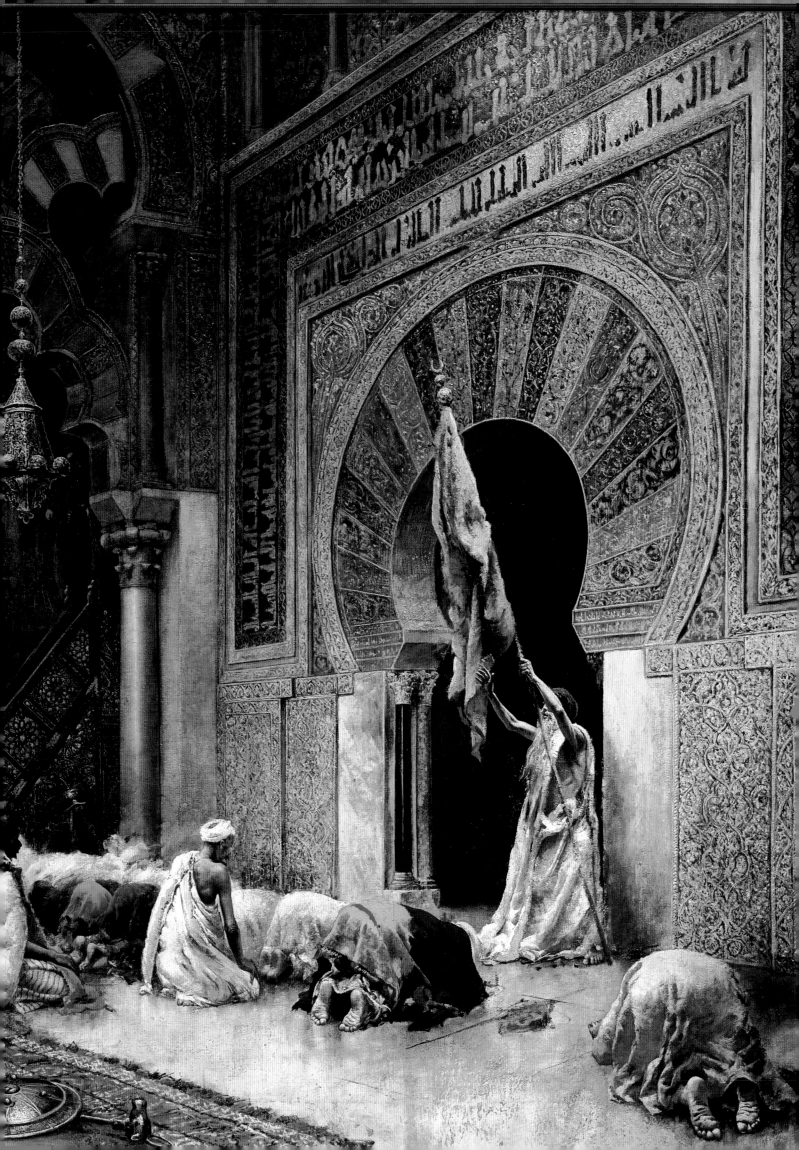

NOBLE DREAMS
Wicked Pleasures

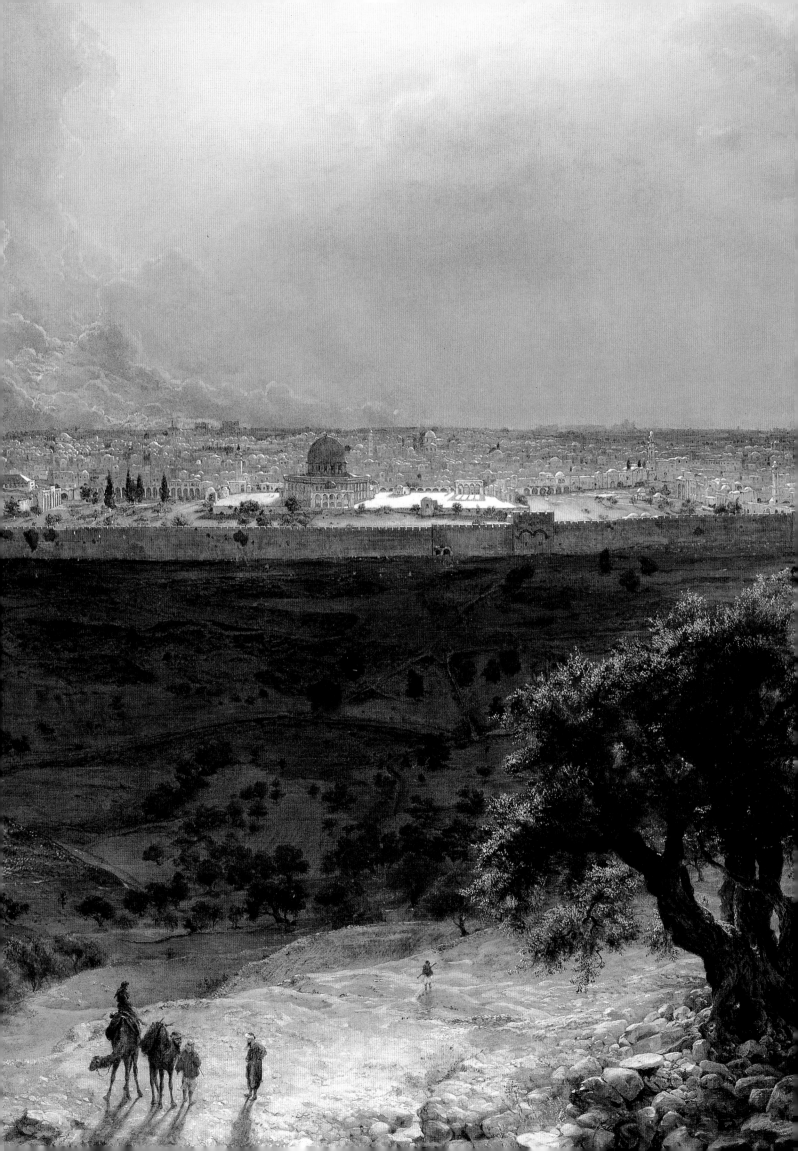

OLEG GRABAR

*A*ll cultures nurture myths and fantasies, wonderful paragons with qualities absent in one's own culture or else nightmarish visions of evil from which deliverance or protection is sought. Paragons of beauty or visions of evil were at times transformations of one's own past in a search for roots as models to imitate or to avoid, as memories to praise, venerate, or curse, as those foundation myths which, from time immemorial, defined and at times even justified the acts and beliefs of a nation or civilization. At other times, they were associated with different cultural realms altogether, as though the psychological need for myths could better be met by contrasting one's own world with different ones, with the "empires of evil" of recent political rhetoric or with all these "others" that have populated philosophical and sociological arguments since Jean-Paul Sartre's celebrated *l'enfer, c'est les autres* (hell is others) of over half a century ago.[1] Whether recollections of beauty or evocations of evil, cultural myths and fantasies lend themselves to images—in order better to be publicized but also because they *are* in fact images (albeit initially only mental ones)—and are thus easy to transform into representations.

The complexity of modern American culture is such that there are many "others" in its psychological makeup and that the "others" of some are the "us" of others. And it is in fact difficult to argue today for a single or even for a prevalent vision or myth about the past or about the rest of the world. Only in science fiction, with its extraterrestrials and space adventurers, do myths and fantasies exist that may be shared by all segments of American culture. As could be seen with reactions to more than one recent film or television program (the phenomenon is much rarer with books or magazine articles, whose audience is infinitesimal by comparison), one can almost always find a group that feels humiliated and offended by the visual portrayal of evil through some association with that group.

Whether matters were really simpler in the past may be a matter for debate. But there is little doubt that, since the early nineteenth century and throughout the twentieth, there has been a mythical world created (at least in part) and consumed by the dominant cultural streaks—European in their roots and Christian, primarily Protestant, in spiritual education—of the United States. To call this mythical world "oriental" is a bit of a misnomer, since India is hardly included and the Far East is part of a different story. But since Edward Said's memorable *Orientalism*, published in 1978, the identification of the Orient with the Near and Middle East and its Islamic extension into North Africa has been generally accepted. Factually and logically incorrect, the term has prevailed in this restricted sense and incorporates a vast fantasy of an Orient that is both a seminal creator (*ex oriente lux*, light comes from the east) and a threat from aliens with an "oriental" mind.

This catalogue and the exhibition it accompanies explore several aspects of this "oriental" phenomenon in American art and popular culture. This brief essay offers a few remarks on the sources of the mythical world of a "Near Eastern Orient" and on

Frederic Edwin Church (American, 1826–1900), *Jerusalem from the Mount of Olives*, 1870 (detail of cat. no. 2)

some of the peculiarly American forms it took. Without claims of exclusivity, I have identified four impulses or processes that have contributed to its shape: Protestant search for the space of the biblical revelation; European aristocratic taste; popular culture as in freemasonry and other fraternal organizations; and the spirit of skeptical curiosity and adventure. In reality, the boundaries between these processes are never clear, and problems arise as soon as one tries to pin one of them down as the single explanation of a work of art or of an activity pertaining to the arts. In a deliberately vague fashion, the presentation of these impulses should be considered only as preliminary thoughts on more or less identifiable aspects of the creation of a very particular visual environment.

The American landscape is covered with biblical references in the names given to rivers, mountains, cities, and villages, as the Promised Land of America often acquired its toponyms from those of God's promise to Israel. There probably is a geography and a chronological development of these place names that surely deserves to be better known, especially in contrast with Native American names or European transfers. And, as the great biblical scholar and explorer of Palestine Edward Robinson implied, his yearning for the specific places mentioned in the Old and New Testaments derived from the ways in which his childhood in Connecticut was infused with an imaginary knowledge of Palestine and its neighbors, Syria and Egypt, so essential in the unfolding of sacred history.[2] While most of the Protestant impulse expressed itself within the boundaries of the United States, it also led to the organization of group pilgrimages, pious individual travels, often ill-fated settlements in Palestine itself in which the spirit of adventure and pious inspiration were often mixed, eventually to the major accomplishments of American Protestantism like the American University in Beirut, any number of medical and educational missions that endured until the middle of the twentieth century, and scholarly institutes like the American Schools for Oriental Research in Baghdad and Jerusalem.[3]

Leaving aside the remarkable results of this impulse in the creation of a brilliant American scholarship in biblical and, by extension, all Near Eastern studies of times before the Muslim takeover in the seventh century c.e., there occurred a fascinating encounter between the spirit of the New World and the spaces of a very traditional one entering, slowly, into its own form of modernity, whether within the Ottoman Empire, which included Palestine, or in the Egypt of Muhammad 'Alī Pasha. Most of the time, the present was simply ignored. Dramatic representations of sacred history, remarkably few in number because of Protestantism's uneasy relationship to a religious imagery usually associated with Catholicism, hardly reflect an awareness of the Orient as it actually was or else are set in a routine Greco-Roman and classical setting. Descriptive sketches are common, especially of Jerusalem seen from the Mount of Olives (see cat. no. 2), which became a sort of cliché for travelers to the Holy Land and, in the late nineteenth century, a painter like James Fairman made a career out of such representations. Others, like Edward Troye, were driven by the same basic impulse of a Protestant pious market, but they expanded their concerns beyond Jerusalem to the Palestinian countryside and to Damascus or Cairo. In nearly all instances, local inhabitants or "natives" are absent or shown in theatrically standard poses.[4] This Protestant strand, mixed with others, eventually led to the much more complex personality of Frederic Church, and his creation at Olana exhibits his own mix of "oriental" and American impulses, which owes something to the association of an aesthetically satisfying space with the biblical message of a Promised Land as imagined by American Protestantism.

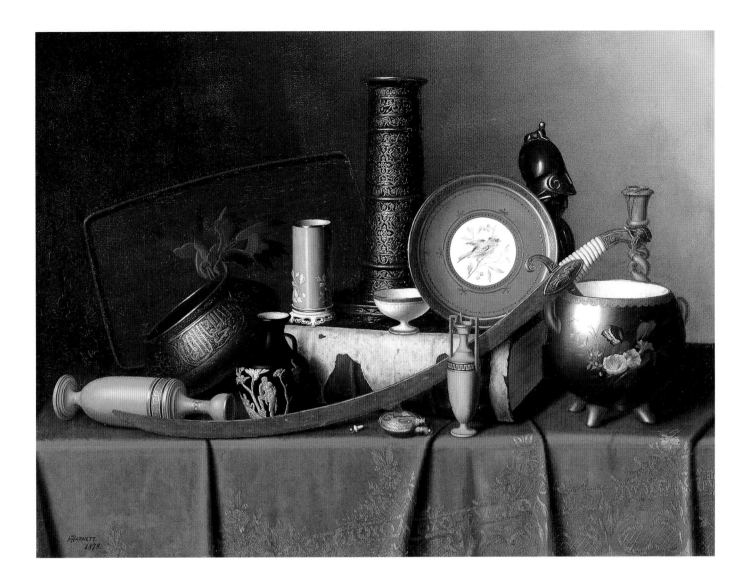

Fig. 1. William Michael Harnett (American, 1848–1892),
Still Life with Bric-a-Brac, 1878. Oil on canvas, 32 × 42¾
inches (81.3 × 108.6 cm). Courtesy of the Fogg Art
Museum, Harvard University Art Museums, Cam-
bridge, Massachusetts. Gift of Grenville L. Winthrop

A second impulse is easier to understand and to define, inasmuch as many of its features are still applicable today. Since the Middle Ages, and in ways which varied from period to period and area to area, the arts and habits of the Islamic Orient have been present in European, mostly aristocratic (or, at the very least, wealthy) taste. For many centuries, expensive items in fancy techniques like silk, inlaid metalwork, or carpet weaving came from the East. It can be argued that Islamic art was for centuries the luxury component of life in Christian courts or ecclesiastical establishments. Except for rugs, whose presence was consistent throughout the centuries, this component lost some power during the Renaissance and Baroque periods, but it reappeared in the eighteenth century with the fascinating phenomenon of an "oriental" taste for exotic clothes, for luxurious interior decoration of private houses, and especially for collecting objects of art or curios of all sorts from the East.

It is important to separate two strands in this impulse. One is exoticism, which creates forms; the other one is collecting, which gathers objects. Sometimes the two can be found together, as in a painting by William Harnett that exhibits an array of objects from Iran (fig. 1), but it is useful to establish a clear division between the two.

Exoticism is a fascination with something alien which manages to enhance the pleasure of the senses, the comfort of daily life, or the image one projects of one's self. At some level, it can become—as it had with Jean-Léon Gérôme's paintings and with his American imitators, in Hollywood's wildest inventions, or in advertising—a more dubious form of sensual provocation and titillation. But, in endless movie houses, hotel lobbies, or even private homes, fancy tile or stucco decoration is meant to depict or reproduce, perhaps only to recall, the Alhambra or whatever antiquarian memory some designer happens to possess. Such are often Iranian motifs, relatively rare in general, but curiously present in the huge griffins at the entrance of the Sam Rayburn building in Washington, inspired by Achaemenid art. All these examples are in fact a continuation of the medieval European association of beauty with the ornament of the Islamic Orient.

There are two much more successful expressions of this exotic impulse akin to, if not always derived from, Europe. One, earlier than the period covered by this exhibition, is the case of Washington Irving who, as a consular official in Spain, had been affected by the "Orient" of European Romanticism. He became fascinated by the Alhambra in Granada and transformed it into a romantic historic narrative, which is still a highly readable work of literature and which elaborates, in very tasteful ways, on the sensuous dream of a paradise-like setting.[5] The other one is Louis Sullivan, the great midwestern architect who had acquired in Paris recent books describing Islamic architecture in Egypt and Iran and who transformed some of the design principles of the fourteenth-century madrasa of Sultan Hasan in Cairo for the composition and decoration of the Wainwright building and mausoleum, both in St. Louis. Both Irving and even more so Sullivan went much beyond exoticism into the creation of true works of art of their own (fig. 2). And much later, at the very end of the period discussed here, Frank Lloyd Wright would also, in his projects for Baghdad, be inspired by the "Orient," but within the very different context of his own architectural development.

Collecting is a very different matter. It begins with a tourist's search for memorabilia and ends with a passion for certain categories of objects. Both exoticism and casual collecting had been present since the early nineteenth century, although systematic and thematic collecting did not really flourish until the appearance, late in the nineteenth century, of an art market. It is also important to recall that the artifacts available, legally or not, in the Islamic world included then, as they still do now, works of Greek, Roman,

Oleg Grabar

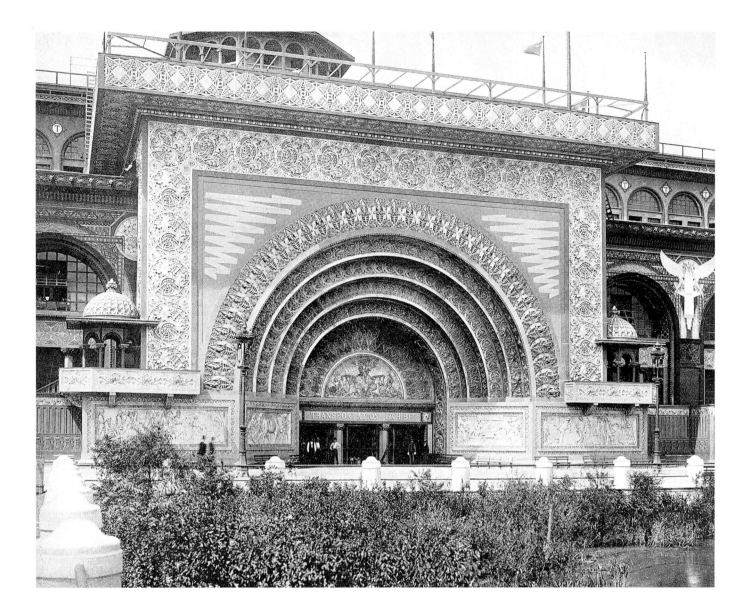

Fig. 2. Golden Portal of the Transportation Building,
World's Columbian Exposition, Chicago, 1893.
Designed by Louis Sullivan (American 1856–1924) and
Dankmar Adler (American, 1844–1900). From James W.
Buel, *The Magic City* (St. Louis: Historical Publishing
Co., 1893)

Assyrian, Sumerian, Hittite, and especially ancient Egyptian art. Works of Islamic art usually fell in the category of ethnographic artifacts and had not yet graduated to the status of art objects. In the shape of relatively recent rugs, old and new brass, ceramics, textiles, and "antiques" of all types, the Orient provided materials for the acquisitive instincts of rich men and women, and the wealth of American museums owes a great deal to all the pilgrims or simply curious travelers who brought back, as they still do, thousands of artifacts from the rich lands of the Islamic Orient. They enhance galleries and living rooms with items whose value lies primarily in being collectibles rather than in expressing something meaningful about the worlds that produced them.

Whatever their wider consequences, the first impulse was limited to a highly educated group and the second to a wealthy one. The third impulse, on the other hand, is more difficult to identify and to explain, but it certainly had and still has a broader and more popular appeal. Its most interesting expression for our purposes is the symbolism and pageantry of American social clubs that has issued from freemasonry. By the end of the nineteenth century, they had adopted a consistent Near Eastern "oriental" coloring. Shriner halls, for example, bear the names of Syrian or Iraqi and Egyptian cities, the fez and the operetta-like attire of Zouave and spahi soldiers are used in parades and in ceremonies, while stars, crescents, and scimitars are included in the panoply of signs and symbols carried by members of these fraternal societies or printed on their literature. The sources of these developments lie in part in the mystical acknowledgment that truth and wisdom come from the East. But the interesting point is that this particular "East" is a simpleminded vision of the contemporary, Islamic East, as it was proclaimed and paraded, among other places, in the World's Fairs of the nineteenth century. It is in the latter that belly dancing made its appearance as a public performance and entered thereby into the ways of displaying the sensuous East. The Orient has become a toy, a game, a required masquerade away from normal and real life. This is the Orient that has dominated the world of advertising until our own times and in much of the movie industry. Curiously poised between desire and repulsion, beauty and ugliness, it is an Orient that answers deep psychological and social needs.

The fourth attitude toward the Orient is that of the skeptic visitor, open-hearted or mean, curious yet unaffected, always critical rather than sympathetic. There is Herman Melville, fed on images of a beautiful Holy Land, yet discovering in it what he called the "unleavened nakedness of desolation."[6] To be true, his own personal uncertainties about his faith may have affected his negative reaction to the world where that faith had been revealed and played out its drama. But no such uncertainties troubled Mark Twain during his long tour of Europe and the Middle East with some seventy middle-aged men. Only the Sphinx and the American consul in Beirut remained unscathed by Twain's characteristically good-natured, but often quite mean, amusement at everything he saw, from the peculiar behavior of his fellow travelers to the holy places, the landscape, or the natives he encountered. It is true, of course, that, even more than today, the occasionally greedy obsequiousness of tourist servicing and the constant presence of beggars were the only contact a visitor had with the inhabitants of foreign places. Yet, beyond the sarcasms, evenly spread over compatriots and natives, these accounts demonstrate little interest in the people, much more in monuments, especially pious or historical ones, although even they receive their fair share of criticism. The Orient only matters as providing illustrations for some significant moments in the long history that led to the American Promised Land, and its very misery is a demonstration of the latter's success. By itself, it was dirty and ignorant, even savage, without the redeeming values of com-

monly accepted artistic treasures found in Europe. There is no sense of aesthetic quality in the remains seen by Twain, with some exception for Ancient Egypt. And yet, in a fascinating description of the ways in which his fellow travelers bought local clothes wherever they went, Twain raves about how all of them "turned out" in Constantinople (Istanbul), dressing up in "turbans, scimitars, fezzes, horse-pistols, tunics, sashes, baggy trousers, yellow slippers. Oh, we were gorgeous," he exclaims. In fact, they must have looked like members of a fraternal order and, as Twain remarks, the yellow dogs of Turkey must have all died laughing at the sight of this motley company.[7]

This last episode ties together several of my impulses in the making of the fantasy world from the Orient: It is the Protestant search for the Holy Land, which explains why this group of men went on their tour ("We were at home in Palestine," writes Twain).[8] Skeptical criticism is mixed with an exotic masquerade in local clothes, even though Twain himself may not have indulged in it. What is missing is the acknowledgment of quality that characterizes the exotic and collecting impulses. It may simply have been unstated in Twain's objective to amuse.

Leaving aside skeptical and critical curiosity, which is rare, and an intellectual search for information, which is laudable but rarely appreciated by a culture as a whole, we are left with two broad thoughts to explain the American involvement with the "Orient," as it appears in the exhibition. One is that the Orient was the maker of a game to play, of ways in which one could acquire, for however short a time, another personality or another experience, both personality and experience being primarily sensuous and, at some extreme, desirable but forbidden. The other one is that it continued to provide, as it had for centuries, the texture of beauty for an appropriate setting for life. But the life to be led in that setting was regulated by rules other than those of the "Orient." The latter was always something "other," a past from which one has escaped or the theatrical performance of a slightly wicked vision of pleasure.

1. The phrase is spoken by the hero of Sartre's play *Huis Clos* (No Exit), published in 1944.

2. Information and bibliography on Edward Robinson (1794–1863) can be found in Meyers 1997, 4:434–35.

3. For a history of American scholarship in the Middle East, see King 1983.

4. See Ackerman 1994a, 216–23.

5. See Irving 1832.

6. Quoted in Sha'ban 1991, 142.

7. Twain 1872. The quotation is curiously outside the main narrative of his trip.

8. Ibid.

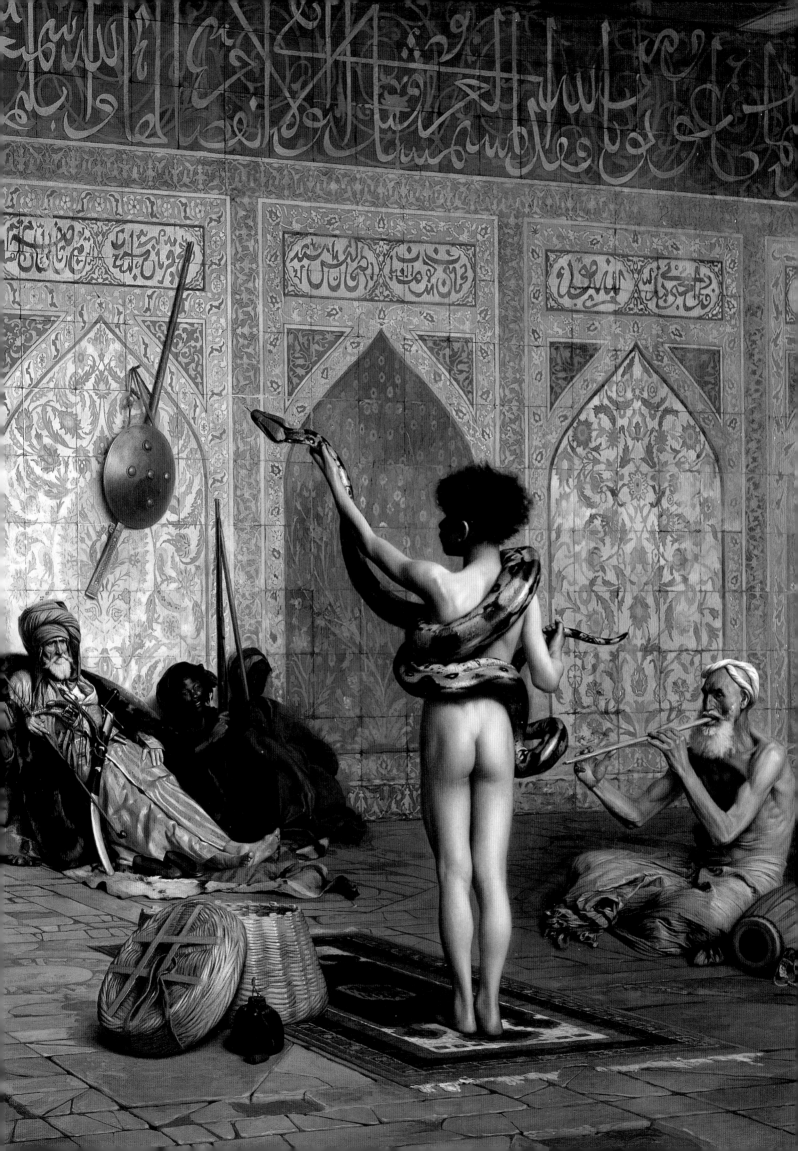

A Million and One Nights: Orientalism in America, 1870-1930

HOLLY EDWARDS

*L*ooking at *The Snake Charmer* by the French artist Jean-Léon Gérôme (cat. no. 5) is an intense experience. Vivid and full of intriguing detail, it implies a titillating story. So seductive is the image, in fact, that many viewers have succumbed to a desire to touch the boy's naked body. As a result, the painting is now under a protective layer of glass. The visual seduction, moreover, is not confined to vicarious pleasures of the flesh. The unwary museum visitor is also enticed into thinking that the story is somehow "true," for such images seem to record reality as it presents itself to the naked eye. This, one might suppose, is what the Orient is really like. But what is the "Orient"? Who says it is "really" like that? And what agendas does it serve to make such claims?

Because the painting invokes these complicated questions, it was chosen as the cover for Edward Said's book *Orientalism,* which analyzes the processes by which the West studies, describes, creates, and controls the "Orient," keeping it in a subordinate role by representing it in a demeaning light.[1] While Said propounded his thesis in reference primarily to literary evidence, art historians extended his insights by considering the visual arts, most particularly nineteenth-century French paintings like *The Snake Charmer.*[2] The ensuing scholarship has generated an increasingly nuanced appreciation of the imperialistic agendas, gender inequities, and racial prejudices that underlie such depictions of the erotic, exotic East and the processes of power that they make manifest.[3]

Graphic and dramatic images like Gérôme's *Slave Market* (cat. no. 4) and *Moorish Bath* (fig. 1) or Henri Regnault's *Summary Execution* (fig. 2) depict an Orient of naked harem girls and tyrannical despots, which served to fascinate, titillate, and ultimately flatter the nineteenth-century French viewer. Such pictures can only be understood with reference to France's protracted colonial machinations in North Africa, and to French cultural and visual traditions. France reduced the Orient to colony, concubine, and indolent heathen, betraying the complex attitudes of an entangled imperialist.

This ideological stance was represented by means of a visual tradition based on the human figure. This mode of expression lends itself well to Orientalist attitudes and even fosters them, for in its rendering of "truth" in corporeal terms, it represents the world as an echo of the human self. The rest is "other." These are basic variables of Orientalism, and by extension, they often stand for aggregate selves such as empires and colonies.

This visual language, moreover, enjoyed the cumulative credibility of antiquity and the Christian tradition, both of which often represented truth by means of the heroic and enshrined male body. It was thus well suited to Orientalist attitudes. It combined the power vested in cultural heroes with the voyeuristic potential of the nude female form to describe the hierarchies embedded in and propagated by the imperialistic milieu of France. Dignified by tradition and history, then, French Orientalist painting conveyed and extended the conviction that power and glory, first vested in the body of Christ, also resided in the body politic of France, while the Orient became the feminized and exotic vessel for colonial energies.[4]

Jean-Léon Gérôme (French, 1824–1904), *The Snake Charmer,* c. 1870 (detail of cat. no. 5)

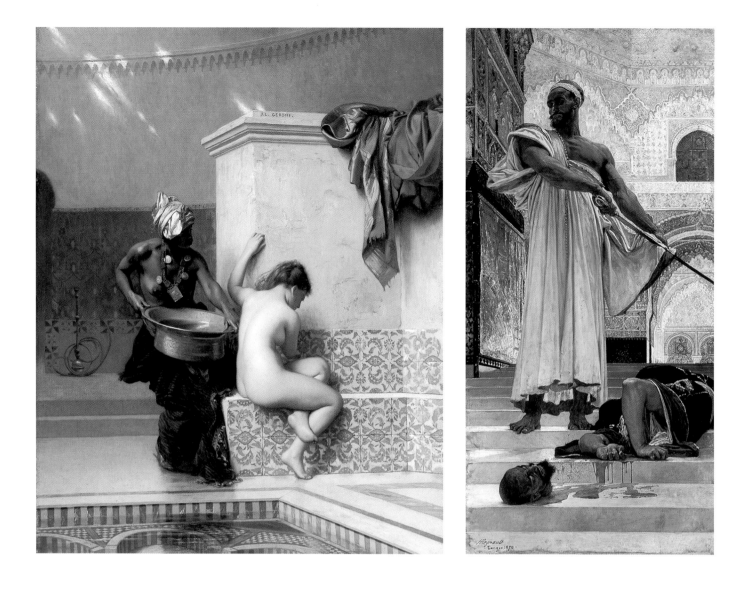

Fig. 1. Jean-Léon Gérôme, *Moorish Bath*, 1870. Oil on canvas, 20 × 16⅛ inches (50.8 × 40.8 cm). Museum of Fine Arts, Boston. Gift of Robert Jordan from the Collection of Eben D. Jordan

Fig. 2. Alexandre-Georges-Henri Regnault (French, 1843–1871), *Summary Execution*, 1870. Oil on canvas, 9 ft. 10⅞ inches × 4 ft. 9½ inches (302 × 146 cm). Musée d'Orsay, Paris

Political circumstances and fundamental aesthetic principles operative in the United States in the mid-nineteenth century provide contrast and counterpoint to the French case. America had not completely shed its subordinate status as a former colony. It had no sustained relationship with the Orient (that is, with any political entity under that larger rubric), and its imperialistic activities were largely confined to the North American continent, where depredations on native peoples were rationalized as exploration and Manifest Destiny. Elites and aesthetes sought "refinement" abroad or equated it with imported artifacts and cultural traditions of greater antiquity than their own. In general, sober Protestants avoided representations of the human body, which were thought to be immodest and even idolatrous, choosing instead landscape as a vehicle for visual expression. Meanwhile, the body politic was virtually dismembered in the Civil War, a conflagration ignited in part by the atrocities of institutionalized slavery. Inevitably, Americans generated Orientalisms resonant with but quite different from their French counterparts.

It would be impossible to understand the idiosyncrasies of American Orientalism without reference to France because of the unique cultural status France enjoyed at the time and the pedagogical dimension of that position. French artists, bureaucrats, and other citizens promulgated certain standards of art and culture, and the visual language they utilized was what many aspiring artists sought to master. They often learned it in Paris, at the École des Beaux-Arts and numerous independent ateliers. As a government-funded school of art and a wing of the establishment, the École epitomized the dominant

12 *Holly Edwards*

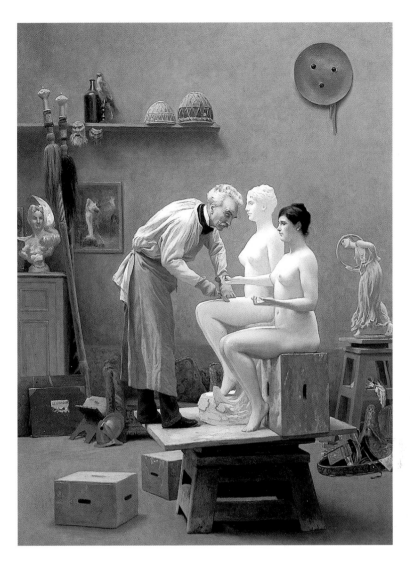

Fig. 3. Jean-Léon Gérôme, *The Artist and His Model*, c. 1890–93. Oil on canvas, 20 × 14½ inches (50.8 × 36.8 cm). Haggin Collection, The Haggin Museum, Stockton, California

visual culture in France. Gérôme, the painter of *The Snake Charmer*, was one of its most prominent teachers for the last half of the century, and he introduced students from many countries to this academic canon. Under his tutelage, fledgling artists were indoctrinated to the western art historical tradition and taught how to draw and paint the human figure with anatomical precision (fig. 3).[5]

Students of Gérôme who studied this peculiar visual language were quite diverse, and they painted pictures that bore the imprint of the teacher even as they betrayed other sensibilities. The painting of Osman Hamdi Bey, for example, exhibits many of the hallmarks of French academic painting (fig. 4): the ethnographic detail, the deft rendering of the human body, the balanced composition.[6] Having studied with Gérôme as well as Gustave Boulanger, Osman Hamdi was well versed in the traditions of French Orientalism. Nevertheless, when he returned to his home in Ottoman Turkey, he chose not to depict despots and harem girls or nude women in the bath. Instead he presented decorous and elegant images of people seeking change and simultaneously suffering the impact of the West. His painting, in effect, was a way of "speaking back" to French artists intent on portraying the Orient in their own image (see Çelik essay, pp. 77–97).

Similarly, the American painter Frederick Bridgman absorbed Gérôme's advice and criticism but nevertheless painted differently than his mentor (see Allen essay, pp. 59–75). His *Siesta* (cat. no. 6), a quiet reprise of the famous French painting *Odalisque with a Slave* (fig. 5), demonstrates his fluency in the French tradition, but, like Osman Hamdi, Bridgman imbued his work with a distinctive flavor. Eschewing the blatantly

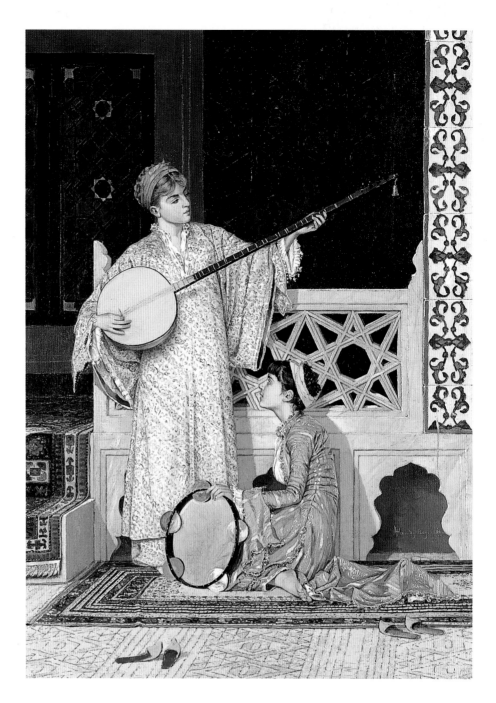

Fig. 4. Osman Hamdi Bey (Turkish, 1842–1910), *The Musician Girls*, 1880. Oil on canvas, 22½ × 15½ inches (57.1 × 39.4 cm). Collection of Suna Kiraç, Istanbul

erotic, he invoked the Orient to describe a desirable world in which women are proper, beautiful, and reticent. This is Orientalism in an American mode.

Clearly, there are many ways to represent the Orient, and each is subject to conditions of time and place. All of these images are partial and contrived; none is "true" or "accurate." Instead, they must be recognized as time-bound constructs, used to give shape to disorderly aspirations and cross-cultural perceptions. The term "Orient" itself was a construct, one that strategically homogenized and circumscribed diverse cultures and traditions for western convenience. I use it here, in echo of nineteenth-century parlance, to refer to the idea behind the imagery, not to validate its distortions or perpetuate its currency.

Much of the material included in this exhibition, especially that dating from before the turn of the century, reflects the diverse perspectives and activities of a small but powerful cohort: the white male elites of the northeastern United States. As I construct a narrative of this material for exhibition purposes, it will perhaps seem that I am extending or condoning the status that these groups enjoyed at the expense of others.

Holly Edwards

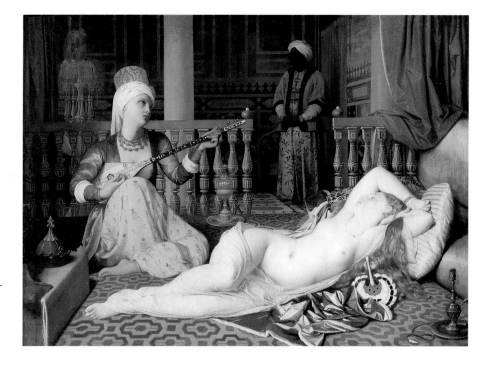

Fig. 5. Jean-Auguste-Dominique Ingres (French, 1780–1867), *Odalisque with a Slave*, 1839–40. Oil on canvas, 28⅜ × 39½ inches (72.1 × 100.3 cm). Courtesy of the Fogg Art Museum, Harvard University Art Museums, Cambridge, Massachusetts. Bequest of Grenville L. Winthrop

This is not my purpose. What I am assembling here, effectively for the first time, are simply the loudest voices within the dominant culture at a particular time and place. When I posit a worldly, wise France or an indoctrinated America, I am not intending to essentialize either country in terms of the privileged and powerful, but rather to acknowledge the inordinately large role that such individuals played and the ideological collusions that they shared. Indeed, there are many other voices to be heard before we understand the nuances and complexities of American Orientalism; Zeynep Çelik's essay in this catalogue, for example, amplifies the previously silenced voices of Ottoman women to complement the myopic stories told by the organizers of the World's Columbian Exposition of 1893. There is much more to be done along these lines.

In the meantime and as an initial foray into the study of American Orientalism, this exhibition and essay attempt to trace a process by which a concept of the Orient was created by a few and then elaborated to many more throughout the United States. The exhibition begins with the gilt-framed paintings of the Hudson River school artist Frederic Church and effectively ends with a national cult figure, Rudolph Valentino, star of *The Sheik*. The story initially transpires in the Moorish smoking rooms of millionaires and continues in the cozy Turkish corners of middle-class parlors, assembled by means of judicious purchases from Sears Roebuck.

Along the way, the focus shifts from "high" art to the media of mass production, reflecting what I see as the trail of Orientalist imagery through society and over time. I am not deliberately or inadvertently leaving out either the popular culture of the nineteenth century or the high art of the early twentieth century. There are a few examples of both included in the exhibition, which are intended to acknowledge the complex roots of mass media as well as the new directions that painting took after the turn of the century. For the present purposes, however, I am focusing elsewhere, in an effort to demonstrate the larger migration of Orientalist imagery from unique objects to mass-produced materials. In so doing, I am highlighting some basic trends in the visual evidence. While there obviously existed material manifestations of "popular culture" in the late nineteenth century (including illustrated books and magazines, simple advertisements, and engaging forms of public entertainment), early-twentieth-century Ameri-

cans produced and were assaulted by a much more vivid and vast array, including photographs, color prints, pictorial advertisements, and movies. Orientalist imagery proliferated in this context of heightened visuality, and the locus of it simultaneously shifted. Thus, by the time advertisements doubled as colorful wall decorations in middle-class homes, and silent movies engaged the attention of the American public, there was no significant tradition of Orientalist painting left; indeed, it had already begun to wane by the time of the World's Columbian Exposition of 1893.

These diverse materials encompass a multifaceted process that I refer to as "Orientalism" throughout this essay. While this term was actually used in the mid-nineteenth century, our collective understanding of it was profoundly altered with the publication of Edward Said's *Orientalism* in 1978. Subsequent scholarly contributions have further nuanced its connotations and implications. In light of these developments, I have used "Orientalism" to refer to the myriad ways that people represent and employ the "Orient" for diverse personal, social, and cultural purposes. In my opinion, these purposes range from imperialism and denigration to celebration and nostalgia; possibilities are as various as individuals and circumstances. Orientalism is not a monolithic or static phenomenon but rather a conflicted and multivocalic process that can only be understood cumulatively and retrospectively. In talking about Orientalist visual imagery in this manner, then, it is critical to be specific about time, place, and players.[7]

In the case of American Orientalism, the period from 1870 to 1930 was complex and formative. It was a time when the United States emerged from the devastation of the Civil War and sought to join what were thought to be the "civilized" nations of the world. Political, cultural, and psychic horizons were expanding in relation to a variety of "others," including Native American peoples,[8] France, and the Orient. As Americans proceeded along their self-appointed path of "progress," they encountered rapid industrialization and urbanization, territorial expansion, and economic upheaval. Victorian values were being eroded by the changes, and men and women both moved uncertainly toward the future.

In this era of transformation, the Orient was a useful construct that enabled people both to revisit the past and to envision the future. It allowed people to declare their convictions and affirm their values. It also offered opportunities to imagine, vicariously experience, and ultimately incorporate new options into their lives. Thus, the Orient was both a tool for self-scrutiny and a foil for social change.

What distinguishes this period and this phase of Orientalism from earlier ones is the abundance of visual evidence of American attitudes.[9] Prior to this time there had been literary evidence of American convictions about the Islamic world, but there was considerably less visual representation of the region.[10] In the postbellum period and the early decades of the twentieth century, however, Orientalist imagery proliferated in the form of paintings, prints, decorative arts, advertisements, photographs, films, fashion, and a variety of performing arts. In part, this resulted from increased travel opportunities and expanding national horizons, but it was also indicative of the efflorescence of mass media and the development of a department store culture. From this explosion of imagery, people were assembling for themselves representations of the Orient that were increasingly vivid and varied.

The images changed over time, subject to domestic needs and social pressures. In the decades after the Civil War, the Orient was conceived primarily as a traditional and monolithic culture in an unadulterated natural setting. As such, it was a distant screen upon which the Protestant narrative could be reenacted, American values could be pro-

jected, and nostalgia could be expressed. In paintings of the 1870s and 1880s, one is struck not by the exoticism of the imagery so much as its comfortable familiarity for a Victorian audience. Some images suggest a wistful review of what America once looked like; others seem to universalize the values of the dominant culture in America simply by presenting them in oriental garb. In effect, this Orient served to reassure nineteenth-century elites that everyone was or should be like them and that, if necessary, they were prepared to show how things should be done.

As the century drew to a close, the Orient was remodeled for new consumers. The "real thing" was brought home and displayed in the form of live ethnographic exhibits at the Chicago World's Fair of 1893. Here, the Orient was constructed not as potentially like America but rather as demonstrably and thankfully different. "Realistic" villages from Egypt and Algeria, for example, were displayed along with other cultures of the world on the Midway Plaisance, and fair-goers visited them with a mix of curiosity and condescension. From the lofty vantage point of "civilized" man sailing around on the technologically superior Ferris wheel, this Orient was belittled and demeaned by anthropologists, fair organizers, and ultimately, the American public.

Thereafter, in the early twentieth century, when women began to enjoy more social latitude and Americans were collectively and individually discovering "the body," the Orient was reimagined around sex. As a catalyst and surrogate for enacting desire, oriental imagery appeared on diverse consumer products and in the entertainment industry as the backdrop for new and titillating personal experiences. Such was the nature of the Orient in the collective imagination that it sustained this extraordinary variety of interpretations, fluctuating between being flatteringly like and reassuringly different, as echoes of self and incarnations of other.

This exhibition offers an opportunity to correlate this new corpus of material evidence with a sophisticated analytical apparatus. This is extraordinarily difficult to undertake within the context of an exhibition catalogue, for one is faced with the rhetorical challenge of telling a new story in an accessible and self-conscious manner while simultaneously exposing its underpinnings—arguably mutually exclusive processes. In light of that difficulty, other essays have been included to complement this one, and extensive commentary has been embedded in catalogue entries in order to segregate the documentation of new materials from the theoretical consideration of their genesis and transformation. It is hoped that this structure will serve to highlight the implications of this material and identify opportunities for further research of diverse kinds.

Clearly, there is evidence of Orientalist attitudes in the paintings, prints, and posturings of turn-of-the-century Americans. The diachronic arrangement of this material and its correlation with political and social developments suggest that visual Orientalism served as a preface to, or part of, the consolidation of the power that America sought in the emerging world order of the early twentieth century. Early imagery viewed the Orient, whereas subsequent renditions emphasized its inhabitants. Ultimately, it would appear that American Orientalism was essentially a therapeutic mechanism as well as a creative process whereby people might construct models of behavior and society and then move into the spaces of power that they had constructed.

The material evidence of these processes stands in peculiar and significant relationship to the literary evidence, I think. Among the American Orientalist paintings in this exhibition, one does not find sanctimonious pictures of "indolent" or "childlike" natives or visions of lustful Turks, though one reads about such "Orientals" frequently in nineteenth-century literature. In fact, wherever we have adequate documentation to

comment, it suggests that painters often went to the Orient presuming such stereotypes, but once there, they painted other things. In effect, they painted the settings for their own role-playing. While this role-playing takes the form of picturesque views and costume studies of "Oriental" players, it is also literally manifest in images of cross-cultural dressing and in the charged and ritualized masquerades of fashion, freemasonry, and world politics that transpired in the wake of increased world travel. The visual character of this material is important, for it provides a transition between word and action and enables the insertion of the self into a new worldview.

GETTING ORIENTED

Strictly speaking, Orientalism is a mode of speech. It is not in this vernacular sense that we propose to consider it, but in a larger and more popular significa-tion. . . . Orientalism is not merely associated with one country, race or era. It is a complex idea made up of history and scenery, suffused with imagination and irradiate with revelation. It is not always associated with Tartar hordes, luxurious caliphs, tea-raising Chinese, Grand Lamas, Indian Sikhs and three-tailed pashas. It may include these as straggling figures in the picture, but to represent it pictori-ally, as it first flashes upon the mind, would absorb all the colors of the chromatic scale and break all artistic unity.

We frame to ourselves a deep azure sky, and a languid, alluring atmosphere; associate luxurious ease with the coffee-rooms and flowering gardens of the Seraglio at Constantinople; with the tapering minarets and gold crescents of Cairo; with the fountains within and the kiosks without Damascus—settings of silver in circlets of gold. We see grave and reverend turbans sitting cross-legged on Persian carpets in baths and harems, under palm trees or acacias, either quaffing the cool sherbet of roses or the aromatic Mocha coffee . . . we see the smoke of the Latakia—the mild sweet tobacco of Syria—whiffed lazily from the bubbling water-pipe, while the devotee of backgammon listlessly rattles the dice; we hear the musical periods of the story-teller relating the thousand and one tales to the over-curious crowd. . . . and this we call Orientalism. This is Orientalism, not as it is, but as it swims before the sensuous imagination. It is too unreal to be defined.

So begins the lead article, entitled "Orientalism," in the June 1853 issue of *Knickerbocker Magazine*.[11] Thoughtful and passionate, the anonymous author evokes a sensuous dream of the Orient and sadly remarks, "To analyze it is to dissolve its charm." Consolidating the mystery and allure that the Orient represented to American readers, such rhetoric was promptly followed by rather more cold-eyed analysis.

First, the author notes what he perceives to be the obscure and contradictory nature of his subject: "How then shall we define this thing of dreams and dirt, despotism and dignity, called Orientalism?"[12] Its peculiar quality, he observes, is due in part to its spiritual dimension: "The Rich stream of poetry which flows throughout the Bible and penetrates our best emotions, springs from the Orient, inspired by God. . . . Here God himself talked with his creatures. . . . Here too is the source of all religions."[13] But Orientalism, for him, was also very much of this world. Indeed, it is its time-bound and political character to which he devotes the most pages: Orientalism was deemed a stage for imperialistic agendas and national fantasies—the French seeking glory; the Russians, more land. Turkey was seen as particularly vulnerable, caught in a precarious

seesaw of power with imperialistic European nations. That tenuous balance was further complicated by burgeoning technology, as the "democracy of steam" brought the East closer for western travelers.

Ultimately, while Orientalism presented prickly quandaries and profound challenges to this writer, still it excited his aspirations: "What part have we of America in the Orient?" he queries. The answer is clear and emphatic. "No power but the ALMIGHTY can prevent the Democratic element of America from making its impress upon the Orient."[14] For him and others like him, there was little doubt that America would reshape the world in her own image and that the Orient would be subsumed therein. The author cites East Asians such as Chinese, Sikhs, and Tartars as "straggling figures in the picture," but defines Orientalism with reference to Constantinople, Cairo, and Damascus. In effect, the Orient was most vividly manifest in regions to the east and south of the Mediterranean Sea. Close to the "West" but not of it, this "East" was exotic, enticing, and accessible. During the period in question, the area witnessed considerable political change as a result of the waning powers of the Ottoman Empire and the escalating colonizing efforts of European nations, primarily France and England.[15] Spain, a common route to the Orient for European and American travelers, exuded its own exotic allure due to the Moorish presence in the Iberian Peninsula centuries earlier (see Allen essay).

But the Orient was more complicated than geography. As the *Knickerbocker* article suggests, it was both a region of the world and a precinct of the heart. Often, it was a target for condescension in the popular media. Newspapers, pamphlets, magazines, tracts, lectures, and sermons that were readily available to the ordinary literate American commonly described the inhabitants of the Orient in degrading stereotypes (cat. no. 34). These patterns of derision, widespread and unquestioned in the nineteenth and early twentieth century, are grotesque in retrospect and might be summarized thus: Turks were thought to be unspeakable, irredeemable barbarians and general impediments to civilization; Arabs were "fanatical, biologically violent, mendacious and larcenous"; and Armenians were "servile, ignorant, bigoted, cunning and mercenary" except when they were being subjected to mass slaughter (as in 1915), in which case they were temporarily and partially redeemed. Often, the rhetoric was breathtakingly inclusive, overriding any ethnic distinctions: All Levantines were deemed to be reprehensibly alike, "physically dirty, ignorant, semi-civilized, superstitious, indolent, parasitic, cunning, shrewd, mercenary, fractious, and violent."[16] Thus, while popular opinion occasionally reflected sympathy for political victims or children, more often the consensus was negative, and it was based on little direct contact.

Of course, most Americans were not predisposed to cross-cultural subtleties at this point. New and ostensibly "scientific" modes of inquiry fostered and validated the tendency to essentialize and typify people according to a limited number of physical characteristics.[17] In this ethos of observation and cataloguing, a person's physiognomy was definable according to type and was thought to reveal all the social and psychic secrets that lay concealed underneath. The new sciences of phrenology and anthropology further organized individuals into tight categories ranging from the bestial to the enlightened. Thus, with supposedly unimpeachable rigor, scientists classified peoples by face, skull, skin, class, and race. Covertly, however, such "objectivity" often served simply to document and legitimate the superiority of the Caucasian race.[18] By such means, it was established that peoples of the Orient, along with many other "foreigners," were simply lower on the rungs of the cultural hierarchy.

Along with growing assurance in matters of science and anthropology, there was a concomitant certainty about spiritual issues. Protestant evangelism was a strong current in American religiosity, and it carried a millennial fervor, for many deemed it part of God's plan for Americans to strengthen and extend the purview of Protestantism. An intimate and ordained connection between the Promised Land of the Bible and the Promised Land of the New World was widely assumed, and the missionary network in the Near East sought to make this manifest.[19] In turn, missionaries served as a primary source of information about the region, inevitably coloring the news that reached the United States. This had the consequence of reinforcing the presumed superiority of Protestantism over other faiths and especially over Islam, often erroneously termed "Mahometanism."[20] It was, however, a more complex picture than that, for not all sermonizing was directed against Muslims. In fact, Muslims were sometimes thought to be less objectionable than various Christian denominations inhabiting the region. At least, so the thinking went, the Muslims were not subject to a corrupt religious hierarchy and they did not wantonly indulge in alcohol. This was contrasted with Armenian Christianity, for example, which was deemed to be a "mummery and abomination" devoid of any genuine spirituality.[21] America's Orient, then, was in part a projection of domestic convictions and anxieties across a vast and inadequately bridged distance.

When direct interaction did occur, it was often perceived through this lens of sanctimonious stereotype and self-aggrandizement. One of the most formative events was a crisis that transpired between the United States and the so-called Barbary States.[22] In July 1785, Algerian corsairs captured the *Maria,* a schooner out of Boston, and took captives. These events and their aftermath over ensuing decades generated a variety of stories and poems, extending and elaborating an established tradition of captivity narratives in which American citizens were celebrated as the noble victims of savage tribesmen, ruthless pirates, or other benighted barbarians. Within this self-serving frame of reference, Americans were not the aggressors but the righteous wronged, the enlightened martyrs. The Orient, by contrast, was a place ruled by despots, prone to cruel displays of power and self-indulgence, and as such it enhanced the nobility of an ethically driven democracy. America and Americans were clearly above such despicable behavior.

The Barbary captivity and American mercantile aspirations ultimately necessitated a protracted and agonizing series of negotiations, which culminated in American marines attacking Derna, east of Tripoli, in 1805. These events were immortalized in patriotic songs ("From the halls of Montezuma to the shores of Tripoli . . .") and embedded in popular consciousness as the evidence of and impulse to American imperial might. Besting Islamic despotism in the Barbary Coast drama enabled the young democracy to prove itself politically at a critical moment in history.

The Orient continued to serve a variety of rhetorical purposes on the home front that can be reconstructed with reference to literary sources.[23] The same tyranny and slavery associated with the Orient were cited by antebellum reformers to focus American attention on indigenous institutions of slavery, and images of the despotic and polygamous Turk enabled American audiences to grapple with the challenges of religious diversity in the guise of Mormonism. In each of these cases, the Orient provided a therapeutic foil whereby America could name its accomplishments and its problems, and, in the process, construct a flattering self-image.

These moments of heightened awareness of the Islamic world encompassed literary and political rhetoric, but they entailed little direct interaction or visual representation.

Throughout the nineteenth century, however, contact increased between the United States and the Orient, and between individual Americans and "Orientals." Formal diplomatic relations were gradually established, and various exchanges took place between American and "Oriental" populations. American personnel were employed to modernize the Turkish navy,[24] select American regiments donned the colorful dress of Zouaves as they assembled to defend the Union,[25] and Civil War veterans later exercised their surveying and engineering skills in Egypt.[26]

Each of these encounters deserves careful scrutiny as pieces in the puzzle of American Orientalism, but for the present purposes it is most germane to consider the growing numbers of tourists that invaded the Orient. The advent of the steamship made travel to exotic places faster and more comfortable.[27] Gradually, a brisk business in luxury package tours developed and tourists stumbled over one another to see the "sights." The *Knickerbocker* article quoted earlier describes this phenomenon in a manner that betrays underlying convictions about the somnolent and retrograde Orient and the inevitable conquest of tourism: "The exclusive repose of the Orient is retreating before the advance of travel. . . . Miss Laura Lisper, of the Fifth Avenue of New York, may be found upon a camel, sketching the 'dear delightful pyramids' . . . The commerce of the caravan, which carried the Koran and its religion throughout the Orient, will give way before the genius of steam."[28] Clearly, technology and travel were to be the means by which America infiltrated the Orient.

During the last quarter of the nineteenth century, the pace of tourism accelerated considerably, inspired in part by what was perceived as the "picturesque" character of the Orient. Many travelers recorded their adventures in sketches and photographs, and that potent visual experience was in turn enthusiastically shared by armchair tourists who devoured travelogues, panoramas, magazines, and lectures.[29] Gradually, then, the personally experienced Orient and the ensuing reportage were beginning to nuance public understanding and consolidate the perspective of the privileged traveler.

Not all of the direct contact between Orientals and Americans, however, occurred overseas. In the late nineteenth century, an increasing number of immigrants, primarily from Syria, arrived on American shores to form a discrete cohort within the urban melting pot.[30] In 1890, Jacob Riis described the enclave in New York in words that reveal the anxiety and hostility that indigenous populations felt toward these immigrants: "Down near the Battery the West Side emerald would be soiled by a dirty stain, spreading rapidly like a splash of ink on a sheet of blotting paper, headquarters of the Arab tribe, that in a single year has swelled from the original dozen to twelve hundred, intent, every mother's son, on trade and barter."[31] As he suggests, most came to make money, expecting to return home rich. Many did so, while others stayed.

From the perspective of native-born Americans, these entrepreneurial immigrants posed social as well as economic threats. Solitary peddlers selling their wares on city sidewalks elicited self-righteous condemnation. Some were linked with duplicitous trade practices, such as "the Arab, who peddles 'holy earth' from the Battery as a direct importation from Jerusalem."[32] But perhaps more important in the era of department stores and escalating materialism was the conviction that peddling itself was offensive. It was summarily equated with beggary, while barter and haggling were deemed throwbacks to primitive modes of economic exchange, just as America had reached a more civilized one-price system and money ruled.[33]

Arabs working in the textile mills of New England were also suspect.[34] Their resistance to unions in the textile industry complicated already contentious labor disputes

and identified them as an independent and intractable element in the larger socio-economic picture.[35] Furthermore, they lived with minimal furniture and personal belongings, thus inciting mistrust and distaste among increasingly materialistic American consumers. Their practice of living in close quarters elicited slurs on their family values. Ironically, although oriental men were presumed to enslave and incarcerate women in their harems, on American shores, those same men were thought to abuse and exploit women because the women worked outside the home. Clearly, the Orient invoked "the woman question" in conflicting and conflicted ways.

The term "Street Arab" encapsulates some of the complex anxieties engendered by these immigrants.[36] Current in impoverished urban environments like Manhattan's Lower East Side, the term was applied especially to indigent little boys who scrambled to survive on city streets. They were homeless, outcast waifs, not necessarily Arab at all, who might make a few coins hawking newspapers on the corner. With nowhere to live and limited prospects, these children elicited disdain as well as reformist zeal among elite urbanites and social workers (fig. 6). Underlying these impulses were haughty convictions about improving one's lot in life and the unquestioned superiority of the American way.

To many Americans then, Arab newcomers were an unpromising contingent among the increasing numbers of immigrants entering the United States. Anglo elites, desirous of assimilating difference and preserving cultural homogeneity, passed stringent legislation designed to curb this looming "threat." While such restrictions were directed at individual ethnic groups, they also revealed anxiety about particular social practices. Thus, 1907 legislation to exclude polygamists from the United States seems to have been a response to both Mormonism and Islam, both of which offended mainstream sensibilities about the ideal family unit. The most sweeping legislation was enacted in 1924, imposing quotas and institutionalizing hostility to foreigners in general.[37]

The evidence cited here, ranging from magazine articles to immigration legislation, suggests that Said's thesis of an insidious and sanctimonious attitude toward the Orient

Fig. 6. Jacob Riis (American, 1849–1914), *Street Arabs, Mulberry Street*, c. 1898. Photograph. Museum of the City of New York. The Jacob A. Riis Collection (no. 122)

Holly Edwards

Fig. 7. Hiram Powers (American, 1805–1873), *The Greek Slave*, c. 1843. Marble, height with pedestal 90 inches (228.6 cm). Yale University Art Gallery, New Haven, Connecticut. Olive Louise Dann Fund

in the West has a qualified relevance for America. While there were no militarized campaigns of colonization, there was in America a strong strain of antipathy and condescension toward the Orient, coupled with a presumption of entitlement, rightness, and power. But Orientalism was a manifold and conflicted process, a product of the diverse experiences of tourists, writers, artists, and bureaucrats. Each spun a strand in a larger web, and each is deserving of diachronic scrutiny. In considering them, it becomes clear that there was no one Orient, or even one collective attitude toward the Orient, but rather a protean set of associations that changed over time. Resisting a neat definition, the evidence suggests instead an attitudinal matrix of three coordinates.

The first is the dominant ethos of Protestant piety. It was a widely held conviction that America had a special typological tie to the Holy Land, for the United States was deemed the new Israel, the Promised Land for a chosen people.[38] Redemption was thought to be not only a personal option but a collective and inevitable destiny, and the grand experiment in American democracy represented the divinely sanctioned ambition of all mankind. Such convictions were writ small in the numerous Bethlehems and Canaans that dotted the American landscape, and when Frederic Church exhibited his *Jerusalem from the Mount of Olives* (cat. no. 2), it was a similar act of cartographic symbolism. Rendering the American viewer's space continuous with sacred topography in the Orient, the painting effectively deleted the intervening time and space as well as the awkward "natives" and nations in between. Thus it reconfigured the viewer's world according to a grand ideal and defined the arena for the perfection of mankind as implemented by American citizens.

This Orient of lofty dreams and pious aspirations was balanced by an Orient of more immediate pleasures, fantasy, and escapism, in the mode of the *Arabian Nights*. For people like the travel writer Bayard Taylor (cat. no. 1), the Orient was a masquerade and an adventure, a place where one might set aside the challenges posed by modern America and encounter a traditional and untrammeled way of life. For him, the Orient represented the option of luxury and self-indulgence, far from the rigors of a humdrum desk job. Orientalism of this sort was therapy for an America in transition, for the country was fast becoming industrialized, urban, and very complicated.

One of the looming anxieties was the "woman question." The period addressed in this exhibition is loosely bracketed by the 1848 declaration of women's rights made by Elizabeth Cady Stanton and her associates at Seneca Falls, New York, and the Nineteenth Amendment to the Constitution, granting women the right to vote in 1920; along the way women were enshrined and recreated in many guises. In this protracted campaign of resistance and grudging concession, Orientalism served as a safety valve for gender friction by providing imagery for male wish fulfillment and idealization. This function was signaled early on by Hiram Powers's sculpture *The Greek Slave* (fig. 7), which depicts a nude woman chained and sold into harem slavery by the Turks during the Greek War of Independence. This unprecedented sculpture came to epitomize the nineteenth-century cult of pure womanhood, with its ideals of chastity, piety, and quietude.[39]

If there were three coordinates defining American Orientalism, there were two visual languages by which these dynamics were played out. Church's painting epitomizes the native tongue in the realm of Manifest Destiny—the language of the land, vast, primordial, and subject to man's control. Powers's statue epitomizes European traditions—body centered, generally female, and also subject to man's control.[40] Over time, the relative prominence of each of these variables fluctuated in response to social dynamics and political change. However, there were larger dynamics at work as well. Orientalist

images of the late nineteenth and early twentieth century—unprecedented in quantity, character, and graphic detail—were a powerful factor in the formation of changing worldviews precisely because they were visual. In effect, they offered viewers a direct, albeit contrived, encounter of exotic places, a fabricated reality that could be grafted onto more familiar backyards to flesh out the shape of the wider world in the mind's eye. In providing this service, Orientalist images were themselves agents of change.

It was, already, a time of extraordinary flux. If Church's *Jerusalem from the Mount of Olives* and Thomas Hicks's *Portrait of Bayard Taylor* can help to characterize the visual and conceptual character of American Orientalism, the convergence of men like Church and Taylor at a pivotal moment in history also reveals the social milieu in which Orientalism became increasingly manifest in visual form. Together they were implicated in a drama of considerable import during which the world turned from an ethos of God's glorious cosmos to the anxious slow ticking of Darwinian clocks. Both men stood reverentially in the shadow of the German author Alexander von Humboldt, whose multivolume *Cosmos: Outline of a Description of the Physical World* appeared in English between 1848 and 1858. Taylor sought out the scholar in Europe on two occasions and wrote a laudatory introduction to Richard Henry Stoddard's *The Life Travels and Books of Alexander Von Humboldt* (1859). He was particularly struck by Humboldt's humanity and his humble vision: "Not his own fame—not his supremacy as an observer or a theorizer—but the advancement of human knowledge, the discovery of grand general laws—the footsteps of God in the Creation—was his aim and his ambition." He celebrated Humboldt's unswerving love of knowledge even in a time "when the thirst for wealth, and place and power seems hotter and fiercer than ever."[41] For Taylor, then, Humboldt was a grand humanistic inspiration in troubled times.

Church was similarly awed by Humboldt, but for him the great naturalist provided even more pointed inspiration. In *Cosmos,* Humboldt propounded a theory of aesthetics in which a great landscape painter was deemed to be a servant of both mind and nature. He invited intrepid painters to "seize, with the genuine freshness of a pure and youthful spirit, on the true image of the varied forms of nature,"[42] and then to synthesize from those varied parts a sense of the organic whole. Church accepted the challenge and traveled to retrace Humboldt's steps, pictorializing the South American landscapes that Humboldt had scientifically documented, and reveling in the handiwork of the divine creator.

When his painting *The Heart of the Andes* was being shown to enthusiastic reviews in New York (from whence it was sent to Europe), Church wrote to his friend Bayard Taylor requesting that he facilitate communication with Humboldt. It was Church's fond desire that the great man who had inspired the Andean venture might see the picture that his work had generated. Alas for Church, that bit of homage remained unrealized, for Humboldt died before this could be implemented. More poignantly perhaps, in 1859, the same year that *The Heart of the Andes* was triumphantly displayed in England, Charles Darwin's *Origin of Species* was published in London.[43]

It is this nexus of events, heralding the massive reorientation of thought often termed the Darwinian revolution, that reveals the larger framework of anxiety and looming modernity within which visual Orientalism was to proliferate. It was a time when commonly held convictions about God and history were being radically revised and cultural boundaries and psychic horizons were subject to radical change. Orientalism, then, was an organic manifestation and an agent of such change, serving to situate Americans in time, space, and the certainties of selfhood.

Holly Edwards

AMERICAN ORIENTALISM
IN THE 1870S AND 1880S

Taylor and Church shared a worldview that was most literally manifest in their enthusiasm for travel. In 1864, Church wrote to Taylor, inviting him to join his newly forming Traveler's Club. It was primarily a social club intended to bring together a very small number of "men of education and talent." The first meeting was to be held in Church's space at the Tenth Street Studio Building in New York, and members would "spin their yarns" about their extensive travel experiences for one another's enjoyment.[44] This convergence of artistic sensibility and the lust for travel, centering in New York and New England, is symptomatic of what was to come. More and more people were venturing eastward, and many of them were artists, inspired by writings such as those of Bayard Taylor.

Among the American artists who traveled to the Orient and painted what they saw, the preponderance were white males from New England, exploring the wider world in search of inspiration, the picturesque, or simply the salable image.[45] They reached the Orient by a variety of routes, primarily by steamship across the Mediterranean from Spain or Italy, with the usual ports of entry being Jaffa, Alexandria, Algiers, and Tangier. Over time, these paths of exploration became increasingly well trodden, and even those artists who set out alone often encountered one another, or other Americans, along the way. While they were there, it was not simply a lighthearted adventure—it was work. They were faced with major challenges: new light, new terrain, and new people. Each day was an opportunity to hone new skills and refine techniques, to prove one's mettle and improve one's lot.

At the outset, the Orient was primarily a context for art making, rather than an imperialistic, voyeuristic, or even ethnographic experience. Ultimately, however, the art that was produced facilitated the absorption of the Orient into public awareness in a particular guise. That guise, a function of artistic choices and social exigencies, bears further scrutiny.

During the zenith of this painting genre in the 1870s and 1880s, the imagery seems to be the visual record of artistic exploration and tourism. To a degree, it reflected the extension of the pioneer ethos into a new terrain. While these pioneers did not conquer the Orient literally, their renditions of the region controlled its character in the viewer's mind. Traveling artists tended to produce pictures that emphasized the most commonly experienced or salient features of particular places that a tourist might encounter along the beaten path. Some artists (William Sartain, for example) were more enterprising than others and sought greater understanding of indigenous cultures than their compatriots, while for others (Sanford Gifford, Samuel Colman, Elihu Vedder) the Orient was a passing interest or exotic metaphor. A few, such as Frederick Bridgman, Edwin Lord Weeks, Frederic Church, and Louis Comfort Tiffany, maintained a focus on the Orient throughout their working lives. Others learned from it and left it behind.

In depicting the Orient that they encountered, these artists made revealing choices in subject matter and depth of field. There is a striking absence of the bath scenes, decapitations, and explicit eroticism that so dominated French imagery of the area, and architectural ruins and monuments were generally eschewed in favor of landscape.[46] Beyond that, there are two general categories of representation: those that foreground people and those that are more general "views." Those in the first category tend to render the Orient in terms of one or more figures depicted in close proximity to the picture plane, thereby offering an opportunity for sustained scrutiny (cat. nos. 9,

27, 28). These pictures replicate ways of seeing that were learned at the pedagogical knee of French Orientalist painters. The academic virtuosity evident in these paintings and the fact that they were often submitted to European salons suggest that they were deliberate showpieces, intended to display the painters' technical skills in the Beaux-Arts tradition. These are essentially paintings of oriental subject matter, painted by enterprising Americans in the French mode with the intent of garnering acclaim in the art market. Orientalism of this sort reveals more about America's relationship with the international art market and with France than it does about America's perceptions of the Orient.

Those pictures in the second category are generally drawn from a distance and are peopled by generically rendered types. It was a comfortable distance for the nineteenth-century tourist, who felt entitled to view but not obligated to interact, much less touch. The chosen vantage point replicated travel experiences and personal encounters in which the tourist was close enough to have seen the Orient and Orientals, thereby acquiring the veneer of worldly sophistication and the trophies of travel, but not so close that either the painter or the viewer might feel uncomfortably threatened or implicated (cat. nos. 16, 18, 21, 25). Virtually indistinguishable from views of pastoral scenery ranging from Cape Cod to the Italian countryside, the represented places are specified as the Orient by generic markers such as palm trees and regionally specific forms of architecture. In effect, they represent an extension of the larger and well-entrenched tradition of the picturesque, adjusted to new terrain.[47]

These two categories suggest that American Orientalist painting was multivocalic and symptomatic of America's uneasy status in the international sphere, aspiring to French standards but still protective of its own traditions. For those who adopted the Beaux-Arts language, the human body was the surface upon which meaning was inscribed, whereas for others, landscape generally served the equivalent function. However, this bifurcation in American renditions of the Orient is neither rigid nor formulaic. Painters who were trained abroad did not confine themselves exclusively to figural works, nor did landscape views exclude the human body.

These options, however, did generate ambivalence and friction, as evidenced in Edward Strahan's envious essay on his contemporary, the preeminent American Orientalist Frederick Bridgman. The author begins by wondering whether there is such a thing as an American art, then proceeds to evaluate Bridgman as a practitioner thereof. Citing Bridgman's training in France and his undeniable sophistication, Strahan nonetheless derides Bridgman's fascination with recondite subject matter generated by a trip on the Nile even as he applauds his attention to natural and landscape effects. Indeed, in Strahan's opinion, Bridgman outshines his French master Gérôme in regard to the depiction of nature, demonstrating that "good figure painting will bear good landscape painting, the best that a man can do, as its foil and support." Despite this admission, Strahan ultimately dismisses Bridgman's work, saying, "It is exquisitely put together, but it is joiner work."[48]

Strahan's conflicted feelings about Bridgman's painting betray the complex connotations of style in the American marketplace and the increasingly entrepreneurial attitudes of American artists. An artist's choice to study abroad and travel in search of subject matter was, in part, a strategy to professionalize. It demonstrated a willingness to hone one's craft, to broaden one's horizons, and to participate in the wider world of image making. Choosing to paint exotic subject matter in a conservative academic fashion was tantamount to aligning oneself with the establishment and catering to the tastes

of the picture-buying elite. Bridgman made this choice and enjoyed extraordinary popularity and commercial success as a result.[49]

The American market for Orientalist pictures was, however, a peculiar one. A large number of paintings by Gérôme, for example, were acquired by industrial magnates and other newly wealthy,[50] and many of these pictures had erotic overtones. However, there is also evidence that pictures that were too erotic in their exoticism offended some American sensibilities. Bridgman's triptych of a rape narrative, for example, elicited little comment in Paris but provoked considerable outrage and consternation in the United States, and the artist gradually moved away from such explicit eroticism in an attempt to suit American markets.[51]

If the general public was not ready for overt sex, what did Orientalist imagery provide? As a subtext of the cult of the picturesque, some Orientalist imagery served many of the same functions for a society in transition. Orientalism and the cult of the picturesque were tangled together in several ways. On a literal level, Orientalists participated in the institutionalization and visualization of the picturesque even as they fabricated the Orient. Swain Gifford, for example, contributed images to the *Picturesque America* series, and Bayard Taylor served as editor of *Picturesque Europe.*[52] Concomitantly, Orientalism and the cult of the picturesque both served to advance the project of nation building and public education. Picturesque views of all sorts, seemingly benign and generic, were part of a larger effort in the United States to absorb new territories and envision the larger world.[53] The collective need to know America's varied terrain was a response to the rupturing upheaval of the Civil War and changing national boundaries, but it also reflected the American intellectual elite's desire to civilize the general public. For them, "touring in search of the picturesque" was not only pleasurable but also socially edifying and spiritually uplifting. It served to render real the land and its recently regained political integrity and to bring into focus what they deemed to be the laudable and inevitable results of America's Manifest Destiny.[54]

By extension, picturesque views of the Orient enabled the viewer to benefit from the lessons embedded in more distant and exotic landscapes. Some artists, such as Bridgman and Weeks, capitalized on the public demand by producing books and magazine articles in which views of the Orient were rendered in both prose and picture. While this picturesque Orient would have been edifying in a general way, it may have played more overtly therapeutic purposes as well, by providing images of universality when regional or sectional differences were divisive and painful. Thus, when North and South were difficult to reconcile under the national rubric, depictions of the Orient may have served to focus public attention on larger horizons and more inclusive "truths."[55]

On another level, picturesque views of the Orient may have served a retrospective purpose. In a sense, such views utilized the characteristic focal distance of nostalgia, close enough to recall the general shape of things but not too close for uncomfortable honesty or distracting specificity.[56] In such images, details were elided into an appealing and encapsulating visual summary or idea. They depict, in effect, what was once the norm in America: a society closely tied to the natural environment, people coming together in public marketplaces for the exchange of goods and gossip, mercantile activities unmediated by huge business concerns and industrial conglomerates.[57] The images suggest a nostalgia for the village and surrounding countryside that were fast disappearing into the dirty and engulfing urban environment. Orientalist pictures provided a respite from this sordid encroachment by capturing simpler forms of life—those of the desert and of the traditional town. One was wild and free, sun-drenched and endlessly open (reminiscent

of the American frontier),[58] the other was dark, labyrinthine, and mysterious, but still manageable in scale and ethnic uniformity. Sartain's rendering of the quiet ambience of an Algerian city (cat. no. 20) is only comprehensible, I think, in comparison to photographs of turn-of-the-century New York (fig. 8), whereas Tiffany's market day scene suggests an antidote to the implacable conglomerates dominating the American economy at the time (fig. 9). American Orientalism, then, can be seen as a foil for the "progress" that many Americans so assiduously pursued as their birthright and destiny.

Some painters participated in the visual discourse about "progress" from a variety of vantage points. Colman, Gifford, and Tiffany, for example, subjected smoke-belching factories on the Hudson to the picturesque gaze and subsequently turned their sights on the Orient (cat. nos. 21, 25, 26).[59] In so doing, they seem to have acknowledged progress with ambivalence, valorizing industrialization even as they mourned traditional ways of life. Some of these conflicted emotions about progress are suggested by Charles Sprague Pearce's *Arab Jeweler* (cat. no. 27). This picture shows a craftsman engaged in the process of making exquisite silver beads in a crude setting with rudimentary tools. On one level, these modest tools are implicitly contrasted with the systems of mechanized production that American industrialists were relentlessly implementing on domestic shores. This traditional way, so the picture seems to say, is being supplanted by superior technology at home.

But the picture is more complex and more conflicted than that. The contorted pose of the Arab jeweler is almost overwrought as a figure study in the Beaux-Arts mode, and the contrived posture serves to juxtapose the bare toes of the jeweler with the beautiful trinkets he produces. As a result the picture can also be read as a paean to traditional craftsmanship and the beauty of its products.[60] Of course, art and industry were under intense scrutiny in American culture at this time. Underlying Pearce's picture and others like it are the fundamental attitudes of the Aesthetic Movement, at its zenith in America at the same time that Orientalist painting enjoyed its heyday—the 1870s and 1880s.[61] This movement represented a multipronged effort to reinvigorate traditional crafts, dignify domestic arts, and transcend any one cultural tradition to find a supreme language of design. Participants in the Aesthetic Movement avidly went in search of beauty, acquiring artifacts and appropriating styles without detailed reference to the cultures or the people that produced them. Collected beauties, like Pearce's silver beads, were to be appreciated simply, in their own right and without footnotes.

This cavalier mode of appropriation has been seen as part of a larger drive to control the world by owning its artifacts,[62] but it can also be measured against Pearce's picture in another way. Viewing the picture, one is struck by the percentage of the picture given over to the jeweler. He is forcefully crammed into straightened circumstances but does he deserve to be there? The pendant loops silhouetted along his own cuff quietly echo the silver beads, and the gold embroidery on his sleeve belies his unshod feet. Is this intense scrutiny a witness of respect or the gaze of disdain? Or both? In finding exquisite silver beads amongst the bare toes and frayed mats, Pearce is conveying his conflicts as well as his accolades. By recording the pathways and appropriations of the Aesthetic Movement, he is betraying a certain nostalgia for simple times and traditional lives, and he is paving the way for the ever more glorious accomplishments of American designers.

It would appear then that the act of representing the Orient must be situated in that crack between nostalgia and aspiration, a vacation from modernity as well as a smug return to it. Late-nineteenth-century Orientalist pictures do not render the indolent native or the decrepit Orient. They focus on its art and industry (see Allen essay). They

Fig. 8. Stanton Street, Lower East Side, New York City,
c. 1900. Photograph. Corbis-Bettmann

Fig. 9. Louis Comfort Tiffany (American, 1848–1933),
Market Day Outside the Walls of Tangiers, Morocco, 1873.
Oil on canvas, 32⅛ × 56 inches (81.6 × 142.2 cm).
National Museum of American Art, Smithsonian
Institution, Washington, D.C. Gift of the American Art
Forum

depict what Americans respect, mourn, or seek to exceed—not simply what they denigrate. This was symptomatic of the burgeoning preoccupation with material goods in American society and the kind of commodity fetishism that had to do with owning things and arranging them around oneself in a cultured and flattering manner.

It is, of course, arbitrary to draw analytical lines between painting pictures of the Orient, collecting the arts of the Islamic world, designing interiors in an oriental mode, and dressing in exotic attire. No such lines were drawn by artists and designers in the late nineteenth century. All of these activities were venues of turn-of-the-century enthusiasm, opportunities for creating selves and settings of aesthetic appeal and social charisma. All of these activities make up what we might term Orientalism, capaciously encompassing product, performance, and person. They collectively reveal what the imagined Orient contributed to individual Americans' sense of self-worth.

Perhaps the archetypal figure in this regard is Frederic Church, whose Orientalist activities spanned several decades and included a variety of media. Driven by spiritual as well as artistic convictions, Church traveled to the Holy Land and painted the landscape after he had explored other parts of the world. Along the way, he collected diverse artifacts and books about other cultures and artistic traditions. His crowning achievement was the design of Olana (figs. 10, 11, cat. no. 36), a villa high over the Hudson River, which incorporated objects and transposed styles into an idiosyncratic aerie. Church likened his grand synthesis to mock turtle soup, saying, "I made it out of my own head."[63] This modest description conveys Olana's unique character but makes light of the voracious study and extensive travel that went into it. Indeed, Church's Orientalism was cumulatively as much a process of aesthetic and moral philosophizing as it was painting, collecting, synthesizing, and designing.

Like Church but a generation younger, Louis Comfort Tiffany underwent a personal and formative experience in the Orient. Visiting North Africa and Egypt in the 1870s, he created luminous and evocative paintings of the atmospheric qualities of the region (cat. no. 26). As it was for Church, the Orient was a continuous theme for Tiffany throughout his career, and its impact was not confined to painting. Tiffany's Orient,

Fig. 10. Facade of Olana, 1870–72 (studio wing added 1889–91). Designed by Frederic Edwin Church. New York State Office of Parks, Recreation and Historic Preservation. Olana State Historic Site

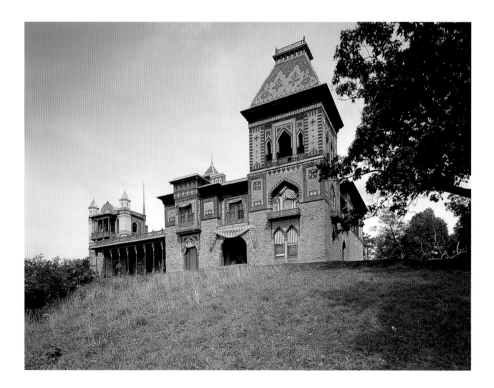

Holly Edwards

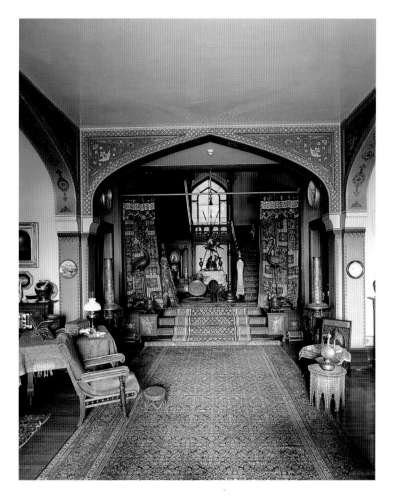

Fig. 11. The Great Hall at Olana. Designed by Frederic Edwin Church. New York State Office of Parks, Recreation and Historic Preservation. Olana State Historic Site

however, was neither a moralized experience nor a pious adventure. For him, the Orient was purely formal: it was all about color. And, whereas Church's Olana epitomized a personal and circumscribed expression of aesthetic synthesis, Tiffany created an entrepreneurial empire, providing consumers an array of objects and aesthetic options for the perfectly appointed interior. In doing so, Tiffany invited the public to be worldly in their own homes.[64]

William Merritt Chase, a third paradigm of Orientalism, did precisely that. He never traveled to the Orient but instead painted a few exotic paintings concocted from carefully chosen artifacts; with extravagant weaponry, inlaid furniture, and sensuous drapery, he created the Orient in his studio in a stereotypical manner.[65] His raw materials were comparable to Church's, and like Tiffany he capitalized on the Orient, but his attitudes and purposes were different. For him, the Orient was an image and a metaphor, providing the means by which to create a public persona of extravagant charm. Indeed, the consonance between a photograph of the artist in his studio (fig. 12) and his spectacular painting *The Moorish Warrior* (cat. no. 35) is striking. His studio was itself a set piece and his social posturing a performance, each worthy of representation and recording. In the process, he created anew the image of the artist by utilizing diverse and exotic artifacts to suggest worldliness, sensuality, and flair.[66]

What these three extraordinarily diverse artists had in common was an omnivorous and acquisitive Orientalism, by which they appropriated pieces or aspects of the Orient and created, thereby, a distinctive oeuvre or persona. This creation of self and setting by means of borrowed treasures was a complex process that began among elite aesthetes but that ultimately trickled down to those of more limited means or more modest aspirations. This dissemination was facilitated by two important engines of mass culture:

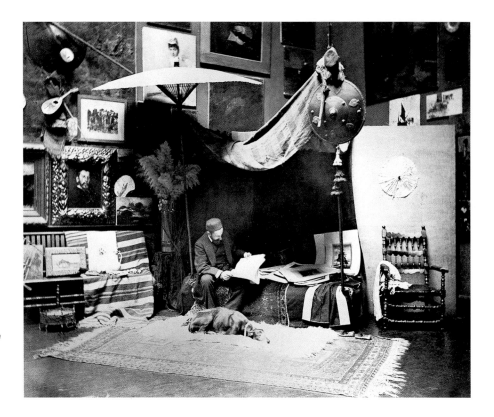

Fig. 12. George C. Cox (American, 1865–1943), *William Merritt Chase in His Studio at 51 West Tenth Street*, c. 1870s. Photograph. Museum of the City of New York. Gift of Miss Rosamund Gilder and Mrs. Walter W. Palmer

department stores and mail order catalogues. Thus, import firms made it possible to furnish a home with exotic touches or dress with an oriental flair without having to visit the Orient personally. Tiffany and Company, for example, imported objects of western production designed to approximate oriental originals (cat. no. 41). A. A. Vantine and Company targeted ever larger markets with their illustrated catalogue *Products of the Orient* detailing, for example, "embroidered slippers as worn by Turkish ladies in Harems" or lanterns that gave off a glow that was "most suggestive of Arabian Nights and Oriental life."[67]

This advertising rhetoric suggests that the purchase of exotic objects was a manifold endeavor, providing the home a veneer of cosmopolitan luxury and the owner an opportunity for fantasy. It also seems to have masked a desire to reconfigure the spaces of social interaction, which had heretofore served the rigid norms of Victorian society. Chase's studio and similar exoticized spaces carried an erotic charge and invited people to succumb to desires of all sorts.[68] Approximating such a setting in a middle-class parlor must have disrupted the enforcement of propriety previously wrought by Victorian interiors.

If the Orientalism served, then, to relax interior spaces and increase the potential for greater intimacy, it inevitably intersected with the construction of gender roles as well. Traditional gender roles were increasingly contested at this time, with women militating to expand their options and men defending their entitlements.[69] The Orient, inhabited as it was presumed to be by despots, sheiks, and veiled harem victims, inevitably infiltrated this rhetorical process.[70] Contemplation of such stereotypes, sanctimoniously deemed different from "proper" people, also invited American men and women to reposition themselves in relation to the opposite sex.

The "plight" of women in the Orient, for example, inspired comment among the painters represented in this exhibition. Ella Pell, herself enjoying the benefits of unimpeded travel in the Orient, made periodic and pointed remarks in her diary about imprisoned women of the region and alluded to their restricted lifestyles in a small drawing; in a letter home, Swain Gifford wondered why American women complained

Holly Edwards

so much about their own circumstances, considering the lives of oriental women.[71] Such editorializing indicates that the "woman problem" was weighing on many American minds, but the artists otherwise refrained from addressing the issue explicitly in their work. Indeed, women in general, whether veiled and imprisoned or otherwise, were seldom depicted by American Orientalist painters.

Only Bridgman, the expatriate steeped in the eroticism and body language of Gérôme and the French milieu, consistently situated women at the center of his oeuvre, and even he transposed the language into a new dialect. In his hands, the French odalisque—potentially replete with explicit erotic overtones—was reinterpreted as an extension of the natural world, a languid hothouse flower, a woman reclining at home (cat. no. 6). Without recourse to nudity or overt sexual invitation, Bridgman projected domestic values onto an exotic screen, representing women as the heart of the home as well as the focus of covert male desire. It was modestly sexy but morally acceptable and even gratifying. In effect, he universalized conservative convictions about women's place in the world, even as he inspired sanctimonious ruminations about the presumed oriental atrocity of incarcerating women for the enjoyment of men.[72]

In retrospect, the exotic veneer of this image may also distract us from its domestic topicality, for the picture may have alluded to a commonplace American complaint— the languor and neurasthenia that incapacitated many elite women at this time. While not confined to the female sex, this degenerative and depressive syndrome has been read, in part, as a sublimated response to the squelched needs and aspirations of Victorian women, as well as a more generalized symptom of the pressures of industrialized society.[73] In his odalisque, then, Bridgman may have universalized American complaints as well as American values.

If such a painting seems fundamentally defensive of the social status quo, it is not representative of all Orientalist painting. The language of the Beaux-Arts tradition was capable of sustaining transgressive meanings as well as conservative, imperialistic, or elitist ones. Ella Pell, having traveled extensively in the Orient and studied with French painters, played with some of the same variables in her painting *Salomé* (cat. no. 14), which was exhibited at the Paris Salon of 1890. Despite Pell's obvious fluency in Beaux-Arts conventions, her depiction of the girl who danced for King Herod and then asked, at her mother's prompting, for John the Baptist's head as reward, does not extend the usual stereotypes. Most contemporaneous renditions of Salome invested the body of the nubile young performer with a range of misogynistic and titillating associations.[74] By contrast, Pell's Salome is strong and self-possessed; she is shown taking the long view, literally beyond the frame. She is neither the object of manipulation nor the independent agent of seduction but rather the handmaid of momentous events whose authorship she would not challenge. The painting thus suggests a hint of ironic resignation in an age of gender constraint and change.

If Orientalism intersected with "woman" in multifaceted ways, then, the Orient also invoked the question of "man" on multiple levels. In both cases, Americans envisioned the Orient in terms of their own ideals and simultaneously extended those ideals by means of oriental imagery. Thus the intersection between Orientalism and gender was a function of projection and desire. During the period between the Civil War and the Great Depression, the need to define the "real man" was an urgent and ongoing process. Some historians have theorized about a crisis of masculinity at this time, while others have pointed out that the superior status of man was never actually in doubt, although the nature of his attributes was undeniably called into question.[75] In any case, in this

Fig. 13. Dressing Up at Olana, early 20th century. Photograph. New York State Office of Parks, Recreation and Historic Preservation. Olana State Historic Site

climate of anxiety, the Orient provided diverse rhetorical devices for male self-fashioning with its stereotypical despots and lustful harem lords.

Thomas Hicks's *Portrait of Bayard Taylor* (cat. no. 1) encapsulates some of the ingredients of Orientalized masculinity at mid-century. The portrait shows the writer in oriental attire, looking out over Damascus in a state of luxurious reverie. While the sitter's magisterial gaze over the landscape has been read as an expression of Manifest Destiny,[76] the act of cross-cultural masquerade suggests further implications in the portrait. Dressing the part, taking on an exotic identity even temporarily, is a safe, genteel way to experience an alternative reality and defy social norms.[77] Many Orientalists did this, including Swain Gifford, Chase, and Tiffany, while other Americans indulged in parlor games and tableux vivants (fig. 13).

In this case, masquerade allowed Taylor to present himself as worldly, sophisticated, and fluent in another culture (fig. 14); he is the privileged surveyor of an exotic land. The picture is, in a sense, a visual ovation for Taylor's accomplishments. On another level, it seems to transfer the proprietary attitudes of Manifest Destiny to the land of the Orient, subjecting that distant and exotic region to a controlling American oversight. On another and seemingly contradictory level, the picture visualizes a transgression of republican social norms by situating the dreamer in a setting of self-indulgence and luxury with servants to do his bidding. Orientalism seems to visualize, validate, and enforce entitlement, but it is not without conflict.

While this Orientalism of borrowed clothing would have a long vogue in American culture, there were other ways in which men utilized Orientalist imagery to visualize heroism and virility. One mode involved the quintessential American hero, the lone rider. As cowboy, scout, or pioneer, the solitary equestrian proved his mettle and masculine prowess through his mastery of horses and of savage natives, ultimately extending his dominion over the exotic and unexplored terrain of the Wild West.[78] Merging this

Fig. 14. *Portrait of Bayard Taylor (The Author of "Visions of Hasheesh" & c.).* Engraving after a daguerreotype by Matthew Brady (American, 1823?–1896). From *Putnam's Magazine,* August 1854

Fig. 15. *A Spahi, Algeria.* Halftone illustration after a painting by Frederic Remington (American, 1861–1909). From *Harper's New Monthly Magazine,* February 1895

frontier hero with the figure of the sheik was not difficult. There already existed a corroborative link between the Orient and fine horseflesh.[79] Man and horse simply found more exotic settings in the paintings of Ryder, Millar, and Bridgman, thereby universalizing American ideals and eliding ethnic differences (cat. no. 19). In this guise, the Orient was rendered continuous with the familiar and the heroic.

Frederic Remington, however, put a finer point on the consonance between the Wild West and the exotic East as he translated both for audiences along the Atlantic seaboard.[80] This quintessential western artist, traveling to North Africa in 1892 to illustrate magazine articles for journalist Poultney Bigelow, inevitably gravitated to familiar subjects such as horses and horsemanship. In his opinion, the Bedouin were both virile and handsome, and Arab horsemanship was undeniably impressive (fig. 15). On a more pragmatic level, however, Remington was also cognizant of French imperialistic strategies, noting that the American government might learn useful techniques for dealing with Native Americans by observing French treatment of the Arabs.[81]

Ultimately, both Remington's rhetoric and Bridgman's odalisque suggest that American dreams of power and glory were accelerating. Viewing a picture of the Orient personified as a languid odalisque, the viewer is cast in the role of voyeur or conqueror. This would have been a heady experience for an American male audience and a gratifying picture to contemplate, for in late-nineteenth-century America, sexual power was more properly repressed and political superiority was still tenuous. In this context, visual conquest would have to serve.

Thus, by the 1890s, when the western frontier had ostensibly been tamed, its inhabitants were envisioned as submissive, like women, within the "civilized" domain of the United States. Charles M. Russell's depiction of a native woman as an odalisque (cat. no. 42), echoing Jean-Léon Gérôme Ferris's exercise in French-style Orientalism (cat. no. 43), suggests this hierarchical attitude.[82] In a sense, then, odalisque imagery may simultaneously suggest

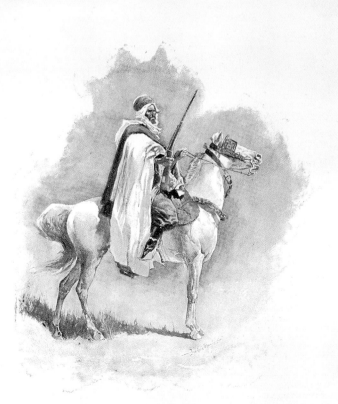

A SPAHI, ALGERIA.

the hobbled status of feminism and the character of American colonizing dreams, for male dominance was commonly elided with cultural superiority.[83] American men were aspiring to larger arenas and broader horizons and, in general, their dominance remained unquestioned.

If American artists did not paint naked women and lustful Turks, then, it was not for want of interest. They visited the Orient and painted what they saw. They acquired objects and designed interiors in exotic modes. And they flirted with impropriety with pictures of tame odalisques. In effect, the images that they created were the contrived stage sets of anticipated power and pleasure. It remained for the World's Columbian Exposition of 1893 to lift the curtain on new performances.

THE WORLD'S FAIR OF 1893

In the last decade of the nineteenth century, the national self-image of the United States came into sharper focus, crystallizing around standards of manliness and civilization.[84] "Others" were posited as subordinates and savages, in effect providing evidence of American cultural superiority. The Orient, in its romantic and idealized guise, was lauded and then bested. As in previous decades, America's industrial accomplishments and advanced technology were critical pieces of the rhetoric:

> *The genie of the lamp, that flashed into creation before the astonished eyes of Aladdin, a palace more gorgeous than all the wealth a mighty Sultan was able to duplicate, has long caused to roam the world, the subject of powerful talismans, ravishing the earth of its jewels, the sky of its gems and the ocean of its treasures; but there are magicians still, who rival the proudest conceptions of imaginary demons with realities as splendid as ever Oriental fancy painted. This is not an age of miracles, but it is one of works, in which the powers of human genius transcend the beauty and opulence of Arabic dreams, when the airy unsubstantials of intoxicated reveries seem to be fabricated into living ideals of grandeur more magnificent than any that every Rajah or Caliph beheld in vision or in fact.*

Thus was the World's Columbian Exposition of 1893 commemorated in J. W. Buel's *The Magic City*, a photographic album of the World's Fair (cat. no. 45). Clearly the fair was a stage for the display of American modernity and technological progress, and the Orient was a foil for those accomplishments. The fair, moreover, was a formative event in the history of the United States, institutionalizing such markers of national identity as the pledge of allegiance. It signaled the American seizure of cultural superiority on the world stage and fostered the burgeoning commercialization of American society.[85]

Despite or because of its formative character, the fair was not a unified vision but rather a complex and even conflicted event (fig. 16). On the one hand was the glistening White City, where the official and institutional components of the exhibition—ranging from industry and transportation to fine arts and chamber music—were presented. It was edifying, proper, and above all, self-congratulatory, charting the millennial progress of white America toward human perfection.

On the other hand was the Midway Plaisance, an exercise in Victorian ethnography that presented the world in myopically conceived microcosms ranging from vignettes of a Lapland village to the streets of Cairo. In many ways, this was the box-office hit of the fair, that which titillated and entertained. Instead of mute, gilt-framed paintings and

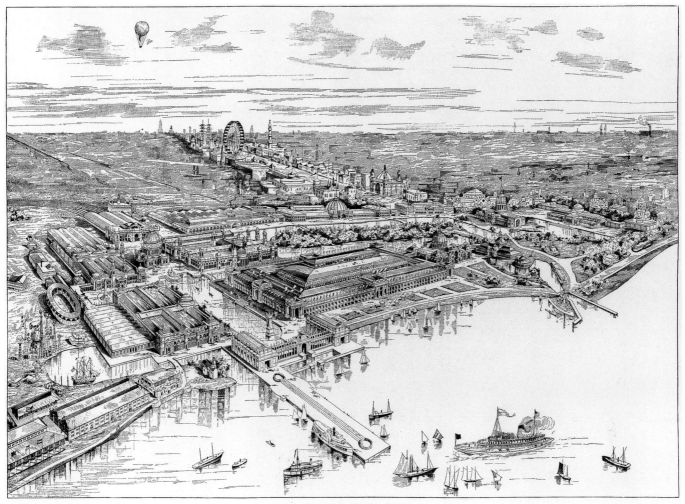

BIRD'S-EYE VIEW WORLD'S COLUMBIAN EXPOSITION

Fig. 16. *Bird's-Eye View, World's Columbian Exposition.*
Engraving after a watercolor by Charles Graham
(American, 1852–1911). From Hubert Howe Bancroft,
The Book of the Fair (Chicago: Bancroft, 1893)

enshrined, insensate machinery, it was throbbing with life, and an extraordinarily popular part of it was oriental life: belly dancers, Bedouins, camels, and donkeys (cat. nos. 45D–G). This was the Orient conveniently brought home for the delectation of privileged American audiences.[86]

Whether in the hallowed halls of the White City or the more vibrant exhibits of the Midway, the fair trumpeted American cultural superiority.[87] Contests and competitions abounded, showcasing the West, the best, and the rest in an ostensibly accurate and edifying manner. Space, color, and design visually reiterated cultural hierarchies. The White City was indeed white, as befit the self-reflective setting of the dominant culture, and it was laid out rationally, according to carefully controlled axes and vistas in domes and columns of the Beaux-Arts tradition (cat. no. 45A). The Midway, by contrast, was neither grand nor unified; it was diverse and even chaotic. It was intended to be a "variety of design so extensive as to be bewildering in its outlines," depicting a "sliding scale of humanity" in which the Teutonic and Celtic races were nearest the White City and the most "savage" (Native Americans and the Dahomeyan peoples of West Africa) were farthest away.[88]

Running throughout this rich and biased map of the world was a striking convergence of gender politics and Orientalism.[89] This was the point where the erotic and the exotic merged, institutionalizing a hierarchy in which white men exercised superiority over women and white people exerted dominion over everyone else. At this juncture, culturally specific notions about gender, race, and empire coalesced in a twentieth-century worldview.

This descending scale of status was spatially manifest in the junction between the White City and the Midway. At that very nexus stood the Woman's Building, far from the center of real power and providing a transition to the precincts of savagery, pinned between staid propriety and exotic performance. This structure resulted from great controversies surrounding the role of women at the fair: What role, status, and space would be granted to the feminine? Would ladies serve as managers of the fair? Would their arts and accomplishments be granted pride of place? Would they participate in the civilized debates and activities of the White City, or would they be warmly applauded but sequestered in a modest and marginalized building of their own?[90] Situating a building dedicated solely to female accomplishments at this particular fulcrum effectively co-opted and ghettoized women in the greater scheme of things, and implicitly linked them with subordinates and savages.[91]

These diverse agendas were manifest as well in the fine arts exhibitions of the White City, wherein American artists seemed to circle around issues of Woman and Orient in a state of confusion, and desire. By this time, the popularity of Orientalist painting was on the wane. Nevertheless, artists like Bridgman continued to represent the entrenched establishment in the art world, and his submissions revealed both a strong debt to the French tradition as well as a fascination with oriental women.

Bridgman's picture *The Bath* (cat. no. 7) is one of the very few Orientalist bath scenes by an American painter. Most productively compared with other American depictions of mother and child, it is quite different from the explicitly erotic bath scenes executed by Bridgman's teacher, Gérôme (fig. 1). This is effectively cozy domesticity rendered with an exotic veneer. In actuality this picture probably did have a salacious dimension for late Victorian viewers. Not only was the exposure of ankle and underarm immodest by Victorian standards, but there was a titillating narrative quandary embedded in the picture: Was this a mother and child or a slave and harem by-product? Despite these mildly erotic innuendoes, however, the picture did not elicit outrage for it was couched in the language of worldly detachment, and it served to universalize dominant American values of home, hearth, and family.

If Bridgman combined French references and oriental eroticism in a tame but worldly fashion, John Singer Sargent conflated the erotic and the exotic more pointedly. At the fair, he exhibited various portraits of people with aquiline features, pale skin, and very fine clothes along with *Study of an Egyptian Girl* (fig. 17), depicting a stark naked, dark-skinned "savage." This was a virtuoso's cocky and shrewd marketing ploy. With this selection of pictures, he flattered his "civilized" sitters at the expense of the oriental model and simultaneously advertised his Beaux-Arts credentials and uncanny skill with a little bit of titillation.[92]

A consummate showman, Sargent surely calculated the impact that such a choice would have on an American audience. Though art centered on the human figure was finding greater acceptance, blatant nudity still confronted an angst-ridden code of propriety.[93] Sargent, it would seem, was playing deliberately with that repressed desire, using the nude figure study of the Beaux-Arts tradition and labeling it exotic. With the lady safely hanging on the wall, however, prudish American fantasies could be disguised with feigned academic sophistication. As one viewer laconically commented, "Studies of the nude are plentiful and as in all French exhibitions, among the best of the works. However, in most of them there is no suggestion of indecency."[94]

The fair, however, was destined to disrupt irrevocably this state of denial. If no one seriously objected to a painting of a naked Egyptian hanging in the exhibition halls of

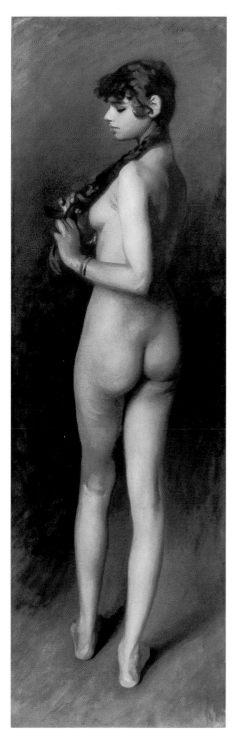

Fig. 17. John Singer Sargent (American, 1856–1925), *Study of an Egyptian Girl*, 1891. Oil on canvas, 72¼ × 23¼ inches (184.8 × 59.1 cm). Private collection, on loan to the Art Institute of Chicago

the White City, modestly clad oriental women performing the "hoochy-coochy" in the theaters of the Midway created considerable furor (cat. nos. 45 F–G). This incendiary act was, in large part, the creative pastiche of entertainer Sol Bloom, who, when faced with a lack of musical accompaniment for his imported oriental dancers, simply sat down at the piano and made something up.[95] Despite this cavalier adjustment in American hands, the act was marketed as the authentic performance of the North African belly dance at a time when such dance was disappearing from the Orient itself.[96] This was a reductionist distortion on many levels, and it stood in pointed contrast, for example, to what Ottoman women themselves submitted to the fair (see Çelik essay). Even so, this was the guise in which oriental women entered the American imagination most profoundly.

As with Orientalist paintings, that public proceeded to measure the hoochy-coochy against the yardstick of French sophistication and lasciviousness. One writer noted in reference to the Algerian women performing on the Midway, "They are beauties in their way, though with strongly marked features and somewhat too plump of outline. Their attire is modest and not without elements of the picturesque; for the Algerian dancing girl wears clothes, more of them at least than the Parisian chorus girl and here there is no unseemly display of tightly hoosiered limb."[97] In retrospect, such disclaimers suggest that one "other"—licentious old Paris—was being quietly superseded by another: the eroticized Orient. Clearly it struck a chord among the male contingent of fair visitors. In fact, the popularity of the hoochy-coochy acts grew to the point that a cartoonist lampooned the hordes of men who stampeded the gates (see p. 81, fig. 7). What was the draw here? What accounts for the difference in public response to Orientalist paintings and Midway performances?

Both represented the Orient by means of the female body, and neither enfranchised the Orient in the process. They elicited different responses, however, because they revolved around different centers of cultural gravity. Sargent's picture, parading French sophistication, was an exercise in artistic worldliness; it invoked the dignity and propriety of someone else's refinement. By contrast, the hoochy-coochy was a performance piece in the American here and now. The titillation turned not on nudity but rather on the physical and public character of the entertainment. Oriental women, albeit quite modestly attired, were dancing on stage. (This was, in fact, unusual for women in the Orient and in the West.)[98] Worse yet, the primary feature of the dance was the undulation of the torso in rhythmic and indecorous ways.

The shocking character of this can only be grasped when viewed in the context of the history of corsetry and women's attire in America, all of which conspired to camouflage, restrict, and generally deny the free flow of energy at the core of the female body.[99] With its liberation of that core, the hoochy-coochy was the sartorial and corporeal transgression of some very basic notions of propriety. The affront to good manners was further exacerbated by the theatrical setting and dramatic intent of the production, for although women had intermittently held power and considerable stage presence in American theater, the brazen act of women dancing onstage elicited consternation and condemnation.[100] Thus the hoochy-coochy opened up certain areas of the public arena for American women and literalized the fantasies of American men.

When the dust settled after the fair, the damage to polite repressed society was done. The hoochy-coochy was exported to Atlantic City and Coney Island, where it regularly collided with the moral codes of fine upstanding citizenry. Gradually, such performances became a staple of traveling carnivals, where they became known as the "cooch"

act, a segment of increasingly salacious character within a larger program. It was further democratized with the advent of film, for the cooch act became the cooch reel, and cinematic striptease was launched.[101] Thus the Orient was irrevocably and explicitly sexualized in the public eye and, on some level, Woman became the obscure object of desire, facilitated in this evolution by Orientalism.

A MILLION AND ONE NIGHTS

If the fair transformed America's notion of the Orient, sexualizing it and bringing it conveniently home, it all happened within a broader context of profound change in American society. The old order—agrarian, republican, and religious—was being replaced by a new society that was secular and market-driven. Outmoded standards of propriety and self-abnegation were being supplanted by the quest for pleasure, security, and material well-being. It was rapidly becoming a land of desire and a culture of consumption, in which money ruled, a cult of the new emerged, and the need to acquire "goods made by unknown hands" was played out in the lavish settings of the department store.[102]

Rigid Victorian social norms and boundaries—boundaries between the upper and lower classes, between men and women, between mind and body—were also beginning to relax.[103] Stifling standards of propriety that had segregated sexes and races were dissolving in the new urban order, where professional men and working women, immigrants and the native-born, were coming together in unprecedented ways. In this setting, free-thinking city dwellers were seeking new amusements and social outlets, and, increasingly, they were doing so with members of the opposite sex. Middle-class men and women were dining, drinking, and dancing together outside the confines of the home, sampling new and popular entertainments without incurring social stigma.

This kind of behavior, unprecedented in the Victorian social structure of women at home and men at work, was transpiring between spouses, friends, and even mere acquaintances. Men were "treating" girls to convivial company and new experiences in exchange for flirtation and sometimes sex.[104] Proper society was going public, and women were thought to be "out of control."[105] In the words of one anxious commentator, "sex o'clock had struck."[106]

Imagining new options in this changing social milieu was a creative process involving a mix of spectatorship, masquerade, and experimentation. Sigmund Freud lectured in the United States in 1909,[107] but more to the point, people were looking at the traditions and activities of members of other races, ethnic groups, and social classes. Masquerade balls enjoyed incredible vogue, for they offered the opportunity to try on surrogate identities and taste illicit pleasures while protected by disguise. People moved across class and ethnic boundaries to dabble in what were perceived to be risqué behaviors. The Vanderbilts, for example, might cautiously invite (or imperiously summon) African-American dancers to their estate to learn "jungle rhythms," while the middle class went to cabarets and tango teas to mingle. Doing the cakewalk, according to one commentator, was little more than a "sex dance," an African belly dance.[108]

The movies were particularly alarming to prudish Victorians. Because of their enthralling verisimilitude, they were thought capable of reaching directly one's innermost thoughts and stimulating all manner of illicit things. The year 1899 witnessed a watershed of voyeurism at the nickelodeon when people could communally witness physical intimacy between John Rice and May Irwin in *The Kiss*.[109] By providing the

public such an opportunity to vicariously participate in erotic behavior, the medium had the potential to ignite "primitive passions."[110]

The possibility of complete social disintegration was, in the eyes of many, a very real threat and society polarized in response. Traditionalists felt that new kinds of entertainment and unbuttoned public activity threatened the very fabric of society, fostering the corruption of and licentious behavior in women. Organizations to protect public morality proliferated, and activists extended the groundwork laid by Anthony Comstock in the 1870s to implement and legislate more stringent standards of ethics and personal responsibility with regard to obscenity and sex.[111] Increasing waves of immigration and the mushrooming practice of prostitution generated widespread anxieties about the white slave trade. People took diverse actions in their fear, ranging from the promulgation of the Mann Act of 1910, designed to curtail the abduction of innocent women for the purposes of forced prostitution, to the production of such movies as *Traffic in Souls,* conceived to expose the evils of the white slave trade.[112]

While some sought a return to traditional values and a defense of social purity, others strove to rewrite the character of American life and love.[113] This was manifest in reforming agendas of all sorts, ranging from a new interest in play and physical exercise to free-love movements and birth-control advocacy.[114] Much of the ferment centered around the body and its natural drives and, inevitably, sex was a social lightning rod.

The life of Mary Ware Dennett demonstrates the syncopated process by which society accommodated new standards of propriety. Forced into divorce by her husband's radical forays into free love at a time when divorce still carried a heavy social stigma, Dennett was painfully aware of mainstream society's total denial of sex. Inspired by her own sons' need for some basic facts, she composed *The Sex Side of Life,* a straightforward sex-education pamphlet. Written in 1915 and published in 1918, this modest effort resulted in Dennett being brought to court, charged with obscenity, and after protracted judicial wrangling, found guilty. The verdict was overturned upon appeal, but by then it had become a cause célèbre, symptomatic of the clash between the old world and the new.[115] Clearly, it would be a fitful and contested evolution toward the open acknowledgment of natural drives, and pioneers like Dennett and Margaret Sanger encountered serious obstacles in the campaign to bring contraception to public attention.[116]

In pursuing Orientalist imagery through this changing environment (and then in packaging it for exhibition format), it has been necessary to adjust the analytical focal distance from examining individual images to encompassing whole networks of imagery manifested in different media at diverse sites in the public domain—in effect, to trace the *paths* of Orientalism as much as its pictures. This reflects, in large part, the mushrooming impact of mechanical reproduction on image-making as well as the emergence of entirely new modes of visual expression, such as film. It also reflects the processes of democratization and domestication, driven by the engines of mass culture, whereby the Orient became the presumed property of the general public regardless of individual wealth or status.

If the following paragraphs then seem to leave unglossed many provocative or insidious representations of the Orient in favor of linking those images in a larger narrative, it points to a deliberate strategy to trace the means and to approximate the pace with which Orientalism migrated throughout American popular culture. Moreover, the nonlinear manner in which that story is told, with redoubling timelines and overlapping themes, is meant to evoke the self-indulgence of fads and to approximate their willful trajectories. This, too, is an aspect of Orientalism as it transpired in the American context.

When "sex o'clock" struck, the Orient was right on time. This is suggested by *Movies* (cat. no. 58), a painting by John Sloan, a member of the so-called Ash-can school. Like many of his colleagues, Sloan was largely oblivious of the Islamic world, preoccupied instead with the facts and foibles of New York City (popularly termed "Baghdad on the Hudson"). In this scene, Sloan conflated the Orient and modernity, capturing the garish street life of New York and labeling it "A Romance of the Harem" with a brightly lit marquee. In that world, unaccompanied women stroll the streets at night and daily near the movie hall. In that world, the "new woman" flirts with the sexual freedoms that men had always dreamed of in the multiple partners of the harem.[117]

It was a whole different world, this urban industrialized life. It was a life enhanced by advanced technology and modern conveniences. It was a life of new pleasures and delightful purchases. This was the era when brand-name selling and fixed prices became institutionalized, and the consumer was increasingly encouraged to buy products of ostensibly superior quality that could be identified by immediately recognizable packaging. While today this constitutes a fundamental premise of American marketing, at the time it represented a major socioeconomic revolution involving the development of national as opposed to regional and local markets, the birth of the modern advertising industry, and the depersonalization of the market process.[118] Orientalist paintings framed in gilt had once alluded wistfully to these implacable forces transforming American society, but as the change accelerated, the Orient was increasingly reduced to familiar stereotypes most useful in the marketplace. General Electric deployed the old trope of traditional craftsmanship and oriental simplicity to herald electric light (cat. no. 57). The clichéd link between the Orient and sweet indulgences was employed to market candy (cat. no. 47).

However, the most sustained campaign to capitalize on oriental motifs occurred in the tobacco industry. This is a particularly interesting case study, for tobacco was intimately tied to the foundation myths of America, but it was also metaphorically linked with the Orient.[119] This association between smoking and the Orient, evident in nineteenth-century painting (cat. no. 1) and interior design (cat. no. 40), was used to market

Fig. 18. O. Bedrossian's Tobaccos and Cigarettes Advertisement. Lithograph on posterboard, 15¾ × 19⅝ inches (40 × 50 cm). The New-York Historical Society. Bella C. Landauer Collection (neg. no. 39536)

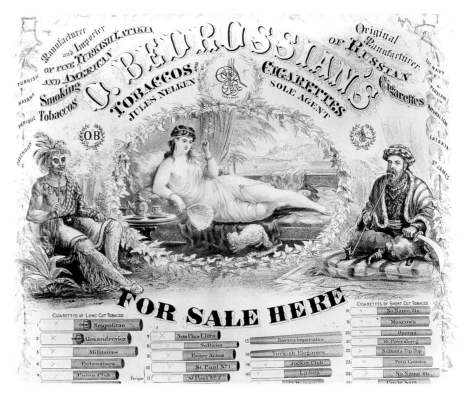

Holly Edwards

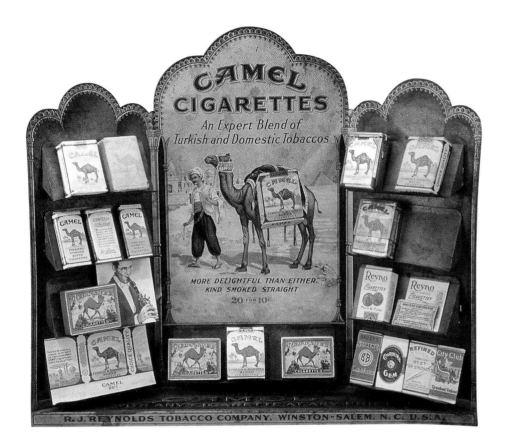

Fig. 19. Camel Cigarettes Counter Display. Lithographed tin, 21 × 24 inches (53.3 × 61 cm). Collection of Thomas A. Gray

tobacco products by means of cigar store sultans and sultanas (cats. nos. 50, 51) and in pictorial advertisements in the nineteenth century (fig. 18).

In the early years of the twentieth century, when technological advances made the mass production of cigarettes the norm, the association of smoking and Orientalia was used to sell new brands, ranging from Mecca, Medina, and Omar to the very successful Fatima (cat. nos. 52, 53). Many of these advertising strategies involved an element of romance, self-indulgence, or sexual innuendo. The most well known brand, Camel, has become a textbook case in the history of the advertising industry. It involved a series of nationally disseminated trailer advertisements announcing the impending arrival of Camel cigarettes and then, upon their arrival, colorful counter displays served to reinforce their market position (fig. 19).[120]

The barrage of the visual in American society, manifest in shop windows and consumer products, advertisements and fine art prints, was made possible, in part, by the advent of color lithography, a process used to reproduce a painted image in vivid colors at nominal cost. By this means, what began as advertisement soon became interior decoration. Thus, the *Lamp Seller of Bagdad*, originally created by Maxfield Parrish to celebrate electricity for General Electric, ultimately found its way into countless homes in the form of wall calendars and fine art prints (cat. no. 57). One single image thus had a considerably enhanced impact.

Such marketing strategies must be appreciated both as products of a culture and as producers of meaning within that culture. How this complex transposition happened may be gauged by the evolution of popular oriental story lines that in turn served as tie-ins for advertising campaigns and department store marketing ploys. One of the most enduring and formative narratives was *The Garden of Allah*, a novel written by Robert Hichens and first published in 1904. The book recounts a conflicted love affair in the North African desert between an adventurous Englishwoman and an apostate priest: "they met by chance but so irrevocably were they bound together that it seemed as if

destiny had led them to each other. . . . And so they journeyed together through the beautiful Garden of Allah to meet a fate they knew they could never escape."[121] It was a turgid romance with a heavy-handed subtext about the stifling nature of "civilized" society and the invigorating experience of "primitive" and untrammeled culture. The heroine, driven by newly unleashed emotions, served as surrogate for the breathless and eager reader of the early twentieth century and provided a vicarious experience of social freedom and unbridled passion in the Algerian desert.

The novel enjoyed tremendous popularity in the United States (forty-four editions over the next forty years), and in 1907 it was turned into a Broadway play (cat. no. 63). The staging of this extravaganza entailed extensive on-site research in Algeria and aggressive editing of a very long narrative, but it was a resounding success in the theaters.[122] Critical reviews at the time raved about the sheer scale of the spectacle, which featured whirling sandstorms and live camels onstage; other critics acknowledged that it was narratively incomprehensible for those who hadn't read the book, but by all counts it seems to have represented a watershed of scenic realism in American theatre. One critic put it rather succinctly: "No poorer play was ever so magnificently gilded."[123]

Setting aside an analysis of the play's representation of the Orient that extended and elaborated the romance of the desert, the soothsayer, and the dancing girl, it is important to consider the implications and legacy of its success. In 1912, *The Garden of Allah* was revived to even greater acclaim, with an explosion of consumer tie-ins. Hotels and restaurants were decorated to evoke the mood of the Garden of Allah and diverse commodities were correlated with the theatrical event. Wanamaker's department store in New York employed members of the cast to parade around in costume as part of a fashion show.[124] The increasingly liberated woman could wear Garden of Allah perfume or switch on a Garden of Allah lamp (cat. no. 64), casting the glow of desert romance around prosaic reality.

Perhaps in tacit acknowledgment of its limited literary merit, the book was reduced to a single phrase, "The Garden of Allah," but it was a phrase that echoed loudly in popular culture for decades. Its connotations, moreover, were remarkably protean. Maxfield Parrish was perhaps the best-known manipulator of this image, using it to decorate candy boxes (cat. no. 49). His employer, Clarence Crane, had suggested the Garden of Allah as the theme, and Parrish was willing but unsure. He had not read the book, could find nothing relevant in his personal research materials, and only vaguely recalled "a silly play I saw in New York."[125] Crane perhaps envisioned a luscious and exotic image, playing on the link between the Orient and sweet indulgences, rather like the image of the *Rubáiyát* that also adorned candy boxes (cat. no. 48), but Parrish's interpretation of the theme was largely devoid of oriental detail. Instead, he rendered an idyllic garden scene, sun-dappled and quintessentially Parrish, that he sheepishly admitted was inspired by a garden scene from the play (fig. 20).[126] Even so, the image was a grand success with the American public. Clearly, it conjured up personal dreams and pleasures and evoked an appropriate setting for their indulgence.

The migration of Garden of Allah imagery from story to product epitomizes the process whereby the Orient was constructed and then disseminated in forms that conformed with American dreams and patterns of consumption. The original Broadway play was based on research undertaken in the deserts of North Africa and was applauded for its scenic verisimilitude; the Garden of Allah as candy box, however, bore only tangential connection to the play and even less to the deserts around Biskra. In this distant guise, however, the image was subject to multiplication, reproduction, and

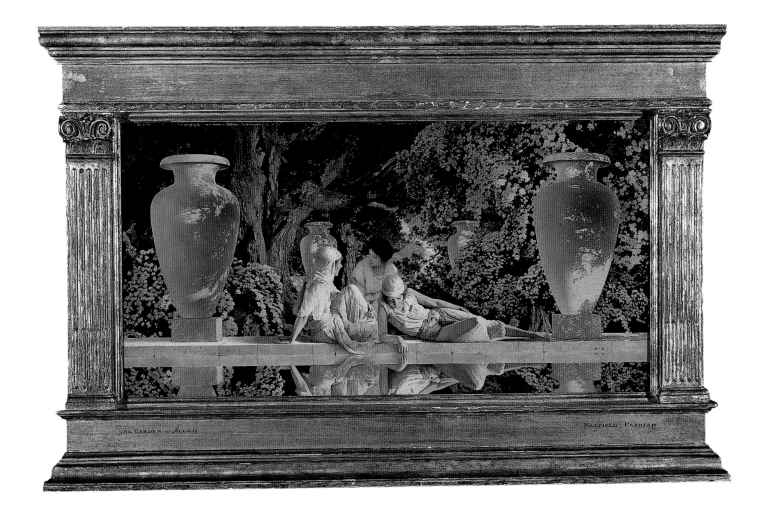

Fig. 20. Maxfield Parrish (American, 1870–1966), *The Garden of Allah*, c. 1918. Oil on panel, 15 × 30 inches (38.1 × 76.2 cm). Private collection, courtesy the American Illustrators Gallery, New York

nationwide dissemination. This was Orientalism driven by the machinery of consumer culture.

If the evolution of this metaphor marks a new phase in American Orientalism, one in which the images are increasingly commodified and protean, it also hints at the evolving therapeutic role that the Orient played for the American public. The popularity of *The Garden of Allah* and other similar oriental tales suggests that when the Orient became sexier in the wake of the hoochy-coochy, it did so in response to social need. Men and women were breaking out of old patterns of behavior and fashioning new ways of being. In this process, the Orient provided metaphors and models for greater sensuality and liberated passions, relaxing enforcement of strict propriety.

Representations of Salome in diverse media parallel the emergence of the new woman but also suggest the entanglement of Orientalism, gender, and desire that transpired in the early twentieth century. In 1890, Ella Pell exhibited her *Salomé* (cat. no. 14) at the Paris Salon. It was solidly rooted in the biblical tradition, and it employed the traditional body language of the French academy to interpret a familiar moral tale. By 1910, Robert Henri would paint Salome in a radically different mode (cat. nos. 59, 60). Instead of a buxom peasant enacting a biblical story, Henri presented a thoroughly modernized and seemingly secularized dancer. This brazen, skimpily clad, and red-nailed challenger stares out imperiously, implicitly equating the viewer with Herod. Perhaps not surprisingly, the painting was summarily rejected by the National Academy of Design for its annual exhibition. What had happened in the interim?

Clearly, notions of "woman" were changing; the body was the site of the revolution, and dance was a formative means of liberation. The hoochy-coochy spread from the fair

to the boardwalk, and along the way it merged with Salome's dance of the seven veils.[127] The so-called Salome craze[128] generated an explosion of repressed desire as well as waves of sanctimonious censure: in 1907, Richard Strauss's opera *Salome* opened in New York then closed quickly, banned for the indecency of the dance of the seven veils. Florenz Ziegfeld presented another Salome in his high-class vaudeville show, the Follies of 1907, and in the wake of the show's success, a host of aspiring Salomes took dance lessons from the star, Mademoiselle Dazie, for two hours every morning in the rooftop garden of the New York Theatre.[129] The same year, Biograph made a movie entitled *If Only You Had a Wife Like This,* in which a wayward husband is tracked down by his battle-ax wife, who ultimately ties him to a chair in their living room and performs her own version of the dance of the seven veils.[130]

Ruth St. Denis moved considerably beyond the hoochy-coochy and Salome's dance of the seven veils to revolutionize American art dance. Steeped in the philosophical principles of François Delsarte and the "aesthetic gymnastics" of his disciples, St. Denis encountered an Egyptian Deities cigarette advertisement at an impressionable moment and ultimately created an extraordinary career based largely on oriental themes (fig. 21).[131] Popular dance crazes like the tango and the Apache swept America in the second decade of the twentieth century. Such wild and suggestive dances offended proper sensibilities, for they fostered "inappropriate" physical intimacies between partners. Worse still, such dancing granted woman an unprecedented opportunity to move in provocative and licentious ways. Inspired by stars like Irene Castle, who projected a sense of youthful, active womanhood, women explored a new arena of physical freedom and expression without incurring unbearable social cost. In doing so, they broadcast a previously denied sexuality and passion for life.[132]

This new "body language" for America owed a singular debt to the revolutionary French fashion designer Paul Poiret. Staging a "1002nd Night" party to launch his oriental line of fashion on 24 June 1911, Poiret posed as a sultan in luxurious regalia, releasing his imprisoned harem slave/wife from a gilded cage midway through the evening. This extravagant drama, replete with palms, parrots, and half-naked "slaves," provided an evocative ambience for the new look of harem pants and turbans that the designer was presenting (cat. no. 88). It was a decided departure from the styles of previous generations. Poiret's most notorious, if contested, contribution to fashion was the "war" that he waged on the corset, thereby transforming the female silhouette from a confined and artificial object to a more natural and fluid physical entity.[133]

American women responded enthusiastically. They were beginning to reclaim their bodies from restrictive clothing and the dictates of public morality, but this protracted emergence was ultimately an ironic liberation—into the harem. Even as women were shedding the cult of the ideal woman and learning the dance of the seven veils, men became unabashed voyeurs, harem hunters, and connoisseurs of cooch (cat. no. 56). Thus the obscure object of desire—part virgin, part whore—took modern form.[134]

One option among the diverse constructions of Woman was the "vamp," which was epitomized by the movie star Theda Bara. First cast as the lead in a film rendition of Rudyard Kipling's *Vampire,* she extended the vamp image in *A Fool There Was* (1915). Thus, she came to represent the evil woman preying on innocent and upstanding men. In the relatively new business of marketing stars, publicists were eager to capitalize on Bara's appeal. At this point it was easy, even second nature, to identify sensuality and potential evil with foreigners, so a concocted genealogy was soon devised. Though she had been raised in a decidedly monochromatic American background in Ohio under

Fig. 21. Arnold Genthe (American, 1869–1942), *Ruth St. Denis in "The Cobras,"* c. 1910. Photograph. Courtesy Jacob's Pillow Dance Festival Archives, Becket, Massachusetts

the name Theodosia Goodman, Theda Bara was heralded as the daughter of a French actress and an Italian artist, born in the shadow of the Pyramids. This exotic lineage was further elaborated with the claim that "Theda Bara" was in fact an anagram for "Arab Death" and was reinforced by publicity photographs of the actress surrounded by the trappings of an obscure desert cult.[135] It is perhaps no surprise that she too enjoyed an incarnation as Salome in a movie directed by J. Gordon Edwards in 1918. As she "vamped" her way to stardom, Bara came to personify many anxieties about free-wheeling women and moral depravity by means of this Orientalized public image.[136]

If the new woman displayed primitive passions and exotic evils that required sub-duing, the new man had to be not just civilized but also virile and passionate. Such was the prescription for the American male promulgated by Teddy Roosevelt and the Boy Scouts.[137] But fashioning manhood in tempestuous times was no easy maneuver, and recourse to ritual and exotic masquerade was not unusual. For a large number of Amer-ican men, secret societies and arcane fraternities provided a venue for role playing as well as convivial male bonding outside the cloistered domain of the home.[138]

Carefully crafted initiation rites, the centerpiece of these brotherhoods, answered deep psychological needs within the male population. They provided satisfaction because they enabled men to reconnect with what was perceived as "primitive." This entailed, in part, the temporary adoption of a different ethnicity, an experience that relaxed the boundaries of self and proper society. The Improved Order of Red Men, for example, allowed American males to take on the personae of Native Americans along with the primal virility associated with an ostensibly more "savage" race. This turn inward was furthered by the enactment of role-playing rituals between father and son. By means of such ritualized psychodramas, men could negotiate the psychological

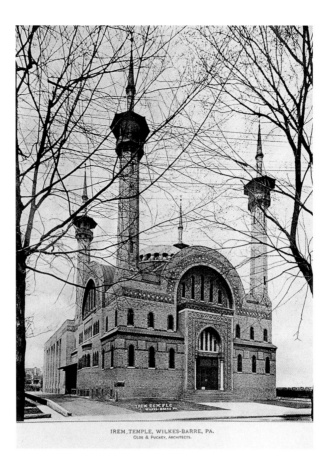

IREM, TEMPLE, WILKES-BARRE, PA.
OLDS & PUCKEY, ARCHITECTS.

Fig. 22. Irem Temple, Wilkes-Barre, Pennsylvania, 1907–9. Designed by Olds and Puckey. Photograph courtesy William D. Moore, Enfield, New Hampshire

tensions generated by the new social order and forge mature identities for themselves in a safe environment.[139] Ultimately, the participants emerged as full-fledged and "improved" (Red) men, potent but also civilized.

Not all fraternal orders accomplished such therapeutic ends with sobriety. The Arabic Order of the Nobles of the Mystic Shrine, the self-styled "playground of the Masons," served a more ebullient clientele, intent on having a few laughs and a very good time. Their stated purpose was legitimate frivolity and a return to the frank democracy of boyhood. All activities were couched in trappings evocative of the Orient, including elaborate costuming and paraphernalia (cat. nos. 69, 73, 74, 76). Docile initiates were subjected to demeaning practical jokes, and then, with humbled mien, they were inducted into the order with all due pomp, circumstance, and celebration. The Shrine thus provided the setting and the rituals of transgression, allowing men to indulge in cathartic communal activities that ameliorated the stiff propriety of their upbringing and daily lives.

While this process was cloaked in secrecy, the Shriners also acquired a distinctive public image, sporting fezzes and marching in elaborately costumed bands. So popular did such Orientalized camaraderie and performance become, that by 1905 the Shrine boasted one hundred thousand members in ninety-seven cities and forty-six states across the United States. They began to build increasingly grand and exotic gathering halls, representing considerable social as well as monetary capital (fig. 22). The Shrine enjoyed extraordinary popularity during the teens and early twenties, enabling men to "feel like men" by playing boyish pranks in oriental dress. It was only in the late twenties, when society had grown more accustomed to the new man, that membership waned and the Shrine shifted its focus from frivolity to philanthropy.[140]

The Shrine may have also provided cathartic therapy when the United States entered World War I, a conflict that spilled over into the fabled Orient. American perceptions of

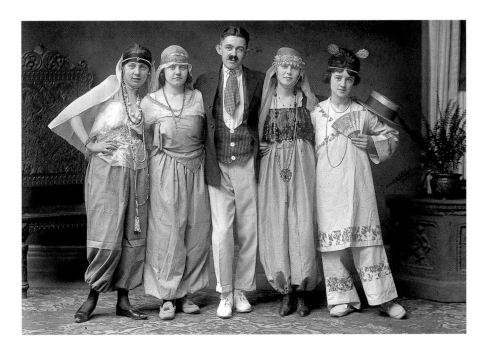

Fig. 23. "Give Me the Sultan's Harem," 1919. Music by Abner Silver, lyrics by Alex Gerber. Whiteman Collection, Williams College, Williamstown, Massachusetts

Fig. 24. Willis T. White (American, 1874–1956), *Uncle Gus Was Sultan for a Day*, c. 1900. Photograph. Courtesy Images from the Past, Bennington, Vermont

that theater of the war were shaped in large part by the exploits of Colonel T. E. Lawrence, a British officer who affected Bedouin dress and organized an Arab revolt against the Turks (see Caton essay, pp. 99–117). The American journalist Lowell Thomas provided the spectacle and the story line, presenting "Lawrence of Arabia" as a modern crusader and a romantic hero in the mode of the *Arabian Nights* (cat. nos. 79–81). Thus conflating disparate themes in American Orientalism, Thomas packaged Lawrence as an optimistic cultural proxy to absorb the enormity of the war and affiliate America with the heroic side.[141]

Heroism, of course, had many guises in wartime. The American songwriter Abner Silver aspired to a different sort of distinction than that of Lawrence. In his song "Give Me the Sultan's Harem," he described an "immense" dream that he had in the wake of the war, inspired by the proceedings of the peace conference. Recounting the demands of various participants, he announced that what he wanted for his part in the action was the sultan's harem. After all, "he's past 83 and his thousand wives need a fellow like me" (fig. 23). His lyrics suggest that titillating Orientalist imagery might serve as a kind of anesthesia for collective pain and confusion. The song must have resonated with the diverse and unspoken desires of many. Harem envy was an apparent undercurrent of Louis Comfort Tiffany's masquerade as an oriental potentate at a grand party in New York.[142] Even a staid-looking unknown, Uncle Gus, enacted self-indulgent charades in his middle-class parlor. Uncle Gus was only "Sultan for a day" (fig. 24), but it was wistfully recorded forever with a snapshot.

If this was the Orientalized fantasy of hearth and home in the early decades of the twentieth century, E. M. Hull added a few twists with her novel *The Sheik* (1919), another romantic potboiler in the mode of *The Garden of Allah*.[143] First a book and then a movie starring Rudolph Valentino, *The Sheik* affected America almost as profoundly as the World's Fair had done some thirty years earlier. The novel tells the story of Diana Mayo, an upper-class British woman, willful and independent, visiting the desert oasis of Biskra. She is abducted and threatened by a man she assumes to be a brutish heathen, but when he demonstrates his nobility to her and she discovers his European ancestry, she falls in love.

As transposed into a film, *The Sheik* is a complex drama in which the fear of miscegenation looms large, and in the end, hero and heroine are both transformed. The audience's female surrogate, played in the film by Agnes Ayres, longs to experience the

passionate and untrammeled life of the desert and impetuously goes where white women would not ordinarily venture, but she ultimately relinquishes independence in the face of Sheik Ahmed's charms. If the movie acknowledged the new woman, it also neatly circumscribed her freedom in the end (see p. 98).

Nor is the hero a simple foil for the woman's eventual subjugation, for he too is changed by the dramatic encounter in the desert. When the audience first encounters the sheik, he demonstrates his unquestioned authority over unruly natives, invokes his seignorial rights by abducting Diana, and generally flaunts his virile mastery of subordinates and "savages." Such stage sets and stereotypes served to establish for flapper audiences the evidence as well as the power of his barbarism, and his virility. In the end, however, Ahmed is also domesticated by Diana's presence and brought more closely to heel under her "civilizing" presence (see p. 113, fig. 6).[144]

The movie rendition of the tale, which departed in critical ways from the English novel (see Caton essay, pp. 99–117), generated the first real cult following around a movie star, and that stardom was premised on overt sex appeal. This served primarily, I think, to ventilate American thinking about sex and to provide a focus for titillating pleasures. Women vicariously experienced freedom, adventure, and intimate relations but ultimately returned to the slightly revised role of idealized keeper of hearth and tent. Men were successfully projected beyond the emasculation wrought by the enervating desk jobs of industrialized America into a guise of romantic virility with reference to the stereotypical primitivism of another culture.[145] Both exhibit passion and vitality, each participates in the other's world, and a companionate marriage is enacted in the desert.[146]

In essence then, the movie version of *The Sheik* allegorized the renegotiation of gender roles that transpired in the 1920s.[147] Just a few years after Margaret Sanger was jailed for trying to promote birth control, men were using Orientalist rhetoric to market new options of freedom at the corner drugstore with the ultimate tie-in of all: Sheik brand condoms.[148]

When interest in Lawrence of Arabia waned, Lowell Thomas capitalized on this climate of permissiveness, parlaying America's burning curiosity about romance in the desert into another lecture entitled "Love in America vs. Love in Arabia." Drawing on his ostensible expertise on the Orient, Thomas juxtaposed what he termed the "sheiks of the corner drugstore" with Bedouin sheiks in their camel-hair tents, declaring with extravagant conviction, "By the beard of the Prophet there is a difference."[149] With what was presumably perceived as roguish charm, Thomas gave his audiences a vicarious peek into desert intimacies, digressing grandly on the relative merits of lipstick versus tattoos and monogamy versus polygamy.

Salome and the Sheik might have suggested wicked pleasures in urban America, but Orientalism could also encompass the morally uplifting reclamation of a rogue. This is manifest in Douglas Fairbanks's classic movie *The Thief of Baghdad* (1924), a swashbuckling cinematic romance in the style of the *Arabian Nights*. Described by Fairbanks as "the story of every man's inner self"[150] (thereby underlining the universal message he sought to convey), the film told the story of a bazaar rat named Ahmad who matures from an unscrupulous delinquent into a real man, winning the hand of a princess along the way. As he undergoes various character-building trials and tribulations, the hero is flatteringly juxtaposed with various rivals for the princess's hand, all of whom are rendered in stereotypical extreme. Consistently, Fairbanks is featured in striking contrast, as a well-muscled, enterprising, and romantic hero, generally bare to the waist. Capitalizing on the star's athleticism, the movie projected early-twentieth-century ideals of

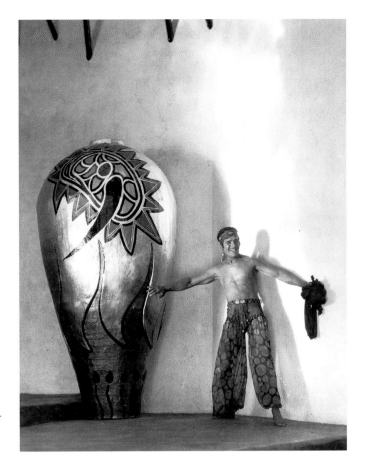

Fig. 25. Douglas Fairbanks, Sr., in a scene from *The Thief of Baghdad*, 1924. Film still. John Springer Collection/ Corbis-Bettmann

boyish charm, heroic chivalry, and a virile but traditional masculinity (fig. 25).[151] It also served up a ponderous moral in subtitles: "Happiness must be earned." For some members of the audience then, Fairbanks would have seemed a real man, not a thinly disguised and feminized tango pirate like Valentino.

The two movies thus present divergent notions of manhood as refracted through Orientalist imagery, and the thief's maturation transpires in a setting that is radically different from the sheik's domain as well. Instead of the sandy verisimilitude of *The Sheik,* Fairbanks sought pure escapist fantasy, replete with dreamy special effects ranging from an underwater treasure hunt to a magic carpet ride (fig. 26).[152] Clearly, there was still no one Orient or one stereotypical Oriental. However, Valentino and Fairbanks both occupied a spectacularized Orient, one that provided the arena for personal transformation.[153]

That Orient was further extended by the very experience of going to the movies. In the hands of such architect/designers as John Eberson, movie theaters were constructed as fantasy spaces, with archways, minarets, and other exotic surface effects.[154] The boundaries between cinematic and mundane reality were also blurred by extravagant publicity stunts designed to promote movie premieres. When *The Thief of Baghdad* opened at the palatial Egyptian Theater in downtown Hollywood, live elephants paraded around its Orientalist courtyard; and when Mary Pickford's *Ali Baba and the Forty Thieves* opened, the auditorium was enhanced with Arabian decor.[155] In such "movie palaces," then, the viewer became Aladdin, engrossed by pictures emerging from a magic lamp of an altogether modern sort. Indeed, it seems no surprise that the first history of this new medium, written in 1926, was entitled *A Million and One Nights,* an allusion to the exotic and erotic character of tales told in darkness on the flickering silent screen.[156] This title is a telling echo of Buel's purple prose dismissing the fantasies of Aladdin for the potential of America's industrial future at the 1893 World's Columbian Exposition. In both cases, the magic of the *Arabian Nights* was surpassed by American know-how.

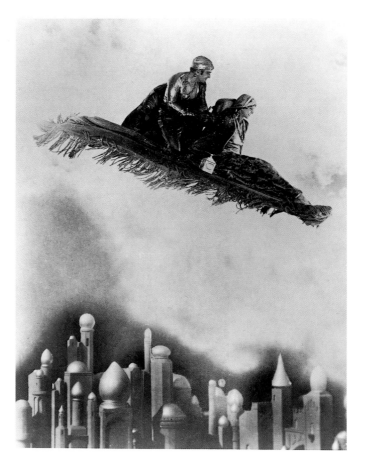

Fig. 26. Douglas Fairbanks, Sr., and Julianne Johnston in a scene from *The Thief of Baghdad*, 1924. Film still. John Springer Collection/Corbis-Bettmann

Perhaps the most profound manifestation of such appropriative improvement occurred in 1923. In that year, the Shriners launched their annual pilgrimage (this time to Washington, D.C.), and the theme was "Park Your Camel with Uncle Sam'l" (cat. no. 77). All over the country, Shriners put on their fezzes, tanked up their automobiles, and mobilized a transcontinental "caravan" for a gala weekend that culminated in a grand parade down the "Road to Mecca," a richly decorated Pennsylvania Avenue (cat. no. 71C). Everyone and everything were decked out in oriental garb for the formal reception in the "Garden of Allah," where President and Mrs. Harding formed the center of a group of distinguished personages that also included Chief Justice and Mrs. William Howard Taft, the secretaries of state, war, navy, and labor, members of the Senate and the House of Representatives, government officials, and members of the diplomatic corps. Units from all the armed services participated, along with numerous floats and Shriner marching bands (cat. no. 71D).

In the florid verbiage of the commemorative volume, the Garden of Allah was granted yet another incarnation, this time as the site of all goodness, light and noble idealism:

> *Whatever of good there is; whatever of joy and gladness, mirth and laughter,*
> *whatever of beauty and culture, intellect and high attainment; whatever is faith*
> *and love, the substance of hope, the promise of noble achievement—these are the*
> *invisible flowers that flourish in the Garden of Allah, unseen of profane*
> *eyes. . . . The Garden of Allah is not the vista of minarets, the color and dazzling*
> *display your human eye sees . . . the Garden of Allah is unknown to the*
> *senses . . . it is the heart of God, a little child redeemed from the discard.*[157]

Thus the Garden of Allah became a gloss for Shriner philanthropy and for goodness in America at large. This was a long way from Broadway and boxes of candy, but perhaps

not so far from Frederic Church's *Jerusalem from the Mount of Olives,* for both the painting and the pageant were acts of cartographic symbolism. While Church accomplished this pictorially, the Shriners' Garden of Allah was literally mapped over the nation's capital. In both cases, the American landscape was conflated with that of the Orient to define the arena of noble dreams.

Another souvenir of the Shriner pilgrimage extends the imagery by showing the Capitol building sporting a fez atop its dome (cat. no. 75). An exuberant bit of self-congratulation, this diminutive keepsake effectively granted Shrinedom a status comparable to the institutions of democracy in American culture. On another level, the souvenir miniature might be seen as one more act of borrowed clothing and cavalier appropriation, albeit manifest in visual shorthand. All of these readings, however, mask a charged political connotation signaled by historical circumstance. The fez, the stereotypical headgear of the Ottoman Orient in particular, had been reduced here to the jaunty attribute of something deemed to be larger, more stable, and more formidable: the United States of America. This iconography enjoyed currency precisely as the Orient was being politically reconfigured in the wake of World War I, thus revealing that the locus of power on the world stage had definitively shifted. What was once anticipatory role-playing had taken on a commemorative character, for America was now recognized as a major force in the twentieth century.

American Orientalism, then, had changed. It was no longer confined to gilt-framed paintings and fancy furnishings in the salons of the elite, but rather it had spilled off the movie screen into the lap of the middle class, bringing with it new forms and manifestations. For the present purposes, however, it is appropriate to conclude our consideration of American Orientalism with the Great Depression of 1929. Not only did this shattering event irrevocably alter the American cultural landscape, but visual expression itself was undergoing transformation. The motion picture industry's introduction of "talkies," the painterly drive toward complete abstraction, and, perhaps most profoundly, the advent of television, would change the parameters within which Orientalist imagery was produced. Over time, this imagery in all of its diverse manifestations served to dismember and package the Orient in convenient building blocks for the construction of American worldviews. It does so even now, at the turn of the twenty-first century, as we continue to grapple with the grim realities of friction between genders, races, and nations.

1. Said 1978.

2. The article that launched the art historical issue is Nochlin 1983, 118–31. A recent exhibition that broke some new ground is Benjamin et al. 1997, and Peltre 1998 offers a new approach to the subject.

3. See note 7 below. Scholarship on Orientalism has mushroomed and diversified in the wake of Said's publication. Said himself has refined and extended his arguments, and others have countered them. See, for example, Mackenzie 1995, esp. 1–42.

4. In bold (and ironic) contrast stands the Islamic artistic tradition, which is premised on a different set of variables. Seldom choosing the human figure as the primary vehicle of communication, Muslim artists more often vest meaning in calligraphy, pattern, or space. Thus they situate values in reference to abstract rather than embodied forms. This artistic choice resonates with basic tenets of Islam and simultaneously hobbles western appreciation of an extraordinary mode of visual expression. For an overtly Muslim explanation of the relationship between the faith and its visual expression, see al-Faruqi 1985; for a telling case in which Orientalism has adversely effected the cross-cultural understanding of ornament in Islamic art, see Necipoğlu 1995.

5. The most comprehensive study of Gérôme is Ackerman 1986b. For a recent assessment of Gérôme's Orientalism, see Peltre 1998, 144–48. See also Williams 1993–94. For a detailed study of the French curriculum and American students' experience of it, see Weinberg

1991 and Weinberg 1984.

6. The Turkish painter Osman Hamdi (1842–1910) resided in Paris from 1860 to 1869, during which time he studied with Gérôme and Boulanger. I am particularly indebted to Emine Fetvaci for my understanding of this artist; see Fetvaci 1996. See also Çelik 1996, 204–5.

7. Discussions of Orientalism are proliferating and compounding quickly in scholarly literature. In general, they share reference to Said's theory and Michel Foucault's discussions of power. John Mackenzie provided the next major contribution by inserting a nuanced sense of history and imperialism into the discussion. Among the works of other scholars, one recent trend is a tighter focus on particular mediums of Orientalist expression (see, for example, Schueller 1998); another is the deliberate ear for diverse individual voices within a multivocalic discourse (e.g. Lewis 1996). Enfranchising previously silenced participants has broadened the debate considerably (see Codell and Macleod 1998). Scholars are effectively addressing the convergence of Orientalism discourse and the implications of multiculturalism (see Shohat and Stam 1994) and the nature of art in global culture (see McEvilley 1992). The definition of Orientalism used here is purposefully broad and somewhat synthetic to suit an exhibition format.

8. Since the American West was this country's most immediate "other," it has been instructive to use that case in thinking about this one. Issues of "frontier" are particularly relevant. See Grossman 1994 and Prown et al. 1992.

9. The only general overview of American visual Orientalism is Sweetman 1988, 211–41. For a case study of American involvement in the region, see Kuklick 1996.

10. See Sha'ban 1991. Sha'ban's seminal work uses literary evidence to characterize American Orientalism. See also Schueller 1998 and Marr 1998.

11. *Knickerbocker* 1853. For background on this magazine and the literary scene in New York at the time, see Callow 1967.

12. *Knickerbocker* 1853, 480.

13. Ibid., 480–81.

14. Ibid., 494–95.

15. For a description of the Ottoman presence in Palestine, for example, see Vogel 1993, 19ff. In 1830, France began a military campaign in Algeria, ultimately declaring it a protectorate in 1848. England gained a controlling interest in the Suez Canal in 1875, enjoying considerable power in Egypt thereafter. Fluctuating Turkish strength in Libya was symptomatic of the political decline of the Sublime Porte. Regions farther east, such as China and Japan, were coming into sharper focus in popular awareness as well, in large part due to trade considerations. However the assumptions and stereotypes to which they were subject were fundamentally different than the tropes that underlie American constructions of the world of Islam. On the latter, see Schueller 1998, 27–28.

16. The comments on American popular images of the region are based on Kearney 1975, introduction, 326. The quotes cited represent her summations of extensive source materials available to the general public.

17. For the impact of phrenology on American views of the Orient see Schueller 1998, 33–38; for a more extended analysis of how Victorian interpretations of human physiognomy invaded the realm of the arts, see Cowling 1989.

18. Carrying a major social burden in the wake of the Civil War, this pseudoscience reinforced negative stereotypes about freed slaves; it also served a pointed Orientalist purpose with regard to Egyptians, for example, who posed to white American elites an excruciating quandary: Egyptians were responsible for great monuments like the Sphinx, but those monuments also exhibited non-Caucasian facial features. This combination of accomplishment and supposed inferiority was simply untenable to racially myopic and status-conscious nineteenth-century Americans. See Schueller 1998, 33ff.

19. The bibliography on American missionary activities and religious attitudes to the Holy Land is voluminous, ranging from Tibawi 1966 to Vogel's more focused study cited earlier. Davis 1996 offers a very insightful synthesis of nineteenth-century activities and attitudes, esp. 27–52. See also Schueller 1998, 38–42; Sha'ban 1991, 83–114; and Marr 1998, 12–86.

20. On American views of Islam see Sha'ban 1991, 27–63.

21. Kearney 1975, 41–45, 51.

22. For varying readings of the Barbary Coast drama, see Sha'ban 1991, 65–81; Schueller 1998, 45ff.; and Marr 1998, 86–131.

23. Following comments are based on Marr 1998, 132–224.

24. A general survey of various forms of nonpolitical American activities in the region is available in Finnie 1967. On the story of the navy see 45–81.

25. Winslow Homer renders the exotic attire in *Pitching Quoits*. See Little 1997, 16, 19 (repro.).

26. For background on this, see Crabitès 1938. See also Hesseltine and Wolf 1961.

27. On the issue of steam power vis-à-vis European Orientalisms, see Benjamin et al. 1997, 14.

28. *Knickerbocker* 1853, 489.

29. On the burgeoning phenomenon of tourism see Sears 1989 and Urry 1990; on the role of travelogues, panoramas, and lectures in the formation of American attitudes, see Davis 1996, 52–97.

30. See Daniels 1990, 206–11, and Naff 1985.

31. Riis 1971, 22.

32. Ibid., 19.

33. Kearney 1975, 323, 327.

34. Ibid., 241ff.

35. Ibid., 317ff.

36. Riis 1971, 153–63.

37. On immigration and relevant legislation, see Daniels 1990; on the Mormon presence in the United States, see Davis 1996, 20–22, and Marr 1998, 183ff. Kearney 1975, 301, contextualizes the polygamy legislation. See also Higham 1955.

38. American identification with the Holy Land is elegantly presented in Davis 1996, 13–26 (esp. 14–15), along with an extended discussion of Church's Jerusalem picture (186–92).

39. On the larger context of American response to the Greek War of Independence, see Pappas 1985; on the *Greek Slave* see Green 1982, 31–39, and Hyman 1976, 216–23. See also Reynolds 1977.

40. Powers lived and worked in Florence and *The Greek Slave* represents the introduction of neoclassical sculp-

tural principles to the American milieu. Its reception
betrayed the complexity of American response to body
language. See Hyman 1976.

41. Stoddard 1859, x.

42. Gould, "Church, Humboldt, and Darwin: The Tension and Harmony of Art and Science," in Kelly 1989,
99–100.

43. Church's letters to Taylor regarding Humboldt
(9 May 1859 and 13 June 1859) are in Cornell Regional
Archives along with other Bayard Taylor correspondence. The text of Taylor's letter to Humboldt on behalf
of Church is available in the Olana archives (OL
1998.1.35.1). I am grateful to Karen Zukowski, curator of
Olana, for providing copies of these. For the fascination
with Humboldt and the impact on the painting see
Avery 1993, 12ff., and Gould, "Church, Humboldt and
Darwin," passim. For the larger picture of American
responses to Darwinism see Pyne 1996.

44. I am indebted to Karen Zukowski for calling my
attention to this link. There are various letters pertaining to this club dating from November and December
of 1864, copies of which are available in the Olana
archives. It is not clear how long the club met or what
the format of the meetings was. Church indicated in
one letter that they were to meet semi-monthly at one
another's houses to "spin their yarns" (Church to James
T. Fields of Boston, Harvard University Library).

45. The only substantive survey of American Orientalist
painters is Ackerman 1994a. See also Thompson 1984,
303–12. A critical monograph is Fort 1990.

46. See Ackerman 1994a, 11–12.

47. This is not to suggest that the picturesque tradition
was solely an American phenomenon. It can only be
understood in reference to Ruskin and the European
tradition of the picturesque. See Rainey 1994, 26ff. Linda
Nochlin argues that the notion of picturesque is
premised on the promise of destruction (see Nochlin
1983, 127). See also John Mackenzie's analysis of the
intersection of Orientalism and the picturesque in
Mackenzie 1995, 53ff.

48. Strahan 1881, 70–71.

49. Strahan calls the act of painting archeological, and
by extension, Oriental imagery is "A heavy bid for popular applause," in ibid., 70. On Bridgman's career and
his status in art world see Fort 1990, 294–350.

50. Williams 1993–94, 136–37.

51. Fort 1990, 212–13.

52. Moure 1973, 29–30.

53. My interpretation of the Orientalist picturesque is
informed by Rainey 1994.

54. Ibid., 26–28.

55. Angela Miller discusses Frederic Church's canvases of
South America and the Holy Land in this way in Miller
1993, 200ff.

56. My suggestion that Orientalism in America is partially about nostalgia is indebted to David Lubin's reading of Harnett's still-life painting in Lubin 1994, 304–10;
his felicitous phrase is "venerate the old while fetishizing
the new."

57. For images of traditional industry and entrepreneurial activity, see Ackerman 1994a, 101, 107, 109, 125, 127–29,
185, 215, 241, 247, 250–51.

58. Ibid., 25.

59. Maddox and Baz 1983, figs. 1, 2, 5.

60. The painting can be compared with contemporaneous pictures of traditional craftsmen in the United
States. See Bolger 1980, 118.

61. In 1998, Barbara Weinberg mounted a selection of
works from the Metropolitan Museum of Art's collection depicting traditional crafts, including Pearce's picture. On the Aesthetic Movement, see Roger Stein,
"Artifact as Ideology," in Burke et al. 1986, 22–52.

62. Ames 1988, 161.

63. Church is quoted in an article by Frank J. Bonnelle
in *The Boston Herald,* September 7, 1890. I am indebted
to Karen Zukowski, curator of Olana, for bringing this
to my attention. On Church as an Orientalist, see Ackerman 1994a, 52–65, and Davis 1996, 168–207.

64. Tiffany's Orientalism has attracted relatively little
scholarly attention, although reference is often made to
his trip to the Orient as a formative experience. See
most recently, Frelinghuysen 1998, 6–7, and Ackerman
1994a, 208–15. See also Barbara Dayer Gallati, "The Exhibition Watercolor in America," in Ferber and Gallati
1998.

65. For a study of Chase's life, see Bryant 1991. Another
major exotic picture, *Turkish Page,* is reproduced on p. 39.

66. On artist studios and the entrepreneurial milieu, see
Blaugrund 1997 and Burns 1993, 209–39.

67. Cited in Lange 1990, 31. My discussion of the commercialization of the Islamic taste in American interiors
is indebted to pages 30–35 of this source.

68. Burns 1993, 232–35 and figs. 10.15–17.

69. There is a large bibliography on gender dynamics in
the nineteenth and early twentieth century. See, for
example, Snitow, Stansell, and Thompson 1983, De
Groot 1989, and Smith-Rosenberg 1985, esp. 167–81,
197–218, 245–96. See also Kimmel 1987.

70. For a more inclusive discussion of the intersection of
Orientalism and gender, see Lewis 1996, 12–52.

71. "One thing is very noticeable: the deference paid to
ladies and women generally in our own country is
something remarkable in comparison with anything I
have seen since I have been on this side of the Atlantic
and I am sure if the women of our country could realize
the great difference they would not complain of want of
consideration on the part of men." R. Swain Gifford to
Mrs. Lydia Swain, 7 October 1870, Gifford Papers.

72. For a detailed consideration of women in Orientalist
painting, see Ilene Fort, "Femme Fatale or Caring
Mother? The Orientalist Woman's Struggle for Dignity,"
in Fort 1983, 31–52.

73. Of course, it would be a mistake to reduce such
imagery to depictions of neurasthenia, but they would
have had particular resonance for a society plagued by
this incapacitating malaise. On the general picture of
neurasthenia, see Lears 1981, 47–58.

74. For an overview of Salome imagery, see Dijkstra
1986, 35–40.

75. On this issue, see Dubbert 1980, 303–19. For an
overview and new synthesis, see Bederman 1995, esp. 1–44.

76. Boime 1991, 101–5.

77. On cross-cultural masquerade, see Dianne Sachko
Macleod, "Cross-Cultural Cross-Dressing: Class, Gender
and Modernist Sexual Identity," in Codell and Macleod
1998, 63–86.

78. For a study of the longevity and deep complexities of cowboy art, see Sweeney 1992, 67–80.

79. For example, Troye traveled to the Orient to paint Arabian horses that his patron was interested in acquiring (see Ackerman 1994a, 216–23).

80. On Frederic Remington's life and works, see Bolger 1980, 396–97.

81. On Remington's Orientalism, see Ackerman 1994a, 162–67.

82. Dippie 1987, 84.

83. On the relationship between male superiority and civilization see Bederman 1995, introduction.

84. This phrase is the title of Bederman's book cited above.

85. Many people have written about the fair from a variety of vantage points. I am most indebted to Elizabeth Broun and Alan Fern, "Introduction," and Robert Rydell, "Rediscovering the 1893 Chicago World's Columbian Exposition," in Carr et al. 1993, 18–61. On the pledge of allegiance, see ibid., 35, which cites many other sources.

86. Rydell 1993, 38, 43–44 (see n. 85).

87. See Çelik 1992, 80–88.

88. Contemporary critic Danton Snider quoted in ibid., 83.

89. See Bederman 1995, 31–41.

90. On women and the fair, see Weimann 1981. On the Women's Building in the context of larger art historical trends see Chadwick 1990, 230–32 and fig. 129.

91. Rydell 1993, 52 (see n. 85).

92. Sargent also exhibited a portrait of Jane Terry as Lady Macbeth. For exhibition pictures, see Brandon Brame Fortune and Michelle Mead, "Catalogue of American Paintings and Sculptures Exhibited at the World's Columbian Exposition," in Carr et al. 1993, 193ff. For a study of Sargent's virtuosity, see Simpson 1997.

93. It is interesting to consider the picture in the social context of scandals generated when Thomas Eakins allowed students to sketch live nude models in 1886 and then in 1895. He is said to have lost two jobs as a result of such improper behavior. In fact, this is an oversimplification, but in its reductionism, it reflects the undercurrent of prudery at the time around the use of the nude model. See Johns 1998, 171–76.

94. Bancroft 1893, 695.

95. Bloom bemoaned the fact that he did not copyright this melody, estimating that it cost him hundreds of thousands of dollars in royalties. See Bloom 1948, 134–36.

96. On the complex construction of women and "cooch," see Allen 1991, 225–36. For background on the dance and its complex social contexts in various parts of the Islamic world, as well as an analysis of the presentation of the dance at European fairs, see Çelik and Kinney 1990, 35–60, esp. 40–41.

97. Bancroft 1893, 877.

98. On the theatricalization of the dance, see Çelik and Kinney 1990, 40. On the history of women on stage in America, see Allen 1991, 79ff.

99. In the late nineteenth century, corsets were made for children as young as three, though not all wore them. Women doctors testified to case after case of atrophied internal organs and stunted growth due to confining dress. On the corset controversy, see Steele 1985, 161–92, 226–27. For just one instance in which dress reform and female movement was of critical importance, see Kendall 1979, 21–23.

100. On the appearance of women on stage and the reputation that ballet and chorus girls had, see ibid., 5–7; on the kinds of dancing that occurred in vaudeville and other popular theater formats, see ibid., 36–37.

101. Allen 1991, 229–36. For evidence of the carnival version of "cooch," see McKennon 1972, 55, 71–72, 78, 100.

102. This summation of the era and my subsequent comments are deeply informed by Leach 1993.

103. The following description is indebted to Erenberg 1981.

104. See Kathy Peiss, "'Charity Girls' and City Pleasures: Historical Notes on Working-Class Sexuality, 1880–1920," in Snitow, Stansell, and Thompson 1983, 74–87.

105. Erenberg 1981, 60ff.

106. Quoted in ibid., 81.

107. Jones 1955, 2:74–76.

108. Quoted in May 1983, 33.

109. May quotes a commentator from *The Evening World,* p. 39. On the early phases of movie history and on *The Kiss,* see Everson 1978, chap. 2 and p. 20.

110. May 1983, 39–40.

111. On Comstock and the milieu of public censorship, see Chen 1996, xiv–xxv.

112. On the milieu of white slave trade and related movies, see Brownlow 1990, 70–85; see also May 1983, chap. 5, on Griffith and reformist efforts.

113. See Barbara Epstein, "Family, Sexual Morality, and Popular Movements in Turn of the Century America," and Ellen Kay Trimberger, "Feminism, Men and Modern Love: Greenwich Village, 1900–1925, both in Snitow, Stansell, and Thompson 1983.

114. See, for example, Lee 1911.

115. For the trial, see Chen 1996, 281–93.

116. On Margaret Sanger, see Chesler 1992; see also Brownlow 1990, 47–55, on birth-control issues in movies.

117. On corollary representations of prostitutes in Sloan's painting, see Kinzer 1984, 231–54.

118. On advertising at the turn of the century, see Lears 1994 and "From Salvation to Self-Realization: Advertising and the Therapeutic Roots of the Consumer Culture, 1880–1930," in Fox and Lears 1983.

119. Heimann 1960; Robert 1949.

120. Smith 1990, 31.

121. This is the wording that appears on the flyleaf of the Popular Library edition.

122. A commemorative album of photographs that were taken during preparatory research in Algeria is presently in the New York Public Library, Collection of the Performing Arts, and is entitled, "Photographs taken from April 5th to May 31, 1911 en route to and from 'the Garden of Allah.'" On the play and its popular reception, see Leach 1993, 108–11.

123. *Evening Sun,* 23 October 1911. Extensive press coverage is available in New York Public Library, Collection of the Performing Arts. In its intoxicating realism, the show recalls the paintings of Gérôme, wherein the enamel-like finish of the painting seduces the viewer into equating the image with truth and reality. See Nochlin 1983.

124. On the fashion show tie-in, see Leach 1993, 110–11.

125. For the genesis of the Garden of Allah image, see Ludwig 1973, 134–35, 138.

126. Ibid.

127. On the whole Salome phenomenon, see Gaylyn

Studlar, "Out Salomeing Salome: Dance, the New Woman, and Fan Magazine Orientalism," in Bernstein and Studlar 1997, 99–129. The conflation of the hoochy-coochy and Salome's dance of the seven veils was so complete and so widely disseminated that it remains current in oral culture in examples such as the jump rope rhyme: "Salome was a dancer, / She danced before the king. / She danced the hoochy-coochy, and shimmied everything. / 'Stop!' yelled the king, / You can't do that in here.' / Salome said, 'Baloney,' and kicked the chandelier." On the relationship of striptease and Salome, see Sobel 1956, 121–25.

128. Zurier, Snyder, and Mecklenburg 1995, 19–21.

129. Kendall 1979, 74–77.

130. A copy of this film resides in the New York Public Library, Collection of the Performing Arts, MGZHB 4-229.

131. See Mazo 1977, 69–71.

132. On the prewar dance craze, see Erenberg 1981, 146–75; on Irene Castle, who "merged the virgin to the vamp and validated a wider range of behavior," see ibid., 167. See also Studlar 1996, 150–98.

133. On the Poiret figure and related changes, see Steele 1985, 224–28; see also Wollen 1987, 10–12.

134. On this much larger issue, see Dijkstra 1986, passim.

135. For the tale told by a near contemporary, see Ramsaye 1964. See also Walker 1967, 19–27, and Brownlow 1990, 30–32.

136. Bara was constantly defending herself from the public assumption that she was a vamp in real life and not just an actress playing a reprehensible character. For example, the *Louisville Herald* (24 October 1915) launched a contest—"Would you marry Theda Bara?"—for which the best one-hundred-word answer would receive complimentary theater tickets. About the moral conundrums posed by her character, she expressed rather lofty convictions: "Every mother and every minister owes me gratitude. . . . I believe I am showing time and again the unhappiness and misery that fall to the lot of transgressors and the contempt and hatred which said people inspire in good society" (*New York Telegraph,* 14 March 1916).

137. Bederman 1995, chaps. 3, 5.

138. The late nineteenth century was called the "Golden Age of Fraternity" in the 1897 *North American Review,* citing the fact that 5.5 million of 17 million adult males belonged to fraternal orders. For this citation as well as for its analysis of the function of fraternal orders in society, see Carnes 1990, 37–66; participation statistics, 38.

139. Ibid., 45ff.

140. I am deeply indebted to William Moore, recent head of Livingston Library, Grand Masonic Lodge, New York City, for what he has taught me about Shriners. More particularly, I have benefited from reading his unpublished article "American Shriners' Mosques,

1904–1929: The Golden Age," 1996.

141. For a study of the emergence and transmission of the Lawrence myth, see Hodson 1995.

142. Sweetman 1988, fig. 142.

143. The book was first published in 1919 and had gone through sixty printings by January 1922.

144. Much has been written about Valentino in the guise of the sheik and what he represented to the American public in the 1920s. See, for example, Hansen 1986 and Studlar 1993.

145. May similarly cites *The Thief of Baghdad* as an example of a man looking to other cultures for traits absent in his own, see May 1983, 216.

146. On companionate marriage, see Brownlow 1990, 44ff. The term "companionate marriage" was coined by Judge Ben Lindsey to describe wedlock in a milieu that accepted both birth control and divorce. Procreation was not deemed the sole purpose of sex or marriage (see ibid.). See also Schneider and Schneider 1994, 147–51, and Brown 1987, 101–26.

147. It is interesting to consider *The Sheik* in the context of producer Cecil B. DeMille's formula for domestic revitalization. His conviction was that the desires that were typically projected onto foreign lovers could be brought into American culture. In so doing, the intention was to incorporate passion and sex into the American institution of marriage (see May 1983, 207ff).

148. Julius Schmid, an associate of Margaret Sanger's and a family planning pioneer, produced two lines of condoms with oriental names in the 1920s. "Sheik" brand was a mid-range product launched in 1924, while Ramses was the top-of-the-line condom, marketed in 1927. I am grateful to Phyllis Barber of Schmid Laboratory, Inc., for providing this information. On the history of the condom, see Parisot 1985; on the larger history of birth control, see Reed 1984.

149. I am grateful to Claire Keith for making this typescript from the Lowell Thomas Archives at Marist College available to me.

150. Quoted in Studlar 1996, 85.

151. Ibid., 80–82.

152. Studlar compares it with German costume films and the Ballet Russes in ibid., 83.

153. For a more complete overview of stereotypes in the cinema, see Michalek 1989.

154. On the emergence of the picture palace, see Naylor 1981, and on John Eberson and "atmospherics," see ibid., 74–77.

155. The Egyptian Theater, the work of Sid Graumann, was one of the most extravagant theaters ever built. On carrying movie themes into the decoration of the theater, see May 1983, 156.

156. Ramsaye 1964.

157. Edgerton 1923.

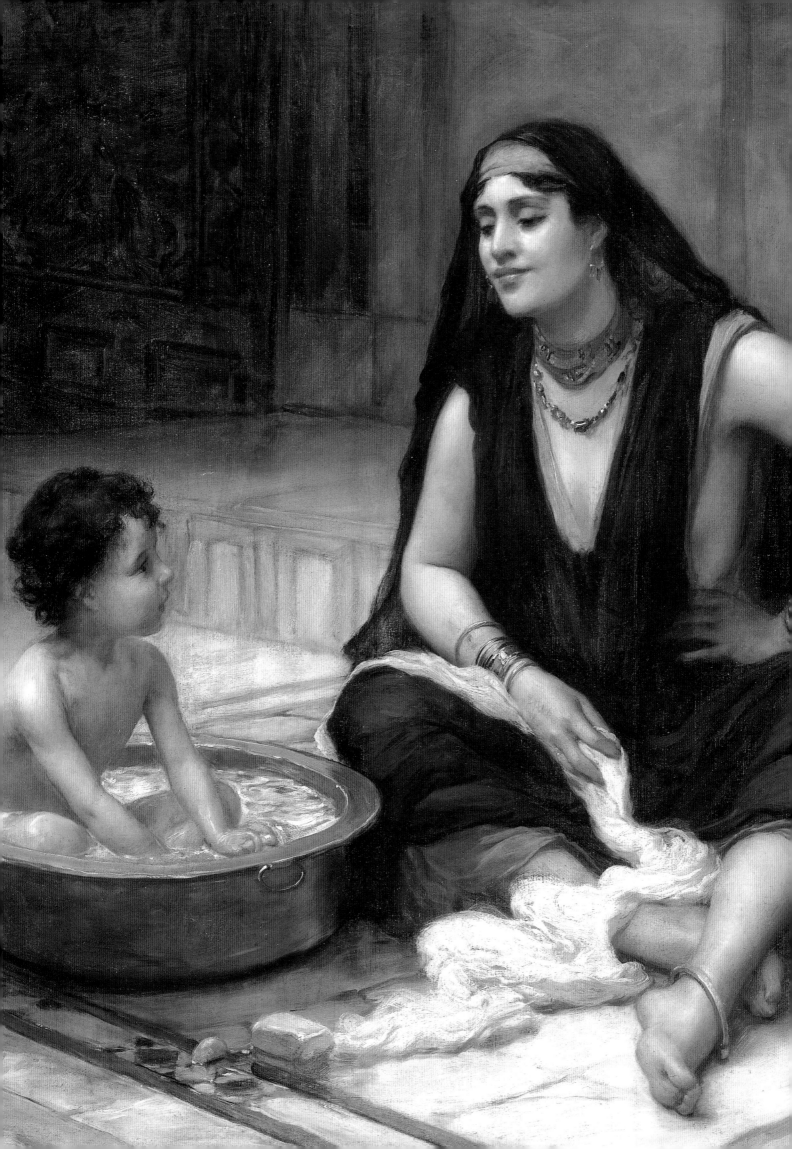

"The garments of instruction from the wardrobe of pleasure": American Orientalist Painting in the 1870s and 1880s

BRIAN T. ALLEN

The range of differences between French and American Orientalism is quickly seen in a comparison of *The Slave Market* (1866; cat. no. 5), by the French Orientalist master Jean-Léon Gérôme, and *The Bath* (1890; cat. no. 7), by his American pupil Frederick Bridgman. Gérôme's painting depicts a nude woman about to be auctioned off. At least four men gather around to inspect her, one pulling her head back and thrusting two fingers into her mouth as his colleagues intently watch. As an account of the humiliation and brutalization of Arab women, it remains a powerful, damning image. Bridgman's painting, on the other hand, depicts an Algerian mother and her child, a scene as wholesome as Gérôme's is depraved. During the 1880s, the same time Bridgman painted *The Bath*, Gérôme also painted a series of bathing scenes, though his works are more explicit sexually than Bridgman's. On the rare occasions when children appear, they are placed in the background, and in none is the relationship between mother and child the central element of the painting that Bridgman makes it. While Bridgman occasionally gave us scenes of mild flirtation, in no work by Bridgman does the theme of sexual invasion proposed in *The Slave Market* appear so brazenly.

One way to explore these differences is to invoke the traditional American aversion to the female nude dating to John Vanderlyn's controversial *Ariadne Asleep on the Island of Naxos* (1814). The differences suggest a more challenging set of questions related not only to the female nude but to the female *Near Eastern* nude. The question of how Bridgman differs from his French mentors in his treatment of the Near Eastern woman leads directly to a wider range of differences between American and European artists *as Orientalists*. This essay tests the applicability to American painting in the 1870s and 1880s of the ideologies first suggested in Edward Said's *Orientalism* (1978). Using the work of Frederic Church (1826–1900), Edwin Lord Weeks (1849–1903), and Frederick Bridgman (1847–1928) as examples, I hope to show that American Orientalism was a distinct phenomenon with some European currents but ultimately unresponsive to formulas based on the schemes of domination or denigration first identified by Said in his landmark work. Rather, American treatments of the Near East and Middle East, amazingly diverse in subject matter, were generally very positive and so various that it is difficult to tag them as ideological.

Said and a range of scholars following in his path have argued that Orientalism operated in the nineteenth century as a discourse in which Westerners constructed the Oriental as inherently inferior to the Westerner. Artists, writers, and scholars depicted inferiority using a set of recurring characteristics—accuracy and reason are foreign to the oriental mind, the Oriental is lazy, a cunning flatterer, oversexed, irrational, depraved, fallen, often feminine or childlike, and "different," while the Westerner is rational, virtuous, logical, a close reasoner, controlled, mature, masculine, and "normal."[1] The creation of a classical Orient by scholars, writers, and artists who celebrated

Frederick Arthur Bridgman (American, 1847–1928), *The Bath*, 1890 (detail of cat. no. 7)

ancient monuments served merely to contrast past triumphs with contemporary decrepitude and to reinforce themes of inferiority, inadequacy, and dependence.[2] The contemporary Oriental was therefore established as inferior even to his ancestors. A final and important ingredient of Orientalism was the association of the Islamic world with the freedom of licentious sex. Hence we see Orientalist literature and painting confer a starring role upon the oriental woman in the harem or the dance hall, exposed, vulnerable, and untiring in her licentiousness.

Studies of Orientalism since Said's book have concentrated almost exclusively on European art and literature. What about America's own Orientalist experience? Said states in the very first pages of *Orientalism* that "American understanding of the Orient will seem considerably less dense" than Europe's.[3] The Orient, he believes, "is an integral part of European material civilization and culture," while America, because of its relative newness as a nation, "will not feel quite the same about the Orient," and, in any event, will see the Orient in terms of the Far East rather than Islamic Asia and Africa.[4]

American preoccupation with the Islamic Orient was certainly never as intense as Europe's, and in the nineteenth century the United States had little if any imperialist agenda implicating the region. Yet the Near East, as the situs of the Bible's dramas, was deeply integral to an American nation founded as a theocracy and nourished on Protestant evangelicalism well into the nineteenth century. Moreover, many of the Americans who painted Near Eastern subjects were themselves intimates of the Europeans—Gérôme especially—who developed the visual vocabulary for European Orientalism. These Americans followed but also amended the example of their French and British mentors and treated Near Eastern subjects with an American gloss of varying contrast. What emerged was a particularly American brand of Orientalism, reflecting what Reina Lewis has called the "multiplicity, diversity, and incommensurability of possible positionings"[5] constituting an Orientalist discourse. American Orientalism imaged the Islamic world as different, certainly, but with a difference presented less negatively than in the work of Europeans.

Artists working in the 1870s and 1880s were not, of course, the first Americans who made the Islamic Orient the center of their creative labors. The subject had preoccupied Americans in varying degrees since the nation's earliest settlement, since Islam represented to the founders so false a religion that it vied with Roman Catholicism as the ultimate in anti-Christianities.[6] Timothy Marr has analyzed the application of the Book of Revelation and other prophetic religious writings by early American fundamentalists, finding an interpretation of Islam—politically envisioned as the Ottoman Empire—as inherently depraved and dangerous but ultimately doomed to failure, a failure seen as one important signal of the coming of the Millennium.[7] In the eighteenth century, Enlightenment views of the Islamic Orient emphasized the centrality of despotism and a servile public to the Islamic state, again, a powerful antidote to the republican virtue.[8]

Americans famously warred against the Islamic Orient during the 1780s and 1790s—the young nation's first post-revolutionary military adventure and major hostage crisis.[9] The episode sparked a body of fiction including *The Algerine Spy* (1798) that recited many of the negative stereotypes about the Islamic Oriental but also "fantasized the capacity of democratic principles to entertain the world and then to lead it to decency. . . . they provided American audiences with the confirmation that underneath the despotic behavior of aliens existed incipient democrats who could be converted to honest love and benevolent works."[10] The characters of these stories began as monsters but evolved through exposure to American institutions, among them the stable family,

into ardent republicans. These works, published in abundance throughout the early nineteenth century, were major first steps in ameliorating Islam's place in American culture as an icon of terror and provided the raw material for its subsequent rehabilitations.

The major figure in refashioning the terms of American Orientalism was Washington Irving. Irving popularized a form of classicizing Orientalism in which the Islamic Orient was viewed in terms of its connection to the past rather than its role in an active present. His 1832 travelogue *The Alhambra,* set in the ruins of Moorish Spain and featuring numerous vignettes of Spain before the *reconquista,* presented quite a positive treatment of the Islamic Orient that was reflected by American painters for the rest of the century.[11] His construction of both a fictive Spain and a fictive Islamic world that are mutually dependent but also quite different may be the most unconsidered aspect of his career. Irving might have been the first American to pry the Islamic Orient from a harping negativism and to present it as very positive on many levels.

Irving's brand of Orientalism in dealing with the Islamic world is a direct function of his treatment of Spain. First of all, Irving dealt in *The Alhambra* and his other writings about Spain with the raw material of the Black Legend, that package of defensive, cardboard generalizations defining Spaniards as uniquely lazy, ignorant, fanatical, and cruel.[12] In approaching Spain, Irving had a bona fide imperial agenda that had been missing in previous American treatments of the Islamic Orient. While he constructed Spain, Anglo America was insinuating itself into the massive Spanish-acculturated real estate to its south and west. The overall result is that when dealing with Spain, Irving, perhaps unconsciously, established a sophisticated series of images that became implicit oppositions to the Anglo-American experience and mind, with the "Westerner" always retaining a position of superiority.

How does the Islamic world fit into this scheme? Irving denigrates Spain and Spanishness, though with the greatest of kindness, professing throughout *The Alhambra* and his other Spanish works to love the place. One of Irving's rhetorical devices is the juxtaposition of contemporary Spain against the glorious Moorish kingdoms it displaced during the *reconquista.* Moorish Spain is classicized and, together with the logical, rational, progress-oriented, and time-oriented Anglo world of Irving, forms the jaws of a vise between which contemporary Spain and Spanishness are squeezed.

Certainly Irving sexualizes the Orient. In *The Alhambra,* Islamic Spain is the site of most of Irving's love stories. Moorish kings cloister their women in towers, pretty prisons of "small fairy apartments, beautifully ornamented . . . the walls and the ceilings . . . adorned with arabesque and fretwork, sparkling in gold . . . round the hall were suspended cages of gold and silver wire, containing singing birds of the finest plumage or sweetest note."[13] Irving endows the architecture of the Alhambra with "a delicate and graceful taste, and a disposition to indolent enjoyment . . . it is almost sufficient to excuse the popular tradition, that the whole is protected by a magic charm,"[14] suggesting an eternal and inviting voluptuary.

Irving also presents the Islamic Orient in terms of a ruin, and this is an important element in Saidian Orientalism. Yet there are two types of ruin in Irving's texts. The first is the ruin of Islamic Spain—the once glorious Alhambra—but this ruin serves for him a subtly aggressive function as a measure of Spain's lost, ancient past, perhaps a better past.[15] The second, juxtaposed level of ruin is that of imperialist, colonizing Spain. Irving judges the most recent ruin as belonging to the truly defective culture. What emerges is a kind of classicizing Orientalism in which Irving heroicizes Islamic Spain through the exploits of Moorish caliphs and the beauty and refinement of its architec-

ture, learning, and women *in direct contrast to contemporary Spain.* The triumphs of infidels are safely consigned to a dead past, and Irving shows no interest in the contemporary Islamic world. What remains is a classical Islamic world of great beauty, love, simple nobility, and timeless values.

Irving's paradigm for evaluating the Islamic Orient was shared in considerable degree by Frederic Church, whose late masterpiece, *Jerusalem from the Mount of Olives,* (1870; cat. no. 2), shows a similar, classicizing type of American Orientalism. The Islamic Orient becomes, for Church, an emblem of enduring spiritual values severely tested in contemporary life. The painting is among a small group of Near Eastern works that constitute Church's valedictory. Arguably his last great landscape, he painted it on the verge of a permanent retirement after a quarter-century career as the country's most famous and financially successful artist. The painting works as a summation, evocatively revisiting concerns Church first raised as a young man and which appeared also in the work of his master Thomas Cole. From this perspective, Church's Orientalism is deeply rooted in ancient American traditions and beliefs. For this reason, we can hardly say that Church's Orientalism is about difference but rather about similarities, the similarities arising from the American world's descent from an older order of chosen people.

For nineteenth-century Americans, Jerusalem was as formidable a symbol of the country's sense of self as the flag, and in this respect Church's painting is a major patriotic paean. In visiting the Holy Land, Church was part of a broader movement that, since the late 1860s, marked a significant increase in American travel to the Near East, especially to sites of biblical drama. John Davis has examined with authority and passion the basis for this new popularity of travel to the Holy Land, noting that "One way of verifying the validity of the concept of a New World Zion was to encounter the material presence of the old Israel."[16] Following the turmoil of the Civil War, ratification of America's fundamental mission and ideological lineage was also an understandably desirable salve for the nation's ego.

But while the circumstances were new, the impulse was not. America's assessment of itself as a "New Jerusalem" had characterized American patriotic and religious rhetoric from the earliest settlement of New England by, among others, Church's ancestors, who were part of the establishment of the first English colony in Connecticut in 1633. The subject of Jerusalem was a powerful component of the art of Thomas Cole, Church's early mentor, and an emblem of the failure of the Old World to achieve the promise subsequently consigned to the new.

The devastated city in Cole's *The Course of Empire,* for example, is ostensibly anonymous but was read by contemporary critics as Jerusalem on the eve of its fall to Rome.[17] Panoramic paintings of Church's youth also evoke Jerusalem as the archetypal victim of its own hubris, including the New York panorama entitled *The Destruction of the City and Temple of Jerusalem,* and John Whichelo's *Destruction of Jerusalem* (fig. 1), which, like Church's painting, included a number-coded map of the city, as did Frederick Catherwood's Jerusalem panorama, which was exhibited in Boston and New York in 1838. Jerusalem as a subject for American painting was hardly new, though it seemed especially active in Church's youth. Why did the artist return to the theme at the end of his career?

Church does not appear to have followed in the more extreme ideological footsteps of, for instance, Holy Land colonizers such as the Philadelphia Quaker Warder Cresson, who in 1844 moved to Palestine as the first American consul in Jerusalem, with the stealthy purpose of colonizing it with American Puritan revivalists. We are led in safer

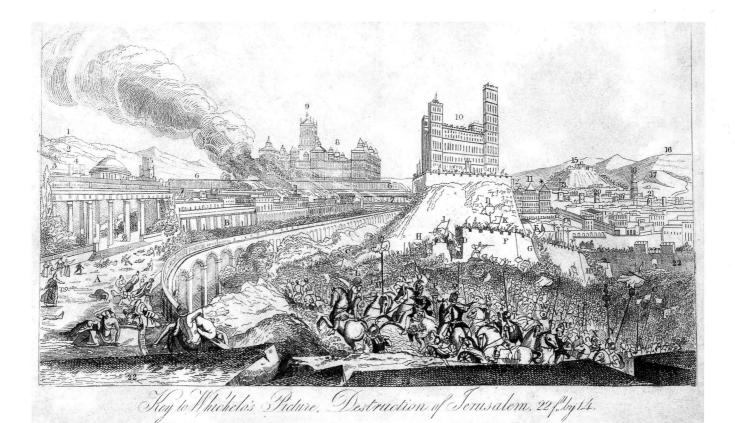

Key to Whichelo's Picture, Destruction of Jerusalem. 22ft by 14.

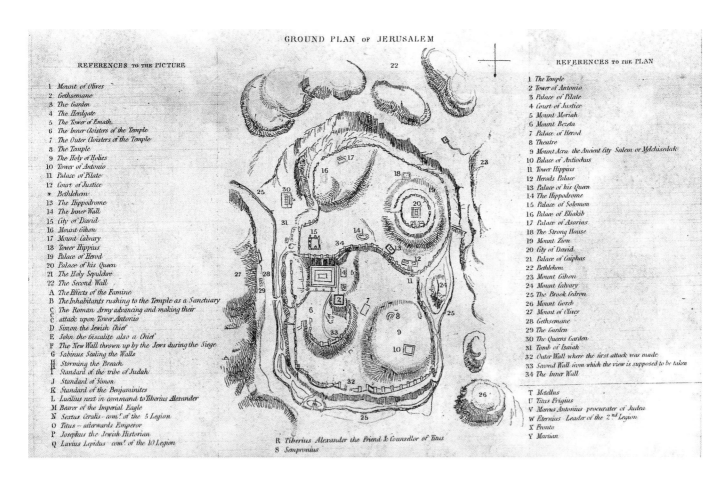

GROUND PLAN OF JERUSALEM

REFERENCES TO THE PICTURE

1 Mount of Olives
2 Gethsemane
3 The Garden
4 The Herdgate
5 The Tower of Emath
6 The Inner Cloisters of the Temple
7 The Outer Cloisters of the Temple
8 The Temple
9 The Holy of Holies
10 Tower of Antonio
11 Palace of Pilate
12 Court of Justice
* Bethlehem
13 The Hippodrome
14 The Inner Wall
15 City of David
16 Mount Gihon
17 Mount Calvary
18 Tower Hippus
19 Palace of Herod
20 Palace of his Queen
21 The Holy Sepulchre
22 The Second Wall
A The Effects of the Famine
B The Inhabitants rushing to the Temple as a Sanctuary
C The Roman Army advancing and making their
C attack upon Tower Antonio
D Simon the Jewish Chief
E John the Giscalite also a Chief
F The New Wall thrown up by the Jews during the Siege
G Sabinus Scaling the Walls
H Storming the Breach
I Standard of the tribe of Judah
J Standard of Simon
K Standard of the Benjaminites
L Lucilius next in command to Tiberius Alexander
M Bearer of the Imperial Eagle
N Sextus Ceralis - com.t of the 5 Legion
O Titus — afterwards Emperor
P Josephus the Jewish Historian
Q Lavius Lepidus com.t of the 10 Legion

R Tiberius Alexander the Friend & Counsellor of Titus
S Sempronius

REFERENCES TO THE PLAN

1 The Temple
2 Tower of Antonio
3 Palace of Pilate
4 Court of Justice
5 Mount Moriah
6 Mount Bezeta
7 Palace of Herod
8 Theatre
9 Mount Acra the Ancient City Salem or Melchisedeck
10 Palace of Antiochus
11 Tower Hippus
12 Herods Palace
13 Palace of his Queen
14 The Hippodrome
15 Palace of Solomon
16 Palace of Eliakib
17 Palace of Asarias
18 The Strong House
19 Mount Zion
20 City of David
21 Palace of Caiphas
22 Bethlehem
23 Mount Gihon
24 Mount Calvary
25 The Brook Cedron
26 Mount Gereb
27 Mount of Olives
28 Gethsemane
29 The Garden
30 The Queens Garden
31 Tomb of Isaiah
32 Outer Wall where the first attack was made
33 Second Wall from which the view is supposed to be taken
34 The Inner Wall

T Metellus
U Titus Frigius
V Marcus Antonius procurator of Judea
W Eternius Leader of the 2nd Legion
X Fronto
Y Marian

Fig. 1. *Key to Whichelo's Picture "Destruction of Jerusalem."*
Engraving after a painting by C. John M. Whichelo
(British, 1784–1865). National Gallery of Art Library,
Washington, D.C. Gift of John Davis Hatch

directions if we understand Church, a member of the board of directors of the American Palestine Exploration Society, as sharing the society's mission to refute disbelief through the verification of biblical history as "real, in time, place, and circumstances."[18]

Establishing the Bible as historical as well as spiritual truth was certainly part of Church's work. In this respect, Church engaged not in cultural imperialism but, rather, worked as part of a broad and diverse artistic movement that included Ernest Renan, among others, and that sought to explore the historical truths surrounding the life of Jesus. He positioned his view from the Mount of Olives, a view that diminished the prominence of Ottoman-era buildings and Roman Catholic clutter, and therefore, like Irving, consciously looked backward to seek the simple visual reality of Jesus' life and to communicate that reality to the Protestant evangelical viewers who professed to follow Jesus' path.

This does not mean, however, that Church saw Jerusalem as a fallen empire, as did Cole, Whichelo, and others. It is best to look at Church's painting in terms of the juxtapositions that occurred periodically throughout his career. His earliest major works, *Hooker and Company Journeying Through the Wilderness* and *Moses Viewing the Promised Land*, both from 1846, are themselves companion paintings that evoke the passage of two chosen peoples to the Promised Land: Moses after the parting of the Red Sea, and Thomas Hooker as he and his party traveled from Plymouth to found Church's native Hartford in 1633. As in *Jerusalem from the Mount of Olives*, the "promised lands" are far in the distance, a device Church also used in the early, patriotic *West Rock, New Haven*, (1849; fig. 2), which depicts the hillock where three of the Puritan parliamentarians who signed Charles I's death warrant hid when pursued by Restorationists. Both paintings evoke ancient history but also the roots of Puritan values. Quite possibly,

Fig. 2. Frederic Edwin Church, *West Rock, New Haven*, 1849. Oil on canvas, 26½ × 40 inches (67.3 × 101.6 cm). New Britain Museum of American Art, Connecticut. John Butler Talcott Fund

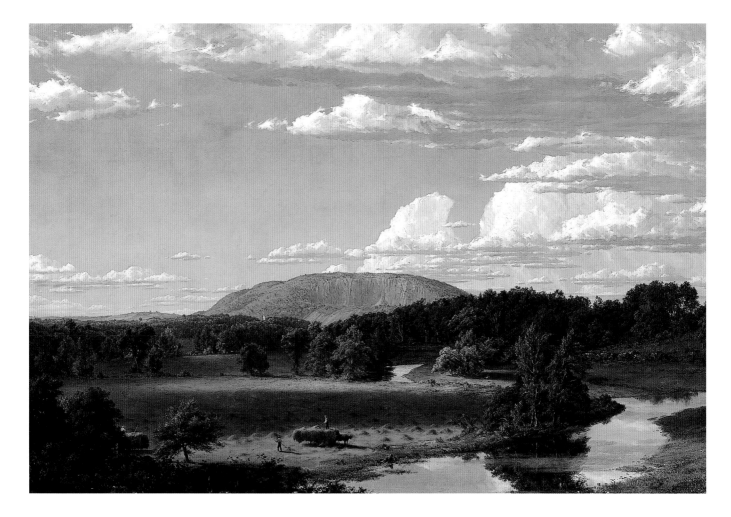

Brian T. Allen

Fig. 3. Thomas Cole (American, 1801–1848), *View of Boston*, 1839. Oil on canvas, 34 × 47⅛ inches (86.4 × 119.7 cm). Private collection

Church's Jerusalem painting was also intended to reference his mentor Cole's own distanced cityscape of Boston from more than thirty years earlier (fig. 3), thus invoking two promised lands, one of the past and one of the present. Seen with these paintings in mind, *Jerusalem from the Mount of Olives* works as an effective summation of Church's career, a reprise of the theme of the Promised Land he had first broached more than a generation earlier and that had preoccupied his master as well. Given the centrality of Promised Land imagery in Protestant thought from the time of the Puritans to Cole's and Church's eras, it is difficult to consider Church's treatment of Jerusalem as an effort to cope with otherness. Thus the application of Saidian Orientalism seems inappropriate. An argument could be made that Church's work asserted a kind of ownership of Jerusalem, something strange and foreign, because of his great attention to topography. This is a difficult argument given the role of Jerusalem as a central part of the fabric of Puritanism since its inception. Jerusalem was not foreign but, rather, the physical heart of the Puritan past.

Thinking of *Jerusalem from the Mount of Olives* in terms of juxtapositions also places it more comfortably with the rest of Church's major paintings from the 1870s stemming from his Near Eastern trip, including his other major cityscape of the period, the destroyed *Damascus from the Heights of Salchiyeh*. Known through surviving oil sketches and drawings, this painting also depicted a city featured in both the Old and New Testaments and described by Mark Twain as having "seen all that has ever occurred on earth, and still she lives."[19] Both cityscapes should be seen as juxtapositions against paintings from the same period that depicted pagan ruins, such as *Classical Ruins, Syria*

(1868; Cooper-Hewitt National Design Museum, New York) or *Sunrise in Syria* (1874; cat. no. 3).

The theme of durable values transcending time and failed values leading to ruin and loss seems strong in this group of late paintings. *Anti-Lebanon* (1868), for example, was described by a critic from the *Chicago Tribune* as "so lonely and so sad, that but for the glow of its evening sky, 'twould have called no color from the palette, save sombre grays; and no emotion beyond sighs."[20] The moral didactic is more closely reflected in *El Khasné, Petra* (1874; fig. 4), which still adorns Church's home at Olana. Viewed through a break in the rocks that works as a curtain drawn, the old temple was thought to have been in biblical Edom, a city destroyed by God because of the corruption of its inhabitants. On the one hand, Church used these scenes to explore the failures of the past, something the *New York Herald* recognized when it dubbed Church's Near East paintings "sermons that lie hidden in stones."[21]

On the other hand, while some of these works are deeply expressive of a loss of promise, a failure in values, others explore the endurance of timeless spiritual truths that are ecumenical rather than defined by narrow religious sects. Church's cityscape of Jerusalem is one such painting. Its accompanying key specifically alludes to ancient mosques as well as to old Christian churches, and the view Church selected suggests that he affirmatively intended to highlight both. For religious conservatives such as Church, classical Islam could be removed from the present and rehabilitated as a spirituality not necessarily superior to Christianity but evocative of the simpler, purer values the artist might have felt contemporary Americans were abandoning on the eve of the Gilded Age. Church's Orientalism effectively isolates the Islamic world from history and packages it as a timeless slice of spiritual simplicity—and in this case he satisfies a significant aspect of Orientalism as defined by Edward Said, although the exoticism of the Near East is not so much enhanced by Church as it is co-opted as part of the history of the American experience.

A less religious American landscapist working in Church's era would look at the Near Eastern landscape and find nothing but trouble. "It is useless for me to attempt such things without plenty of time," Church's friend Sanford Gifford wrote of paintings of Near Eastern subjects drawn from his travels there. "I have long since given up the expectation of making anything of the East."[22] Gifford was, in contrast with Church, a galloping secularist, a Unitarian, a believer in life on other planets, and almost anti-historical in his approach to landscape.[23] Jerusalem or Syrian ruins did not have great didactic appeal for him, though in 1880 he painted the magnificent *Ruins of the Parthenon,* his last major picture.

The desert landscape might have proven a major challenge, though given the predisposition of Luminists toward airless silence and strong horizontals, the Near East should have provided fruitful subject matter. On the one hand, Gifford as a colorist was the hottest of the American Luminists, an artist whose preference for what Earl Powell called "warm spectral colors" gave his paintings an evocatively smooth and smoky silence.[24] He worshiped what one of his eulogists called "an effulgence of irruptive and glowing light,"[25] yet the dryness and power of Egyptian light might have abstracted landscape forms in a way too foreign for Gifford to capture. Gifford, for example, normally thrived when painting the fiery effects of twilight on heavily wooded mountains. This was a feature unrepresented in the Near East, which simply could not offer the wooded landscape bowls he loved to paint.

This is not to say that his handful of Near Eastern paintings are unsuccessful. Rather,

Fig. 4. Frederic Edwin Church, *El Khasné, Petra*, 1874.
Oil on canvas, 60½ × 50¼ inches (153.7 × 127.6 cm).
New York State Office of Parks, Recreation and
Historic Preservation. Olana State Historic Site

they are exceptionally beautiful, his most rigorously abstract designs. In terms of the
format of parallel horizontals Gifford used in *On the Nile* (cat. no. 16), for instance, and
the pervasive silence of this painting and the others he produced as a result of his Near
Eastern travels, these paintings are arch-Luminist. In these respects his Near Eastern
works are close to Martin Johnson Heade's disciplined marsh scenes or the heavily hori-
zontal seascapes of Fitz Hugh Lane or John Kensett.

Church and Gifford worked in an American landscape idiom, and neither had Euro-
pean training. Quite a different approach appears in the work of Edwin Lord Weeks.
Three paintings by Weeks both confirm and challenge the existence of an Orientalist
discourse in American painting as outlined in Said's *Orientalism.* Gerald Ackerman
considered Weeks "the most famous American Orientalist,"[26] and this is probably cor-
rect, though only a portion of Weeks's production concerned the Near East or the Mid-
dle East, and much of his work depicted life in India. Born in Newton, Massachusetts,
in 1849 and encouraged by his affluent parents to study art, by 1872 the artist was visit-
ing Morocco, Egypt, Palestine, and Syria. He was a student of the French realist painter
Léon Bonnat (1833–1922), but even prior to his entry into Bonnat's atelier Weeks seemed
committed to painting Near Eastern subject matter. In the 1880s and 1890s, Weeks trav-
eled extensively in North Africa, Turkey, present-day Iran, and India, with each stop
represented prodigiously both in paintings and in travelogue-style writing.

Can *The Arab Gunsmith* (fig. 5), a wonderful, exciting painting from the middle of
Weeks's career and a period during which his work was of the highest quality, be read as
an expression of Saidian Orientalism? Can we say that Weeks's picture shows no ante-
rior reality but, rather, a selective composite of images designed to advance a culture-

Fig. 5. Edwin Lord Weeks (American, 1849–1903), *The Arab Gunsmith*, c. 1880. Oil on canvas, 27 × 32 inches (68.6 × 81.3 cm). Courtesy Vance Jordan Fine Art, New York

wide agenda? No, we can't. Possibly Weeks chose the scene to emphasize the archaicism of Near Eastern production of guns, since by the 1880s almost all American guns were made not in small forges but in bustling factories, but this is a stretch if we look at it more objectively.

Rather than depict figures that are depraved, fallen, feminine, or lazy, Weeks gives us a collection of men, all of whom are black, virile, dynamic, armed and, because of their "otherness" (both racially as well as culturally), potentially dangerous. Perhaps we can argue that the painting frankly considers the perils the exotic "other" can pose. Yet a close look at the painting hardly shows a denigrating archaicism. The method of production is slow but nonetheless efficient. The painting in fact depicts something akin to an assembly line, with one gun fashioned at the forge, another inspected by the entry to the forge, possibly by another craftsman, a third demonstrated to an attentive onlooker, and the fourth held by a man on horseback who seems ready to go shooting. It is not about weakness and depravity but strength, productivity, and purpose.

The exact terms of the dangers of Islamic otherness are more clearly seen in Weeks's dramatic and impressive *Interior of the Mosque at Cordova* (1880; cat. no. 10). When the painting was sold at Weeks's death in 1905, it was described in the auction catalogue as follows:

Preaching the holy war against the Christians, the old Moor holds aloft the green flag of Mohammed, while he curses the "dogs of Christians" with true religious

fervor, and calls on Mohammed to drive them out of Spain. The devout audience, kneeling facing the shrine, composed of all classes of Moors, rich and poor, as well as soldiers in armor, is probably an ideal and almost photographic view of the Mosque of Cordova as it was at the beginning of the downfall of Moorish power in Spain. The entrance to the shrine is most artistic, composed of many-colored glass mosaics, with texts from the Koran set in. Down the long vista of arches the crowd of worshippers gives one some idea of the enormous size of this mosque, that stands to-day an imposing monument of the grandeur and power of the Moors several hundred years ago.[27]

What we are seeing in *Mosque at Cordova* is a scene familiar to most contemporary American television viewers or newspaper readers: an Islamic religious leader exhorting his followers to fight and to resist the Christian (or Western) menace at all costs. It strikes an unsettling chord today for Anglo viewers and certainly did so in the nineteenth century, when views of Islam as an especially pernicious, tyrannical, and despotic form of anti-Christianity were widely held in America. Islam was considered by many American religious fundamentalists as a collection of false values driven by fanaticism, aggression, and a vicious disregard for civic virtue. It is true that this continuity of representation, from Weeks's painting to television's *Nightline,* could be seen not as proof of the reality of Islamic fanaticism and hostility but as a continuity of Western representation and fantasy that confirms Said's own theories.

Yet the notion of Weeks's overarching ideological preoccupation with the dangers of otherness posed in both of these paintings is easily undermined if we are less selective and more inclusive. Weeks also painted *Blacksmith's Shop at Tangiers* (fig. 6), where the only danger would seem to be the possibility of a kicking horse. Is the scene primitive?

Fig. 6. Edwin Lord Weeks, *Blacksmith's Shop at Tangiers,* 1876. Oil on canvas, 34 × 58½ inches (86.4 × 148.6 cm). Private collection, courtesy Vance Jordan Fine Art, New York

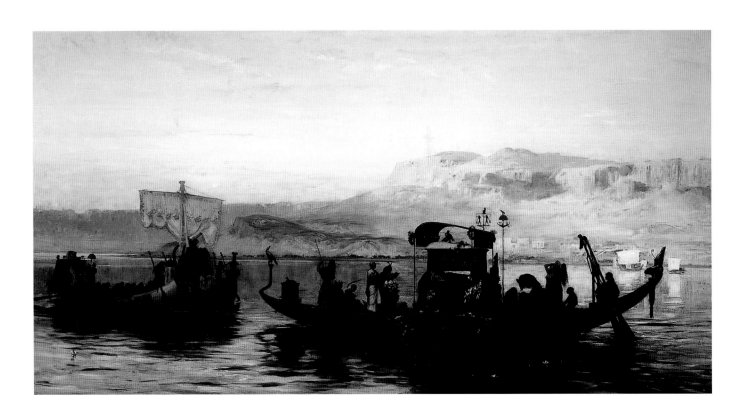

Fig. 7. Frederick Arthur Bridgman, *The Funeral of the Mummy*, 1877. Oil on canvas, 32⅞ × 62¾ inches (83.5 × 159.3 cm). Private collection, courtesy Berry-Hill Galleries, Inc.

It is difficult to say that it is pejoratively so, and it is difficult to say that it is unrealistic or that it reflects no objective reality of the kind Said and scholars most influenced by his work insist Orientalist painting lacks. *Blacksmith's Shop at Tangiers* and *The Arab Gunsmith* also feature something that would seem lacking in Orientalist painting if we embrace Saidian scholarship: men at work.[28] Granted, we do not find in the painting of Weeks or any other Orientalist a consistent celebration of Islamic industry or ingenuity, though paintings such as *The Arab Gunsmith* posit both demanding and discerning consumers and responsive suppliers united by manufactured goods.

Another ingredient missing in Weeks's work that makes it less than ideological is the harem. Joanna de Groot has shown the extent to which Islamic societies were represented "by reference to the way in which women were treated, by descriptions of the laws and customs affecting women, by references to polygamy, veiling, and the seclusion of women, or by fascinating anecdotes of harems, dancing-girls, and sexual encounters."[29] These are exactly the types of subjects that do not appear at all in the work of Weeks, "the most famous American Orientalist." The discourse of control or possession at the heart of Saidian Orientalism is difficult to find if we use gender as its vocabulary. Bridgman in fact comes closest to espousing the Orientalist ideologies outlined by Said and others, though for many reasons the ideologies are weakly expressed. During his two years in Gérôme's atelier, Bridgman was an exceptional student—industrious, conscientious, talented, and attentive, perhaps too attentive since he was often identified with his master's work.[30]

Like Irving and Weeks before him, Bridgman's first practical experience with oriental subject matter was through Spain. In 1872 and again in 1873, Bridgman stayed in Ustariz-près-Bayonne, in southwestern France near the Spanish border. During the winters of both years, he traveled throughout Spain, and the experience changed his work by providing a very different type of light from what he had known in Paris or Breton as well as his introduction to North African subject matter, as Bridgman visited Córdoba and Granada. His visits also intensified his experience with the work of the

Spanish painter Mariano Fortuny (1838–1874), who in the 1860s was considered a dazzling and original artist. Bridgman regarded Fortuny as "a comet" among contemporary artists and, despising Impressionism as he did, saw Fortuny's saturated colors and free handling of paint as the antidote to academic technique.[31]

The critic Edward Shinn identified Fortuny's influence in Bridgman's work,[32] and certainly Fortuny's miniaturist sparkle and dazzling colors were visible guideposts for the young American. But Fortuny's example might have worked in another key way as well. Edward Sullivan has indicated that Fortuny's approach to the Islamic world may have been more candid and naturalistic than many of his French contemporaries because the Islamic world was so integral a part of the development of Spanish culture. Fortuny's Spanishness allowed him to approach the Islamic world with a deep affinity for its significance in his own past.[33] Fortuny's special Spanish brand of Orientalism quite possibly encouraged Bridgman to move from a slavish devotion to Gérôme to an interpretation of the Orient colored by Bridgman's own American heritage.

By the late 1870s, Bridgman had become known as a classicizing Orientalist whose paintings of historical scenes in period architecture established his reputation. *The Funeral of the Mummy* (1877; fig. 7), his first major Salon success, depicts an ancient Egyptian funeral in Luxor.[34] The historical scene itself might have left some American critics curiously nonplussed as they preferred to emphasize Bridgman's achievements in the painting in terms of its landscape. Lucy Hopper found it "redolent in the warm glow of a tropical sunset,"[35] while Shinn felt its success was as "a masterpiece of landscape" whose secondary interest was its archaeological content.[36] But the combination of the flowing river and the antiquity of the scene depicted could not be ignored, as is evident in the poem by George Ferrars that was written in response to the painting:

Down the silent, sacred stream,
Slow, with muffled oar doth float,
Freighted with the dead, a boat,
Dusky forms upon it seem
Like strange figures in a dream,
As they float.

Far away the river vast
Gleams like burnished silver pale
Pale as that pure sky whose veil
Seems upon the water cast;
On the long, low hills the last
Red gleams fall.

Kneeling women, crouching low,
Loosened locks of wild, black hair
Streaming o'er their bosoms bare
Beat their dusky breasts in woe,
Lift their dirge with wailing slow
Through the air.

Down the ancient stream have gone
Countless boats as mournfully

> *Loud lament and agony*
> *Countless times have made their moan*
> *But the river flows on*
> *To the sea.*[37]

The world Bridgman depicted as an Orientalist is funereal in more than subject matter. The entire tone of Ferrars's poem situates the Near East as removed from the Western world of progress, time consciousness, materialism, and industrialism. This is certainly a recurring theme in *Winters in Algeria,* Bridgman's 1890 travelogue and autobiography describing his career as a painter of Near Eastern subjects.[38] The book is a useful resource in understanding his paintings and suggests Bridgman's point of view in approaching the Near East.

The litany of denigrating observations in *Winters in Algeria* is designed to define the otherness of the Orient in terms that are very Saidian. Arabs never keep appointments because they are not governed by time.[39] "Among the pure-blooded Algernines you must not expect to find me of a business turn of mind, strictly speaking," he writes, describing the Arab economy as "a long struggle between poverty and misery."[40] The Arab judicial system is characterized by "the quarrelsome, suspicious, and vindictive nature of the Arab people and operated largely on the basis of bribes."[41] Women are ruled by "the incongruity and inconsistency of superstition,"[42] and "women's rights have not been heard of here."[43] Christian missionaries are still butchered regularly, he reports.[44] While Bridgman frequently refers to the richness and exoticism of the landscape, his overall approach in the book emphasizes the archaicism of the Islamic Orient and its primitivism in contrast to the West.

Bridgman's emphasis on the otherness of the Near East in *Winters in Algeria* possibly explains why, in contrast with Church, there is so little religious feeling in paintings such as *The Funeral of the Mummy.* Church's Near Eastern paintings depict scenes explicitly connected with the Bible. Bridgman's historical and archaeological paintings are tangentially related to the Bible in the sense that they depict Egypt or, as in *Divertissement d'un roi assyrien,* ancient Assyria—this at a time when the Englishman George Smith was gathering international headlines for his search of the area for ancient tablets and scrolls thought to contain firsthand accounts of the Deluge. Yet there is a distinct difference between Bridgman's deployment of Egyptomania or Assyriamania if we consider his mummy funeral scene and its evocation of a dead, antimodern past, and Church's roughly contemporaneous use of the Near East to explicate deep religious views.

Of all the American Orientalists, Bridgman concentrates most heavily on the Islamic woman. By the late eighteenth century, Reina Lewis has found, "the licentious sexuality that had previously been regarded as the propensity of all women now came to function as a division between women in which the construction of the middle-class woman as innately chaste and asexual was countered by the attribution of a virulent, rapacious, unchristian sexuality to working-class women at home and all women in the colonies."[45] Depictions of beautiful Near Eastern women, both reposed and exposed—the odalisque— began to appear in substantial numbers in travelogue engravings and paintings by the first decade of the nineteenth century.[46]

One obvious difference between the Americans and the French is that neither Bridgman nor Weeks ever attempted, as Linda Nochlin stated of Gérôme, to convince viewers that there was no artifice to their representations of the Orient. Nochlin argues that Gérôme's tight, glassy style, in which all evidence of the artist disappears, was designed

to enhance the realism of the work and give it a "dauntingly objective and scientific" look.[47] This look was suitable to an Orientalist discourse in which the semblance of precision was a convincing veneer atop an aggrandizing campaign of denigration. In contrast, both Weeks and Bridgman were highly painterly, and in their finished works there is ample evidence of their lifelong commitment to spontaneous sketching.

There are other differences between the Americans and the French. *The Bath* (cat. no. 7) is a most instructive example and is more typical of Bridgman's oeuvre in its inclusion of mother and child. Instead of free sexuality, Bridgman offers us the domesticity of a crypto-bourgeois home, a sphere where women are autonomous and where themes of submission to men are difficult to find. The painting thus can be seen to neutralize the intense sexual charge of the harem or the bath present in many French paintings, removing the erotic charge from both sites as it had been interpreted by French artists from Ingres to Gérôme. *The Bath* could be seen as offering no sexual intrigue or sense of confinement at all but, rather, the ordered doings of a domestic scene, a geographically varied version of similar works by John George Brown or even Lily Martin Spencer or Mary Cassatt in which women are presented not only as practically engaged in the everyday affairs of life but as functionally independent in their efforts and spheres.[48]

Bridgman's Orientalism certainly more closely resembles works by British artists John Frederick Lewis and Frederick Goodall, both of whom indulged sexual fantasies less explicitly in their Orientalist paintings and tended to present Islamic women in bourgeois Victorian terms.[49] I would argue that Bridgman did this in *The Siesta* (cat. no. 6), which can be read as merely a sanitized version of Gérôme's or Ingres's odalisques. Bridgman clothed the figure, but this concession to modesty itself is important because it undermines "the fantasy of absolute possession of women's naked bodies," makes the "delicious humiliation" of Gérôme's subjects more obliquely rendered, and challenges the assumption that Near Eastern women are "innocents, trapped against their will . . . their nakedness more to be pitied than censured."[50] At the same time that Bridgman clothed his oriental women, he also often depicted them without veils, helping to demystify them and denying the viewer the frisson arising from sexuality that is simultaneously offered and then barred.[51] Also absent in Bridgman's oeuvre is the slave scene, a staple in French Orientalism. It might not have been politically correct in post–Civil War America, but that would have been all the more reason for Bridgman to depict the subject if his goal was critique and contrast.

The Bath is more closely pitched to American audiences, elevating as it does the Islamic woman to the status of doting mother. In this sense, the painting is hardly eligible for a Saidian analysis. It owes its domestic slant not to any interpretation particular to the Near East but, rather, to the huge popularity in postwar America of paintings of women and children, Eastern and Western, by Winslow Homer, John George Brown, Eastman Johnson, and a range of other Americans working in America at the same time as Bridgman. When Rana Kabbani wrote that Orientalist painters depicted Near Eastern women who "hardly perform any duty at all" but "simply prepare and adorn themselves for the absent male, and they wait," she was not looking at Bridgman's place in the context of other American artists painting very similar works using not Islamic but American women.[52]

The two paintings are fundamentally similar in impulse in that they both offer versions of the Islamic woman as "a pretty object to be enjoyed by her man and then locked up in a domestic cage when he leaves home to go out into the world."[53] Ilene Fort has seen Bridgman's Orientalism in this respect as a presentation not as "the Other but

the Familiar—that is, a simpler, more natural society similar to England and the United States before modern industrialism upset social and gender roles."[54] She argues convincingly that Bridgman presented the Orient as a nostalgic example of a society where women were firmly consigned to the domestic sphere.

This is a very appropriate point on which I would expand slightly. Bridgman's depiction of Near Eastern motherhood was possibly more than a nostalgic fantasy; instead, among bourgeois families in the United States in the 1870s and 1880s, it was an everyday norm. Moreover, it does not strictly constitute Saidian Orientalism since the subjects of mother and child or, for that matter, the sleeping woman, are as old as Western painting itself and have appeared in every century and in virtually every culture, enlisting both foreign and domestic subjects.

In conclusion, I would observe again that the variety and nuancing of subject matter portrayed by American Orientalists make it difficult to impose specific ideologies on their painting. Most would have understood the great differences between their culture and the Islamic culture they depicted and probably felt their own culture superior in many measures. Yet their basic impulse seems to have been to make the Islamic world more familiar rather than more exotic or even inferior through their concentration on its connection to American spiritual traditions and their view of Islamic subjects through the lens of American iconographic traditions.

The title quote originally appeared as follows in the newspaper *The Emerald,* 21 March 1807, 140: "We have often to admire the morality of the eastern fable; when judiciously contrived, it borrows the garments of instruction from the wardrobe of pleasure, and engages the mind in the contemplation of a principle, or impresses the force of some important truth, when the object of the reader was merely to occupy an idle hour in the most free and desultory reflections."

1. Said 1978, 38–40.

2. Ibid., 92.

3. Ibid., 2.

4. Ibid., 1.

5. Lewis 1996, 4.

6. See generally, Friedman 1981, 62–69, for earlier misrepresentations of Islamic society that influenced Puritan constructions.

7. Marr 1998, 22–42.

8. See generally, Carrithers 1982 and Thomson 1987.

9. See Barnby 1979.

10. Marr 1998, 102.

11. Irving began his consideration of Islamic subjects in *Salmagundi,* the 1807–8 series of burlesque-type vignettes in which Mustapha Rub-a-Dub Keli Khan figures. Mustapha marvels at the freedom of American women and finds American political institutions mystifying because he has been acculturated to despotism. *The Alhambra* (1832) was preceded by *A Chronicle of the Conquest of Granada* (1829), a romantic history that traced the events leading to the collapse of Moorish rule in Spain in 1492. One of his final major projects was the two volume *Lives of Mahomet and His Successors* published in 1849 and 1850.

12. Weber 1982, 299. For a history of the Black Legend, see Powell 1971.

13. "Legend of the Three Princesses," in Irving 1832, 936.

14. "Palace of the Alhambra," in ibid., 759.

15. In his private notes, Irving compared the ancient Romans and the Moors as equals. See Irving 1829.

16. Davis 1996, 24.

17. Parry 1988, 143–44.

18. Thompson 1871, 36.

19. Twain 1872, 331.

20. "Church's Pictures" 1869.

21. See "Academy of Design" 1874.

22. Gifford, April 25, 1869, Archives of American Art, Washington, D.C., roll D-21.

23. Weiss 1987, chap. 2. Worthington Whittredge quoted him as saying that "no historical or legendary interest attached to the landscape could help the landscape painter," in ibid., 165.

24. Earl A. Powell, "Luminism and the American Sublime," in Wilmerding 1989, 86.

25. John Ferguson Weir, "Address, Sanford R. Gifford Memorial Meeting, The Century," quoted in Cikovsky 1970, 16.

26. Ackerman 1994a, 234.

27. American Art Association 1905, n.p.

28. See generally, Ackerman 1986a, 78.

29. De Groot 1989, 104. All of these, de Groot argued, "provided powerful evidence of the 'Otherness' of the Orient."

30. Ilene Susan Fort describes Bridgman's experiences as Gérôme's student in Fort 1990, 6.

31. Bridgman 1898, 55–56, 67–68.

32. Shinn 1881, 71.

33. Sullivan 1981, 97.

34. Other Egyptian historical genre scenes were *Fete in the Palace of Rameses* (1877), *Ancient Egyptian Priest Descending the Steps of the Temple* (1878), *Egyptian Fete, House of Rameses II* (1878), and *Procession of the Bull Apis* (1879), which depicted an event that occurred in the time of Rameses III.

35. Hopper 1877, 283.

36. Shinn 1881, 71. Ilene Fort has successfully identified Bridgman's source for the painting as Charles Gleyre's *Le Soir* (1843), a twilight scene depicting a boat on a river, possibly the Nile, which Gleyre had visited in 1835. Fort 1990, 146.

37. George Ferrars, "Burial of an Egyptian Mummy," *Lippincott's Magazine;* reprinted in *Art Interchange* 6 (17 March 1881): 58.

38. Bridgman 1890.

39. Ibid., 4–7.

40. Ibid., 47–48.

41. Ibid., 76.

42. Ibid., 43.

43. Ibid.

44. Ibid., 34–35.

45. Lewis 1996, 54.

46. Fort 1983, 44–45.

47. Nochlin 1983, 122.

48. Reina Lewis has written that British women artists were among the first to "desexualize the harem" by presenting settings such as the bath or the harem as populated not by "half-clothed somnolent women and desirable consumer durables" but by women who live in "a calm and austere social space, marked by relations among the women" and "a social realm, its walls regularly penetrated by visitors, friends, and musicians from the outside." Lewis 1996, 148–49.

49. Fort 1983, 46. Reina Lewis argues that "instead of explicit sexual fantasies, British Orientalism concerned itself with the anthropological chronicling of lives and customs with an emphasis on exotica and difference" (Lewis 1996, 111).

50. These are the features of French Orientalist painting identified in Nochlin 1983, 125.

51. Fort 1990, 225.

52. Kabbani 1986, 60.

53. Fort 1983, 45.

54. Ibid.

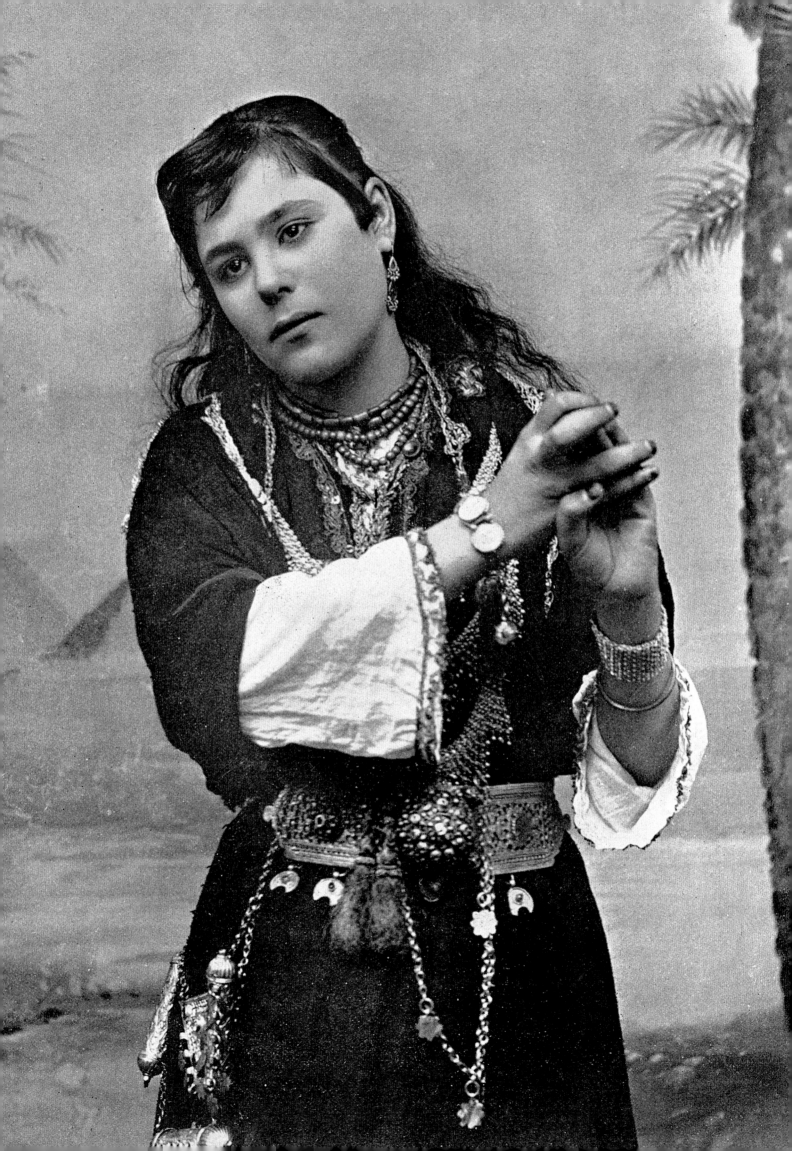

Speaking Back to Orientalist Discourse at the World's Columbian Exposition

Zeynep Çelik

*E*xoticism, the dominating theme among late nineteenth-century American perceptions of the "Orient," owed a great deal to the "authentic" sets designed for the World's Fairs and peopled by true "natives." Islamic countries were brought to North America and represented according to the successful formulas and the titillating clichés already rehearsed in the fairs held in European capitals. The aura of the *Thousand and One Nights* was complete and enduring. Nevertheless, the story is more complicated. If the displays catered to the populist expectations and reiterated them at large, they also included oppositional perspectives to challenge Orientalist constructions—the latter totally lost amidst the glitter of the former. Focusing on Ottoman representation in the World's Columbian Exposition, this essay begins to introduce some of the unheard but highly articulate voices that coexisted with and contradicted the more popular ones.

The Ottoman participation in the World's Columbian Exposition, held in Chicago in 1893, was an ambitious enterprise. Capitalizing upon the wisdom and know-how acquired in the previous universal exhibitions held in Europe since the mid-nineteenth century, the Ottoman Empire staged a multifaceted display for the New World. The main building (fig. 1), situated among the national pavilions in Jackson Park, was a sophisticated interpretation of the Sultan Ahmed fountain, an early-eighteenth-century landmark in Istanbul. While its overhanging roof and exterior wall, which consisted of intricately carved wood panels, referred to Ottoman forms, the placement of a horizontal band of windows right under the roof and the planar treatment of the orthogonal panels endowed it with a tone of modernity. Here, "the most delicate and expensive manufactures of the Turkish countries, . . . silk and needlework, gold and silver, embroidery, pipes, jewelry, soaps, and perfumes," were exhibited. The centerpiece was the reconstruction of an Ottoman living room, complete with surrounding couches covered by rare rugs, silk draperies hanging from walls, and carved teakwood tables scattered on the carpets on the floor (fig. 2). Imbued with a particular "sense of elegance and luxury" that "might have surprised even Edgar Allan Poe," this room was considered "quite as Oriental as if it was not the distance of half a globe from its origin."[1]

The specialized buildings of the fair were dotted with Ottoman displays as well. The Transportation Building, for example, received several caïques and other boats constructed at the Admiralty in Istanbul, as well as a display of the "street carriers" that consisted of humans and mules (fig. 3).[2] The Ottoman practice of using human labor for transportation, a much-criticized curiosity at the fair, included carrying "rich people" in sedan chairs and boxes, as well as "immense loads" that were "said to be no exaggeration of what they were in the habit of transporting even considerable distances" at home.[3] A large quantity of agricultural produce from the Bursa region was exhibited in the Agriculture Building, and industrial products in the Manufactures and Liberal Arts Building. The Ottoman Administration of Mines and Forests sent specimens of "all kinds of wood for carpenters and cabinetmakers produced in the Empire," destined for the Mines Building.[4]

"An Odalisque from the Seraglio," 1893 (detail of cat. no. 45E)

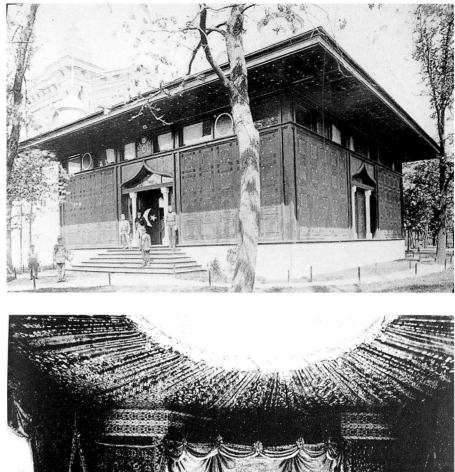

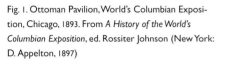

The populist Ottoman displays were on the Midway, the fabled artery where entertainment intermingled with the more curious aspects of foreign cultures. Tucked away from the main fairgrounds and placed behind the Woman's Building, the Midway projected a chaotic image in contrast to the self-conscious order and elegance of the "White City." Here, the "Turkish Village" offered a "business street of Constantinople," with a row of booths that constituted the "bazaar," a restaurant, and a theater, and a wooden replica of the obelisk that stood in the Hippodrome (fig. 4). Nearby, next to the theater were a "Palace of Damascus" and a "Camp of Damascus," the former representing the residential domain of "rich Turks," and the latter the living conditions of tribal people. The marble palace, reduced to a main room, opened onto a court with a fountain; it was decorated with wall hangings, a divan, and teakwood tables (fig. 5). The tent exhibited the "simple furnishings and necessary utensils of a camp life" (fig. 6). Both staged "authentic" activities for visitors. For example, the palace turned into the setting of a daily "oriental wedding ceremony," whereas the tent was permanently peopled with Arabs in "traditional" costumes, "squatting about as at home" and smoking their

narghiles.[5] Bedouin scenes, set specifically to represent the "nomadic Ismaelites of the Syrian desert," were completed by a troop of forty Arab horsemen, who were transported to Chicago together with their "pure Arab steeds." They held races on the hippodrome, another component of the Ottoman exhibits.[6]

Ottoman subjects in indigenous costumes crowded all the spaces on the fairgrounds and participated in diverse activities, from the Manhattan Day procession to honor New York to demonstrations of the efficiency of the "Turkish fire engines," carried on the shoulders of four firemen every day on the Midway.[7] In the words of an American observer, Ben Truman, the theater brought to Chicago "Eighteen *houris* of the Orient, and sixty-five men . . . picked up from the companies of Constantinople, who dance,

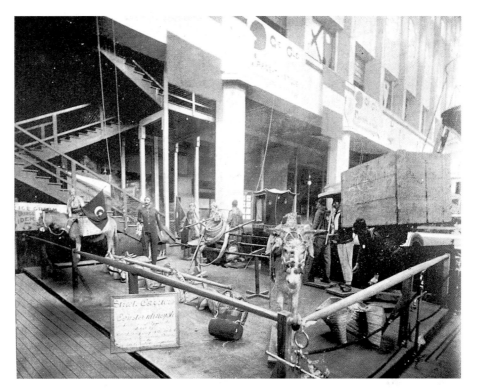

Fig. 3. Ottoman display in the Transportation Building, World's Columbian Exposition. From *The Vanishing City: A Photographic Encyclopedia of the World's Columbian Exposition* (Chicago: Laird & Lee, 1893)

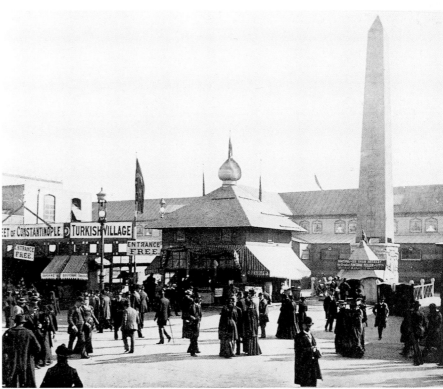

Fig. 4. Turkish Village, World's Columbian Exposition. From *The Vanishing City: A Photographic Encyclopedia of the World's Columbian Exposition* (Chicago: Laird & Lee, 1893)

Speaking Back to Orientalist Discourse

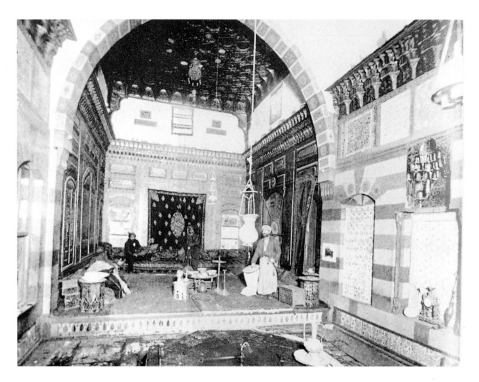

Fig. 5. Palace of Damascus, World's Columbian Exposition. From *The Vanishing City: A Photographic Encyclopedia of the World's Columbian Exposition* (Chicago: Laird & Lee, 1893)

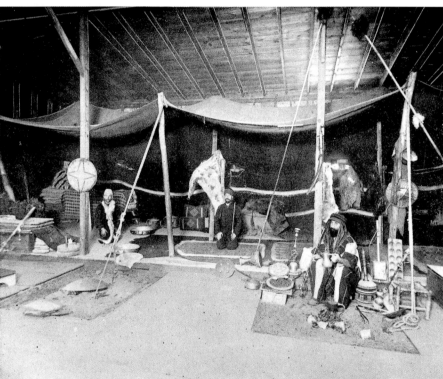

Fig. 6. Camp of Damascus, World's Columbian Exposition. From *A History of the World's Columbian Exposition*, ed. Rossiter Johnson (New York: D. Appelton, 1897)

play, sing, and form an orchestra, a stock company, and a chorus. The complement is fully made-up, and there are soubrettes in baggy trousers, heavy tragedy in fez, and low comedy in a turban."[8] The music played in the theater contributed to the creation of an authentic atmosphere, albeit "bizarre," "strange," and even "irritating." Truman described it as "mournful, weird, plaintive, and funereal by turns—never lively or rhythmical; yet, when floating out from a latticed window or portiered doorway, not entirely unenchanting."[9]

The theater also capitalized on an entertainment form that had become indispensable at the previous Parisian universal exhibitions: the belly dance. The press reported on the new obsession regularly, often in an ironic tone. The *Chicago Tribune* declared,

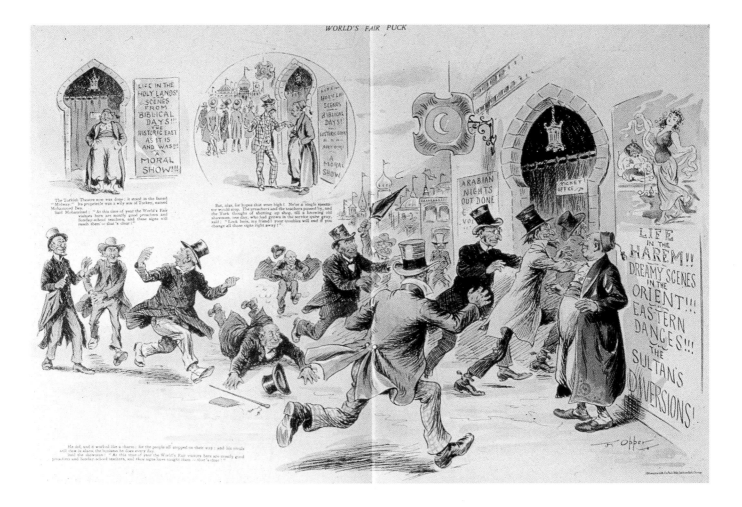

Fig. 7. Cartoon from *World's Fair Puck*, 4 September 1893

tongue-in-cheek, that "the soiled devotees of Constantinople and Cairo corrupted western morals by the seductive allurements of the danse-du-ventre."[10] A cartoon, titled "Human Natur" and published in *World's Fair Puck*, effectively summarized the popularity the belly dance found in Chicago, as well as its business potential: changing his original and financially unsuccessful display intended for good Christians, "Life in the Holy Lands: Scenes from Biblical Days . . . A Moral Show," to "Life in the Harem. Dreamy Scenes in the Orient. Eastern Dances. The Sultans Diversions," a Turkish entrepreneur managed to attract great crowds to his booth (fig. 7).

The belly dance constituted an intriguing aspect in the construction of the image of Muslim women, based on highly sexualized clichés. By 1893, this image stood as one of the main signifiers of Islamic cultures and societies, together with that of the reclining odalisque (figs. 8, 9). It was also toward the end of the century that the Ottoman intelligentsia began to analyze the image of the Muslim woman in an attempt to show the misconceptions it embodied. Ahmet Mithat, a prominent writer, captured the Ingresque formula to indicate the epistemological status the representation had achieved:

> [This] lovable person lies negligently on a sofa. One of her slippers, embroidered
> with pearls, is on the floor, while the other is on the tip of her toes. Since her gar-
> ments are intended to ornament rather than to conceal [her body], her legs dan-
> gling from the sofa are half-naked and her belly and breasts are covered by fabrics
> as thin and transparent as a dream. Her disheveled hair over her nude shoulders
> falls down in waves. . . . In her mouth is the black end of the pipe of a narghile,
> curving like a snake. . . . A black servant fans her. . . . This is the Eastern woman
> Europe depicted until now. . . . It is assumed that this body is not the mistress of

Speaking Back to Orientalist Discourse

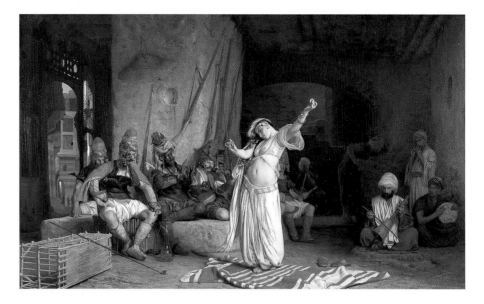

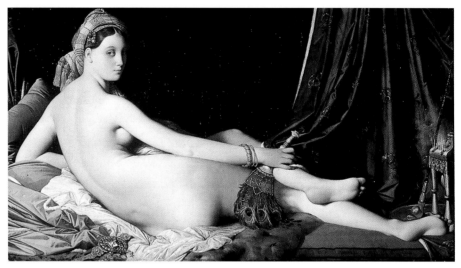

Fig. 8. Jean-Léon Gérôme, *Dance of the Almeh*, 1863. Oil on panel, 19¾ × 32 inches (50.2 × 81.3 cm). The Dayton Art Institute. Gift of Mr. Robert Badenhop

Fig. 9. Jean-Auguste-Dominique Ingres, *The Grand Oda-lisque*, 1814. Oil on canvas, 35¾ × 63¾ inches (91 × 162 cm). Musée du Louvre, Paris

her house, the wife of her husband, and the mother of her children, but only a ser-vant to the pleasures of the man who owns the house. What a misconception![11]

The eminent Ottoman artist Osman Hamdi reinforced Ahmet Mithat's argument in his paintings.[12] Educated in Paris in the atelier of Gustave Boulanger and possibly also of Jean-Léon Gérôme, Osman Hamdi's work matured under the technical and thematic influence of the French Orientalist school. Nevertheless, his "scenes from the Orient" provide acute and persistent critiques of mainstream Orientalist paintings. They repre-sent a resistant voice whose power derives from the painter's position as an Ottoman intellectual as well as from his intimate acquaintance with the school's mental frame-work, techniques, and conventions. Osman Hamdi thus addressed the major themes of Orientalist painters from his critical stand as an insider within the outside. His reper-toire of women, both in public and domestic spaces, makes a statement about their sta-tus in the society. Dressed in elegant and fashionable clothes, they are shown moving freely in the city.

Osman Hamdi's home scenes provide a striking alternative to the myriad familiar and titillating views of harem and bath by Orientalist painters. Several of his works, among them *The Coffee Corner* (1879) and *After the Iftar* (1886; fig. 10), depict a couple in a tranquil domestic environment, the seated man being served coffee by the woman. While the hierarchical family structure is not questioned, the man of the house is not

the omnipotent tyrant of European representations, enjoying his dominion over scores of women at his mercy and pleasure. Instead, a dialogue is offered that redefines the gender relationships in Orientalist paintings. Osman Hamdi's reaction to Orientalism's innumerable reclining odalisques is *Girl Reading* (c. 1893; fig. 11). The painting shows a young woman stretched out on a sofa, totally immersed in a book. Her relaxed and casual tone implies that she is not reading a religious text but most likely a work of literature. The composition has the familiar collage of Orientalist details, complete with rugs, tiles, inscriptions, and "Islamic" architectural fragments, but the alcove in the background is filled with books, making a statement that reading occupies an important part of her life. The girl is thus given back her thinking mind and intellectual life, which had been erased by Orientalist painters.

In the intellectual climate created by prominent figures such as Ahmet Mithat and Osman Hamdi, the Ottoman Empire offered a corrective to Orientalist stereotypes in the Chicago fair and re-presented the Muslim woman to the Western world by means of

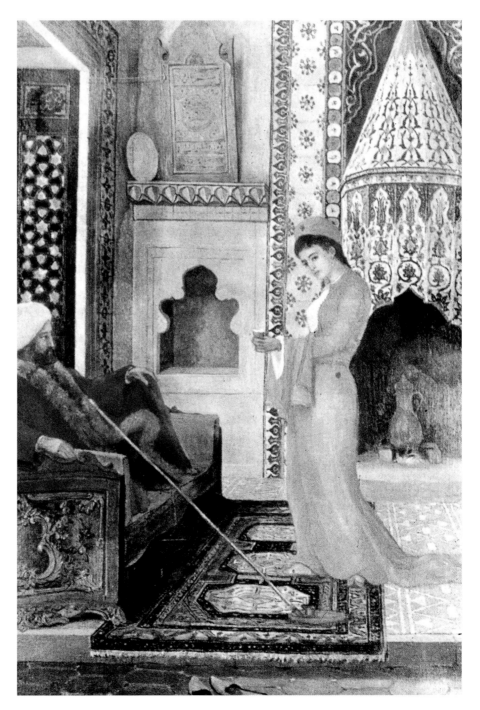

Fig. 10. Osman Hamdi Bey, *After the Iftar*, 1886. Location unknown. From Mustafa Cezar, *Sanatta Batı'ya Açılış ve Osman Hamdi* (Istanbul: Türkiye İş Bankası, 1971)

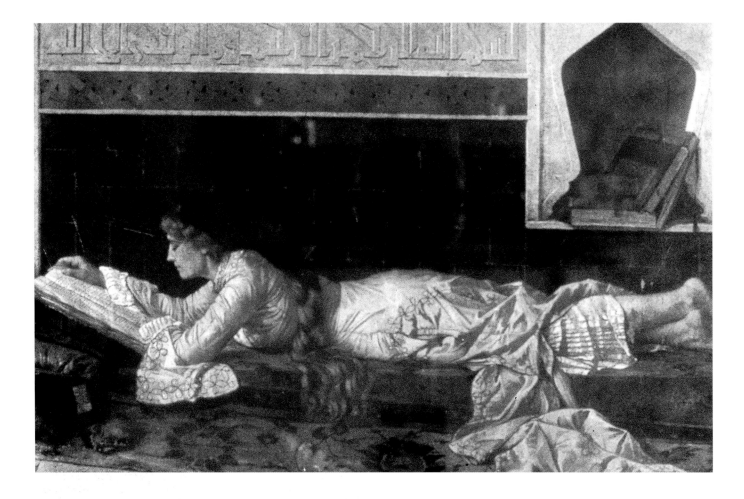

Fig. 11. Osman Hamdi Bey, *Girl Reading*, c. 1893. Location unknown. From Mustafa Cezar, *Sanatta Batı'ya Açılış ve Osman Hamdi* (Istanbul: Türkiye İş Bankası, 1971)

two interventions: a collection of photography albums known as the "Abdul-Hamid II Albums" and the publications of an Ottoman woman writer, Fatma Aliye Hanım. Fatma Aliye Hanım's writings on the status of women in Islam and the Ottoman Empire overtly criticized European representations of Muslim women and contributed to the growing debates among Ottoman intellectuals at home. The photography albums, prepared on the occasion of the Chicago exhibition, contributed to this debate in a visual format.[13] A present from the sultan to the United States and selected from his extensive photography collection, they were destined ultimately for the "National Library of Washington" [i.e., the Library of Congress].[14] Nevertheless, these interventions contradicted other Ottoman displays in Chicago that reinforced the constructions of the Orientalist discourse, thereby blurring the messages they carried.

The ornately bound Abdul-Hamid albums, fifty-one in total, contained 1,819 photographs by various Istanbul photographers. The collection drew a specific image of the empire according to several categories. While historic grandeur, expressed by photographs of major monuments from the Byzantine and Turkish periods, as well as natural landscapes, were given their due respect, the major theme was that of modernization. Modernizing reforms to rejuvenate the empire had been in place since the eighteenth century in response to successive military defeats experienced by the Ottoman army. In search of quick and practical remedies, the Ottoman rulers first imported technological innovations that were seen as proofs of European superiority. Nevertheless, the exposure to the West soon embraced the other fields, and the history of the late Ottoman Empire became a history of westernization. This significant development, which affected all aspects of Ottoman life, remained noticeably absent from Orientalist accounts.

Modernization covered many areas, extending from military reforms to education to

Fig. 12. Dolmabahçe Palace, Istanbul. Abdul-Hamid II Albums, Prints and Photographs Division, Library of Congress, Washington, D.C.

Fig. 13. Grand Reception Hall, Dolmabahçe Palace, Istanbul. Abdul-Hamid II Albums, Prints and Photographs Division, Library of Congress, Washington, D.C.

artistic production. It introduced, for example, a new architecture based on European models. One of the most telling statements regarding architectural modernity was made by the construction of the Dolmabahçe Palace in 1856 in Istanbul (fig. 12). This building, designed by court architect Karabet Balyan, hailed the official acceptance of western models, not only as fashionable novelties, but also as instruments of radical transformations in lifestyles. The overall organization of the palace, based on Beaux-Arts principles of symmetry, axiality, and regularity, was complemented by its ornate classical facade that evoked the contemporary French Second Empire style. Its main facade turned

Speaking Back to Orientalist Discourse

toward the Bosporus, the impressive mass of the Dolmabahçe Palace was highly visible from various vistas and defined a new image of monumentality for the capital. The interior spaces corresponded to changing fashions in the everyday life of the palace: European furniture filled the rooms, revealing new customs that ranged from eating around elaborately set tables on high-backed chairs (as opposed to the former pattern of sitting on the floor on low couches around a tray) to substituting built-in couches for armchairs and sofas in living rooms in a redefinition of socializing habits (fig. 13). The paraphernalia that filled the rooms—including items such as crystal chandeliers, armoires, sideboards, and European paintings—contributed further to the rupture with the former decorative traditions that relied, for example, on an extensive use of tiles on wall surfaces.

Dolmabahçe's exterior and interior photographs in the Abdul-Hamid albums thus offered a very different palace from the older Ottoman palaces. They also contradicted the Orientalist discourse that had constructed innumerable imaginary serai scenes, cluttered with eclectic architectural and decorative fragments derived from various "Eastern" sources and assembled to stimulate the fantasies about the private realm of the Ottoman sultans. Nevertheless, the photographs of Dolmabahçe Palace did not conform to the "living room" constructed in the main Ottoman pavilion in Chicago, either. While displaying the highest quality craftsmanship, the artifacts in this room did not reflect much about the late-nineteenth-century palace life in Istanbul. The overall picture reiterated rather the frozen imagery of the Orientalist visual discourse. The dual representation of palace interiors in Chicago highlighted a major conflict in the definition of cultural identity at the time: was it to be modern, hence European and not "exotic" to European eyes, or "oriental" according to the expectations of the Western world?[15]

Among other aspects of modernization, industrialization was underlined in the albums by photographs of factories, docks, and arsenals (fig. 14). From the 1840s on, a number of state-run industries were founded on the outskirts of Istanbul. They included foundries that produced iron pipes, steel rails, swords, and knives, and factories that

Fig. 14. The Large Dock, Istanbul. Abdul-Hamid II Albums, Prints and Photographs Division, Library of Congress, Washington, D.C.

Fig. 15. School of Law, Istanbul. Abdul-Hamid II Albums, Prints and Photographs Division, Library of Congress, Washington, D.C.

specialized in textiles, glass, paper, chemicals, and rubber. Boats were made and maintained in modern arsenals. The photographs of such facilities in the Abdul-Hamid albums delivered a picture of the industrial environment in the empire and provided views of the physical contexts for the Ottoman products displayed in various sections of the World's Columbian Exposition.

Educational reforms, conveyed in the albums through new school buildings and their students, occupied the largest component of the exposé. To demonstrate the widespread nature of modern education, photographs of schools covered the entire spectrum, from the highest institutions of learning (such as the law school) to middle and elementary levels, and offered examples from diverse regions of the imperial territory (fig. 15). Certain institutions of prestige were given more space. For example, an entire album was devoted to the Imperial High School of Galatasaray, where instruction was given in Turkish and French. The photographs flaunted the school's building, with its expansive and manicured garden, and proudly displayed the age range of students (from elementary through high school), students with their distinguished teachers, and even gym classes (fig. 16). Another important establishment was the school of medicine, shown in one photograph with its entire population. The emphasis on science and scientific research was revealed by a photograph of a group of students in front of a cadaver, with other relevant articles framing the view (fig. 17). Respect for learning and knowledge

Fig. 16. Lycée de Galatasaray, Istanbul. Abdul-Hamid II Albums, Prints and Photographs Division, Library of Congress, Washington, D.C.

Fig. 17. Students of the Imperial School of Medicine, Istanbul. Abdul-Hamid II Albums, Prints and Photographs Division, Library of Congress, Washington, D.C.

Fig. 18. Imperial Library, Istanbul. Abdul-Hamid II Albums, Prints and Photographs Division, Library of Congress, Washington, D.C.

were conveyed, for example, by interior views from the Museum of the Imperial Maritime College and the Imperial Library. A scholar of theology (judging from his attire) shown reading in a well-equipped modern library in a converted historic building (the Imperial Library) made a statement about the enlightened nature of Islam and its compatibility with contemporary ideas (fig. 18). This image reads as a corrective to Orientalist presentations of Islam as a fanatical, irrational, and even violent religion. Compared with Gérôme's paintings of Islamic worship or the innumerable nineteenth-century photographs of wandering dervishes, for example, the theologist of the Abdul-Hamid albums brings forth the intellectual and scholarly aspects of the religion.[16]

To demystify another misconception, the albums dedicated many photographs to women's education. Education of girls in the Ottoman Empire had become an important issue on the official agenda during the second half of the nineteenth century, in accord with the 1856 Reform Declaration (Islahat Fermanı), which argued against discrimination based on gender. The 1868 Regulation of Public Education (Maarif-i Umumiye Nizamnamesi) predicated elementary school education for girls between the ages of six and ten, and the 1876 constitution (Kanun-i Esasi, the first Ottoman constitution) made primary education mandatory for both sexes.[17] As though to revise the image of the oriental woman as the lascivious odalisque, the Abdul-Hamid albums provided many scenes that depicted the emphasis placed on girls' intellectual development. The photographs are in two categories. The first shows street views of newly built schools in neoclassical designs (fig. 19). The second takes the viewer into the school gardens, where groups of students carrying their books and diplomas are portrayed (figs. 20, 21). Some dressed in uniforms and others in everyday clothes (both according to contemporary European modes), they look straight at the camera, serious and proper.

Fig. 19. Mekteb-i Hairié Middle School for Girls, Istanbul. Abdul-Hamid II Albums, Prints and Photographs Division, Library of Congress, Washington, D.C.

Fig. 20. Students of the Ruchdié Girls' School in Emirghian, Istanbul. Abdul-Hamid II Albums, Prints and Photographs Division, Library of Congress, Washington, D.C.

Fig. 21. Students of the Dar et-tahsil Girls' School, Istanbul. Abdul-Hamid II Albums, Prints and Photographs Division, Library of Congress, Washington, D.C.

Fig. 22. Tuberculosis ward of the Women's Hospital in Haseki, Istanbul. Abdul-Hamid II Albums, Prints and Photographs Division, Library of Congress, Washington, D.C.

Women appeared in the albums in one other classification: health care. A special hospital for women in Haseki, Istanbul, received extensive coverage, complete with exterior views of the administrative offices and the various pavilions in the gardens, an interior view of the tuberculosis ward showing the patients (fig. 22), and a group photograph of the doctors on the staff. The photographs of the women's hospital also introduced a category of working women: nurses. Whether posing in the tuberculosis ward or shown walking in the gardens, the nurses testified to the emergence of a new profession. Nursing education had, in effect, been integrated into the structure of the school of medicine in 1842 and by the end of the century had become a respectable career option for girls.[18]

The representation of Ottoman women in the Abdul-Hamid albums did not attempt to be comprehensive but addressed two key issues pertaining to the welfare of women at that time. The selective approach was symptomatic of the circumscribed imperial image drawn by the albums, which sought to present the empire in a progressive light, thereby replacing its tired image at the end of the century with a rejuvenated, dynamic, and modern one.

The contributions of Fatma Aliye Hanım (1862–1936) to the World's Columbian Exposition served this agenda further. Fatma Aliye Hanım, the highly educated daughter of Ahmed Cevdet Paşa, an Ottoman statesman, historian, and lawyer, was a prolific writer of novels and essays.[19] By August 1893, when she received an invitation from Edith Clark, the cataloguer of the Woman's Library of the World's Fair, to send her publications for an exhibition of works by women from all over the world, Fatma Aliye Hanım had published three books: *Hayal ve Hakikat* (Dream and Reality, 1892–93), a romantic novel she co-authored with prominent Ottoman writer Ahmet Mithat Efendi; *Muhazarat* (Conversations, 1891–92), another novel that dealt with problems of family structure from a woman's perspective; and most importantly, *Nisvan-ı Islam* (Women of Islam, 1891–92), an analysis of women's status in Islam.[20] All three must have been sent to Chicago, as the Library of the Woman's Building recorded "three books in Turkish" under the name of "Fathma Alié."[21]

Despite the letters of courtesy sent to Fatma Aliye Hanım from the Library of the Woman's Building that mention the interest expressed in her books, the appeal of these publications could not have been more than visual to the visitors. Textually inaccessible, they nevertheless must have raised some curiosity, adding another flavor to the collection of foreign language books with their Arabic script. It can thus be argued that Fatma Aliye Hanım's books made a statement about the "oriental woman" by the simple fact that their author was an intellectual with a productive writing career—well-established, respected, and influential in her home country. Even if the impact was bound to remain restricted, the representation in the Woman's Building contradicted the quintessential image of the odalisque.

Yet, there were other representations of the oriental woman at the fair, specifically on the Midway. The performers were the most talked about, but "natives" in local costumes also crowded the Ottoman exhibits in order to complete the local flavor created by the architecture and the artifacts on display (see cat. nos. 45D–G).[22] The message they conveyed was no doubt more in accord with popular expectations than the book exhibit in the Woman's Building. The Woman's Building also became the site of a serious presentation on the condition of women in the Ottoman Empire. Echoing commonly held beliefs in a paper delivered at the Congress of Women, Mary Page Wright, an American missionary who had spent eight years in Turkey, reiterated that women were "held to be essentially inferior to men," that they were "ignorant" despite the recent emphasis

placed on their education, and that polygamy and seclusion in harems made their lives "monotonous and sad," the latter sentiments expressed so clearly, she added, in the Turkish music played on the Midway Plaisance.[23]

Fatma Aliye Hanım's *Nisvan-ı Islam* directly addressed the European misunderstanding of women in Islamic cultures and societies as being oppressed and submissive. Basing her information on numerous conversations she had had with female foreign travelers, she attributed the errors and deficits in their knowledge of Ottoman society to their sources, namely the travel literature, which did not reflect reality but was written as "fiction from the imaginary." Furthermore, she blamed the local informants—the translator-guides found in Pera (the Europeanized neighborhood of Istanbul) and only familiar with the trendy lifestyle of that neighborhood—for disseminating wrong information. Listening to European travelers' opinions on Muslim women gathered from these unreliable sources, Fatma Aliye Hanım admitted her "extraordinary shame" and surprise as she fell under the impression that "the topic of conversation was another nation." As she set forth to correct the predominant vision, Fatma Aliye Hanım constructed imaginary conversations between Ottoman and foreign women, emphasizing the fact that the former maintained their "religious traditions" and "national customs," although they had adapted to modern norms and were fluent in French. The most effective procedure for eliminating the misconceptions, she maintained, was welcoming foreign women into the heart of Ottoman houses, to the realm of the women.[24]

The book purports to record three visits by European female travelers to Fatma Aliye Hanım's house. She is present in all and the accounts are told in first person, but her Ottoman guests change in order to show the range of issues and concerns that occupy the minds of the women at the time. The European guests are also varied, as though the scope was intentionally kept broad in order to evoke the widespread nature of the opinions held among Europeans. The conversations cover a list of themes central to Orientalist discourse and seem to address a foreign audience. However, they include at the same time contemporary debates in the Ottoman Empire about late-nineteenth-century cultural and social developments and the search for a balance between advancement and preservation of traditional values—the latter being Fatma Aliye Hanım's real agenda for the future of Ottoman culture and society. She used the conversations as platforms to critique the total immersion in European *(alafranga)* values, which were highly popular among a considerable number of upper-class Ottoman families.[25]

The first conversation takes place between Fatma Aliye Hanım and a certain Madame F. from "European aristocracy," accompanied by a nun, and focuses mainly on the practice of keeping concubines *(cariyes)* in wealthy households. Answering her guests' questions about a practice that the European women consider "slavery," Fatma Aliye Hanım presents the institution as one of benevolence and charity. Differentiating the *cariyes* from the other servants, she clarifies that a life-term commitment would be made to the former, whereas the latter were simply paid laborers. Conforming to the teachings of Islam that protected the rights of *cariyes,* the family that owned them was obligated to provide them with a considerable sum of money and a dowry at the time of their marriage. In the case of divorce or death of the husband, Fatma Aliye Hanım continues, concubines would be welcome back, with their children, just like other family members. She rebuts Madame F.'s assumption that selling their young children is a criminal act by greedy fathers by explaining that among the modest people of Circassia (the regions from which *cariyes* historically came), this is considered a great opportunity for the future of a young and good-looking girl.[26] Indeed, she continues, these girls

are given a fine education and the manners of a "city girl" *(şehir kızı)* so that they can become true *hanıms*, or ladies. She assures her visitors that many *cariyes* marry into good families. Nevertheless, Fatma Aliye Hanım acknowledges abuses in the practice, such as reselling a *cariye* for financial gain. Convinced by her answers, Madame F. admits that she had totally misunderstood the system and that its shortcomings do not seem to be much different than conflicts that can take place within any family.[27]

The second conversation is with an Englishwoman, Madame R., who speaks fluent French and was sent to Fatma Aliye Hanım by a Frenchwoman who had visited her a year earlier. Since their meeting takes place during Ramadan, the Islamic holy month, the house is full of other guests and relatives, a situation that pleases Madame R. because it allows her to meet more than just one Ottoman family. Gazing at this crowd of women, Madame R. asks her first question: "Which of these women in this room share their husbands?" The hostess's answer, "none," shocks the Englishwoman, for whom the condition of "oriental women" had been defined until that moment by polygamy. Fatma Aliye Hanım then proceeds to explain that while Islam permits polygamy, its conditions are so complicated that it is rarely practiced, even in economically prosperous circles. Starting with the prophet Muhammad, she then lists prominent Muslim leaders who contended with one wife at a time. Criticizing the men who take more than one spouse, Fatma Aliye Hanım likens them to roosters in a chicken coop. Yet, she argues, the practice may have valid reasons, as in the case of wives who are not able to bear children. She maintains that despite its shortcomings, in the long run polygamy is a better alternative to the European custom of keeping mistresses, because in the Ottoman society polygamy is not considered a social disease, and its children are legitimate as opposed to the innumerable European children who carry throughout their lives the burden of being born out of wedlock.[28]

The next topics Madame R. raises are "covering up" *(tesettür)* and not intermingling with men. Her hostess responds by explaining that these are customs and traditions that had evolved over time, and that they are not inscribed in religion. Covering the hair, a tradition that has passed into Islam from the Jewish practice, is sufficient to meet the requirements of the religion. The veil is a recent invention. As can be observed in any social gathering, contemporary Turkish women dress exactly like European women, but simply cover their heads with a scarf to observe the rule of *sharia,* Islamic law. Fatma Aliye Hanım clarifies that when dressed in modest clothes, with their hair covered, Muslim women can communicate with and intermingle with men according to Islamic law. It is thus the custom, not the religion, that originated the practice of gender segregation. She adds, answering another question, that arranged marriages also stem from custom and bear a great deal of wisdom, given that the flame of youthful love does not endure—a fact that Madame R. agrees upon.[29]

Women's fashions occupy a considerable part of the third conversation. The visit of three European guests is preceded by a discussion among Fatma Aliye Hanım and her two friends, S. Hanım and N. Hanım. S. Hanım is introduced as good-hearted, informal, and cheerful, extremely conscious of the latest fashions, fluent in English, weak in French, and able to express herself in writing in Turkish. N. Hanım is well-educated and intellectually haughty, with a disdain for fashion but obliged to be à la mode because of her social status. S. Hanım epitomizes *alafranga* styles; N. Hanım tries to live her life *alaturka* (in the Turkish style).[30] As opposed to these two extreme positions, Fatma Aliye Hanım opts for a moderate stand representative of her general synthetic attitude: "I get dressed *alaturka* or *alafranga* depending on what I feel like."[31] The European

guests are three Parisian women: two attractive and elegantly dressed sisters, a twenty-seven-year-old married woman and a twenty-year-old mademoiselle, accompanied by their aunt, an older mademoiselle of about forty years.

As the French guests had expressed their desire to see their hostesses in local costumes, the three Ottoman ladies change into *alaturka* dresses to welcome them. Nevertheless, the outcome does not satisfy the Europeans, whose questions reveal certain expectations: a cropped, embroidered silk vest, a thin shirt, and a pair of shiny silk baggy pants. Fatma Aliye Hanım grasps the situation and brings an album that includes a photograph of a woman dressed according to the image in the minds of the guests. The guests admit that they had seen such representations in Paris and express their disappointment when Fatma Aliye Hanım explains that such photographs do not depict Turkish women, but Christian women who pose as Orientals. She then deconstructs the exotic "Turkish" scene in the photograph: the head scarf is the Arabian kaffiyeh, the vest and the pants are Albanian, the chair in the foreground is from Damascus, and the cup on it from India. Fatma Aliye Hanım adds sarcastically that she is unable to identify the national identity of the Muslim woman to whom the narghile in the odalisque's hand belongs. Now criticized from an Ottoman woman's perspective, the eclectic construction that defined the Eastern woman to European audiences stands out, nevertheless, in terms of its enduring authority. Fatma Aliye Hanım's attempts to revise this misconstruction concentrate on acquainting the European guests with authentic Turkish customs and artifacts. For example, she gives them advice on where to buy fine fabrics and silver pots similar to the one in which coffee was served in the "Turkish style."[32]

The conversation between the Parisian and Ottoman ladies then shifts to marriage and family, providing a comparative analysis of these institutions in the East and the West. The catalyst is the spinster aunt, whose story evolved around her deep love for a "rich, polite, handsome, and hard-working" youth. Yet, the marriage had to be called off as an inquiry into the young man's family revealed that the young man was born out of wedlock—a fact that turned the young woman's feelings into hatred. The Ottoman women sympathize not with their guest but with the "poor man," revealing a major difference in social norms and restrictions. The guest explains her situation further by revealing that her lack of a dowry prevented her from getting married later, and she asks if there are Turkish girls who end up in her situation. The answer is definitive: "Not in a million. In our society, neither the ugly nor the poor remain unmarried."[33] The advantage of the Eastern woman over the Western one is thus clearly understood by both parties and underlines the unmarried Frenchwoman's unfortunate dependence on relatives. Another question related to marriage customs in the East concerns the unequal relationship of husbands and wives in the Ottoman society. Fatma Aliye Hanım challenges the statement that Turkish women are considered "slaves" by explaining that obedience to husbands is expected in all societies but is more taxing according to Christian marriage contracts. An outstanding issue for her is the woman's right over her property: in the Ottoman society, she maintains, a woman is free to spend her money and sell her property as she wishes, whereas in Europe she has to obtain her spouse's permission.[34]

The third visit ends on a lighter note. The Parisian ladies demonstrate their musical talents by playing classical music on the piano, and the Ottoman ladies reciprocate with *alaturka* music, first on the piano then on regional stringed instruments, such as the *ud* and the *kanun*. While the atmosphere described is festive, Fatma Aliye Hanım cannot refrain from injecting a few didactic elements for her readers. A rather lengthy com-

mentary on the training and time required to play the piano well seems to have been addressed to upper-class Ottoman ladies who toy with the piano as a fashionable pastime but do not bother with serious instruction in classical music. An extensive discussion about the origin of the piano as a descendent of the *erganun* (organ), an Eastern musical instrument that was given to Charlemagne by Harun al-Rashid, the caliph of Baghdad, seems intended to remind both parties of the intersections and cross-fertilizations between the East and the West.[35] The harmonious exchange reached at the end, through music, reiterates the compatibility of the cultures, as well as the importance of comprehending and valuing each other.

In her enthusiasm to resituate her culture and society in the eyes of Europeans, Fatma Aliye Hanım substitutes the distorted "truths" of the Orientalist discourse with her own truths. However, truth is hardly the issue here; it is representation that matters. As such, the contents of Fatma Aliye Hanım's important book could have sparked debate and discussion in Chicago, at least in the Woman's Building. With a "missing text," however, the impact remained insignificant. The conditions that silenced Fatma Aliye Hanım's voice may have been only tangentially associated with the broader project of Orientalism to produce, interpret, and control the "Orient" as a system of representations framed by "Western learning, Western consciousness, and later, Western empire," as defined by Edward Said in his pivotal book *Orientalism* (1978).[36] Nonetheless, the suppression of her voice calls for a revisit to the question, "Can the subaltern speak?"— a central point of investigation since Said's book appeared. It could be argued that the phenomenon of not listening and not hearing was more profoundly engraved into the consciousness of the observers and that it went beyond the technical impenetrability of a foreign language. After all, neither the photography albums nor the other Ottoman displays that attempted to highlight the modernity of the empire heralded any revision of widespread perceptions. Visitors to the World's Columbian Exposition read the Ottoman Empire according to the set of criteria already registered in their intellectual frame of reference by the multiple mechanisms of the Orientalist discourse, ranging from popular to scholarly representations.

1. *Dream City* 1893, caption to "The Ottoman Pavilion"; *Vanishing White City* 1894, caption to "Interior of Turkish Building."

2. *Levant Herald and Eastern Express,* 6 March 1893.

3. *Vanishing White City* 1894, caption to "Street Carriers of Constantinople."

4. *Levant Herald and Eastern Express,* 16 January 1893.

5. *Vanishing White City* 1894, captions to "Palace of Damascus" and "Camp of Damascus."

6. The Istanbul-based *Levant Herald and Eastern Express* reported on the decision to send the horses and riders to Chicago (16 January 1893) and on their shipment on a large steamer from Beirut to Chicago (27 March 1893).

7. *Vanishing White City* 1894, caption to "Turks on Manhattan Day"; *Chicago Tribune,* 8 April 1893.

8. Truman 1893, 558.

9. Ibid., 558.

10. *Chicago Tribune,* 30 April 1893.

11. Ahmet Mithat 1890.

12. The discussion on Osman Hamdi is derived from Çelik 1998, 202–5; and Çelik forthcoming.

13. The Abdul-Hamid II albums are discussed in Çelik forthcoming.

14. *Levant Herald and Eastern Express,* 27 March 1893. The albums were prepared in several copies, with minor changes. In addition to the collection in the Library of Congress, there is one set in the Yıldız Archives, Istanbul University Library, and another in the British Museum, London. The latter was sent to the library as a gift from the sultan. For an informative article on the Abdul-Hamid albums in the Prints and Photographs Division of the Library of Congress, see Allen 1984, 119–45. Allen not only introduces the contents of the albums, but also points to their use as "a propaganda effort." In an appendix, he lists the subject matter of each album.

15. If the formulation of the issue was crystalline in terms of extreme images in the Chicago fair, the search for a synthesis between the two constituted a main preoccupation of Ottoman administrators and intellectuals, with ramifications that continue to the present day.

16. As such, this photograph complements the men of religion engaged in scholarly activities in Osman Hamdi's paintings. See Çelik forthcoming.

17. Çaha 1996, 88–89. By 1905, there were 304 public primary schools for girls in the empire, and 3,621 coeducational schools.

18. Ibid., 88.

19. As typical of upper class Ottoman girls at the time, Fatma Aliye Hanım was educated at home. While well read in classical Ottoman and Arabic literature, fluent in French, and interested in Greek, Arabic, and post-enlightenment European philosophy, her background had gaps according to her father, Ahmed Cevdet Paşa. He expressed his sentiments in a conversation with Ahmet Mithat Efendi, along the way making a powerful statement about the status of women in the Ottoman society: "I am appalled at this girl's abilities. Although her knowledge and education are limited, her mind functions on such elevated and complicated issues that this situation almost scares one. If she had been a boy, if she had had a rigorous education, she could have been a true genius." See Ahmet Mithat 1994, 86.

20. Kızıltan and Gençtürk 1993, 11–13.

21. Board of Managers, 1894, 99. There are two non-dated translations of *Nisvan-ı Islam* in French: *Les Musulmanes contemporaines,* trans. Nazimé Roukié (Paris, n.d.); and *Les Femmes musulmanes,* trans. Olga de Labedeff (Paris, n.d.). These must postdate the Chicago fair. An Arabic translation, *Ta'rib-i Nisâ al-Muslimîn,* was published as a serial in the Beirut newspaper *Semeretul Funûn* in 1892, then published as a book (see Kızıltan and Gençtürk 1993, 9). In a letter draft dated 27 December 1913, Fatma Aliye Hanım mentions an English translation of the book and states that she never received a copy (see ibid., 27). According to Mahmud Zeki, an early-twentieth-century writer, an English translation exists (see Kızıltan 1990, 293). I have not been able to locate this translation and have not come across any specific reference to it.

22. A number of these were, in effect, Chicago residents hired by Ottoman exhibitors to pose as Ottoman subjects.

23. Mary Page Wright, "Woman's Life in Asiatic Turkey," in Eagle 1894, 305.

24. Fatma Aliye Hanım 1993, 64–66.

25. Ibid., 65–66.

26. To make her point, Fatma Aliye Hanım quotes a Circassian lullaby sung to baby girls ("You will go to Istanbul! You will be the wife of a paşa!") and constructs a parallel to a French lullaby for baby boys ("En attendant sur mes genoux, beau maréchal, endormez-vous!"). The latter, in French, is written in Arabic script in the original text (see ibid., 71).

27. Ibid., 67–74.

28. Ibid., 87–94.

29. Ibid., 95–97.

30. Ibid., 110–11.

31. Ibid., 116.

32. Ibid., 134–37.

33. Ibid., 139–40.

34. Ibid., 140–43.

35. Ibid., 144–48.

36. Said 1978, 202–3.

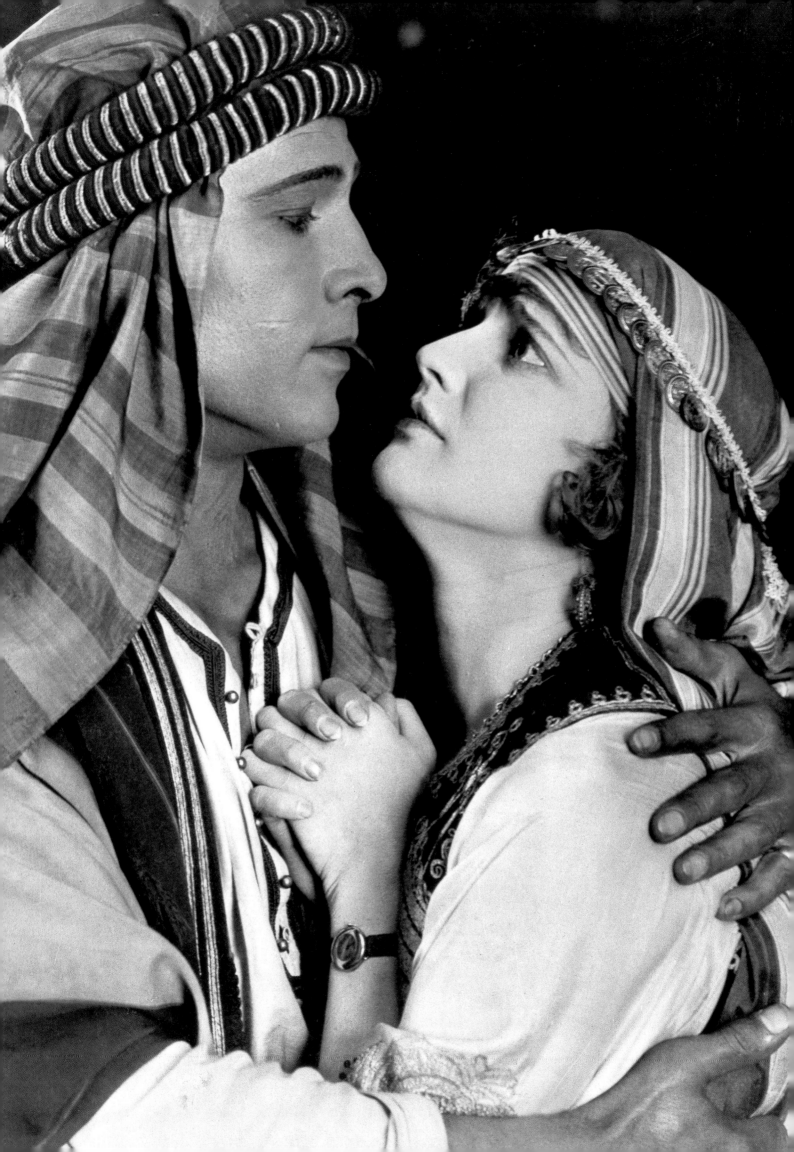

The Sheik: Instabilities of Race and Gender in Transatlantic Popular Culture of the Early 1920s

STEVEN C. CATON

In the period from roughly the end of World War I to the beginning of the 1920s, Orientalism was spectacularized in Anglo-American popular culture, and nowhere more dazzlingly so than in three hugely successful public entertainments. First, there was Lowell Thomas's lantern slide lecture show "With Allenby in Palestine and Lawrence in Arabia" (1919–26?), which turned an obscure British colonel into a celebrated war hero. At the height of its popularity came the publication of the British romance novel *The Sheik* (1919), by Edith Hull, one of the hottest best-sellers of all time on both sides of the Atlantic. Capitalizing on the successes of Thomas's show and Hull's novel there followed the wildly popular American film *The Sheik* (1921), which catapulted Rudolph Valentino into superstardom. As the connections between these three sites of popular culture suggest, Orientalism was very much a transatlantic commodity in this period, not just the product of one nation or of several nations separately. I begin with the earliest, Lowell Thomas's show, because in many respects it set the precedent for the others. Here was a Yankee reporter telling a story about British heroism to audiences on both sides of the Atlantic. Is he an example of "American" or "British" Orientalism, or is he in fact impossible to situate within just one tradition? As for Hull's novel, there was no question that it spoke to British themes and anxieties and yet was read widely in Britain and the United States. It was, after all, its popularity with American audiences that occasioned the making of the film based on its story.

In all three entertainments, the figure of the sheik emerged as a popular icon or metaphor for the Orient, and this essay will focus on three aspects of his identity: race, culture, and gender. As for race, it is interesting that in none of the works in question is the figure of the sheik meant to be "Arab" in any "pure" sense, as understood according to the fraught racial categories of the day; but neither is he "white" in an unproblematical sense either. To be sure, there may be little question as to his "whiteness" when it comes to Thomas's representation of T. E. Lawrence, but what does one make of a man who is born of a British father and a Spanish mother (especially when the latter is said to contain "Moorish blood"), as in the case of the title character in Hull's novel, or when that same character as portrayed by Valentino takes on a "Latin" ethnic stereotype, marking him as not quite "white" but not "black" either? On the other hand, as ambiguous as his racial identity may be, there seems to have been little doubt in the minds of the audiences for whom these popular entertainments were intended that the sheik could perform cultural Arabness authentically and flawlessly. Indeed, in all cases he could pass as a "native" more convincingly than the native himself (or herself, as we shall see in the case of Lawrence). This could produce anxieties for white audiences, who might see the crossing of cultural boundaries as a betrayal of civilization. What he might have represented to non-white audiences we may never know. As unstable as he is in his racial identity, the sheik is also fluctuating in his gender. The androgynous figure of Lawrence versus the feminized one of Valentino are each worlds apart from

Rudolph Valentino and Agnes Ayres in a scene from *The Sheik*, 1921. Film still. UPI/Corbis-Bettmann

the hypermasculine character of the novel. What are these fluctuating representations of race and gender doing in these texts?

To answer that question, it is useful to situate these texts in their historical social contexts—namely, the public memory of World War I, the consolidation of British colonialism in the Middle East, transformations in race and gender in the workforce during and immediately after the war, and the crisis of immigration into the United States during the first two decades of the century. The rich and often contradictory representations of the sheik performed different ideological functions, as it were, for different audiences in these various historical contexts.

As a result of being one of radio's longest running and highest paid news broadcasters and commentators, Lowell Thomas (1892–1981) became in his lifetime one of the most famous public figures in the world. He readily acknowledged that what had launched his fabled career was his lucky "discovery" of Colonel T. E. Lawrence (1888–1935) and the chance to tell of his legendary exploits in a travelogue–film exhibition, which toured the eastern United States, Great Britain, and parts of the British Empire from 1919 until roughly 1926. It is estimated that four million people saw the show.[1] It is one of the most remarkable examples of the creation of a celebrity in the history of mass media, and for that reason alone it is astonishing what little attention has been paid to it in cultural studies.[2]

Already experienced as a travelogue lecturer, the young and ambitious Thomas was either contacted by or himself approached the U.S. Secretary of the Interior Franklin K. Lane in 1917 with the idea of a slide lecture show that would propagandize the war. In Europe, he searched for an appealing "doughboy" whom he could photograph with the help of his Hollywood cameraman Harry Chase, but unfortunately all the likely candidates got themselves killed in action, and the stalemate in fighting on the western front did not exactly lend itself to a dramatic story either. Eventually, it came to Thomas's attention that the British General Edmund Allenby was leading Allied troops to victory in the Near East, and after the fall of Jerusalem he decided to pay him and his field of operations a visit. Thomas arrived in Jerusalem in February of 1918, only to find that the great general wanted as little as possible to do with the brash young American reporter, fobbing him off on one of his more colorful officers attached to the Arab revolt. Though Thomas and Lawrence spent only two weeks together touring parts of western Arabia (Thomas would later intimate that the period of time had been much longer), it was enough time for him to realize that he had finally found his doughboy.

But now Thomas faced another dilemma. By 1918 it was clear that the war was winding down, and there was no longer any need to propagandize it. What, then, would be the purpose of his travelogue? As he explained to one of the show's financial backers in a letter dated February 22, 1922: "The fortunate and timely, but unexpectedly sudden termination of the World War nearly wrecked our first plan. After the armistice no one wanted to hear about the War. But fortunately for us no one had heard about the war in the Holy Land and in far off Arabia."[3] As it turned out, the only lectures that consistently interested the war-weary public were the ones on the seemingly romantic campaigns in the Near East. Accordingly, with the help of his wife Fran and long-term collaborator as well as fellow publicist Dale Carnegie (1888–1955)—later to become famous in his own right as the author of the hugely best-selling *How to Win Friends and Influence People* (1936)—Thomas arranged the material into an informative and action-packed lecture entitled "With Allenby in Palestine and Lawrence in Arabia." The decision to focus on the exploits of Lawrence, Thomas confessed to his backer, "was all that

saved us during our season in New York City."[4] The text was accompanied by over two hundred hand-painted lantern slides and numerous dramatic film clips. The final product was a brilliant hybrid medium, owing as much to the nineteenth-century tradition of the illustrated lecture[5] as it did to the newsreel and "chills-and-spills" entertainment of the early American cinema.[6] After successful runs in Madison Square Garden, the show came to the attention of the British promoter and publicist Percy Burton. "Burton realized something which we didn't," observed Thomas, "that we were shouting the praises of Britain and patting John Bull vigorously on the back in a way which would make the dour, unemotional natives of the British Isle stand up on [*sic*] their seats and cheer right lustily."[7] In other words, Burton understood that this was really a British story about the war and hence would likely be more popular on the other side of the Atlantic, but the voice would be distinctively American, and that would add to its appeal. Thomas had extraordinarily successful runs in London's Royal Albert Hall and Covent Garden, not to mention other venues in Great Britain and the empire.

In his justly celebrated *The Great War and Modern Memory* (1975), Paul Fussell has brilliantly analyzed the way in which World War I was remembered, more or less as myth, in literature of the 1920s. Given, however, that his theme is for the most part "high" culture and concerns the memory of the western front, the emphasis and argument presented here will necessarily be different. After all, Allenby and Lawrence had fought and won their battles on the eastern front, not the western one. Thomas was faced with a bit of a problem, for he was telling a story about a theater of the war which few people in the audience had read about and fewer still had experienced at first hand; therefore, the challenge was not so much of memory as it was of acknowledgment. Furthermore, he was utilizing mass or popular forms of art to do so—the slide lecture show and film clips, which drew millions of people into the auditoriums—a fact that has gone unremarked in studies of representations of the war, which tend to slight popular culture. I would go further and push two central and connected claims: first, that he was trying to *displace* the popular memory of the western front—a far more gruesome scene of death and destruction and a morally far more equivocal field of heroism—by the romantic imagery of the eastern one, thereby making it easier for audiences to glorify the war; and second, that for this rhetorical task, Orientalism was essential. Lawrence cut a dashing figure in his Arab robes. Moreover, the fighting was pictured as antique and almost quaint by comparison to the millions of men routinely slaughtered on the battlefields or succumbing to mustard gas in the trenches. "One day," Thomas recounted, "the Arabs shot down a German plane with their rifles, and when it landed in the desert they ran out and clipped off its wings so that it wouldn't fly away."[8] Orientalism was essential for creating a place of fantasy and romance, a place that was not yet Europe and yet whose peoples helped turn the tide of a European war. And if the British might have searched their souls as to why they had fought fellow Europeans, they would have lost little sleep over the Turks, not to speak of a cause represented as a "crusade" to liberate the Holy Land.

The figure of the sheik, our chosen icon for Orientalism in popular culture of this period, emerged in Part Two of the show, "With Lawrence in Arabia." Here, Thomas recalled his first startling meeting with Lawrence, who "was dressed in the robes of an Oriental Potentate, and wearing the gold sword of a Prince of Mecca," yet at the same time stood out from the other Arabs as a "beardless blond."[9] Lawrence possessed all the stereotypical characteristics of the "white" race: fair hair, white skin, blue eyes. Thomas also informed the audience repeatedly that the war hero was only five feet three inches tall (he was actually two inches taller), a detail which, along with his beardlessness, con-

COLONEL LAWRENCE CONFERRING WITH COMMANDER
D. G. HOGARTH, ONE OF HIS ADVISERS AT THE
ARAB BUREAU IN CAIRO

THE "UNCROWNED KING" OF THE ARABS ON THE GOVERNOR'S BALCONY
IN JERUSALEM

Fig. 1. Lawrence *(left)* in British uniform. From Lowell Thomas, *With Lawrence in Arabia* (New York and London: Century, 1924)

Fig. 2. Lawrence in Arab dress. From Lowell Thomas, *With Lawrence in Arabia* (New York and London: Century, 1924)

tributed to his androgynous appearance. It was the Arab costume, excessive in splendor, that especially accentuated the latter. Thomas pointedly told his audience that while Lawrence was "an insignificant looking chap dressed in the garb of a British officer" (fig. 1), his figure became remarkable, and also perhaps even more androgynous-looking, when draped in the gorgeous raiment of an "oriental potentate" (figs. 2, 3). (The ensemble does not resemble any outfit I recognize; though each item is "authentic" by itself, the whole outfit gives the impression of having been invented rather than adopted by Lawrence or his Arab handlers. In other words, it was never intended to make Arabs believe that Lawrence was in actuality a descendant of the Prophet—a blasphemy in any case—or that he was really "one of them." Obviously, Lawrence as "sheik" was meant to appeal not to Arab audiences but rather to the general staff and, after the war, to the British public.) Lawrence's Arab identity was deepened, as it were, by his supposed fluency in Arabic and in Arab ways. "He became so accustomed to living in the desert with the Arabs that he actually preferred to squat down as they do instead of sitting in a chair" (fig. 4). In brief, he may have been racially white at the core, but the audience was supposed to suspend its disbelief when it came to his passing culturally as an Arab.

Steven C. Caton

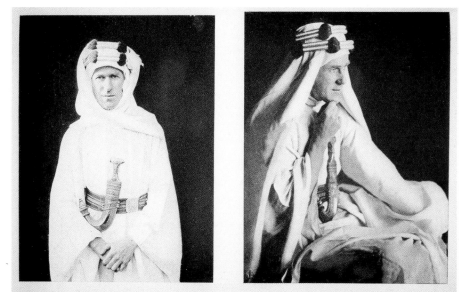

IN HIS WHITE ROBES LAWRENCE LOOKED LIKE A PROPHET THE DREAMER WHOSE DREAMS CAME TRUE

Fig. 3. Lawrence in the white robes of a Bedouin sheik. From Lowell Thomas, *With Lawrence in Arabia* (New York and London: Century, 1924)

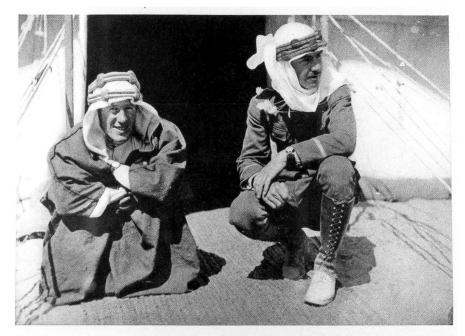

COLONEL LAWRENCE AND THE AUTHOR

Fig. 4. Lawrence *(left)* and Lowell Thomas. From Lowell Thomas, *With Lawrence in Arabia* (New York and London: Century, 1924)

"Going native" in the colonial outback was often regarded with alarm by colonial settlers and administrators—it represented a betrayal of white civilization, after all—and a note of slight unease, if not panic, would have been struck at the sight of Lawrence in Arab robes, an offense made even more heinous if the audience suspected that he might have actually *liked* dressing as an Arab (which he purportedly did). There had to be a compelling reason other than personal fancy to explain such eccentricity, and Thomas lost little time providing one: "this blue-eyed poet of Gaelic ancestry succeeded in accomplishing what no caliph and no sultan had been able to do in over a thousand years. He wiped out the century old blood feuds and built an army and drove the Turks from Holy Arabia." Arabs are said to be "tribal" and thus by nature "feud-addicted" (a trope of Orientalism that goes back to the Crusades and is still powerful to this day, whether in anthropological accounts of so-called segmentary societies or in journalistic accounts of the Middle East).[10] According to Thomas's narrative, Arabs had tried and failed to rule themselves by representatives of their own religion, so to insure peace and order, intervention by an *outside* state or charismatic figure was required.

Little wonder, then, that the colonial agent Lawrence strides onto the tragic stage of tribal Arabia like a *deus ex machina*. Thomas preposterously asserts that "these Bedouin regarded him as a sort of supernatural being—someone sent down from Heaven to free them from the Turks."

But why must the central character in this drama wear the mask of a "native"? Why should he not appear in topee and white riding gear? The Arab cannot rule without the white man; but the white man must know how to blend in with the alien ways of the native without, in the end, betraying his own race (for then he sacrifices his effectiveness, since it is the genius of the one race that is supposed to relieve the dullness of the other). Appearing as a "descendant of the Prophet Muhammad," Lawrence would be, like the caliphs and sultans, deemed a legitimate and just ruler of Arabia, but he could do what no Arab had accomplished before him because of his racial superiority, not to speak of his individual brilliance.

In his Orientalized portrait of Lawrence we find the complete justification for British imperialism, and it is provided precisely at the moment in the 1920s when Great Britain successfully (though not without some resistance, particularly in Iraq) established its foothold over oil-rich lands that had been vacated by the Turks and that lay on the route to India, the "jewel in the crown." A mandate system was set up in the Near East, according to which local rulers like the sons of Emir Hussein of Mecca, who inaugurated and led the Arab revolt in 1916, became kings of Iraq, Syria, and Transjordan, while their bureaucracies and armies were staffed by the British or by British-trained local elites. In light of this system, it is noteworthy that when Thomas described, in glowing terms, the efforts and successes of the Arabs in the revolt, he also made certain the audience understood that "Young Lawrence was really in control." Not surprisingly, one of the most enduring epithets from the show was Lawrence as "the Uncrowned King of Arabia."

Thomas's mythologizing of Lawrence was not limited to his immensely popular show. He also wrote a best-selling memoir, *With Lawrence in Arabia* (1924), among other works in which he continued to tell the story that made not only Lawrence but himself famous. In the memoir, the theme of "going native" becomes even more pronounced, and a note of foreboding is introduced. "To gain his ends it was necessary for Lawrence to be a consummate actor. He was obliged completely to submerge his European mode of living, even at the risk of winning the criticism and ridicule of his own countrymen, by appearing in cities like Cairo, where East and West meet, garbed as an Oriental."[11] It is thus made clear that Lawrence does not identify with the Arabs at all but merely assumes their identity for his own purposes—as an actor might slip into a role on stage—thereby supposedly remaining uncontaminated by their baser qualities. And what are his purposes? In the following passage, they appear almost fascistic. "The magnificent Bedouin clothes that Lawrence wore . . . were a part of his carefully worked-out plan to gain complete mastery over the Arabs."[12]

An intriguing consequence of this "carefully worked-out plan" of "complete mastery" is that it entailed behavior on Lawrence's part that was potentially compromising. Thomas informs us that "on a few occasions he [Lawrence] did disguise himself as a Bedouin woman and made his way through the Turkish lines"[13] (fig. 5). It has already been noted how androgynous Lawrence appeared, dressed in splendid Arab robes. Here the masquerade went deeper, for he was meant to pass as a woman. It is presumed that the objective was secret intelligence gathering. "This was the best disguise for a spy, for the Turkish sentinels usually considered it beneath their dignity to say 'Stop, who goes there?' to a woman . . . Whenever Colonel Lawrence was not engaged in conducting

LAWRENCE WOULD OCCASIONALLY DISGUISE HIMSELF AS A GIPSY WOMAN
OF SYRIA

Fig. 5. Lawrence as he might have looked in disguise. From Lowell Thomas, *With Lawrence in Arabia* (New York and London: Century, 1924)

major military operations or planting tulips [explosives] along the Hedjaz Railway, he would disguise himself as an outcast Arab woman and slip through the enemy lines."[14] His diminutive stature and hairless face—aspects of his appearance that were hinted at as unmanly—were advantageous in his new-found disguise. The head-to-toe veiling of an Arab woman, more importantly, allowed him to mask his racial identity. "For even though he did wear the robes and accoutrements of a shereef [*sic*] of Mecca, he only actually posed as an Oriental when he slipped through the Turkish lines wearing the veil of a native woman."[15] Thus, the dress of an "oriental potentate" was, after all, a disguise that fooled no one. It was only when he masqueraded as a woman that Lawrence *succeeded* in fooling anyone.

This female masquerade served other than tactical purposes, and we do not have to go far in the text to find them. The chapter preceding the revelation about Lawrence's cross-dressing is one of the several ethnographic snippets that periodically interrupt Thomas's narrative and that are aimed at educating a readership presumed to be generally ignorant about Arab society and Islamic customs. This particular interlude is about the place and experiences of women in Arab society. It begins provocatively enough: "'Perhaps the reason why women played such a small part in the war in the Land of the Arabian Nights,' explained Colonel Lawrence, 'was because their men-folk wear skirts and are prejudiced against petticoats.' Then adding philosophically: 'Perhaps that is one of the reasons why I am so fond of Arabia. So far as I know, it is the only country left where men rule.' . . . Arabia is one country, indeed, where the equal suffrage propaganda of Mrs. Catt and Mrs. Pankhurst has made little headway."[16] One should be suspicious of the attribution of these lines to Lawrence; nonetheless, Arabia is triumphantly

Race and Gender in Popular Culture

invoked as a refuge—possibly the last one—from the feminists who had become problematical for men throughout the period immediately preceding the war and the decade after it. Is the purpose of representing Lawrence as a female spy, then, to conjure up a fantasy of masculine "mastery" so complete that it makes women superfluous? In the context of the antifeminist remarks attributed to Lawrence, this interpretation would seem to be plausible.

But Thomas's text also markedly betrays an anxiety about this masquerade, as though it could backfire and subvert masculine mastery:

> *Masquerading as a woman also entailed many difficulties. At Amman, in the hills of Moab, east of Jordan, Lawrence went through the Turkish lines disguised as a Bedouin Gipsy. He spent the afternoon prowling about the defenses surrounding the railway station, and, after deciding that it would be futile for his Arabs to attempt to capture it on account of the size of the garrison and the strength of the artillery, he started toward the desert. A party of Turkish soldiers, who had been looking with favorable eyes at the Bedouin "woman," started in hot pursuit. For more than a mile they followed Lawrence, trying to flirt with him and jeering at him when he repulsed their advances.*[17]

As a "Gipsy woman" Lawrence was in danger of being mistaken for a prostitute and therefore approached, a danger he would have surely foreseen and one he would have hardly risked, if the purpose of the disguise was to render him less, not more, conspicuous. There is, of course, the possibility that Lawrence *wanted* to be caught. Apart from making the Turks seem gullible to the point of stupidity, is the deeper significance of this story, then, that Lawrence wanted to turn himself into an object of male desire? It is significant that just preceding this passage Thomas recounts Lawrence's capture by the Turks in a town called Deraa, where he was savagely beaten. Are we to presume that the disguise failed and that perhaps more than just a beating took place in the Turkish prison? The anxiety provoked in the reader over Lawrence being "found out" by the Turks—and possibly raped—momentarily overwhelms the sense of imperial mastery, of heterosexual masculine control, that the text wants to effect.

While men were fighting at the front, many qualified and educated women in Great Britain began to take over their jobs in basic industries. In *Women and the Popular Imagination in the Twenties* (1988), Billie Melman informs us that "The number of employed women rose from 5,966,000 in August 1914 to 7,311,000 just before the Armistice. More importantly, the workforce gravitated from the classical female occupations (the textile industries and domestic service) toward male ones, notably the munitions and ordinance industries."[18] Women continued to predominate in the workforce because of the high numbers of war fatalities among men. Melman points out that this numerous and relatively more affluent female working force became the basis of a new reading public, and we might add also a new film-viewing public. As a result of this perception of the "overabundance" of women, an antifemale reaction set in. The popular press, among others, dubbed them "superfluous women." "As the demobilization of some 4 million men progressed, the image of the patriotic female, epitomised in the figure of the woman munitions worker, was being superseded by that of the parasite who 'takes men's jobs.'"[19] The woman's supposed ubiquity was given as a reason for not extending her the vote, the fear being that she would end up dominating more than she supposedly already had.

Antifeminist reaction also set in against the emergence of a new concept of female beauty, the flapper, whose boyish figure and independent ways were associated in the press with a dangerous moral decline, not to speak of internal racial degeneracy. Melman argues that the flapper was contrasted to the "modern woman" of the same period who was imagined as simultaneously exaggeratedly feminine and sexless. According to her analysis, too, the flapper and the modern woman had their equivalents in the "modern man" and the *homme moyen sensuel,* the former of which came to signify intellectualism, bohemianism, effeminacy, or affectation (even homosexuality), and the latter of which was often represented in the figure of the "sheik" and is described as follows: "In the idiom of the period 'sheik' signified a virile, sensual male, a priapic, violent lover who masters females by sexual prowess and physical force. Significantly, the epithet was applied to oriental and occidental men alike. The new idiom became current at exactly the same time as the 'flapper' entered popular myth."[20] It is clear that the gender and sexuality of Lawrence are ambiguous in Thomas's representations—more like the "modern man" when Thomas emphasizes his androgynous appearance, scholarly pursuits, poetic inclinations, and seemingly asexual nature, and yet also like the sheik as a man of magnetic attraction to women. In regard to the latter, Thomas reveals in his memoir that "as a result of my production at Covent Garden he was being hounded night and day by autograph-fiends, reporters, magazine-editors, book-publishers, and representatives of the gentler sex whom he feared more than a Turkish army corps."[21] Lawrence's panic in the face of heterosexual entanglements, of course, reverses the predatory relationship of male and female as it was stereotyped in the image of the sheik. Hull's novel, to the contrary, reveled in that relationship to the hilt.

Almost nothing is known about the life of Edith Maude Hull, who signed her work using only her initials to preserve family anonymity. Biographical entries under her name don't even mention a date of birth and often fail to include a date of death, even after her novels had become famous. She was supposed to have been married to a gentleman farmer (or a dull pig breeder called Percy, depending on whom one reads) and lived in Derbyshire. While her husband was away at war, she is supposed to have sat down to write her first romance novel, *The Sheik* (1919), ostensibly because the family needed the money (or was it as solace for her own lack of sexual fulfillment, which is why she called herself Diana like her ravished heroine?). It is conceivable that interest in the novel—its sales are said to have surpassed those of "all the contemporary best sellers lumped together"[22]—was partly due to the success of Thomas's show and the interest it stimulated in English noblemen disguised as Arabs. Hull went on to write six more romance novels, including *The Sons of the Sheik* (1925), but none would come close to the popularity of her first book. She was dubbed "the queen of desert romance," and in the history of the genre has secured a lasting place, though her predecessors were also noteworthy (among them, of course, Robert Hichens and his best-seller *The Garden of Allah* (1904), which acquainted the English reading public with the Sahara Desert).

Whereas Lawrence was largely a creation of (and one suspects also largely for) men, Sheik Ahmed was the figment of a woman's imagination in a narrative that, in spite of its title, has a woman as its central protagonist, the Lady Diana Mayo. Identifying herself with the Victorian "lady travelers" of the desert, Diana Mayo is in a sense the female inverse of Lawrence and might be equated with Lawrence the "Gipsy woman" after "she" has been found out by the Turks. Her story is not that of the victor but of the vanquished, of the ravished. And, as Melman notes, her fate is supposed to be seen as a

redemption, even though (or perhaps because) its manner is the most harrowingly misogynistic imaginable. Astonishingly, it is this story that millions of women read and loved. And why? Is it another instance of a sadistic patriarchal system placing women in a humiliating position and teaching them masochistically to crave it? The echoes of Diana's predicament can be heard all the way up to Paul Bowles's even more chilling *The Sheltering Sky* (1949).

Diana Mayo has many of the cultural attributes of the flapper of the period. For example, the novel stresses over and over again her androgynous appearance and independent will. An unsuccessful American suitor of hers in the Biskra Hotel laughingly comments, "She was sure meant for a boy and changed at the last moment. She looks like a boy in petticoats, a damned pretty boy—and a damned haughty one."[23] With Sir Aubrey Mayo [her brother], it is explained, "she behaved like a younger brother, and as such entertained his friends. . . . Dressed as a boy, treated as a boy, she learned to ride and to shoot and to fish—not as amusements, but seriously, to enable her to take her place later on as a companion to the man whose only interests they were . . . her upbringing had been Spartan."[24] The one exception to the flapper image—and it is an important one—is her apparent lack of interest in sex. "I have never been kissed in my life," she warns the same suitor in the "oriental garden" of the Hotel Biskra. "It was one of the things that I do not understand." Her voice, we are told, "was almost fierce."[25]

In the first few pages of the novel, however, it is revealed that Diana's passion is less dead than dormant. In the same "oriental garden" in which she explains to her frustrated suitor that "A man to me is just a companion with whom I ride or shoot or fish; a pal, a comrade, and that's just all there is to it,"[26] she hears a beautiful baritone voice "singing in English, and yet . . . strangely un-English,"[27] a voice to which she is powerfully lured. Only much later will she learn to whom the voice belongs. For now she takes note of its resonances within herself, the awakening and quickening of her erotic desire. Her suitor understands the irony of her reactions only too well. "You say you have no emotion in your nature, and yet that unknown man's singing has stirred you deeply."[28] She explains that the song reminds her of India, the first hint that her passions are connected somehow to colonial possession. She reveals to her suitor, "The happiest times of my life have been spent camping in America and India, and I have always wanted the desert more than either of them."[29] She felt strangely at home, "as if the great, silent emptiness had been waiting for her as she had been waiting for it."[30] Another peculiar irony of Diana's Orientalism is the notion of the desert as a "home," a place for which she has been yearning but which has been denied her as an orphan brought up in the sterile society of upper-class England, and yet it is a home that is desolate. Nevertheless, those who do not quite fit in British society are supposed to find their "home" there.

Diana's strong-willed independence shows itself at the beginning of the novel when she stubbornly insists on undertaking an excursion into the desert, accompanied only by her Arab guides and porters, a trip that she takes against the outspoken disapproval of the English Victorian matrons at the hotel. However slightly, the scene suggests a rebellion against matriarchal culture. Diana receives even blunter criticism from her racist brother. "It's quite unthinkable that you can wander for the next month all alone in the desert with those damned niggers," he remonstrates with her.[31] Diana replies, "my life is my own to deal with, and I will deal with it exactly as I wish and not as any one else wishes. . . . I will *never* obey any will but my own."[32] Utterly exasperated, her brother throws back at her what seems, retrospectively, like a curse: "Then I hope to Heaven that one day you will fall into the hands of a man who will make you obey."[33]

Thus the stage is set for the inexorable contest of wills between an independent and seemingly frigid but beautiful white woman and the despotic, brutal, handsome, passionate "nigger" to whom she succumbs.

As she embarks upon her journey the next day, Diana's Orientalist vision of home is shattered when her party comes across a caravan carrying veiled women. Jarringly she is forced to recognize an unwanted prospect:

> *The contrast between them and herself was almost ridiculous. It made her feel stifled even to look at them. She wondered what their lives were like, if they ever rebelled against the drudgery and restrictions that were imposed upon them, if they ever longed for the freedom that she was reveling in, or if custom and usage were so strong that they had no thoughts beyond the narrow life they led. The thought of those lives filled her with aversion. The idea of marriage—even in its highest form, based on mutual consideration and mutual forbearance—was repugnant to her. . . . To be bound irrevocably to the will and pleasure of a man who would have the right to demand obedience in all that constituted marriage and the strength to enforce those claims revolted her. For a Western woman it was bad enough, but for the women of the East, mere slaves of the passions of the men who owned them, unconsidered, disregarded, reduced to the level of animals, the bare idea made her quiver and bring her hand down heavily on the horse's neck.*[34]

The ideological function of this passage is only too blatant, namely to place the Orient in a degraded position and, through Diana's censorious tone, to lift European civilization above it. Yet, as the story unfolds, the surprising, even shocking, lesson she learns is that this vision of the Orient is not only worse than she had anticipated, it is more desirable to her than she could have ever imagined. As the strange but beautiful voice in the garden had prepared her to expect, what she desired above all—though she did not realize it at the time—was to submit completely to the will of a man. Orientalism thus has everything to do with the sadomasochistic nature of her feminine desire. While the text is at least ambiguous as to whether rape should be condoned as her lot, it is unequivocal as to the goodness of the consequence: the taming of her willful nature.

Soon after she crosses the caravan's path, her own is overtaken by the sheik's party. She tries desperately to flee, but the sheik catches up with her horse and lifts her out of the saddle. Though she struggles mightily in his arms, his brute strength proves too much for her: "'Lie still, you little fool!' he snarled with sudden vehemence, and with brutal hands he forced her to obey him, until she wondered if he would leave a single bone unbroken in her body, till further resistance was impossible. Gasping for breath she yielded to the strength that overpowered her, and ceased to struggle."[35] He carries her back to camp and that evening rapes her. Every time he tries to have his way with her, she resists, but her struggles are in vain.

Why does rape figure in this shocking story about a woman abducted in the desert? In a very real sense, the independent modern woman that Diana represents has to be punished. Hull isn't even indirect or equivocal about this point. "She [Diana] had paid heavily for the determination to ignore the restrictions of her sex laid upon her."[36] Even more misogynistic is the presumption that rape is her redemption. By the end of the novel, for example, when our heroine loves the sheik in spite of his brutality toward her, we are told that "her alert, vigorous boyishness that had been so characteristic was gone. Her slim figure drooping listlessly in the big chair, her white face with the new marks of

suffering on it, and her wide eyes burning with dumb misery, were all purely womanly."[37] The flapper gives way to the modern woman, suffering sexual martyrdom.

What does Orientalism have to do with the rapist? Everything as it turns out. "He was pitiless in his arrogance, pitiless in his Oriental disregard of the woman subjugated. He was an Arab, to whom the feelings of a woman were non-existent. He had taken her to please himself, to amuse him in his moments of relaxation."[38] In other words, as an Oriental, and especially an Arab, he is the ideal man to teach a woman submission. To be sure, the figure of Ahmed is also a highly romantic one—handsome, lean, and preternaturally strong—and it is interesting the way in which his physical attributes elide into political ones, for he is also ceaselessly attentive to the affairs of his tribe, which he rules with an iron fist. The text draws an equivalence between the oriental rapist and the oriental ruler. He embodies the popular image of the "oriental despot," a not uncommon rhetorical maneuver in Orientalist texts.[39]

Melman argues that there is subversive agency in this story of Diana Mayo's rape. "For, unlike Clarissa [the heroine of Samuel Richardson's classic novel], the Englishwoman [sic] who is ravished in the Sahara does not virtuously die but lives to enjoy a blissful state of concubinage in the imaginary desert."[40] This conclusion is more apparent perhaps in the novel's sequel, The Sons of the Sheik, where we learn that Diana and Ahmed are happily married, she remaining virtually unchanged since her epiphany in The Sheik, whereas "love had come to soften the harshness of his expression."[41] Indeed, the realization of the enormity of the wrong he had committed against Diana almost crushes his soul. Here, a woman's agency transforms a wild, ruthless, and egotistical lover into a tender, considerate, and devoted husband. But one has to ask, What is subversive about living out this fantasy of contented submission to a determined, if repentant, patriarch? And it is interesting that whereas Diana was portrayed as more passionate in the first novel, she appears subdued and indeed marginal in the sequel that is centrally about the patriarchal regime of fathers and sons. Melman has surprisingly little to say about the horror of miscegenation that is at the heart of the text. "Only rage filled her—blind, passionate rage against the man who dared to touch her, who had dared to lay his hands on her, and those hands the hands of a native. A shiver of revulsion ran through her."[42] This fear, even more than rape, is her supreme punishment for her willfulness and independence. If brutality is what forces her submission and in turn awakens and quickens her passion, it is a sign of her love that she can eventually overlook the racial difference between her lover and herself. "A man of different race and color, a native; Aubrey would indiscriminately class him as a 'damned nigger.' She did not care. It made no difference."[43] Diana defies the color bar for the sake of love, and it is in this defiance, if anything, that she seems subversive. But then again, to love a "nigger" may be a sign to a patriarchal, racist audience of just how degenerate her gender has become.

There is perhaps another way in which to link the story with some form of female agency. It is important to remember that the period during and just after World War I was one of unprecedented discussion and expression of female sexuality. Freud was not the only important figure of the period to insist that women had powerful erotic interests.[44] In Hull's novel, consider the contrast between the corseted, full-skirted matrons in the Biskra Hotel with Lady Diana in her loose, knee-length, and flowing garments. She enjoys a freedom of movement, a confidence in her athleticism, that seems connected to a very different image of the female body: everything is in place in that body except for an erotic sexuality which, of course, her experience in the Sahara is supposed

to arouse. This sexuality is so threatening that it can only be expressed within a reinforced patriarchal order, represented by none other than the sheik. If Diana's "caretaker," her brother, was unable to discipline her, it is because western patriarchy had weakened and faltered. One had to travel to the Orient to find another, stronger, "redemptive" one. The sheik succeeds where Diana's brother had failed, confining her to the "freedoms" of the desert, in which she rides her horse literally to nowhere while giving her powerful libidinous drive free reign.

The novel's underlying theme of miscegenation can only be addressed by going beyond a history of gender, even one complicated by theories of race, in the 1920s. In Great Britain during and just after World War I, there was a sort of white mania against blacks just as there was against women, and for many of the same political-economic reasons, which in fictional works like *The Sheik* were displaced onto representations of the colonial "other." There had been a relatively sizable black population living in London and other parts of Great Britain for hundreds of years,[45] but it greatly increased during the war years. The anthropologist K. L. Little offered one of the earliest, and in many respects also one of the fullest, explanations for this increase:

> *The war brought to Great Britain many coloured men who in normal circumstances would have been repatriated by the government to their own country. For example, a larger number of ships which ordinarily operated on the West African and other routes on which Negroes and other coloured seaman are usually employed, were requisitioned by the Government for transport service, and their crews left behind. About the same time, coloured labor battalions were formed for service abroad, and the men were subsequently demobilized in Britain.*[46]

Just as women during the war were filling factory jobs ordinarily held by men, men of color were taking the place of white men, primarily in the shipping industry. They found lodgings in the major port cities of Great Britain—London, Liverpool, Cardiff—and in many cases settled down into marriage with English women. After the war, a fierce competition for jobs ensued. Letters in the press inveighed against black seamen who had added to the injury of taking jobs away from brave soldiers the insult of marrying their women. Race relations became frayed, with riots eventually breaking out in the summer of 1919 in Cardiff and Liverpool. The following year Parliament passed the Aliens Order, which severely restricted further immigration into the country.

This is the greatly abbreviated story as it is told in most of the literature on the period. However, a recent work by Laura Tabili[47] complicates it in ways that are both interesting and important for our study of Orientalism. As she points out, men of color who came from Britain's colonies made up a sizable number of troops fighting on both fronts, though this is not acknowledged often enough in the histories of the war. They entered the war, like Lawrence's Bedouin marauders, with explicit hopes of gaining their freedom. Because of their contributions to the war effort, they felt a sense of entitlement that was subversive to the empire. Moreover, black troops fighting in Europe were "allowed" access to local non-elite women in exchange for their participation in the war while the authorities looked the other way.[48] This "tolerance" of interracial sexual relations, of course, stopped as soon as the war ended. In the fraught race relations of Great Britain just after World War I, the fearful image of the sheik and the horror of miscegenation it evoked were probably not the product of Hull's feverish imagination alone. And it is significant that at the end of the novel, Diana does not return to England with

Ahmed but remains in the "oriental garden" of the colony, as it were, permanently "out there," where their outrageous coupling cannot threaten the society at large.

It is difficult to know how many people saw the movie *The Sheik* when it was released in 1921. According to one estimate, "The first filmed version . . . was seen by 125 million viewers, the majority of them—to judge from contemporary press reports—women."[49] If the figure seems inflated, there is nevertheless no doubt as to the film's popularity.

The sheik, not Diana, is at the heart of the cinematic melodrama, a significant departure from the characterization of the novel. Accordingly, it is not she who undergoes a profound transformation but he. In turn, he is much more "feminine" to begin with than his novelistic counterpart. One reason for both his centrality and effeminateness may have been due to the casting of Rudolph Valentino in the lead role. His signature performance accentuated a flamboyantly exhibitionist masculinity that flagrantly contradicted the notions of male ruggedness, forthrightness, and so forth, that were being codified in America at the time by the Boy Scout movement as well as amateur and professional sports (fig. 6). In feminist film criticism dealing with constructions of masculinity, Laura Mulvey's influential thesis—that women acquire a fetishistic status as objects to be looked at for male pleasure in patriarchal cinema—is applied to Valentino, who is "feminized" as a consequence of becoming a fetishized object, but not for male audiences so much as for female ones.[50] Miriam Hansen argues that "the Valentino cult gave public expression to a force specific to relations *among* women . . . as a synechdoche for a female subculture as strong as, though ideologically quite distinct from, the nineteenth-century cult of domesticity."[51]

Contributing to the analysis of Valentino's representation of masculinity, Gaylyn Studlar reminds us of how popular social dancing was in the United States from roughly 1900 to 1920, the period in which Valentino emerged as a performer.[52] Because of the proximity of the sexes in what was considered "dangerously physical" relations, social dancing was not always approved of. Most scandalous of all were dances like the tango and the apache, which on the one hand were associated with ethnic stereotypes such as the passionate Latin lover and on the other with the supposed violent lack of restraint of the lower classes. "Dance in the United States was offering a startling transformation of gender norms through androgynous inscriptions of the male body and reversals of sexual role playing, often mediated through the iconography of the Orient that reversed the long-standing male fascination with the culturally taboo (i.e., darker) woman and that conflated a wide range of foreignness, Mediterranean, Middle Eastern, Russian and Asiatic."[53] The masculinities performed in these kinds of dances were, as it was said of them in the period, "woman-made." They, like Valentino's screen character, existed for the libidinal imagination of women.

To counter the potency of Valentino's on-screen and off-screen personality, mostly male critics in the press unleashed vicious attacks on his "dubious" background as a professional tango dancer, with its air of social ill-repute and its taint of sexual vampirism and perversion. A "pink puff" article written for the *Chicago Tribune* implied that his effeminacy was connected to a homosexual identity. In part these reactions were defensive of a white middle-class masculinity that was "in crisis," as stereotypically male occupations such as farm laborer were supplanted by more sedentary, less wholesome jobs in the office. It was also under threat from immigrant "others" who were coming to the United States in greater numbers than ever before in the country's history, competing with white men for jobs and social recognition. Thus, Hansen connects the femi-

Fig. 6. Rudolph Valentino in a scene from *The Sheik*,
1921. Film still. Corbis-Bettmann

nization of the sheik's character with the ideological threat that Valentino's otherness
posed to white middle-class men; that is, "the feminization . . . functioned as a defense,
as a strategy to domesticate the threat of his ethnic-racial otherness."[54]

> When Valentino entered the movies in 1917—at first in bit parts and, then begin-
> ning in 1918, as a leading seducer-villain in several minor productions—the
> injunction against casting actors with distinct ethnic, not to mention racial, fea-
> tures in leading roles was firmly in place as ever. Even a star like the Japanese
> actor Sessue Hayakawa could succeed only in the part of a villain. The social
> discourse that maintained this injunction was the nativist movement that had
> gained momentum in the 1890s and culminated in the 1920s in response to the
> massive influx of the "new" immigrants from southern and eastern Europe—
> Italians and Jews—the very groups that populated the nickelodeon and entered
> the industry. . . . After World War I, as the failure of concepts of instantaneous
> "Americanization" became obvious, the discourse on the new immigrants increas-
> ingly assumed a racist tone, as differences of class and nationality were submerged
> into a biological discourse on race.[55]

This is an insightful analysis, but I think it reduces "otherness" a little too quickly within
the film to racial distinctions. It is not simply that "white" is contrasted to "black," but that
it is opposed also to "Jew" and "Italian." The question being posed in this period was
whether Jews or Italians, say, counted as "whites." Thus, the revelation of Ahmed's mixed
parentage at the end of both the novel and the film (he is born of an English nobleman

Race and Gender in Popular Culture

and a Spanish mother) has a precise correlate in the contested notions of whiteness and non-whiteness in this period of American history. Could Italians in America (Valentino, for example) claim to be white? Could Jews? I argue that the film shows us how "others" like Ahmed (but not the villainous Sheik Omeir) can become white.

The characterization of the sheik undergoes a drastic change in the film version, in that he is not a rapist. The threat of rape is constantly implied but ultimately displaced upon other "others," namely Sheik Omeir and his men, who appear decidedly more negroid or black in the film than the ambiguously colored sheik. This kind of racism is echoed in such films of the period as D. W. Griffith's *Birth of a Nation* (1915). I would argue, however, that the whole point of *The Sheik* is to show that he can act differently from racial others and therefore be worthy as a partner to a white woman like Diana and as a citizen of the American nation. His transformation into whiteness is closely related to her own character. It is she, I would argue, who tames and redeems *him*—and not, as in the novel, the other way around—and largely through her Christian faith.

The movie plays upon racist fears by intimating that the threat to Lady Diana is one of white slavery. This is established by a scene inserted at the beginning of the movie that does not appear in the novel. Trotting out one of the most predictable tropes of Orientalism, it depicts eastern marriage as a "slave market." We see loosely veiled, nubile young women alluringly displayed for purchase by Ahmed. The very beginning of the movie, which immediately precedes this scene, shows the call to prayer, with Islamic worshipers prostrating themselves on the desert floor, the editing suggesting that religion is to blame for this reduction of women to commodities.

The most attractive of the slave women, we soon learn, is in love with a servant named Yousef, who is present at the auction and declares his love for her. Showing that he can be moved by romance, the sheik allows them to get married, saying that he will not stand in the way of their love. This scene is crucial in the way it sets up motivations and actions to come. It makes clear that his erotic imagination can warm to the concept of romantic love, by means of which he is subsequently subdued and won over by Diana; and it establishes the background of Islam as a retrograde religion in contrast to Christianity, which, we later learn, sustains Diana's faith and makes possible Ahmed's redemption.

And what of Lady Diana Mayo's insistence upon remaining single and independent? Recall that toward the beginning of the novel, she is wooed by a young man in the oriental garden of the Biskra Hotel. She gently but firmly turns him down, explaining that "Marriage for a woman means the end of independence."[56] This much of the action follows the novel closely. Just as the man is making his proposal of marriage in the film, however, Diana begins to be aware of the sheik's grand entrance into town with his colorful entourage. In the novel, the sheik remains invisible to her in the garden; in the film, they quiveringly exchange such smoldering looks that we feel it is less the idea of sex and marriage that is repugnant to her than the unwholesome sort of men who have been its candidates—until now, that is. The sheik is obviously a different "breed" from the pomaded and bloodless creature who had been wooing her only a moment ago. She is more willful than independent, rather like a spoiled child than a committed feminist.

The second scene inserted in the screenplay that is not present in the novel follows Lady Diana's first fateful encounter with the sheik. She schemes to find a way to crash his private party in the hotel, though what the audience knows and she does not is that the men are gambling for women who have been purchased by Ahmed in the marriage market. She hits upon the idea of dressing as an Arab dancing woman so that she can sneak past the guards at the entrance to the sheik's inner chambers. She quietly takes a seat at the

back, thinking she will not be recognized under her veils. But she is saddened to discover what is happening in the room and then mortified when she is chosen to be the next "wife" placed in the lottery. She is dragged before the sheik, who roughly grabs her, the contrast in the skin colors of their arms now becoming blatantly and alarmingly apparent. Growing suspicious, he loosens her veil and is delighted to find the beautiful white woman whom he admired earlier that evening. Diana, in effect, has put herself on the market to be sold into white slavery. But unlike the defenseless girl at the slave market who had to plead for her master's mercy, she brandishes a gun at the sheik and wards off his advances. He asks her to leave and with an air of mock civility escorts her to the door.

What happens next? In the novel, once Lady Diana is captured by the sheik and taken to his encampment, she is raped repeatedly until her will is broken and she submits to his power. In the film, although rape may have been his intention, there is ample reason to believe that the sheik never carries it out.

Shortly after Diana Mayo arrives in the sheik's elegant desert encampment, obviously dazed but still very much clothed in her white colonial topee and riding outfit, the sheik commands her to dress for dinner. She next appears in elegant evening attire with, significantly, a cross around her neck. In the novel, there is a jade necklace—a present of her lover—in the place of the cross, but the film means to leave no doubt as to the power of Christianity in saving this young woman and her lover and thus triumphing over its arch adversary, Islam.

The two struggle, and Ahmed seems on the verge of overwhelming Diana when the servant Yousef barges into the tent. He reports that the horses have gotten loose in a sandstorm and that the sheik's help is required in retrieving them. Disgusted by this interruption, he nevertheless leaves to tend to this chore while Diana, visibly relieved, slumps by the side of the bed with her hands clasped in fervent prayer, her head raised heavenward, the cross around her neck gleaming like a beacon in the infernal darkness. Upon returning, Ahmed leans over the praying figure with a lascivious grin and crudely signals his predatory intent, but Diana's uncontrolled sobbing—as well as her prayerful attitude—stirs his pity and remorse. He is chagrined. Slowly he moves towards the tent door, his hand clutching the flap, his arm, which is extended from his body fully erect, suddenly falling limp at his side, a none too subtle allusion to his impotency. He claps his hands for the servant to enter.

The same young woman who was given to Yousef in marriage by the sheik comes in at his command, and it is in her comforting embrace that Diana spends the night, not Ahmed's. Her presence, precisely because it reminds us of the faithfulness of true love, reinforces the idea that devotion, not rape, must frame the erotic entanglement of man and woman. The next morning Diana awakens to find rose petals being strewn upon her bed by the servant girl. She looks ruefully at the other room, where she supposes Ahmed to be, but the servant girl, who seems to have read her thoughts, reassures her that the sheik never touched her during the night. The film creates a flashback by fusing a scene of Diana sitting upright in bed with a scene of her lying asleep with the servant girl on the floor beside the bed, at both times in unmolested repose. Clearly, up to this point the sheik has not only *not* carried out his design of rape, he seems to have had a change of heart about how to win his beloved. He intends to woo her rather than rape her. The next morning, a breakfast tray is prepared for Diana upon which Ahmed delicately places a rose.

The horror of miscegenation, so central to Hull's novel, is considerably abated in the movie, in part because abduction and white slavery give way fairly quickly to courtship

and Christian marriage, but also because it is displaced onto Ahmed's rival and archenemy Sheik Omeir and his people, who are portrayed as "black." At the end of the movie, after Diana falls in love with Ahmed and agrees to live with him, she is once again abducted, this time by Omeir. In his stronghold, we see women in dark and skimpy outfits dancing to tom-toms, as if in a Tarzan movie. Diana is guarded by a giant black man who leers at her significantly when it is time for her to be presented to his master. Ahmed rescues Diana from her fate—even asking her whether he was "in time" (and is assured that he was)—but in the process is almost killed by the black guard. In fact, he survives, whereas the black man does not. This too, of course, is allegorically significant in the context of American race relations.

Why is this a story about a man learning how to become a "civilized" or "bourgeois" (and therefore suitable) mate for a white woman? Bear in mind that the sheik, the son of a British nobleman and a Spanish mother, is different from someone who is racially "pure" (at least in terms of the racial categories prevalent in that day), but he is not "black" either. Later, he would be called a distinct ethnic type, but the difference between ethnicity and race had not yet sorted itself out in this way. In the United States after World War I, immigrants coming from the Mediterranean, Russia, and elsewhere were supposed to become citizens of the country, yet they could not readily or easily assimilate to prevailing biological or cultural notions of "whiteness." The character in the film personifies this racial and cultural ambiguity, as Matthew Frye Jacobson points out in his study of the period,[57] for Valentino's face appears light-skinned while his hands are dark, especially as they clasp the very fair arms and shoulders of Agnes Ayres, who played Diana (see p. 98). One could argue that what was ideologically at stake in the film was the question, Who could claim "whiteness" in America? The immigrant who is neither white nor black but confusingly in-between could become a "bourgeois" citizen of the country with the helping hand of the patronizing white woman. The love story of Diana and Ahmed is a parable of what is required of the ambiguously "white" other, if he is to join the American polity. He must learn to act white (that is, become "Christian" and "bourgeois"), learning to tame his savagery in order to become a fit mate for the white Diana. And so, libidinal attraction to a dangerous type is justified and legitimate for the sake of a national melting pot, paid for by the exclusion of the black man. And this is also part of the story of how immigrants in the United States constructed themselves as "white" in contrast to "black" Negroes.[58]

In one final speculation, playfully offered, I would suggest that the film's exoticism is suggestive less of the Sahara than the Mojave Desert, less of the British colony than of Hollywood, and this makes sense because Hollywood was itself built by immigrant "others" clamoring for recognition and respectability. Anyone who has seen the film is struck by its staged quality. This quality can be obvious in the way that whole cities seem to shimmer on canvas; or subtle, in the way that tents look like houses looking like studio sets; or more subtly still, as when many scenes are framed by tent flaps and awnings, as if on a proscenium stage. These effects were calculated, in my view, not the crude outcome of a naive, fledgling industry. Even many desert shots are "framed" by a black circle suggestive of the camera's rim, reminding the audience that this is, after all, still a Hollywood film. In other words, the "faraway" place portrayed in the film is, on another level, Hollywood. And this is what is also peculiarly American about *The Sheik* at this time of the infancy of the American film industry: it offers the dream of a partnership between white and ethnic other, implied by the handclasp of Diana and Ahmed before the final fade-out, presided over by Hollywood in America's final frontier.

My thanks to Holly Edwards, Victoria Hattam, Amit Rai, and Donald Scott for their careful reading and criticisms of this paper. Victoria Hattam and Amit Rai both suggested helpful texts from which I learned a great deal about the history of race in Great Britain and the United States in the first two decades of this century.

1. Hodson 1995, 28.

2. Besides Hodson 1995, see also Thomas 1976.

3. See Thomas 1922b.

4. Ibid.

5. See Scott 1980 and Scott 1983.

6. See Gunning 1991 for some background on the early years of American cinema.

7. Thomas 1922b.

8. Unless indicated otherwise, all citations herein are from the transcript prepared by Thomas for Dale Carnegie. See Thomas 1922a.

9. See Dawson 1991, which has a great deal to say about constructions of masculinity in the post–World War I period. His analysis is based, however, on Thomas's published writings about the show and not on the actual transcript, which he wrongly presumed did not exist.

10. See, for example, Friedman 1995, 88.

11. Thomas 1924, 366.

12. Ibid., 243.

13. Ibid., 244.

14. Ibid., 245.

15. Ibid., 371.

16. Ibid., 230.

17. Ibid., 251.

18. Melman 1988, 6.

19. Ibid., 17.

20. Ibid., 89.

21. Thomas 1924, 348.

22. Melman 1988, 90.

23. Hull 1921, 2.

24. Ibid., 12, 20.

25. Ibid., 15.

26. Ibid., 11.

27. Ibid., 13.

28. Ibid., 14.

29. Ibid., 15.

30. Ibid., 24.

31. Ibid., 26.

32. Ibid., 28.

33. Ibid.

34. Ibid., 35–36.

35. Ibid., 54.

36. Hull 1921, 88.

37. Ibid., 243.

38. Ibid., 92.

39. See Rai 1998.

40. Melman 1988, 93.

41. Hull 1925, 44.

42. Hull 1921, 53.

43. Ibid., 133–34.

44. See Hobsbawm 1989, 192–218.

45. See Scobie 1972.

46 Little 1947, 56.

47. I leave aside the larger and original argument of Tabili's book, which has to do with the contradictions in British institutional racism, in order to focus on some of the details she provides on men of color in the war and immediately thereafter.

48. Tabili 1993, 24.

49. Melman 1988, 90. No explanation is given as to how the figure was determined.

50. Mulvey 1975, 6–18.

51. Hansen 1991, 260–61.

52. Studlar 1993, 23–45.

53. Ibid., 33.

54. Hansen 1991, 260.

55. Ibid., 255.

56. Hull 1921, 11.

57. Jacobson 1998. I also owe a great deal of my understanding of the complexities of the discourses on race in the United States from 1900 to 1940 to conversations with Victoria Hattam.

58. See Roedigger 1944.

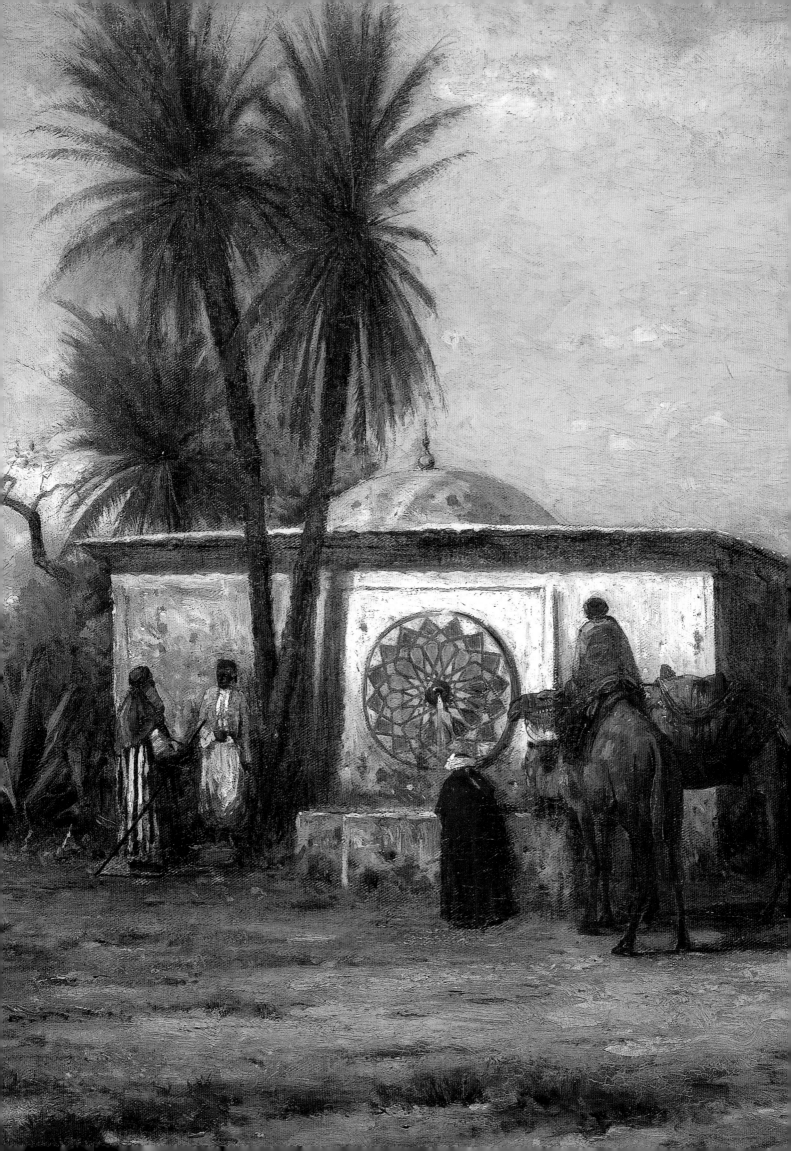

R Swain Gifford -76

Portrait of an Orientalist

Thomas Hicks's portrait of Bayard Taylor (1825–1878)[1] depicts the author of *Lands of the Saracen* (1855), one of the most widely read travelogues of the nineteenth-century.[2] Travel accounts, which were often serialized in magazines first, enjoyed a remarkable popularity at the time, verging on a craze. Those who wrote them scrambled to avoid being "scooped" in their evocations of far-off places.[3]

In this competitive milieu, Taylor reigned supreme as "The American Traveler," garnering an enthusiastic following and large sums of money on the lecture circuit. In so doing, he established a genre of Orientalist performance that capitalized on the mystery and allure conventionally associated with that part of the world. Like Lowell Thomas half a century later (see pp. 100–107), Taylor provided audiences with an armchair experience of the Orient. He presented himself as a charismatic adventurer, causing Victorian women to swoon and becoming, in a straight-laced nineteenth-century way, a sort of sex symbol, anticipating the stardom of Rudolph Valentino, who also rose to fame in Arab dress.

Taylor loved to dress the part, frequently donning Arab costume and generally cutting a dramatic public figure.[4] At one raucous party in the Tenth Street Studio building in New York City, he dressed as an Arab and delivered an impromptu speech, ostensibly in Arabic.[5] Such flamboyant acts were a celebratory extension of his travel experiences, during which he adopted "the Oriental costume, which, from five months wear in Africa, I greatly preferred to the Frank." At one point, he described himself and a companion riding out of Beirut as "a pair of Syrian Beys, while François, with his belt, sabre and pistols, had much the aspect of a Greek Brigand."[6] Clearly, dressing up and indulging in heady adventures was to his liking.

Dressing "native"—any kind of native—was a rest cure for Taylor, a masquerade "to escape from everything that could remind me of the toil and confusion of the bewildering world."[7] However, the Orient in particular seems to have epitomized for him freedom from the confines of civilization. He admitted that there were a number of ingredients in his decision to travel there. Aesthetic inspiration came largely from the painter Miner Kellog, who had spent two years in Egypt, Palestine, and Turkey, and whose sketches turned Taylor "half crazy to travel there."[8] He was also "threatened with an infection of the throat for which the climate of Africa offered a sure remedy." But most important of all was the sheer escapism. For him, it offered a "release from the drudgery of the editorial room. After three years of clipping and pasting and the daily arrangement of a chaos of ephemeral shreds, in an atmosphere which soon exhausts the vigor of the blood, the change to the freedom of Oriental life . . . was like that from night to day."[9]

Having benefited from this revivifying experience, and having garnered considerable acclaim as a travel author and lecturer, Taylor extended and institutionalized his exotic persona by commissioning Hicks to paint his portrait in Arab dress. As a record of

1. Hicks painted another orientalizing portrait with similar features. See Davis 1996, 42 and note 35. In general, Hicks is not a well understood painter, despite his considerable reputation during his own life. See Tatham 1983.
2. Taylor traveled to Egypt, Asia Minor, and Syria in 1851 to write articles for the *New York Tribune*, which were ultimately turned into book form. See Davis 1996, 43.
3. On the genre and popularity of travel literature see Sha'ban 1991, 115–40.
4. Tomsich 1971, 28.
5. McCoy 1966, 8.
6. Taylor 1855, 33. See also Smyth 1896, 88–89.
7. Tomsich 1971, 42–43.
8. Davis 1996, 42.
9. Smyth 1896, 97.
10. Letter to his mother dated 13 June 1854, in Taylor and Scudder 1884, 277. The image appeared as the frontispiece of *Putnam's Magazine* 4, no. 20 (August 1854).

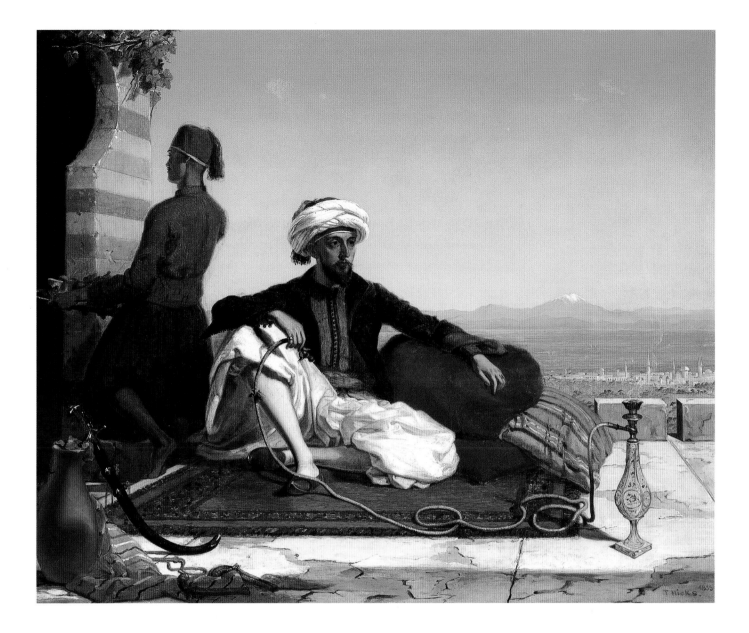

1 THOMAS HICKS

American, 1823–1890

Portrait of Bayard Taylor

1855

Oil on canvas, 24½ × 29¾ inches (62.2 × 75.5 cm)

Signed, lower right: T. Hicks 1855

National Portrait Gallery, Smithsonian Institution,

Washington, D.C.

adventure and accomplishment, the portrait no doubt served a complex personal function of self-aggrandizement and fantasy. But Taylor was intent on creating a public image as well. Shortly before this portrait was done, a daguerreotype was made of Taylor in Arab dress, to be engraved for *Putnam's Magazine* (p. 35, fig. 14). [10] The broad dissemination of such imagery, by means of widely circulating popular magazines, presumably served entrepreneurial purpose, consolidating Taylor's charisma in the public eye.

Visually recording oneself in the garb of "other" is a loaded act of Orientalism. What are the sources and ploys of this particular painting, and what are its implications? To answer these questions, it is useful to compare Taylor's prose with his portrait. In *Lands of the Saracen*, there is a chapter entitled "Pictures of Damascus" that begs for comparison with Hicks's depiction of Taylor, which was exhibited in 1856 at the National Academy of Design under the title *A Morning in Damascus:*

> *Wednesday, May 19, 1852: Damascus is considered by many travelers as the best*
> *remaining type of an Oriental city. Constantinople is semi-European; Cairo is fast*
> *becoming so; but Damascus, away from the highways of commerce, seated alone*
> *between the Lebanon and the Syrian Desert, still retains, in its outward aspect*
> *and the character of its inhabitants, all the pride and fancy and fanaticism of the*
> *times of the Caliphs . . . it is the realization of all that you have dreamed of Orien-*

tal splendor; the world has no picture more dazzling. It is Beauty carried to the Sublime, as I have felt when overlooking some boundless forest of palms within the tropics.[11]

Clearly, Damascus epitomized the Orient for Taylor; it was "the representative of all that is gay, brilliant and picturesque in oriental life."[12]

At the hotel in the Soog el Harab, or Frank quarter, the illusion was not dissipated. It had once been the house of some rich merchant. The court into which we were ushered is paved with marble, with a great stone basin, surrounded by vases of flowering plants, in the center. . . . The walls of the house are painted in horizontal bars of blue, white, orange and white—a gay grotesqueness of style which does not offend the eye under the eastern sun. . . . Beyond this is a raised floor covered with matting, and along the farther end a divan, whose piled cushions are the most tempting trap ever set to catch a lazy man. Although not naturally indolent, I find it impossible to resist the fascination of this lounge. Leaning back, cross-legged, against the cushions, with the inseparable pipe in one's hand, the view of the court, the water basin, the flowers and lemon trees, the servants and dragomen going back and forth, or smoking their narghilehs in the shade—all framed in the beautiful arched entrance is so perfectly Oriental, so true a tableau from the times of good old Haroun al Rashcid, that one is surprised to find how many hours have slipped away while he has been silently enjoying it.[13]

Taylor's portrait transposes his prose into self-indulgent image. It replicates certain details exactly and captures that indolent enjoyment by means of relaxed pose, rich palette, and compositional quietude. There is, quite literally, not a cloud in the sky of this luxurious experience.

When Taylor wrote about his travels, he wanted to share his experience with those less fortunate than he:

If a few of the many thousands, who can only travel by their firesides, should find my pages answer the purpose of a series of cosmoramic views . . . should in them behold with a clearer inward eye the hills of Palestine, the gilded minarets of Damascus . . . should feel by turns something of the inspiration and the indolence of the Orient—I shall have achieved all I designed and more than I can justly hope.[14]

His tone in this passage seems just a little disingenuous, the coy modesty of the last phrase betraying condescension from a vantage point of privilege and expertise.

The painting upholds Taylor's haughtiness most literally with regard to race. White stockinged limb lounges while bare black leg works; white hand toys with hookah pipe while black arm provides refreshment. Indeed, that soft white hand stretched out across the scarlet pillow is an eloquent and spacious gesture. It serves to encompass Taylor's domain, to define Taylor's entitled status, and to underline his privileges—pipe, comfort, and view. But it is perhaps the view itself that sustains his hauteur most tellingly. Even the snow-capped mountain in the distance is lower than his turbaned head, and the glistening white cityscape implies a population at his fingertips. This is not the portrait of a humble man.

That the portrait would extol its subject by means of landscape is not surprising.

11. Taylor 1855, 120.

12. Ibid., 122, 126.

13. Ibid., 123.

14. Ibid., preface.

15. Taylor, on the experience of buying his own farm, quoted in Boime 1991, 104.

16. On Taylor as illustrator, see Davis 1996, 42.

17. Boime 1991, 101–5.

18. Taylor 1855, 451.

19. The *Thousand and One Nights* is alluded to with the reference "times of good old Haroun al Rashid" (Taylor 1855, 178, 197).

Like others of his generation, including pioneers, railroad magnates, and wealthy industrialists, Taylor perceived land as the currency of accomplishment, worldliness, and status. Ownership was critical: "Yes one cannot properly be considered as a member of the brotherhood of Man, an inhabitant of the Earth, until he possesses a portion of her surface."[15]

These widely held convictions, moreover, were amplified in Taylor by a pronounced aesthetic sensibility. Taylor was a friend of Frederic Church (see cat. no. 2), as well as many other landscape painters of the day. He shared their tastes and interests and dabbled in painting himself.[16] He was someone for whom landscape was language, and panoramic views were insight. Knowing all of this, how are we to understand a portrait of Taylor viewing the landscape of the Orient?

One scholar has concluded that Taylor's elevated position may be equated with the magisterial gaze of Manifest Destiny, in which the viewer subjects the land to surveillance as well as dominion.[17] It is conceivable that the portrait effectively extends that proprietary attitude to the landscape of the Orient, thereby visualizing the privileged relationship to the Holy Land that so many Americans presumed. Alternately or additionally, Taylor did lay pedagogical claim to the Orient and had himself portrayed grandly surveying his domain of expertise.

Ultimately, however, the Orient was Taylor's domain metaphorically. His was a tourist's adventure, complete only upon his return to "civilization." As he says at the close of his book, "next to the pleasure of seeing the world, comes the pleasure of telling it, and I must needs finish my story."[18] In telling that story and then commissioning a portrait based upon the story, Taylor revealed his genesis as an Orientalist. It was a progressive process. First he formed a set of expectations and associations at home by means of such sources as the *Thousand and One Nights*,[19] then he traveled in search of respite from the worries of the world. Finally, he returned home to relive his experiences, enacting them with sartorial verisimilitude for his contemporaries. In this way, Taylor became a consummate Orientalist, for he fabricated both an Orient for his public, and a public for his Orient.

Painter of the Holy Land

Jerusalem from the Mount of Olives (cat. no. 2) was presented to the New York public in 1871, after Frederic Edwin Church returned from abroad.[1] Having spent eighteen months in Europe and the Holy Land (1867–69), the artist was forty-four years old and his reputation was beginning to wane. He did not endear himself to his colleagues by unveiling the picture in a private exhibition at Goupil's rather than in a group show at the National Academy of Design. Many considered it an act of self-aggrandizement; moreover, the painting was not unanimously applauded. It was criticized, in part, because it was not perceived as an artistic "composition"—a creative whole synthesized from discrete and carefully observed elements. Instead, the painting was characterized as "cold, logical and true," a literal transcription of a particular site. As such, some viewers argued, it did not inspire or appeal.[2]

The vantage point of the painting also elicited comment. One critic noted: "The point of view chosen by Mr. Church is one which permits nearly all the objects of interest in and around Jerusalem to be comprehended at a single glance."[3] The *New York Tribune* called the picture "a map of Jerusalem and its suburbs."[4] These comments suggest that the picture was *not* a simple transcription of fact but rather a synoptic and controlling vision. All maps are, and this particular one was imbued with the Protestant convictions of its maker.

Church was profoundly pious. His Presbyterian faith provided the framework for his existence and punctuated the daily rhythm of his life, from morning prayers to regular hymn singing. In fact, he was so earnest in his religious convictions the artist Jervis McEntee described him as being "too heavily weighted with Presbyterian strictures to have a very good time."[5] It was this sober, even ponderous, religiosity that inspired his trip to the Holy Land. While he was there, he and Isabel, his wife, spent much of their time in the company of like-minded missionaries and expatriates. They became close friends of D. Stuart and Ellen Dodge and Daniel and Abby Bliss, who were instrumental in the Syrian Protestant College (later the American University of Beirut), attended prayer services, visited charitable institutions, and generally participated in what Isabel called a "lovely Christian circle of friends."[6]

Jerusalem from the Mount of Olives, in turn, was a pious picture. Its spiritual connotations and the complex setting of Protestant religiosity in which it was received have been analyzed brilliantly by John Davis.[7] Composed from careful sketches and earnest exploration, the painting offers the viewer an opportunity to walk in the footsteps of Christ toward spiritual transformation. As the accompanying key stipulated, "The spectator is supposed to stand in the early spring on the Mount of Olives facing the west."[8] From this vantage point the viewer is invited to enter the picture and follow the Savior to see what he saw each day at the end of his life and to experience personal redemption in the distant radiance of the divine.[9]

If the painting was suffused with spiritual convictions, it was also a product of

1. The bibliography on Church in general and on this painting in particular is large. The best and most synthetic treatment is that in Davis 1996, 186ff.

2. Ibid., 189.

3. *New York Times*, 2 April 1871, 3:7. I thank Kyle Johnson for this citation.

4. Davis 1996, 189.

5. Karen Zukowski, curator of Olana, provided me this quote from the *Diary of Jervis McEntee* for 19 May 1885, Archives of American Art, Washington, D.C.

6. This description of Church's piety is informed by Zukowski forthcoming.

7. Davis 1996, 185–92.

8. Davis reproduces the key in ibid., 190.

9. Ibid., 190–92.

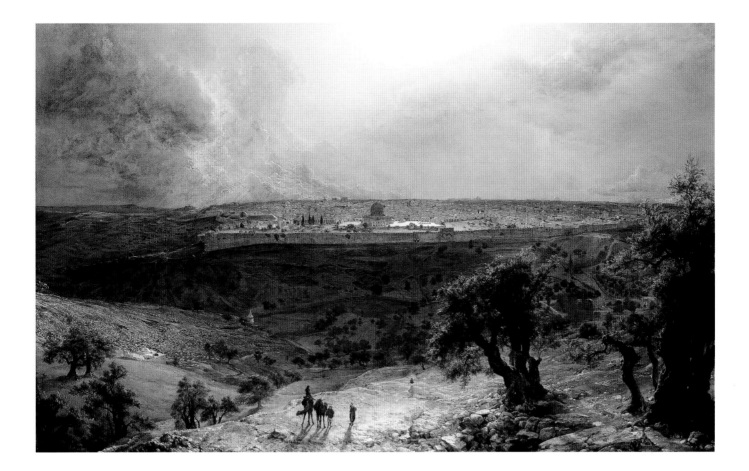

2 FREDERIC EDWIN CHURCH

American, 1826–1900

Jerusalem from the Mount of Olives (with Engraved Key)

1870

Oil on canvas, 54¼ × 84⅜ inches

(137.8 × 214.3 cm)

Signed, lower right: F. E. Church 1870

The Nelson-Atkins Museum of Art, Kansas City, Missouri. Gift of the Enid and Crosby Kemper Foundation

documentary enterprise. The painter shared these attitudes with another group of "friends," as a larger enterprise of exploration, excavation, and mapping of the Holy Land was being undertaken at the time.[10] This era witnessed the construction of the first "modern" roads (e.g., that from Jaffa to Jerusalem, which facilitated tourism), the first "accurate" map of the Dead Sea and Jordan River, compiled by United States naval officer William Lynch for the Department of War, and the extensive mapping and archeological excavations undertaken by the Palestine Exploration Fund. That Church was implicated in these processes is clearly demonstrated by his "member" status in the American Palestine Exploration Society. Along with its British counterpart, this organization set about establishing a detailed and accurate map of Palestine with reference to archaeology, geography, and natural history, in an effort to contextualize biblical sites in an unimpeachable scientific fashion. The publications that these societies produced are replete with racist and imperialist sentiments, and the maps that they generated were later used in campaigns against the Ottoman Empire.[11]

In general, maps *are* ideologically burdened world pictures. They are most often compiled by military forces and often serve the purposes of surveillance and conquest. But they are also suspect for their encoding of geographical "fact." In any translation of spatial and geographical elements into the confines of two dimensions, the evidence is inevitably distorted, deleted, or otherwise infected with the mapmakers' own agendas. Church's "map" was no exception. The selection of a high vantage point (which generated the maplike quality of the painting) is particularly telling. Church chose the Olivet site from which to depict the holy city, following the advice of colleagues and geographers. In so doing, he was able to delete all that was deemed crass and squalid in the Ottoman city and erase "distasteful" evidence of non-Protestant shrines and churches.[12] To a degree, Church compensated for this editorial policy in his key, wherein he identified the Mosque of Omar, a Russian hospice, and a Jewish cemetery, along with the Holy Sepulchre and the Tomb of the Virgin. Thus, he acknowledged the "other" without having to look too closely at it. In this fashion, the painter as well as the viewer was granted a perspective conducive to personal comfort and spiritual redemption in a Protestant mode.

In his map, Church renders the viewer's space continuous with an idealized Orient. Like his colleagues in the American Palestine Exploration Society, he mapped the Orient for his own purposes and made it conform to some peculiarly American convictions. Of course, exploration was a symbolic act for a citizen of the land of Manifest Destiny. Church was implicated in a national campaign of exploration, and he was effectively mapping a new world. The viewer was given a summary of Jerusalem "at a single glance" and then provided with a route through the landscape by means of a key. In a sense, he supplied "an aperture of dominion"[13] through which the public might view the Holy Land.

This painterly directive was amplified by the moralized context in which it was executed. America, it was generally presumed, had a special typological tie to the Holy Land; the United States was deemed to be the New Israel, the Promised Land for a chosen people. By this logic, redemption was not only a personal option but a collective and inevitable destiny. And it is by this logic, too, and in the implicit slippage from the individual to the collective, that Church's piety and Orientalism intersect.

Ultimately, *Jerusalem from the Mount of Olives,* with its printed key and topographical specificity, was anomalous in Church's oeuvre. By contrast, *Sunrise in Syria* (cat. no. 3) was an artificial "composition" of carefully observed vignettes and tested tropes,

10. Johnson 1996, 19–23.

11. Davis describes it as an "acquisitive, ideologically charged enterprise of Palestinian exploration." Davis 1996, 187.

12. Ibid., 188.

13. This is Kyle Johnson's phrase. See note 10.

3 FREDERIC EDWIN CHURCH

Sunrise in Syria

1874

Oil on canvas, 30½ × 25½ inches (77.5 × 64.8 cm)

Signed, lower right: F. E. Church 1874

Courtesy of Alexander Gallery, New York

more in keeping with the rest of the artist's work. With its isolated and weathered columns standing in microcosmic natural Eden, this painting served to classicize the Orient as a site of ruins and past glories, thus creating a counterpoint to the pristine and profound potential of the New World. Together, these two pictures encompass the scope of Church's painterly Orientalism, in which time and space are telescoped to convey the artist's dearly held truths.

A French Orientalist

\mathcal{T}he inclusion of paintings by the French orientalist Jean-Léon Gérôme in a catalogue about American Orientalism requires explanation. The pictures represent what has come to be seen as the paradigm of Orientalist painting[1] and declare a fundamental methodological premise: Orientalisms are most clearly revealed by a comparative method. The paintings also serve to suggest the general trajectory of current scholarly thinking about Orientalism in the visual arts and indicate where further work might still be undertaken.

To date, Gérôme is perhaps the only Orientalist to have received sufficient critical attention to allow a nuanced understanding of his accomplishments and attitudes. Ironically, the reevaluation of Gérôme's role as an Orientalist was launched in 1972, by Richard Ettinghausen, a scholar of Islamic art and architecture. Ettinghausen, intent on determining the range and documentary reliability of Gérôme's depictions of the Orient, concluded that Gérôme was "a very gifted and truthful observer of long past colorful scenes of the Near East."[2] This generous assessment was irrevocably altered by the 1978 publication of Edward Said's incendiary work, *Orientalism*. Scholarship then split into the Said camp,[3] intent on unpacking the unsavory ideological underpinnings of such painting, and a more celebratory contingent, who see it as a respectful (and respectable) genre with deep art-historical roots.[4]

Predictably, the current consensus lies between the extremes. Thus, one can acknowledge the accuracy of Gérôme's Arabic inscriptions, his architectural renderings, or his ethnographic detail[5] and also point out his predilection for faked ensembles and titillating narratives. A key factor in this incongruous combination of "authenticity" and fabrication was the new medium of photography, which enabled Gérôme to record the elements of verisimilitude and rearrange them in the studio. His final products, then, were mosaics of authentic pieces, sometimes rearranged for pictorial effect, which often involved cultural distortion.[6]

Scholars have also begun to address the relationship between the artist and buyer and its effect on Orientalist imagery and the modern understanding of it. Gérôme painted many Orientalist pictures between 1855 and 1880, a period which witnessed considerable economic vitality and expansion in France. Even after 1880, when he was more interested in sculpture, Gérôme continued to turn out pastiche pictures from his huge store of sketches and memories. And in these pragmatic productions, misrepresentations undoubtedly increased. But then, as Emile Zola noted at the time, "Gérôme works for all tastes."[7] Ironically, the postcolonial marketplace has been particularly enthusiastic about Gérôme and his cohort, a fact that undermines Saidian theories about the denigrations implicit in Orientalist paintings.[8]

Gérôme's oeuvre has also been analyzed with reference to his life and personality. According to one scholar, Gérôme was conflicted about women and power, and was obsessed with the markers of ownership, amassing bibelots and depicting enslaved vic-

1. Gérôme's de facto status as the paradigmatic figure of Orientalist painting was formalized, for example, in Benjamin et al. 1997, 16–17; 99ff. Two basic sources on this artist are Ackerman 1986b, and Weinberg 1991, chap. 5.

2. Richard Ettinghausen, "Jean-Léon Gérôme as a painter of Near Eastern Life," in Ackerman and Ettinghausen 1972, 16–27.

3. E.g., Nochlin 1983, 119.

4. E.g., Ackerman 1986a, 75–80.

5. Denny 1993, 220–21.

6. Williams 1993–94, 137–39.

7. Cited by Williams, in ibid., 134.

8. Roger Benjamin, "Post-Colonial Taste: Non-Western Markets for Orientalist Art," in Benjamin et al. 1997, 32–40.

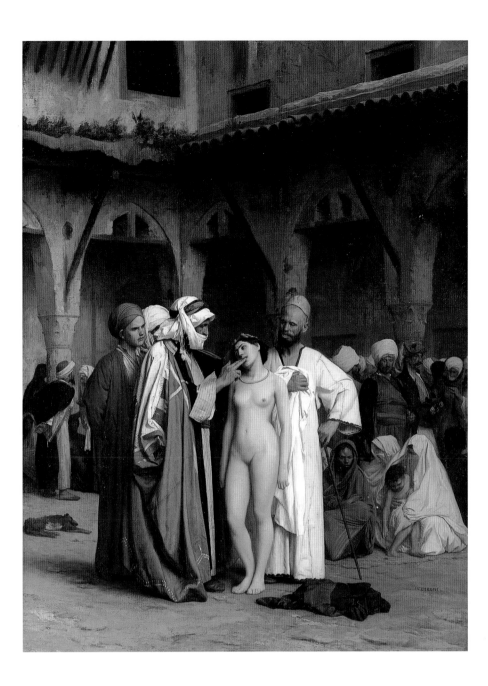

4 JEAN-LÉON GÉRÔME
French, 1824–1904

The Slave Market
1866
Oil on canvas, 33³⁄₁₆ × 24¹³⁄₁₆ inches (84.3 × 63 cm)
Signed lower right: J. L. GEROME.
Sterling and Francine Clark Art Institute,
Williamstown, Massachusetts

tims. And as he grew older, he became very opinionated, aligning himself against liberal causes and the growing forces of modernism.[9] Thus, while paintings from the last decades of his life can be read in terms of their pragmatic response to plebeian buyers, perhaps they also reveal the emotional vulnerabilities of old age.

So what of *The Slave Market* and *The Snake Charmer*? The pair of paintings is particularly interesting as an index of Gérôme's maturation. *The Slave Market* (cat. no. 4) is, at heart, an academic exercise: a painting that parlays well-learned, academically rendered motifs—luxuriant drapery and the nude body—into an effective composition and labels it ethnographic observation.[10] Painted in 1866, when Gérôme was in his prime, it depicts the exposure and violation of a slave—a subject of both titillating and offensive character.

The Snake Charmer (cat. no. 5) is a later work of greater technical finesse, assured in its balanced synthesis of figure study, ethnographic detail, and sexual overtone. The deployment of color across the canvas is almost suggestive of landscape and is ruminative in its depiction in the reds, browns, and ochres of earthbound and sprawling humanity, silhouetted against the tiled blue of art and history. Seen in this way, one cannot help but focus on those elements that punctuate the horizon line—the weaponry.

9. Boime 1983, 67–68, 72.
10. The ways that artists managed to turn figure studies into finished compositions was hotly debated and lampooned at the time. See Munsterberg 1988, 40–47.

129 *Catalogue*

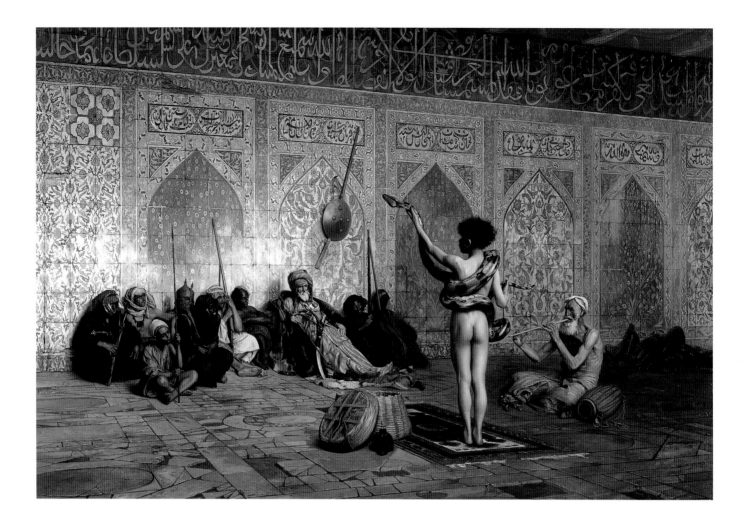

5 JEAN-LÉON GÉRÔME

The Snake Charmer

C. 1880

Oil on canvas, 33 × 48¹⁄₁₆ inches (83.8 × 122.1 cm)

Signed below center, left edge: J. L. GEROME.

Sterling and Francine Clark Art Institute,

Williamstown, Massachusetts

A shield and spear hang on the wall, with their dull metallic shine at center stage, and gun barrels stand between the knees of mesmerized owners. The snake held aloft by the young boy is the most prominent of all. Conforming to no known herpetological type, this phallic creature faces the army arrayed against the wall in a posture of command. Surely this is a picture about sexual prowess, seniority, and self-image, with homoerotic overtones, executed at the height of Gérôme's technical skill.

An American in Paris

\mathcal{F}rederick Arthur Bridgman was arguably America's preeminent Orientalist painter and is certainly the most well documented.[1] An enterprising student and traveler, he advanced his prolific career in both Paris and New York. From 1866 to 1870 he studied with Jean-Léon Gérôme, becoming one of the primary acolytes of his mentor's Orientalist style, and he made repeated trips to North Africa, establishing a comfortable niche for himself in France as an academic painter of Algerian genre scenes. The peak of his popularity in the 1880s coincided with the zenith of Orientalist painting in America. From this position of professional accomplishment, he acted as a member of the Paris advisory committee for the World's Columbian Exposition of 1893.[2] During this period, Bridgman expanded his home and studio in Paris into a showplace that included a room combining the interior and exterior of an Algerian house, with divan, mashrabiyya, mosaic pavement, and staff dressed in Moorish attire.[3] His popularity continued into the last decade of the nineteenth century, but as the demand for exotic imagery waned he gradually receded in the public eye, selling his grand home and moving to Normandy, where he died in relative obscurity in 1928.

These three paintings by Bridgman (cat. nos. 6–8) reveal how the artist elaborated on and diverged from Gérôme's paradigm. Drawn from the period of Bridgman's greatest fame, each of these works represents Bridgman's rendition of an established trope of the French Orientalist tradition—the odalisque, the bath, and the game. In comparison with French paintings of similar subject matter, each suggests that Bridgman engaged with that tradition in a discriminating fashion, assiduously advancing his technical skills and gradually personalizing his own style.

The intersection of Orient and woman is a critical index of cross-cultural perspectives. Bridgman's paintings that depict women—*The Siesta* and *The Bath*—invite comparison to French paintings as well as American corollaries, betraying the complex molding of cultural traditions that the painter accomplishes in his Orientalism. *The Siesta* (cat. no. 6), reminiscent of Ingres's *Odalisque with a Slave* (see p. 15, fig. 5), stands in closest proximity to the French tradition. While the two images show women in similar poses and settings, the French picture includes evidence of institutionalized subjugation—other people wait on the harem inmate, the railing suggests privileged seclusion, and the eroticism is overt. The woman's pose conveys either satiation or abandonment.

In contrast, Bridgman's woman is alone and her station in life is more open to interpretation. The space merges seamlessly with a riot of tropical vegetation beyond. "Woman" is thereby elided with the natural world. However, there are hints of danger here. The doorway at the far right, closed enough to suggest privacy but sufficiently open to suggest access or surveillance, adds ambiguity to the scene. The monkey, too, perched on the back of the divan, has been interpreted as a symbol of licentiousness,[4] but that unsavory feature is external to the woman, divorced from her and embodied in

1. See Fort 1990, and Ackerman 1994a, 20–48.
2. Fort 1990, 383.
3. Ibid., 301.

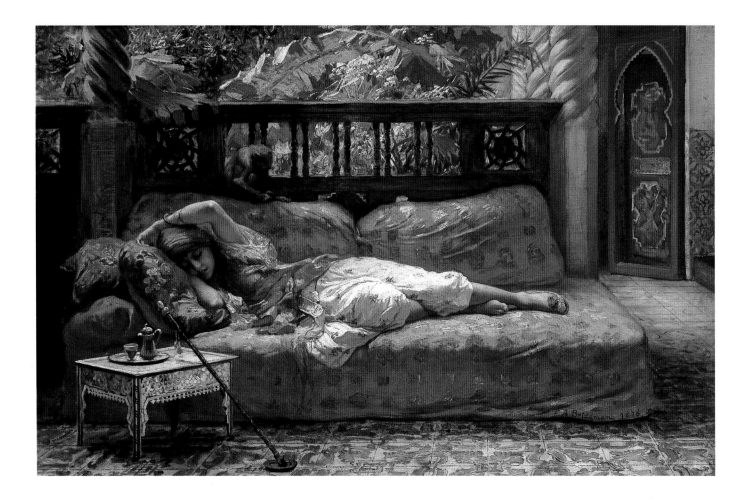

6 FREDERICK
ARTHUR BRIDGMAN
American, 1847–1928

The Siesta

1878

Oil on canvas, 11¼ × 17 inches (28.6 × 43.2 cm)

Signed, lower right: F. A. Bridgman 1878

Private collection, courtesy of Spanierman Gallery, LLC, New York

4. Ibid.

5. Lubin 1998, 205–72.

6. Fort 1983, 49–50.

7. Ackerman 1986b, cat. nos. 116, 202–4. Loosely traced by Ackerman to the Dutch genre tradition, the connotations of gaming in the French sphere had changed from a moralizing *vanitas* theme to a glorification of honest recreation. Ibid., 52.

bestial form. The pipe in the foreground, the apparent source of her torpor, bars the viewer's access to the most complex part of the picture, where a table, coffee, pipe, pillows, and the dreamer's head converge. Ultimately, the picture is about dreams and fantasies: those of the girl and those of the viewer.

While *The Siesta* resonates with the French tradition, it can also be compared to the contemporaneous iconography of the "American girl." This iconography proliferated after the Civil War and served to confirm gender stereotypes in the face of social change. In this kind of imagery, the youthful maiden functioned as a screen upon which private as well as public dreams were projected.[5] Bridgman's painting of a young woman suggests availability as well as idealization, providing the (male) viewer a springboard for gratifying fantasy.

The Bath (cat. no. 7) likewise alludes to a French trope (see p. 12, fig. 1) but eschews visions of naked harem girls to explore the realm of Victorian domesticity. In it, a mother surveys a child with bemused intimacy, perhaps anticipating a mischievous splash of water to come her way. Similar to many other late-nineteenth-century depictions of mother and child, this representation grants the oriental woman a maternal identity and larger purview than was typically admitted to stereotypical harem inmates. In so doing, the picture universalizes the standards of domesticity that were valued in America.[6]

An Interesting Game (cat. no. 8) depicts a game of chess, with various onlookers, in a softly lit interior. Paintings of similar subject matter executed by Gérôme were effectively costume studies, in which men in meticulously rendered clothing were posed in various contexts—ethnographic specificity thus complementing an iconography of modest entertainment.[7] Like those of Gérôme, this painting by Bridgman is, in part, a

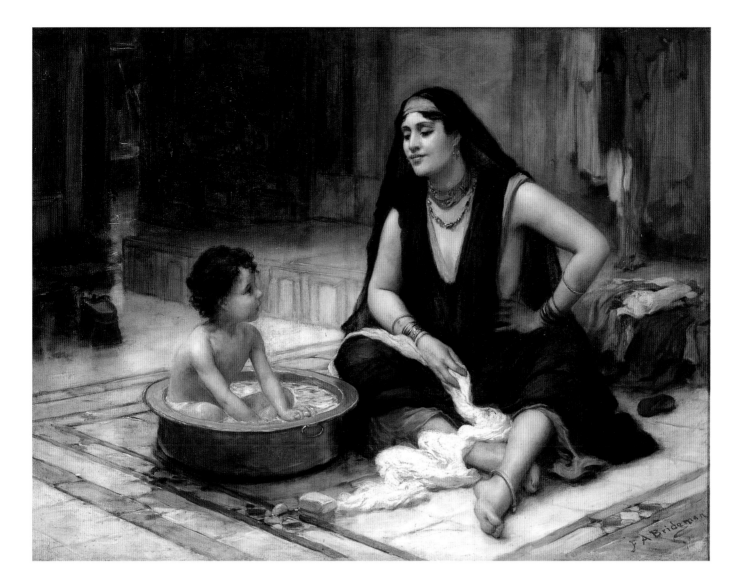

8. See, for example, Ackerman 1994a, 45–46

9. Fort 1990, 217ff; Ackerman 1994a, 30.

10. In the group I would include pictures with a slightly different emphasis, such as *Queen of the Brigands* (Ackerman 1994a, 44) and *Oriental Interior, Cafe at Biskra* in the National Museum of American Art.

7 FREDERICK
ARTHUR BRIDGMAN

The Bath

1890

Oil on canvas, 23½ × 31½ inches (60 × 80 cm)

Signed, lower right: F. A. Bridgman

Elizabeth Cumbler, Princeton, New Jersey

genre scene of ethnographic interest, in which intriguing setting and attire contextualize the quiet drama of the game.

Bridgman painted the trope of gaming more than once, however, and the paintings as a group bear scrutiny, for they depict men and women together in interior settings.[8] More typically, Bridgman painted women alone or in groups, but seldom interacting with men. Furthermore, at least two of his gaming pictures represent encounters between a man and a woman in a relatively confined space without any onlookers; in each case, the pair is situated close to the picture plane and the room angles away to disclose or imply other people in the distance. In effect, then, the viewer is privy to otherwise unwitnessed intimacy. While these pictures depict familiarity and candor, the exact nature of the exchange remains ambiguous—is the game of chance a preface to prostitution, for example, or is it simply a convivial pastime in humble circumstances?

Such questions are premised on the notion that the paintings depict some kind of verifiable custom or indigenous practice to which Bridgman had access. However, it is perhaps more productive to consider the fundamental artificiality of these pictures. Although Bridgman spent considerable time in North Africa and enjoyed unusual access to the sphere of women through a young widow in Algiers, one would be rather surprised if Bridgman had actually witnessed the scenes that he painted, given the largely segregated nature of Algerian society.[9] In fact, the similarity of the compositions and the appearance of the same female in varying attire suggest that Bridgman concocted them in his studio, employing the same model. As complex arrangements of the human

8 FREDERICK
ARTHUR BRIDGMAN

An Interesting Game
1881
Oil on canvas, 37¼ × 57⁹⁄₁₆ inches
(94.6 × 146.2 cm)
Signed, upper right: F. A. Bridgman / 1881
Brooklyn Museum of Art. Gift of George D. Pratt in
memory of Mrs. Charles Pratt

figures in varied spaces, these pictures offered the opportunity to exercise the techniques of the academy in exotic guise, and their artificiality is, in part, an artistic conceit.

However, Bridgman's gaming pictures and related imagery[10] also may have been a venue for addressing social conventions and confusions. In the milieu of Victorian America, contact between the sexes was problematic and overdetermined, with little interaction going unsupervised. Pictures showing such intimate and unchaperoned encounters, ostensibly transpiring in exotic settings, represent interactions that would have been considered inappropriate in the milieu in which Bridgman matured. As such, these concoctions would have carried a mildly erotic charge and must be seen, in part, as a bit of Victorian voyeurism and wish fulfillment, and a desire to expand the boundaries of polite society in the United States.

Exotic Virtuosity

*J*ohn Singer Sargent was born in Italy to American parents and educated in Europe; he visited Morocco in 1880, Egypt in 1890, and Palestine in 1905. The Orient provided subjects for some in his most extraordinary paintings, as well as a formative inspiration for his enigmatic murals in the Boston Public Library.[1]

Fumée d'ambre gris (Ambergris Smoke)[2] (cat. no. 9), exhibited at the Paris Salon of 1880, helped launch Sargent's career, establishing at a young age his uncanny skill and distinctive style. He described it as "a little picture I perpetrated in Tangiers . . . the only interest of the thing was the colour." Surely disingenuous, the comment alludes to the virtuosity with which Sargent orchestrated innumerable shades of white into the depiction of a Moroccan woman censing herself in the lee of an elegant, lobed arch.[3] The comment also reveals Sargent's relative disinterest in the subject matter and his early commitment to the idea of art for art's sake. This distinguished him from contemporaneous Orientalists, who pursued the genre in a traditional, academic mode, assiduously depicting their subjects with ethnographic precision. Thus, the picture suggests that Orientalism could be a springboard for modernism as well as a vehicle for conservative establishment values.

Painted fourteen years after Jean-Léon Gérôme's *Slave Market* (cat. no. 4) and two years after Frederick Bridgman's *Siesta* (cat. no. 6), the picture also presents yet another way to combine "woman" and Orient. While images by Gérôme and Bridgman of the slave and the dreamer capitalize on the allure of the female body (albeit in different ways), Sargent offers a woman who neither incites voyeurism nor displays vulnerability. In fact, she does not invite at all. Powerful in her solitude, she denies entrance to the viewer with the imperious warning of a raised finger.

Whether or not the picture was considered sexy at the time may have depended on the viewer and on the viewer's associations with ambergris, the waxy substance derived from the intestines of the sperm whale. A. Genevay, writing for *Le Musée artistique et littéraire* in 1880, commented specifically on the voluptuousness of the image, citing ambergris as the favorite condiment of the notorious rake Casanova. By contrast, Henry James, writing for *Harper's Monthly* in 1887, noted chastely that "this stately Mohammedan . . . is beautiful and memorable."[4]

Primarily used as a fixative in fine perfume, ambergris was also ingested as a circulatory stimulant and aphrodisiac, to promote the growth of marrow and semen.[5] Such, presumably, was Casanova's intent. In the land of *Moby Dick*,[6] however, it is possible that ambergris represented an aphrodisiac of another sort—money. In the late nineteenth century, ambergris sold for more than a hundred dollars per pound, and large quantities could generate thousands of dollars.[7] These sums were sufficiently high that whalers thoroughly searched whale carcasses before casting them adrift, hoping to strike gold. If they did, they likely did business with David C. Stull, the "Ambergris King" of Provincetown, Massachusetts, who spent over fifty years as the premier buyer and

1. The bibliography on Sargent and on this particular painting is extensive. See especially Conrads 1990, 172–77. Simpson 1997, 79–80, 92–94. On Sargent as Orientalist, see Ackerman 1994a, 175–83.

2. This title was used in an American publication of 1881. Simpson 1997, 94.

3. For a discussion of the ethnographic, architectural, and ritual aspects of this picture, see Conrads 1990, 174–75.

4. Both responses are cited by Simpson 1997, 92, 94.

5. Read 1932, 482. See also Stoller 1957, 6–7.

6. Melville devotes a chapter of *Moby Dick* to ambergris, without mention of its ostensible aphrodisiac qualities.

7. In 1866, the crew of the *Sea Fox* of New Bedford, Massachusetts, sold 150 pounds of ambergris to the Arabs of Zanzibar for $10,000 in gold; in 1878, the *Adeline Gibbs* brought in 132¼ pounds, which sold for $23,231. By 1894, a quantity of 109⅞ pounds sold for about $26,000. These figures are quoted from a 1903 government pamphlet called "Aquatic Products in Arts and Industries." It is described in Tripp 1938, 80–81.

8. Ibid., 73.

9 JOHN SINGER SARGENT
American, 1856–1925

Fumée d'ambre gris
(Ambergris Smoke)
1880
Oil on canvas, 54¾ × 35¹¹⁄₁₆ inches
(139.1 × 90.6 cm)
Signed, lower right: John S. Sargent Tanger
Sterling and Francine Clark Art Institute,
Williamstown, Massachusetts

wholesale dealer of ambergris. Describing a find of 229 pounds, he noted that the "ambergris was worth more than all the oil they'd got from the other whales, and the whole schooner together."[8] His matter-of-fact recitations suggest that, for some Americans, a painting depicting a woman burning ambergris may have been comparable to other late-nineteenth-century images of beautiful and sequestered women surrounded by the trappings of luxury.

Words and Pictures

\mathcal{E}dwin Lord Weeks is arguably the most enterprising of the American Orientalist painters. He traveled frequently and widely, often under arduous and even life-threatening circumstances, sketching, painting, photographing, and writing along the way.[1] Born in America and a resident of Paris, Weeks straddled cultures for a living, rendering his observations and experiences in prose and pictures. He traveled most extensively in the Orient, from Egypt and the Holy Land to Morocco and, ultimately, to Persia and India. Indeed, the Orient dominated his prolific career, which spanned the last three decades of the nineteenth century. His interest in the Orient was an organic extension of his experiences in Paris, where he studied with Léon Bonnat and Jean-Léon Gérôme.[2] During the course of his travels, he was sufficiently impressed by "Moorish" art to write a lengthy magazine article on the subject,[3] and by 1880 he was exhibiting paintings of Moroccan subjects on both sides of the Atlantic.

Weeks had not assuaged his wanderlust, however, and in the late 1880s, he shifted his focus to India. This enthusiasm generated an illustrated travelogue[4] as well as numerous paintings, which firmly established his reputation. By 1894, he was ensconced in a grand apartment in Paris and was friends with Frederick Bridgman and other expatriates. He died in 1903, and two years later the contents of his studio were sold in New York, effectively erasing the artist from the public eye. His work awaits full publication.

Interior of the Mosque at Cordova (cat. no. 10) is a product of the complex and cosmopolitan world that Weeks inhabited, somewhere between his native New England, his adopted Paris, and his constructed Orient. Executed in the mid-1880s, the painting is an asymmetrical composition based on a diagonally plunging space.[5] This format, dramatized by the swath of crimson carpet on the mosque floor, enabled Weeks to capture the extraordinary scale and dramatic character of the Great Mosque of Córdoba, animated by repeating lobed and stacked arches.[6] Nor did he neglect the details: the dull reflectivity of stone, the sheen of armor, and the glitter of mosaic are all precisely rendered. A crowd is evoked from particularized individuals in the foreground and more indistinct forms in the background. The striking figure of the worshiper in the center of the picture, his white turban silhouetted against the architectural salient, is known from a separate study. Clearly, the artist had personally observed the wrinkled elbow, the bunching drapery, and the quiet humility of the pose.[7]

Although Weeks painted individual worshipers, specific acts of worship, and the architectural setting with precision, he did not witness the particular event that is suggested in the painting. Its fabricated nature is betrayed by the standard-bearer, whose gesture and position are inconsistent with the basic rituals of Islam. Holding a flag aloft in the shelter of the *mihrab* (the niche indicating the direction of prayer) while people are engaged in prayer, this figure insidiously distorts the faith by suggesting that devout believers make obeisance to a human being. Such a scene conjures up demagoguery rather than the true Muslim submission to God. Turn-of-the-century audiences did not

1. Ellen Morris of Los Angeles, California, is assembling materials for a catalogue raisonné of the artist's work. To date, the most detailed studies are Ganely and Paddock 1976; Ackerman 1994a, 234–57; Thompson 1985, 246–58; Bolger 1980, 77–79.

2. Ganely and Paddock 1976, 7–8.

3. Weeks 1901, 433, 452.

4. Weeks 1896, and in installments in *Harper's Monthly* starting in 1903 (vols. 87–105.)

5. Weeks used this feature elsewhere, e.g., *Hour of Prayer at the Moti Masjid*, illustrated in Thompson 1985, pl. IV.

6. In general, the architecture is represented accurately, although the maqsura area is opened out inappropriately. See Jerrilynn Dodds, "The Great Mosque of Cordoba," in Dodds 1992, figs. 8, 11; Ettinghausen and Grabar 1987, figs. 110–11.

7. Illustrated in Ackerman 1994a, 246.

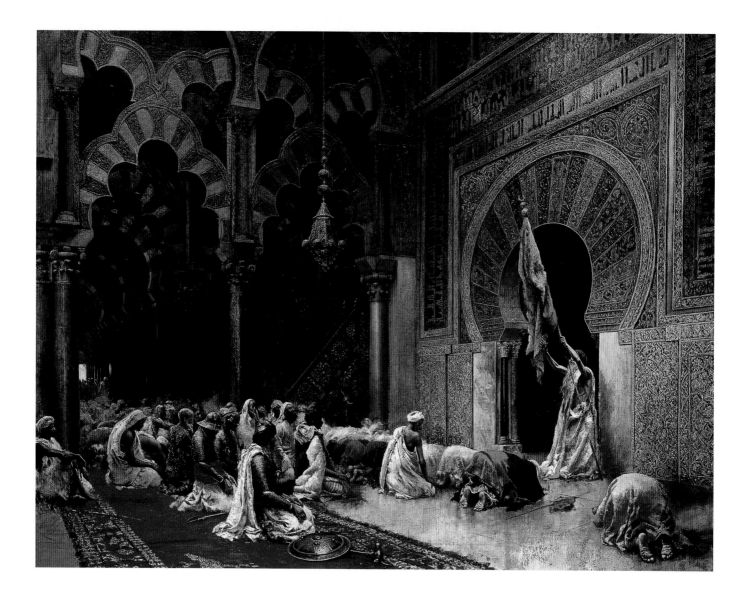

10 EDWIN LORD WEEKS
American, 1849–1903

Interior of the Mosque at Cordova
1880s
Oil on canvas, 56 × 72 inches (142.2 × 182.9 cm)
The Walters Art Gallery, Baltimore

question the stereotype, however, and the 1905 auction catalogue amplified menace in the scene rather than pious humility:

> *Preaching the holy war against the Christians, the old Moor holds aloft the green flag of Mohammed, while he curses the "dogs of Christians" with true religious fervor, and calls on Mohammed to drive them out of Spain. The devout audience, kneeling facing the shrine, composed of all classes of Moors, rich and poor, as well as soldiers in armor, is probably an ideal and almost photographic view of the Mosque of Cordova as it was at the beginning of the downfall of Moorish power in Spain. The entrance to the shrine is most artistic, composed of many-colored glass mosaics, with texts from the Koran set in. Down the long vista of arches the crowd of worshippers gives one some idea of the enormous size of this mosque that stands today as an imposing monument of the grandeur and power of the Moors several hundred years ago.*[8]

8. *The Works of the Late Edwin Lord Weeks*, Free View Day and Evening at the American Art Galleries, Madison Square South, New York, 1905, Unrestricted Public Sale. No. 269. Applied to the picture decades after it was painted, this description may have been an auctioneer's ploy to promote aggressive bidding rather than an accurate reflection of the artist's intent. The picture did sell for three times the price of any other item in the sale. "Paintings Sold at Auction," *American Art Annual* 1905, 105

In fact, with the exception of the figure of the standard-bearer, the picture is prosaic rather than contentious in tone. Each of the foreground figures is doing something different, and, in their diversity, they suggest the quotidian rather than the momentous. The only weaponry in evidence, the shield in the center foreground, is a visual device anchoring the composition; it is not an ideological rallying point. Moreover, the soldiers

9. On American fascination with Muslim prayer, see Sha'ban 1991, 190–94.

10. For Gérôme's renditions of this theme, see Ackerman 1986b, cat. nos. 152, 163. For Bridgman's treatments, see Ackerman 1994a, 33.

11. Ibid., 253, 255.

12. Weeks 1901, 434.

are few in number, providing a martial accent in an otherwise pacific crowd. Thus, most of the image is notable for its quietude rather than stridency.

As a depiction of the ritual practices of Islam, the picture reiterates an established theme in American constructions of a romanticized Orient. Nineteenth-century literary Orientalism includes frequent assertions about the simplicity of Muslim devotions and the physically active prayer ritual. Some observers were awed, some were mystified, and still others laughed in derision, but the idea of Muslim prayer was consistently fascinating.[9]

Religious practice was also an established trope of painterly Orientalism. Jean-Léon Gérôme painted devout Muslims in prayer several times, and his pupil Bridgman extended the tradition.[10] In pictures of this nature, Muslims engaged in prayer are situated in dramatic architectural settings, and ethnographic details are carefully rendered. Weeks's treatment of this theme is noteworthy for its emphasis on architecture, an interest that he maintained for the rest of his career.[11]

While Weeks's personal response to Muslim devotional practices is not known in detail, his prose suggests that he, like Washington Irving before him, heroicized the culture of the Muslim Moors and the artistic traditions that linked the Iberian Peninsula with Morocco, divorcing them from contemporary people. In his introduction to Moorish art, Weeks felt no compunction about applauding the art and relegating the country to the status of edifying curiosity: "The world can well afford to neglect this corner of Africa for a few decades yet, or even a century, and allow it to exist as a museum of antiquity, a working model of the Middle Ages; the silence of its cities, undisturbed noise of factories and tramways, and its broad, sunny reaches of open country untraversed by railways or macadamized roads." Clearly, he shared with many of his compatriots an ambivalence about industrialization and "progress" but he was also a condescending modernist, susceptible to familiar images of exotic mystery: "Beyond this alluring horizon, again, lie the mysterious cities of the Moor, unchanged and unchanging save in their ceaseless, inevitable decay. No other Moslem country has so long resisted and successfully baffled the aggressive progress of modern civilization."[12]

Ultimately, then, the picture reveals Weeks's complex attitudes about the Orient. He was clearly fascinated by the architecture, and he had observed Muslim culture with sufficient attention to populate the Great Mosque of Córdoba with credible figures. But he placed those figures in an imagined bit of history. Such is the nature of Weeks's Orientalism—a fabricated story given the appearance of verisimilitude.

A Woman Orientalist

"This is an important day in my calendar for it completes my 30th year and turns me into the era of Oldmaidism! The time so much dreaded by all young girls and not seldom much deplored by the maturer ones, but I can't say that I feel old maidish! Life has at no time been more cheery and pleasant to me."[1] So stated Ella Ferris Pell in Algiers on 18 January 1876. By this time, she was a seasoned traveler, having departed from New York City in the summer of 1872 with her sister and brother-in-law, Evie and Charles Todd, to travel in Europe, Egypt, Palestine, Turkey, and back to Europe for "five years, seven months and eighteen days." Algiers was the final destination before a return to the United States, and she devoted her brief stay to painting portraits and costume studies. While most of her work still awaits discovery, a few paintings (cat. nos. 11, 14), a sketchbook (cat. no. 12) and a detailed diary (cat. no. 13) of her travels in the Orient can suggest the broad outlines of Pell's Orientalism.

Pell's life and work attest to the complexity of American Orientalism. Prior to her departure for the Orient, she graduated from the Design School for Women at the Cooper Union (1870), having studied there with William Rimmer.[2] Although she had shown an early talent for sculpture, her subsequent work seems to consist primarily of painting.[3] She did not paint exclusively oriental subjects but drew on her travel experiences throughout her life.[4]

Pell was an enterprising traveler, with a sober and antiquarian mind-set. Mesmerized by the intricacies of hieroglyphs in Egypt and awed by the sheer scale of Baalbek, she was not daunted by a headlong race with a Syrian guide down a Palestinian road, noting with satisfaction afterward that everyone was "astonished with my fearless riding."[5] Indeed, she seems to have been a free spirit by nineteenth-century standards, rising to the rigors of travel with considerable aplomb and recounting it all in daily entries in her travel diary (cat. no. 13). The protracted trip included weeks spent on a boat on the Nile, camping out in Palestine, and living in a "third class" hotel in Algiers.

Her statements about the Orient are laced with blatant condescension. At one point she comments, "How very like grown children these people are in some things,"[6] and at another moment, "The crew seem like simple-minded creatures, without intellect or thought—very like animals."[7] She was outraged by the living conditions that she encountered, claiming, "Our very dogs would disdain such lodging."[8] Pell did not love the Orient, but she found it an edifying experience from a position of entitled detachment. "This is our farewell to Egypt, and I am not sorry to go."[9]

Most of this editorializing is evident in passing remarks. Otherwise, Pell recounted her activities in a straightforward and linear fashion. She often concentrated on the view rather than detailed ethnographic observation. Indeed, she expended considerable effort for the sake of a spectacular or elevated view of the surroundings, and, like her friend and compatriot R. Swain Gifford (see cat. nos. 21, 22), she found the setting and climate endlessly appealing and supremely "picturesque." This rubric, however, is a

1. Pell 1872–78, 2: 375. The four-volume journal dating from 1872 to 1878 is in the collection of Fort Ticonderoga, New York. I am grateful to Christopher Fox for enabling me to study it at length and facilitating the inclusion of Pell's work in this catalogue.

2. Rimmer painted an enigmatic oriental picture called *Flight and Pursuit*. See Weidman 1985, 68–69.

3. See Tufts 1987, no. 45.

4. Among the remnants of her oeuvre at Fort Ticonderoga are mythological scenes, oriental imagery, and a landscape.

5. Pell 1872–78, 2: 211.

6. Ibid., 23.

7. Ibid., 90.

8. Ibid., 52.

9. Ibid., 180.

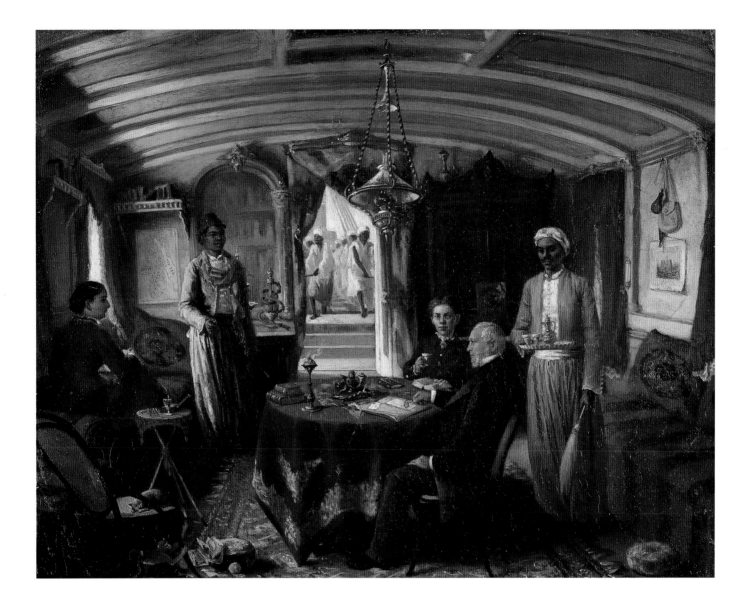

11 ELLA FERRIS PELL
American, 1846–1922

Interior of the "Sibyl"
1875–79
Oil on canvas, 16 × 25½ inches (40.6 × 64.8 cm)
Signed, lower left: E. F. Pell 1879 NY
Collection of the Museum of Fort Ticonderoga,
Ticonderoga, New York

10. Ibid., 181.
11. She enhanced her wardrobe by making new dresses
but also indulged in a ready-made dress at the Bon
Marché in Paris and a good winter coat in England.
Ibid., 348, 340.
12. Ibid., 171.
13. Ibid., 198.
14. She commented with astonishment that Cook's
steamers "do" the Nile up and back in twenty-one days.
Ibid., 144.
15. Ibid., 8.
16. Ibid., 4: 76.

complex one, for it encompasses contradictory characteristics. She described Jaffa as
follows: "It is the quaintest, queerest, dirtiest, most picturesque town we have yet seen."[10]

Pell was not by nature self-indulgent, and her spending habits during her travels
reveal the options and priorities of a middle-class, late-nineteenth-century consumer.[11]
Though she bought little, she regularly explored the marketplaces. At the Turkish bazaar
in Cairo, for example, she "saw enough elegance to make one covetous for a month."
And upon seeing a beautiful embroidered jacket, she declared, "I wanted one dread-
fully," but it was "beyond my purse."[12] However, she and her sister Evie did purchase
olive wood covers for their Bible and an Algerian coffee set, both predictable acquisi-
tions for American travelers to the Orient and similar to objects acquired by Frederic
Church for Olana (see cat. nos. 36 B–F).[13]

Clearly Pell was operating on a modest budget. Her mode of travel, for example, seems
to have been qualitatively different than that offered by the increasingly visible Cook's
tours, which—much like luxury tours today—seemed to overrun, overspend, and gener-
ally speed up the travel experience.[14] Having servants on the trip up the Nile was a novelty
and burden for her, but it did not inspire ruminations about slavery as a moral or political
issue. When faced with the challenge of finding jobs for one of the boat's crewmen, she
reiterated a familiar cliché: "Certainly oriental indolence is not a part of our American
nature."[15] Upon her return to New York City in November 1878, she commented that she
sold various household possessions to finance her last year and a half of travel.[16] Her atti-

12A ELLA FERRIS PELL
AND EVIE A. TODD

Title page of "Our Winter in Egypt and Nubia"

1874–75
Graphite on paper, 12 × 18 inches
(30.5 × 45.7 cm)
Frances Lehman Loeb Art Gallery, Vassar College,
Poughkeepsie, New York. Gift of Mr. and Mrs.
Anthony Cinelli, Jr., 1987

12B ELLA FERRIS PELL

*Native Cab, Algiers
From "Our Winter in Egypt
and Nubia"*

1876
Graphite on paper, 10 × 5⁵⁄₁₆ inches (25.4 ×
13.5 cm)
Signed, lower left: E. F. Pell; inscribed, lower
right: Native Cab. Algiers. / Jan. 1876
Frances Lehman Loeb Art Gallery, Vassar College,
Poughkeepsie, New York. Gift of Mr. and Mrs.
Anthony Cinelli, Jr., 1987

12C ELLA FERRIS PELL

*The "Sibyl"
From "Our Winter in Egypt
and Nubia"*

1874–75
Graphite on paper, 8 × 6¼ inches
(20.3 × 15.9 cm)
Signed, lower left: E. F. Pell / (from a photo-
graph); inscribed, lower right: The "Sibyl" /
"Tied Up" on the Nile. 1875.
Frances Lehman Loeb Art Gallery, Vassar College,
Poughkeepsie, New York. Gift of Mr. and Mrs.
Anthony Cinelli, Jr., 1987

13 ELLA FERRIS PELL

Diary Pages

1874

8⅛ × 7⅛ inches (22.5 × 18.1 cm)

Collection of the Museum of Fort Ticonderoga, Ticonderoga, New York

tudes are thus particularly interesting, as they reflect a middle-class woman encountering the Orient without the buffers provided by great wealth.

So what were those attitudes? Like many of her compatriots, she read before she traveled, and her expectations were defined by scholarly works as well as more general travel literature.[17] Though her sober, elderly, and academically minded brother-in-law was compiling a tendentious tome entitled "Bible Synopsis and Jewish Institutions" during their trip, they do not seem to have been a particularly pious or opinionated party. Easter, for example, went by without great fanfare or ritual acknowledgment.[18]

Pell was, however, solidly Protestant in her biases. While commenting that the mosque of Sultan Hasan in Cairo was "old and dilapidated but grand and venerable," she also noted that "the absence of all tawdry decorations is a great relief after the Roman Catholic churches."[19] When she finally arrived in the Holy Land, the sectarian rhetoric became more pointed: "I entered the Church of the Sepulchre with reluctance, dreading the feelings that might arise at the sight of so much priestcraft—but I was most wonderfully impressed with the sight of places held sacred by so many honest hearts, even if they were not true and what if that was not the exact spot—surely it was near enough!"[20]

Pell's response to sacred topography was quite heartfelt before the incontestable Nazareth, "made holy by nearly thirty years of the life of Jesus being spent in it."[21] She declared in her diary: "Surely the secluded position of the village itself and the grand scenery encompassing it formed a fitting school for the development of a mind and spirit like Jesus. It is very charming to sit here where there is no doubt or question about the genuineness of the locality and to feel that every spot for miles around has been visited by Him."[22] While the pastoral ideal and the pedagogical character of landscape

17. Ibid., 12: "How real such a sight makes the stories we have so often read of all this life of travel."
18. Ibid., 202.
19. Ibid., 5.
20. Ibid., 193.
21. Ibid., 228.
22. Ibid., 229.

seem quintessentially American, ultimately one has a sense of a rather free and unorthodox spirit, capable of claiming effusively, "verily Jesus lived for the wide, wide world, not alone for the 'chosen' people."[23] This naive-sounding magnanimity, fueled by her rediscovery of the New Testament in the wake of visiting the Holy Land, was coupled with an omnivorous spirituality, open to table-tipping seances,[24] the Vedic literature of India, and late-nineteenth-century Spiritualism.[25]

Pell held deeply rooted convictions about what she deemed to be the natural order of things. In many ways, Egypt was her training ground as a traveler and an Orientalist, and the majority of her ethnocentric comments occur during this initial period of adjustment. Then, too, expectations were different in the Holy Land, and she found it "difficult to pass so quickly from Egyptian heathenism to our own Biblical history and it will be sometime before I can realize Palestine."[26] In contrast to both Egypt and Palestine, Algiers was a French colony, obviating the need for a dragoman and seeming therefore to be less foreign and more accessible. Here, Pell focused most intently on her painting and was able to secure a variety of models, some of whom were obtained through the helpful agencies of what she termed an "energetic Negro" woman.[27]

Pell's paintings presented here reflect change and growing sophistication. Her picture of a Nile boat (cat. no. 11) and sketches of the landscape and peoples that she encountered, suggest an innate, albeit relatively untutored, talent and an enterprising eye. It took several weeks (from January to March 1875) to complete her boat picture, but when finished it elicited "three rousing cheers" from the ostensibly delighted crew.[28] She typically conceived of her sketches in terms of middle-distance views, a convenient and predictable focal distance for an artistically inclined tourist. She became increasingly intrigued by indigenous dress, assembling a series of costume studies during the course of her travels. On several occasions she comments on the acquisition of costumes and noted that she understood the garb well enough to "make variations for future pictures."[29]

Upon returning to America, Pell lived in New York City and submitted paintings to the National Academy of Design in the early 1880s, including pictures that reflect her travels: *La Annunziata* and *Water Vendor, Cairo, Egypt*.[30] By 1890, when she submitted her *Salomé* (cat. no. 14) to the Paris Salon, at the age of 44, Pell appears to have matured beyond her travel experiences and explored the French academic tradition, citing as her teachers Jean-Paul Laurens, a history painter; Jacques Fernand Humbert, a history and religious painter; and Gaston Casimir Saint-Pierre, a portrait and genre painter at the Académie des Beaux-Arts des Champs Elysees.[31] Whether as a result of this training or by dint of sheer dedication and talent, her *Salomé* exhibits a scope and sophistication lacking in her earlier work. Moreover, the interpretation of this complex biblical figure, as a self-assured and forceful peasant woman, suggests that Pell was at the height of her powers and sure of her own convictions as an independent woman and artist.

In retrospect, a critical factor in Pell's particular brand of Orientalism was perhaps her gender. Her own comments about "oldmaidism" and the typical limitations placed on female artists in the later nineteenth century attest to social dynamics that presumably hindered her professional development.[32] Indeed, the Orient provided a welcome respite from social expectations at home,[33] freeing her to paint and hone her skills without censure. In her diary she records no serious hindrance to her artistic activities in the Orient (leaving aside the common experience of attracting crowds of onlookers), and she may have had an easier time finding models in the Orient precisely because of her gender. She makes passing reference to what she assumed to be the predicament and

23. Ibid.

24. Ibid., 328.

25. The Vedas are the subject of a painting currently located at Fort Ticonderoga. She also contributed illustrations to Paul Tyner's *Through the Invisible* (1897), a spiritual allegory imbued with the philosophy of Madame Blavatsky.

26. Pell 1872–78, 2:183.

27. Ibid., 370.

28. Ibid., 154–55.

29. Ibid., 376. Frederic Bridgman's interest in costume as a threatened tradition and his desire to record it for posterity is also noteworthy. See Fort 1990, 222.

30. Tufts 1987, no. 45.

31. Ibid.

32. On the larger issue of female artists at the turn of the century, see Gail Levin, "The Changing Status of American Women Artists, 1900–1930," in Tufts 1987, 13–25.

33. When invited to a soiree in Paris, for example, she states flatly, "The dance was a stupid affair for me." Pell 1872–78, 2:326.

34. Tufts 1987, no. 45.

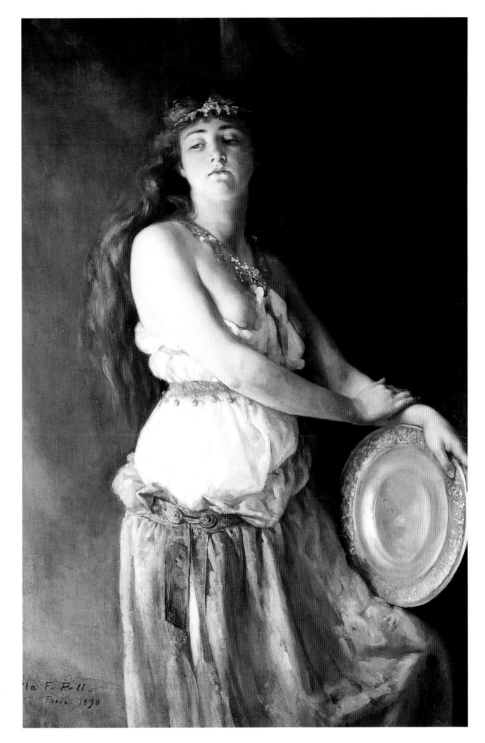

14 ELLA FERRIS PELL

Salomé

1890
Oil on canvas, 51¼ × 34 inches (131.5 × 86.4 cm)
Signed, lower left: Ella F. Pell / Paris 1890
Collection of Bram and Sandra Dijkstra

imprisonment of women in the Orient, but she had only a few perfunctory social encounters with local hosts.

The impact of Pell's travels on her life and work is difficult to gauge since her later years remain somewhat obscure.[34] However, it is clear that she was neither a homegrown Orientalist like Gifford nor an expatriate Orientalist like Weeks or Bridgman, in part because she was a woman. For her, the Orient did not launch a successful career, it perhaps granted her respite from the lack of one, providing artistic stimulation along the way.

Poet-Painter of Palestine

*H*enry Ossawa Tanner, dubbed the "poet-painter of Palestine" by a contemporary art critic, traveled to Palestine in 1897 and 1898–99, to Algeria in 1908, and to Morocco in 1912, after the vogue for Orientalist painting in the academic mode had waned. Using his experiences abroad to conjure up images of scriptural narrative, he laid claim to an arena of visual expression in which he had few rivals. In so doing, he extended the tradition of painterly piety epitomized earlier by Frederic Church (see cat. no. 2) and forestalled the "nullification of content" evident in other early-twentieth-century images of the Holy Land.[1]

Christ Appearing to Nicodemus (cat. no. 15) was painted in Jerusalem during Tanner's second visit to the region in 1898–99. It garnered him considerable fame and his first major honors in the United States, including the Lippincott Prize for the best figure painting at the annual exhibition of the Pennsylvania Academy of the Fine Arts in 1900. Clearly, Tanner was honing the technical skills that he had acquired under the tutelage of Thomas Eakins in Philadelphia and Benjamin Constant in Paris. He was also moving away from themes relating to the African-American experience seen, for example, in his 1893 painting *The Banjo Lesson.*[2] This shift had profound ramifications, and signaled his talent and predilection for animating scriptural narrative within the setting of sacred topography.[3]

The story, recounted in the Gospel of John (3:1–3), describes Nicodemus the Pharisee coming to Jesus by night to acknowledge that he was a teacher sent by God. This passage was seen in the context of post-Emancipation America as a biblical precedent for the clandestine religious activities of African-Americans that were necessitated by the climate of unchecked bigotry.[4] It was, however, imbued with the realities that Tanner experienced in Jerusalem, where he employed an old Yemenite Jew as a model for the figure of Nicodemus and made rooftop sketches for the dramatic night scene.

The painting provides provocative counterpoint to Frederic Church's *Jerusalem from the Mount of Olives* (cat. no. 2), wherein the landscape is rendered in cartographic detail to evoke a setting conducive to spiritual transformation. Tanner retreated from the specifics of sacred topography to contextualize the conversation between Nicodemus and Christ in an evocative envelope of sanctity. Instead of depicting the landscape in detail, he personally experienced it and then allowed that experience to imbue his painting with conviction and verisimilitude.

Tanner's spiritualized style became even more marked later in his career, when he traveled to North Africa. He continued to explore biblical themes, but he relaxed the narrative integrity and the geographic parameters of his subjects to encompass his new experiences, depicting the Flight into Egypt, for example, in front of the Palais de Justice in Tangier.[5] How are we to understand this overlap of religiosity and Orientalism, and how does it differ from that of Church?

These elements have been treated by some scholars almost as discrete phases in a larger career, linked with different travel experiences. Thus, he has been deemed a reli-

1. Clara T. MacChesney, "A Poet-Painter of Palestine," *International Studio* 50 (July 1913): xi–xv. Gerald Ackerman discusses Tanner as an Orientalist in Ackerman 1994a, 198–201. Extensive documentation is available in Mosby 1991. John Davis describes the denouement of painting in the Holy Land in Davis 1996, 208–18.
2. Judith Wilson, "Lifting the 'Veil': Henry O. Tanner's *The Banjo Lesson* and *The Thankful Poor*," in Calo 1998, 199–220.
3. Mosby 1991, 146.
4. See ibid., 168–69.
5. Ibid., 201.
6. Ibid.

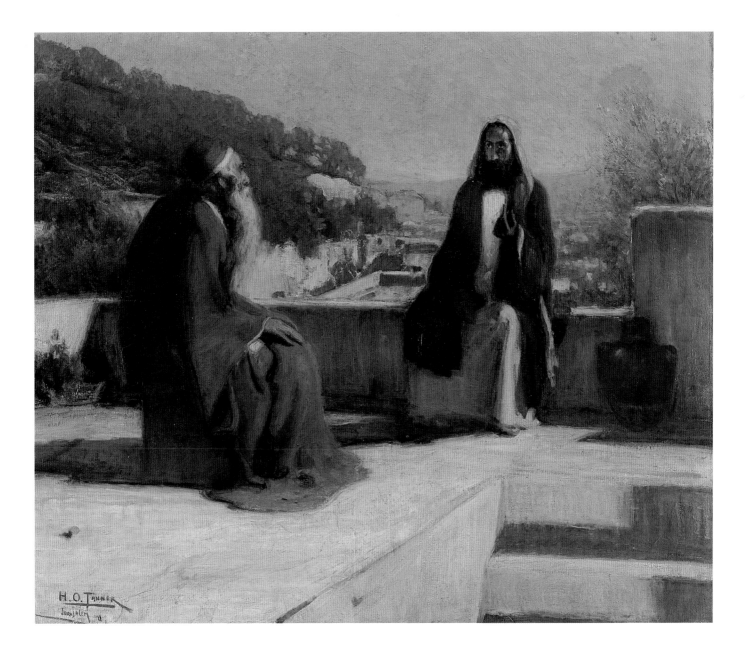

15 HENRY OSSAWA TANNER
American, 1859–1937

Christ Appearing to Nicodemus
1899
Oil on canvas, 33¹¹/₁₆ × 39½ inches
(85.6 × 100.3 cm)
Signed, lower left: H. O. Tanner / Jerusalem
1899
Pennsylvania Academy of the Fine Arts, Philadelphia.
Joseph E. Temple Fund

gious painter when he visited Palestine and then, briefly, an Orientalist when he explored Algeria and Morocco.[6] Such an approach presupposes that Orientalism is a matter of "local color" and that seeing North Africa simply provided additional stage sets for his favored biblical dramas.

Orientalism, however, is more complex than that, for it involves cross-cultural attitudes that can become tangled up with religious convictions. In the case of Frederic Church, a well-established painter of the Hudson River School, piety and Orientalism converged to produce an image of the Holy Land that was imbued with the ethos of Manifest Destiny and muscular Protestantism. Tanner, by contrast, was an African-American largely alienated from an increasingly secular country ridden with racial conflict. As a result, Tanner stood in a different relationship to the Orient. For him, the Orient served as spiritual antidote and aesthetic inspiration. In fact, it is arguable that he did not paint the observed Orient at all, but rather an inner spiritual landscape, informed by a personal experience of Palestine and North Africa, an increasingly modernist aesthetic and a fundamental independence of mind.

1. Quoted in Ackerman 1994a, 88.
2. Ackerman 1994a, 84–88. See also Weiss 1987.

16 **SANFORD ROBINSON GIFFORD**
American, 1823–1880

On the Nile, Gebel Shekh Heredee
1872
Oil on canvas, 17 × 31 inches (43.2 × 78.7 cm)
Signed, lower right: S. R. Gifford 1872
Private collection, courtesy of Berry-Hill Galleries, New York

Sanford Robinson Gifford went to the Orient as a tourist in 1868–69. After the standard tour up and down the Nile, across the Sinai Peninsula to Jerusalem, and from the Holy Land by boat to Constantinople, he produced only about fourteen paintings. He was a mature artist, and he had already traveled to Europe three times, but he expressed frustration about his experiences in the Orient: "I saw many things that I would like to paint—but I made not a line. It is useless for me to attempt such things without plenty of time. I have long since given up the expectation of making anything of the East."[1]

Despite the small number of Gifford's Orientalist works, his paintings of the Nile transpose the Luminist sensibility to the riverine landscape beautifully, capturing the limpid clarity of Egypt in nearly abstract terms. Stunning renditions of atmospheric conditions, these paintings distill the visual data of an exotic locale into minimal oscillations of light on the horizons. Gifford's extraordinary merger of Luminism with exotic subject matter reveals the extent to which Orientalism transcends stylistic categorization. Typically associated with realism and conservative academic modes of visual expression, Orientalism also intersected with the diverse agendas of modernism. John Singer Sargent used it as a springboard for exploring art for art's sake (see cat. no. 9), and Albert Pinkham Ryder distilled oriental subject matter into essential elements of color and form (see cat. no. 19). Gifford was similarly adventurous, manipulating the most basic elements of light and landscape. One wonders if his voiced frustration was actually veiled astonishment that a place might so perfectly serve his painterly purposes.

1. A quote from Vedder's *The Digressions of V.* (1910), cited in Ackerman 1994a, 228.

2. J. L. Gérome also painted the Sphinx, confronted by Napoleon (1867–68, Hearst Castle Collection). It was a thinly disguised eulogy of French power over Egypt, and provides pointed contrast to Vedder's early work. See Hardin 1996, cat. no. 18. The most innovative interpretation is Honour 1989, 229. I am indebted to Isabel Taube for her enterprising analysis of the *Questioner of the Sphinx* and to Ann Musser for her consideration of Vedder's relationship to transcendentalism.

3. On issues of Orientalism and Egyptomania, see Jean-Marcel Humbert, "Egyptomania: A Current Concept from the Renaissance to Post-Modernism," in Paris and Ottawa 1994, 21.

Elihu Vedder is an art historical conundrum. An expatriate who lived in Rome for over a half century, Vedder was a modest and retiring man who retrospectively mourned what he perceived as the "home-made air" of his work.[1] All that is commonly agreed upon is that his works are romantic and mysterious. His Orientalism is seldom addressed directly, but rather it is assumed to be an attribute of the mystery that his pictures so often evoke.

In fact, Vedder's fascination with the Orient had at least two phases—a first in which his expatriate European existence and a preoccupation with Egypt generated images of a fabricated fantasy, the Orient through the veil of antiquity. By contrast, the second phase was defined by a direct experience of the Orient. In the company of George F. Corliss, a manufacturer from Rhode Island, Vedder went to Egypt in the winter of 1889–90; he was overwhelmed by the experiential realities of the landscape and atmosphere. These phases were not mutually exclusive: the first phase, in which Vedder honed his distinctive style of intellectualized romance, imbued the second with an overlay of mystery, despite the less fantastic imagery to which it was applied.

The complexity of Vedder's Orientalism is evident in his preoccupation with the Sphinx. *Questioner of the Sphinx*, perhaps Vedder's most famous painting, is enigmatic and variously interpreted.[2] It represents a conflation of the Greek myth of Oedipus with the nineteenth-century notion of Egypt as a desert land filled with the ruins of antiquity. As such it falls more appropriately into the category of Egyptomania than Orientalism, a reverie on the stages of man rather than the powers of nations.[3]

17A ELIHU VEDDER

American, 1836–1923

Cover of "Rubáiyát of Omar Khayyám"

1884

Leather with gold stamping

16 × 27 inches (40.6 × 68.6 cm)

Chapin Library, Williams College, Williamstown, Massachusetts. H. Richard Archer Memorial Book Fund

17B ELIHU VEDDER

Title page of "Rubáiyát of Omar Khayyám"

1884

Lithograph, 16 × 27 inches (40.6 × 68.6 cm)

Chapin Library, Williams College, Williamstown, Massachusetts. H. Richard Archer Memorial Book Fund

17C ELIHU VEDDER

Rubáiyát of Omar Khayyám

1884

Lithograph, 16 × 27 inches (40.6 × 68.6 cm)

Chapin Library, Williams College, Williamstown, Massachusetts. H. Richard Archer Memorial Book Fund

4. On the character of Fitzgerald's translation and the accidents by which Omar Khayyám gained celebrity in the West, see Arberry 1952, 7–45.

5. Broadley 1981, 39–51. On the motivations for going, see ibid., 41.

6. Ackerman 1994a, 226.

7. Quoted in Broadley 1981, 44.

8. Ibid.; cited also in Ackerman 1994a, 228.

Vedder's illustrations, annotations and arrangement of *Rubáiyát of Omar Khayyám* (cat. no. 17) also belong to his first Orientalist phase. A text of modest significance in the history of Persian literature, it was translated by Edward Fitzgerald and came into the hands of Dante Gabriel Rossetti, Algernon Charles Swinburne, and George Meredith. Thereafter its reputation in the English-speaking world was insured.[4] It fell to Vedder to produce the first illustrated rendition of this collection of quatrains.

Responsible for every aspect of the book's design, Vedder coupled his own name with that of the Persian poet on the cover, demoted the translator to a virtual footnote, and visualized the already free "translation" into images that won him considerable fame. The images have very little to do with Persian poetry but instead resonate with the traditions of ancient Greece and Christianity: even a reference to Mahmud of Ghazna, an important figure from Persian history, is illustrated with classicized figures (cat. no. 17c).

18 ELIHU VEDDER

Egyptian Nile
1890
Oil on canvas, 10½ × 15 inches (26.7 × 38.1 cm)
Signed, lower right: Vedder
Kennedy Galleries, New York

Vedder was fifty-three when he was invited to join a Nile cruise organized by George F. Corliss. He went with the assumption that he would produce saleable images or acquire the necessary materials from which to produce them.[5] In fact, Vedder produced relatively few finished images while traveling. However, the trip had considerable impact on the mature artist, altering his depiction of the Sphinx from a small-scale object imaginatively buried in the sand to a distilled rendition of a monument of isolated grandeur.[6] Much of what he saw seemed oddly familiar to him, confirming his earlier fantasies about Egypt, but his response was first and foremost painterly: "I can't help thinking how much it looks as if painted . . . as if nature tried to imitate a good picture."[7]

Indeed, Vedder's response to the environment is particularly strong. His description of the region around Aswan (22 January 1890) might serve as the caption to *Egyptian Nile* (cat. no. 18), so closely does it approximate the extraordinary effects of light on sand that animate the painting: "Such a perfect bit of desert just exactly what I had imagined it to be . . . the sand lodged in the hills like yellow snow, the absolute barrenness of all—the cold wind and a bit of steel blue water to the south made it seem to me like a strange winter scene."[8] The painting is a study in light and color, and there are no clues as to its exact location. The only indication of life at all is the tree sprouting behind one of the boulders at mid-distance. The picture exudes a curious though uninhabited vitality, familiar from the sphinx pictures but here invested simply in the desert. Ultimately, Vedder is a painter of mysteries and, for him, the Egyptian landscape was imbued with that character.

A Visionary Recluse

1. Broun 1989, 22, 23, 246. On Ryder as Orientalist, see Ackerman 1994a, 170–74.

2. Scholars disagree about the dating of Ryder's Orientalist images. Broun dates major pictures including *The Lone Scout* to the 1870s, prior to the 1882 trip, while Homer and Goodrich cite the Tangier sketches and argue that the finished paintings date thereafter. See Broun 1989, 22; Homer and Goodrich 1989, 38.

3. Bolger 1980, 31–32.

4. Ackerman 1994a, 170.

*A*lbert Pinkham Ryder first encountered the Orient vicariously, through the paintings and descriptions of his friends R. Swain Gifford (cat. nos. 21, 22) and Louis Comfort Tiffany (cat. no. 26), whose pictures of the Orient were exhibited during the 1870s. Ryder owned two watercolors by Tiffany, and like Tiffany, he was increasingly fascinated by color. Scholars have noted similarities between their works.[1]

Ryder traveled to Tangier in 1882. It was a brief and reluctant visit, however, made in the company of his dealer, Daniel Cottier, who had taken him to Europe for a vacation and artistic inspiration. Only a few sketches are known from the trip, but the merging of North African imagery with Ryder's unique vision produced a handful of hauntingly evocative pictures.[2] In a sense, these pictures are not about the Orient per se, but rather they signal the emergence of Ryder's highly personal aesthetic.

The Lone Scout (cat. no. 19) typifies Ryder's style of visionary distillation, showing a solitary rider silhouetted against a stark horizon line. Details of the man's dress and accoutrements are unusually precise, anchoring the otherwise ephemeral figure in physical substance. Even so, the figure hangs lightly, mirage-like on the canvas, conjuring up exotic tales like Thomas Moore's *Lalla Rookh*, which Ryder illustrated around the same time.[3] It is not a painting of ethnographic precision but an evocation of a heroic and timeless type. Color and form are concentrated and economical, and the composition is uncluttered by extraneous subject matter.

Ryder's exotic paintings have been described as "the beginning of the end of nineteenth-century Orientalism."[4] Produced relatively early in his career, these images reflected a move away from the academic specificity that characterized the works of Bridgman and Weeks, for example (see cat. nos. 6–8, 10), and anticipated instead the experiments of early modern painters. In his old age, Ryder was lionized by a younger generation, and his works were hung prominently in the central room of the revolutionary Armory Show of 1913, the only American pictures to be exhibited alongside paintings by Matisse, Cézanne, Gauguin, and van Gogh. It was a new era—one in which Orientalism was manifest on Broadway and in the department stores but no longer figured prominently in the realm of "high" art.

19 ALBERT PINKHAM RYDER

American, 1847–1917

The Lone Scout

C. 1880

Oil on canvas, 13 × 10 inches
(33 × 25.4 cm)

Signed, lower left: A. P. Ryder

Fine Arts Museums of San Francisco.
Gift of Mr. and Mrs. John D.
Rockefeller, III

The Curious Things

William Sartain's career coincided with the zenith of American Orientalism, and in many ways, his experiences were not unusual. Like many of his contemporaries, he spent years in Paris honing his craft and went to North Africa as an extension of that process. His stay in Algiers lasted several months during the winter of 1874–75, and he was not the only American in the area. He was accompanied by Charles Sprague Pearce (see cat. no. 27), and he met Robert Swain Gifford and his wife Fannie in Algiers (see cat. nos. 21–24).

What was different about Sartain, however, was that he did not fit the mold of the usual tourist. A disturbed young man, he perhaps sought respite from an unhappy home in travel.[1] Once overseas, however, he made considerable effort to learn Arabic and opted to remain in the old city when Pearce moved into the European section. During the course of his visit, he shaved his head and adopted local dress, trying assiduously to seek out "the curious things."[2]

Algerian Water Carrier (cat. no. 20) reflects Sartain's particular fascination for the old city of Algiers, a place he characterized by intricate winding streets and "mysterious effects in all the little angles and corners."[3] The composition is a sophisticated one, depicting one of those streets plunging downward through a prismatic pile of architectural forms to the point of most intense light at the end of an enclosed alley. The palette is restricted primarily to browns, ochres, and grays, but elements of red and green in the water carrier's garb and in the door and window along the right-hand salient animate and unify a quiet scene without suggesting intercourse between the houses.

Sartain depicted the narrow and irregular streets and dead ends that suit a traditional and introverted lifestyle. In such settings, the integrity of the individual home was protected as well as the self-contained nature of the neighborhood. The quietude and the cleanliness of the streets are striking. Indeed, the broom and the collected trash in the foreground seem to corroborate the citizens' pride in the upkeep of their thoroughfares.[4] Sartain approached the people of Algiers self-consciously, trying to learn their ways rather than demanding his own, and he painted the old city with care and respect.

Sartain's representation of an Algerian water carrier must also be contextualized in reference to the larger tradition of the picturesque. Thus, it is interesting to note that Pearce, Sartain's traveling companion, painted a French peasant carrying water, which was exhibited at the Salon of 1883. A juxtaposition of Sartain's water carrier with that painted by Pearce highlights both the exoticism of the Algerian picture (its difference) and the tropes of the picturesque (its similarity). Water carriers epitomized the traditional and unmechanized ways of rural life, perhaps serving a nostalgic and compensatory purpose in industrializing society.

Ultimately, however, Sartain's *Algerian Water Carrier* illustrates the complexities of Orientalism. As an American tourist in a French colony, he witnessed a time of radical change.[5] What Sartain did not paint is the larger context of colonial campaigns to trans-

1. Gerald Ackerman, "Why Some Orientalists Traveled East: Some Sobering Statistics," in New York 1996, 10–11.
2. Ackerman 1994a, 184–91. I am also grateful to Todd Smith of the Mint Museum for sharing his unpublished manuscript, "'An American in Algiers': The Politics of Late Nineteenth-Century American Orientalism."
3. Sartain's description of the "Arab quarter" is quoted in Ackerman 1994a, 189.
4. Çelik 1997, 11–15, fig. 4.
5. Çelik comments on the mythification of the casbah as a part of the colonial process. Ibid., 22–26.
6. Ibid.

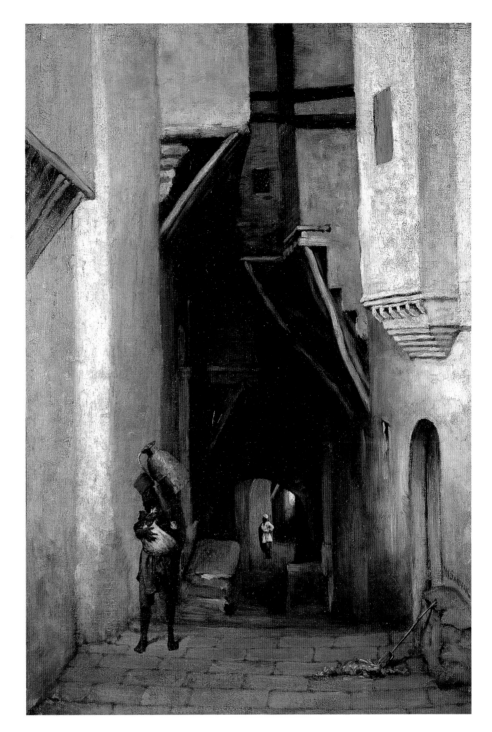

20 WILLIAM SARTAIN
American, 1843–1924

Algerian Water Carrier
c. 1875
Oil on canvas, 22 × 15⅛ inches (55.9 × 38.2 cm)
National Museum of American Art, Smithsonian
Institution, Washington, D.C. Gift of William T.
Evans

form the cityscape of Algiers and transpose it into something more suited to French agendas. In effect, Sartain's painting documented and respected the old city, even as invading forces began to modernize it.[6] Thus, he stands as a reminder of the independent agency of the artist who tries to capture something that others are intent on eliminating.

1. For a contemporary discussion of his career see "American Painters" 1877, 310–12. The best introduction to Gifford's work is Hall 1974. The only detailed discussion of Gifford as an Orientalist is Ackerman 1994a, 90–93.

2. "American Painters" 1877, 311.

3. Moure 1973.

4. See Rainey 1994.

5. For commentary on and reproductions of some of the images, see Moure 1973, 31.

6. He wrote to his benefactor Lydia Swain from Gibraltar on 11 September 1870: "We thought we would come and stay long enough to see whether we could find picturesque material to warrant our staying some time and we are so delighted with the place that we shall probably stay a month or more longer." Robert Swain Gifford Papers, 1722–1968, MSS 12, Old Dartmouth Historical Society, New Bedford Whaling Museum Library, New Bedford, Massachusetts. All references to Gifford's correspondence are taken from this source.

7. Gifford to Fannie Elliot, 9 August 1870.

8. Ibid.

9. Gifford to Fannie Elliot, 9 September 1870.

obert Swain Gifford was a "homegrown" Orientalist.[1] Born into modest circumstances on Nonamesset, a small island off the coast of Massachusetts, he made two trips to North Africa (1870–71 and 1874–75) and eventually became a significant figure in the burgeoning New York art world, enjoying a considerable reputation as a landscape painter during his lifetime. Working in oil, as well as in the newly fashionable media of watercolor and etching, he was a full academician by 1878, a member of the American Association and director of the art schools at the Cooper Union.

One of Gifford's contemporaries claimed that despite a short stint in the studio of the marine painter Albert Van Beest, he had had, in effect, "No teacher but Nature."[2] In a sense, travel was his training. Branching out from his native haunts around New Bedford, he ventured to Maine, Oregon, and California. He went west, at a moment when the art market was low, to gather materials to illustrate three articles in the *Picturesque America* series.[3] Sold by subscription, this nineteenth-century equivalent of a travel magazine was tremendously popular among armchair tourists.[4]

Images that Gifford produced, including a view of Mount Hood and a scene showing men spearing fish at Salmon Falls,[5] transcribe particular sites with modest genre elements in a straightforward and documentary manner. Typically characterized by a low vantage point with a focus on human or animal activity at the center foreground or middle ground, these images present the simple and pastoral rather than the rugged and sublime. Appropriate for the publication, they brought a comfortable and generic

21A ROBERT SWAIN GIFFORD
American, 1840–1905

Tangier
From Sketchbook, vol. 11
1870
Graphite and watercolor on paper,
5¾ × 9¼ inches (14.6 × 23.5 cm)
Signed, lower right: RSG / Tangier Sep. 22nd
/ 1870
Old Dartmouth Historical Society–New Bedford
Whaling Museum, New Bedford, Massachusetts.
Gift of Anne Dechert, granddaughter of R. Swain
Gifford

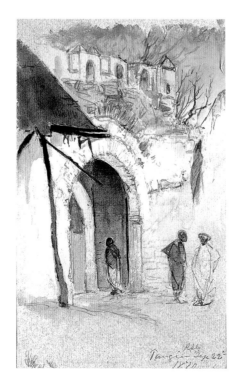

21B ROBERT SWAIN GIFFORD

On the Nile
From Sketchbook, vol. 8
1870
Graphite and watercolor on paper,
5¼ × 7¼ inches (13.3 × 18.4 cm)
Inscribed, lower right: On the Nile, Dec. 5th
1870
Old Dartmouth Historical Society–New Bedford
Whaling Museum, New Bedford, Massachusetts.
Gift of Anne Dechert, granddaughter of R. Swain
Gifford

21C ROBERT SWAIN GIFFORD

Camels and Figures with Child—
Tangier
From Sketchbook, vol. 11
1870
Graphite and watercolor on paper,
5¾ × 9¼ inches (14.6 × 23.5 cm)
Signed, lower right: RSG Tangier 1870
Old Dartmouth Historical Society–New Bedford
Whaling Museum, New Bedford, Massachusetts.
Gift of Anne Dechert, granddaughter of R. Swain
Gifford

rendition of picturesque scenery to the sedentary audiences of the East Coast establishment. It appears to have been a formative opportunity for a young landscape artist of middle-class sensibilities and little income, for in subsequent years while he honed his painterly skills and sense of color, he never lost the taste for the modest, sober and picturesque. Indeed, the quest for the picturesque took Gifford much farther afield.[6] In August 1870, he set out with Louis Comfort Tiffany (see cat. no. 26) for Europe and Africa. Tiffany was footing the bills, and Gifford was orchestrating the details. Having met at the Tenth Street Studio, they did not know each other well before departing, and, as shared travel often does, their adventures strained the relationship.

Gifford's letters to Fannie Elliot, his future wife, provide some sense of how he coped. While still in London, Gifford wrote: "I think I shall like Tiffany very much—the only fault I find is want of decision. If I waited for him there would be nothing done."[7] Their travels were periodically punctuated by sickness (largely Tiffany's), homesickness, heartsickness (Gifford for Fannie), and frustration: "Poor Louis is very homesick tonight. I have been trying to cheer him up. It doesn't do for me to show a particle of my own feelings to him."[8]

Ultimately, the two artists developed a modus operandi that suited their divergent goals and artistic aspirations: "Louis and I are seldom together while we are working as we are trying to do different things and so after painting in the morning we do not see each other again until night." For his part, Gifford seems conscious of and excited by the unprecedented opportunity: "Almost every spare moment from sleep has been spent in work, and work of quite a different character than what I have done before."[9]

157 *Catalogue*

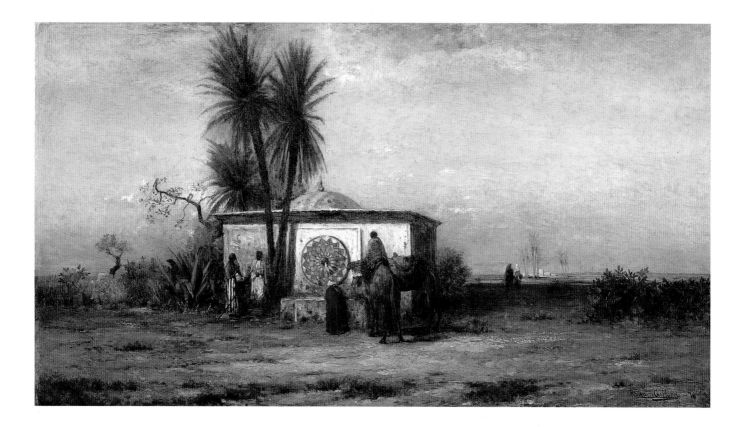

22 ROBERT SWAIN GIFFORD

An Arab Fountain (Near Cairo)
1876

Oil on canvas, 28 × 50 inches (71.1 × 127 cm)
Signed, lower right: R. Swain Gifford 76
Private collection

10. "We shall take the steamer and go to Tangier on the African coast, we have seen some photographs from there and we will probably find what we want there." Gifford to Lydia Swain, 11 September 1870.

11. Gifford to Fannie Elliot, 28 November 1870. This statement is corroborated by Gifford's sketchbooks and provides an interesting complement to Tiffany's claim that the Orient opened his eyes to color.

12. Gifford to Lydia Swain, 18 March 1875.

13. See, for example, the illustration of a Nile boat and interior in *Illustrated Christian Weekly*, 15 July 1871.

14. For a general discussion of the Aesthetic Movement, see Roger Stein, "Artifact as Ideology: The Aesthetic Movement in its American Cultural Context," in Burke et al. 1986, 22–52.

15. Gifford to Lydia Swain, 11 September 1870.

16. Gifford to Lydia Swain, 7 October 1870.

Gifford's working process primarily consisted of a simple conversation with nature based on sketching outdoors. Unlike Frederic Church (see cat. nos. 2, 3), who assembled a vast quantity of data from a wide variety of scenes to create complex and synthetic compositions, Gifford focused on the details of individual settings in a more literal manner. While he writes enthusiastically about dramatic figures and vivid costume, he shows little facility for rendering them. The figures in his sketchbooks are often seen from behind as forms shrouded in voluminous robes, and those in his finished works are usually diminutive and generically conceived. This is perhaps a reflection of Gifford's lack of formal academic training and his preference for landscape as a mode of visual expression.

Gifford occasionally mentions using photographs in his correspondence. Although he did not take photographs himself, nor did he actually paint from them, purchased images sometimes enabled him to anticipate the potential of future destinations.[10] Gifford's apparent lack of enthusiasm for photography is consistent with his simple and increasingly painterly approach to his craft. When he was in Egypt during the course of his first trip to the Orient, he observed, "Nearly everything I do now I tint with color and have made very few sketches with pencil entirely."[11]

When Tiffany became ill with the measles in Egypt, Gifford was obliged to act as nursemaid for weeks, shepherding his ailing companion back through Italy and finally home. When Gifford returned to North Africa with Fannie in 1874–75, the frustrations and weariness that he had experienced with Tiffany were replaced by a genuine enthusiasm for the adventure and beauty of it all. During the course of their travels, they met William Sartain (see cat. no. 20) in Algiers and coordinated activities with Samuel Colman and his wife in March of 1875. Gifford and Colman "improved the time with constant work out of doors" and made at least one longer excursion to Tlemcen, leaving their spouses together in Algiers.[12]

In diverse ways, Gifford's career exemplifies American Orientalism. Like many of his

colleagues, he illustrated travel articles in magazines[13] as well as familiar tales from the *Arabian Nights* (see cat. no. 29), but he is best known for his paintings. *An Arab Fountain (Near Cairo)* (cat. no. 22) is typical of Gifford's treatment of oriental subject matter. Conceived from a comfortably detached middle distance and evocatively peopled by small figures and animals, the composition revolves around the colorful fountainhead at the center of the canvas. That Gifford pivots his picture around this focal point of color and pattern is consonant with stylistic convictions underlying the Aesthetic Movement. It was precisely elements like this, representative of a non-industrialized and exotic artistic tradition, that excited nineteenth-century theorists of design.[14]

If Gifford was susceptible to the appeal of indigenous crafts, what mattered most to him was the picturesque view. He paid careful attention to what things looked like but generally refrained from commenting on what they might signify on an ethnographic or philosophical level. His trip was undertaken for the purpose of professional advancement, and he went about his responsibilities in a sober, industrious, and straightforward way.

Although he seems neither terribly pious nor particularly self-indulgent, his expectations were clearly framed by religious conviction and childhood fantasy: "When we entered the town it seemed as if we had gone back to the time that the old Testament was written . . . everything is so full of beauty. This is one of the kind of places I have seen in my dreams way back in early youth when I had been reading tales of the East and particularly the 'Arabian Nights'"[15] In retrospect, some of his comments sound condescending and sexist: "This is a great country for the Historian and Painter but for the social life and rights of living generally, it seems to me there cannot be found anything—at least for us who have been born there—like or equal to our own country. One thing is very noticeable: the deference paid to ladies and women generally in our own country is something remarkable in comparison with anything I have seen since I have been on this side of the Atlantic and I am sure if the women of our country could realize the great difference they would not complain of want of consideration on the part of men."[16]

If he was a tourist with a sober but artistic sensibility, Gifford was also personally and professionally changed by the experience of traveling to the East. Indeed, his Orien-

23 THOMAS EDWARD
MULLIGAN WHITE

Quittacus Club Members in Costumes from North Africa
c. 1875
Stereograph, 3½ × 7 inches (8.9 × 17.8 cm)
Old Dartmouth Historical Society–New Bedford
Whaling Museum, New Bedford, Massachusetts

24 *Caricature of R. Swain Gifford (included in Fannie Elliot's sketchbook)*

c. 1875

Graphite and watercolor, 5 × 7 inches
(12.7 × 17.8 cm)

Old Dartmouth Historical Society–New Bedford
Whaling Museum, New Bedford, Massachusetts

17. On the general studio scene in New York, see Blaugrund 1997. See also journalistic coverage of artists' studios, e.g., "Art Studios," "American Painters" 1877.
18. Gifford briefly describes the reception in a letter to Lydia Swain, 21 January 1872.
19. See note 16.

talism became part of his public and private persona. To a degree, this was a calculated act of self-promotion that he and Tiffany jointly undertook in the increasingly flamboyant and competitive New York art scene.[17] For weeks after their return, the two artists assembled the pictures and memorabilia from their trip to the Orient for a formal reception in their studios.[18]

And so Gifford's reputation as an Orientalist was launched. His studio was a study in restrained exoticism,[19] and his Orientalist pictures formed a large part of his oeuvre, complementing landscapes drawn closer to home. Meanwhile, he maintained and extended his oriental experience in his own backyard, dressing up in exotic finery and cavorting with other members of the Quittacus Club of New Bedford, Massachusetts (cat. no. 23). An unknown caricaturist captured him in such garb, looking urbane and witty at his easel, very much the lampooned aficionado (cat. no. 24). While there is surely satire among friends here (the caricature derives from an album of sketches executed by artists in Fannie Elliot's social circle), the image also alludes to the artist's self-conscious posing. Like Bayard Taylor before him (see cat. no. 1), Gifford assumed a posture of worldliness and expertise in the wake of his travels. The Orient became a cultivated attribute of his identity, in a sense, and a distinctive element in his public personae. Thus Gifford was a man of his times, masquerading an exotic identity in an era of social change.

Views of North Africa

Samuel Colman was renowned for his landscape painting and his active involvement in the American art world. An academician in the National Academy of Design, he played a prominent role in the American Watercolor Society, the New York Etching Club, and the Society of American Artists. Traveling extensively in Europe and the American West, he was also among the earliest American painters to tour North Africa.[1] He left for Europe in 1860, visiting Paris and Rome before moving on to Spain and Morocco. Spain, in particular, captured his imagination and inspired numerous sketches and eight paintings that he exhibited in the five years following his return to the States in 1862.[2] Colman went to North Africa again in 1871–75, a trip that also included stops in Italy, France, and Holland.

Colman is often linked with fellow Orientalists Louis Comfort Tiffany (see cat. no. 26) and R. Swain Gifford (see cat. nos. 21–24). Colman was older than the other two artists and traveled at different times with each. He went west with Tiffany in 1870[3] and with Gifford and his wife in Algiers in the spring of 1875.[4] The Giffords had originally expected that Tiffany would also come to Algiers, but the birth of Tiffany's child intervened and he never arrived. Gifford described the situation in a letter home: "Mr. Colman and I have improved the time by constant work out of doors. . . . Next week Mr. Colman and I are going to make an excursion to Tlemcen, leaving Fannie and Mrs. Colman to keep house together or rather Fannie is to stay with Mrs. Colman. We shall be gone about a week and soon after our return we shall get through here and leave for Bone a town on the coast east of us to take the steamer for the coast of Italy."[5]

The trip that Gifford anticipated may have provided the inspiration for Colman's watercolor, *The Moorish Mosque of Sidi Halou, Tlemcin, Algeria* (cat. no. 25). There are two versions of the work, of which this is the more fully realized.[6] This may well be the painting that graced Colman's easel when a writer from the *Boston Daily Evening Transcript* visited his Manhattan studio on 3 December 1875. Noting the exotic eastern fabrics decorating the space, the writer commented on the watercolor in progress that depicted a street scene outside the city of Tlemcen.[7] It was certainly highly acclaimed in the 1876 exhibition of the American Watercolor Society, for its monumentality and masterful manipulation of a medium that was just beginning to gain credibility as a refined mode of artistic expression. This was the exhibition watercolor par excellence.[8]

Colman's work was juxtaposed in the 1876 exhibition with pictures by Gifford and Tiffany, as it is in this exhibition as well (see cat. nos. 21–24, 26). This demonstrates the commonalities and differences among American Orientalists who traveled in the Orient without extensive academic training in Europe. These three artists, all significant figures in the history of American art, gained technical skills and formative inspiration from their oriental experiences. All three chose subject matter in the open air, seeking out picturesque views that served their diverse agendas.

The view captured in *The Moorish Mosque* served as a superb vehicle for displaying

1. Ackerman 1994a, 66–68. Craven 1976, 16–37. For particular reference to Colman's trips to the West, see Moure 1973, 27–28.
2. *The Hill of the Alhambra, Granada*, for instance, demonstrates Colman's maturity. See Craven 1976, fig. 5; 19–20. There is also a lovely sketch of arches in the Córdoba Mosque in the Cooper-Hewitt National Design Museum, New York (acc. 1939.85.104).
3. Ackerman 1994a, 212.
4. This fact is debated by scholars, but this interlude is clearly described in letters that Gifford wrote home from Algiers, which are quoted below.
5. Gifford to Lydia Swain, 18 March 1875.
6. The other version, *Arabian Street Scene*, is in the Memorial Art Gallery of the University of Rochester. It is considerably smaller (12 x 20 inches) and lacks the detail and compositional clarity of the New York Public Library version. I am grateful to Cathy Irzgard for providing me with a reproduction of the Rochester painting.
7. Quoted in Ackerman 1994a, 68.
8. Barbara Dayer Gallati, "The Exhibition Watercolor in Amcrica," in Ferber and Gallati 1998, 48.

25 SAMUEL COLMAN
American, 1832–1920

Moorish Mosque of Sidi Halou,
Tlemcin [Tlemcen], Algeria
1875
Watercolor, 44 × 26 inches (111.8 × 66 cm)
The New York Public Library, Astor, Lenox and
Tilden Foundations

watercolor technique. In this work, Colman achieved a masterful balance between monumental forms and diverse surface textures, between inanimate buildings and vital human activity. Beautifully cadenced in an unusual vertical format, the image culminates in the stereotypical stork at the top of the tower. The picture retains the limpid delicacy of the medium even as it commands attention as a forceful and finished work of art.

The Preeminence of Color

Louis Comfort Tiffany's involvement with the Orient was multifaceted. He traveled to the Orient, and he painted it throughout his life. His decorative arts often evoke the Islamic artistic tradition, and his architectural magnum opus, Laurelton Hall, was replete with Orientalisms of all kinds. Nevertheless, the exact nature of Tiffany's debt to the Orient remains difficult to pinpoint. His own claim, made to the Rembrandt Club of Brooklyn in 1917, was that "the preeminence of color was brought forcibly to my attention" during a trip to the East early in his career.[1] Color being the single most important component of his oeuvre, Tiffany's Orientalism bears serious scrutiny.[2]

Tiffany's claim about color and the East seems, on one level, to overburden the facts, for his direct contact with the Orient was both short and problematic. Traveling with his friend and colleague R. Swain Gifford (see cat. nos. 21–24),[3] Tiffany spent about three weeks in Tangier (3–26 September 1870) and about a month in Cairo at the end of 1870.[4] During most of their stay in Egypt, Tiffany was dangerously ill with the measles and spent much of his time in bed. He was miserable, anxious, and even feverishly delusional at times. When he finally recovered, he simply wanted to go home.[5] It is of great interest that fifty years later, the artist would attribute so much to his experience in the Orient.

Of course, the trip could have been both traumatic and formative. The most substantive evidence of it is a corpus of paintings executed in the wake of his travels in North Africa. Although generally well received by his contemporaries, these pictures have attracted only modest scholarly attention due to what has been deemed their "drab" character.[6] During the course of the 1870s, these pictures were Tiffany's primary contributions to New York City's art world, and they presumably furthered his growth as an artist, helping him to translate his overseas experience into aesthetic convictions that underlie his subsequent work in the decorative arts.

Among Tiffany's recorded works from the 1870s, three are of particular relevance here: *On the Way between Old and New Cairo* (cat. no. 26), *Snake Charmer at Tangier*, and *Market Day Outside the Walls of Tangier*. The latter two pictures derive from the Tangier trip, while the first picture is based on the Egyptian sojourn. None were actually painted in the East but rather were produced after Tiffany returned to New York in February 1871. All three reveal Tiffany's overriding aesthetic concerns and suggest that he was already focusing on the role of light and color to create mood, atmosphere, and an experience of beauty for the viewer. What the Orient seems to have contributed was raw material.

In order to appreciate this, it is useful to correlate *On the Way between Old and New Cairo* (originally exhibited at the National Academy of Design in 1872), with a letter from 28/29 November 1870 from R. Swain Gifford.[7] He and Tiffany had been in Cairo for only a few days, and Tiffany had not yet succumbed to the measles. Gifford recounted that he had left Tiffany out in the desert because he wished to make a distant

1. This statement is quoted frequently. See, for example, Frelinghuysen 1998, 6. On Tiffany as Orientalist, see Ackerman 1994a, 208–15.

2. On the role of color in Tiffany's work, see, for example, Reynolds 1979, 20. See also Taube 1996.

3. There is scholarly discrepancy about whom he traveled with, where, and for how long. My comments are based on the letters which R. Swain Gifford, Tiffany's traveling companion, wrote to various family members in America.

4. Tiffany was in Tangier from 3 September to 26 September. October and November were spent in Malta, Sicily, and Naples. They arrived in Alexandria on 24 November and Cairo on 28 November.

5. By 5 December, Tiffany was quite ill, and by 9 December, the measles had "come out." Tiffany was still sick when they spent Christmas in Rome.

6. Duncan 1992, 15. In Duncan 1989, 11, the author describes the pictures as "a dreary selection of landscapes and Arab bazaar studies."

7. Gifford to Tiffany, 28/29 November 1870.

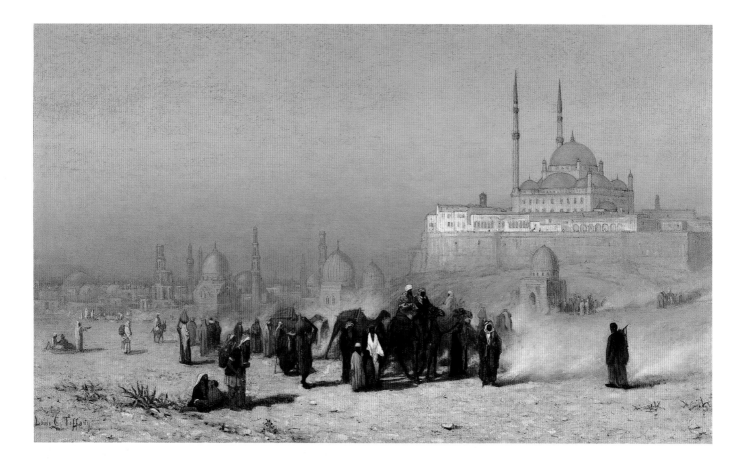

26 Louis Comfort Tiffany

American, 1848–1933

On the Way between Old and New Cairo, Citadel Mosque of Mohammed Ali, and Tombs of the Mamelukes

C. 1872

Oil on canvas, 41½ × 68 inches (105.4 × 172.7 cm)

Signed, lower left: Louis C. Tiffany

Brooklyn Museum of Art. Gift of George F. Peabody, April, 1906

view of the citadel. Apropos of this day's venture Gifford added, "It is impossible to do anything out of doors in oil as the dust is so fine and light that it gets into everything."[8] Such, we may suppose, were the working conditions under which Tiffany recorded his direct impressions of the citadel and tombs of Cairo. Not surprisingly, the dust is a formidable and formative presence in the finished picture. The architectural panorama, punctuated by domes and minarets, is subtle and opalescent, incorporating a rainbow of hues as if refracted and homogenized by grains of dust.

Such a background in turn provides the setting for a congregation of figures and camels rendered in a qualitatively different palette.[9] The figures are indistinct types of varying tones of browns, ochres, and reds, and they stand before the luminous background as obscure players on a dramatic stage. Within this dark mass, variation is largely a function of color. One isolated figure at the right side of the canvas is simply a dark and undifferentiated silhouette in the dust. Another figure, economically evoked with blue and red robes and a bold white head garment, stands in a faceless but engaging address to the viewer. Another individual holds the very center of the canvas with his startlingly white robe, very dark skin, and red turban. Other figures are engaged in recognizable activities—the lone figure seen from the rear balancing a water jug on her head, the woman and child in the left foreground—but they are types meant to people the setting in a generic way, articulated by means of pure color.

This is not ethnography nor is it a picturesque slice of Egypt really. Instead, it is an effort to transpose an atmospheric experience and its aesthetic implications onto canvas. Wind and sun come from the same direction, and the viewer is sufficiently close as to be implicitly subject to their buffeting. But while the sun is most obviously or literally present as the cause of long shadows in the picture, light is a more active and multifarious agent here. It blindingly obliterates detail and nuances of color in the foreground, and it imbues the background with an internally lit and coloristically varied homogene-

ity. Ultimately, the picture is about the relationship between color and light, rather than about the place.

It is revealing to compare *On the Way between Old and New Cairo* to a work by Gifford that also depicts a Cairene subject (see cat. no. 22). Whereas Gifford's painting is picturesque and documentary, Tiffany's is self-conscious and experiential; whereas Gifford depicts a little bit of the Orient, Tiffany addresses the nature of representation.

Tiffany's *Market Day Outside the Walls of Tangier* (p. 29, fig. 9) exhibits many of the same features as *On the Way between Old and New Cairo*. Both are panoramas rendered with a limited palette strong in browns, ochres, and reds. In both, the human component is generically conceived and placed against a setting defined by the play of light on architectural and landscape forms. Scholars have noted that Tiffany utilized a photograph of almost identical subject matter in the creation of this painting, and that, in the process, he deleted the discordant presence of Westerners visible in the photo.[10] Tiffany thus deliberately constructed a timeless and traditional Orient, which in some details contradicted his personal experiences and primary source materials. While revealing, such comments are ultimately tangential, however, for Tiffany's Orient is fundamentally an issue of light and atmospherics rather than ethnography.

Snake Charmer at Tangier[11] reveals further the idiosyncratic nature of Tiffany's Orientalism. For his compatriots Frederick Bridgman and John Singer Sargent, Orientalist imagery was inextricably linked with the experience of French academic training. Tiffany, too, had a dose of Paris, but it does not seem to have exerted the same impact.[12] *Snake Charmer* addresses a longstanding trope in French Orientalist imagery (for example, see cat. no. 5), and intimates that Tiffany was dutifully taking up the genre as part of his education. The coloristic effects of the sun falling across the courtyard picking out details of the architecture and the carpet are intriguing and finely wrought. The composition is interesting, but there is little specificity in the depiction of the people or culture. One senses that Tiffany approached this subject half-heartedly, using it to further his own as yet inchoate ends. Ultimately, he turned to other subjects that better suited his aspirations.

So what of Tiffany's much-vaunted debt to the Orient? Do his paintings of the 1870s record a revelation? Preceding comments suggest that they can be seen as a preface to Tiffany's larger project about light and color and as a reflection of his idiosyncratic pursuit of beauty in many forms. However, it would be inappropriate to equate these paintings with Tiffany's experience of the Orient, even though they may be our most immediate record of his impressions. The Orient, after all, was filtered through a variety of lenses in the later nineteenth century, and these secondary renditions of the Orient perhaps merged in the mind of the elderly Tiffany in 1917 with the primary Orient that he encountered overseas.

The Orient, for example, was also the purview of two of Tiffany's mentors, Samuel Colman and Edward C. Moore. In the hands of these men, the Orient might easily have linked effects of color and light. Colman overtly explored these issues in his paintings, and his manipulation of that coloristically most sensitive medium, watercolor, had a formative impact on the young Tiffany (see cat. no. 25). Similarly, Moore provided access to the tradition of Islamic art in which color is generally pure, unmodulated, and saturated. Even in important secondary publications that Tiffany had access to, such as those of Owen Jones, the formal significance of color would have been inescapable.

If Tiffany's coloristic debt to the Orient may have been due to secondary Orients in addition to his primary travel experience, his representation of the Orient was perhaps

8. Ibid.

9. Reynolds 1979, 16, describes these figures as "awkwardly rendered and . . . too much like a montage of posed studies rather than a lively teeming crowd of travelers." He also notes that one contemporary critic found the painting "only moderately good."

10. See Reynolds 1979, 17.

11. Reproduced in Frelinghuysen 1988, 6.

12. Reynolds comments on Tiffany's "disinterest" in the French academic tradition in Reynolds 1979, 11. Charles de Kay comments on Tiffany's experiences with Belly and Bailly in France but notes that he basically went his own way. De Kay 1987, 8.

13. Gifford to Lydia Swain, 21 January 1872.

14. Moran 1880, 3–4.

also more varied in media other than painting. The most dramatic manifestations of his Orientalism are arguably the creation of his studio and the fabrication of his entrepreneurial public persona. These activities, inextricably bound to his subsequent work in the field of interior design and his role as creator of public taste, were inaugurated by Tiffany and Gifford's grand reception upon their return from the Orient. With this event, staged on two separate evenings in January 1872, the pair presented their paintings and their memorabilia to the public. It required extensive planning and orchestration, leaving them both exhausted, but it efficiently launched their careers as Orientalists in the artistically dynamic setting of metropolitan New York:

> We had our reception two afternoons and evenings. A great many of our friends wished to see what we brought home from our foreign tour and it seemed better to have them all come at once and get through with it. It was a great success. We had over 500 people, the best and most highly cultivated people in the city. I sold one picture during the reception and made arrangements to paint three or four more. We had such new and strange things to show our friends that they expressed a great deal of pleasure at the entertainment.[13]

Subsequently, Tiffany's studio continued to be a place of colorful and dramatic exoticism, which, according to John Moran writing for the *Art Journal*, "fairly dazzles" in its oriental splendor. By contrast, the same author describes Gifford's studio, also liberally sprinkled with Orientalia, in terms of its gravity and repose.[14]

Clearly, Tiffany was a dramatic personality and a dynamic presence in the city, and his élan was largely a function of his Orientalism. It is in this light, along with reference to the paintings, that the ruminations of the elderly Tiffany must be viewed, for his emphatic claim of discovering color in North Africa rhetorically telescopes the variegated reflections of the Orient in his life and work.

The Simple Life

1. Ackerman 1994a, 158–61.
2. Bolger 1980, 118–19.

*A*n expatriate artist known primarily for his depictions of peasant life in rural France, Charles Sprague Pearce also painted oriental imagery after traveling to North Africa in search of a climate more conducive to his chronic respiratory ailments. In the company of Frederick Bridgman (see cat. nos. 6–8), he traveled first to Egypt (1873–74), spending time in Cairo and taking a tour on the Nile. His second trip, made in the wake of another bout of illness, was in the company of William Sartain (see cat. no. 20), when they spent the winter of 1874–75 in Algiers. For Pearce, these trips generated a corpus of material that encompassed scenes of ancient Egypt, biblical histories, and images of modern Arab life.[1]

Pearce enrolled in the atelier of Léon Bonnat in 1873 and lived for most of his adult life outside Paris. Exhibiting *The Arab Jeweler* at the Paris Salon of 1882, he demonstrated the sure modeling of the human body and the sophisticated rendering of fabrics and setting. If this betrayed his French experience, the work also resonates with craftsman imagery popular in America at the time.[2] The unifying thread running through Pearce's oeuvre, however, is a dedication to the picturesque aspect of traditional societies.

27 **CHARLES SPRAGUE PEARCE**
American, 1851–1914

The Arab Jeweler
c. 1882
Oil on canvas, 46 × 35⅜ inches (116.8 × 89.9 cm)
Signed, lower left: Charles Sprague Pearce
The Metropolitan Museum of Art, New York.
Gift of Edward D. Adams, 1922

Painting on the Surface

*F*rancis David Millet was an artist, a polyglot, an adventurer, a war correspondent, and a civic-minded humanitarian. But was he an Orientalist? Not exactly, except insofar as he traveled along the western border of the Ottoman Empire, witnessing a grotesque conflict in the Russo-Turkish War of 1877. He also paddled down the Danube while working on a series of articles for *Harper's Magazine*, making wonderful drawings along the way that are notable for their economy of line and incisive depiction of people, some of whom were Turkish.[1] He did a few extraordinary paintings of oriental "types," in which single male figures are shown wearing exotic costumes. It is arguable, however, that Millet was not an Orientalist at all but, rather, a man fascinated with life, lingering none too long anywhere but dabbling everywhere with the flair of a virtuoso.

Millet graduated from the Akademie voor Schone Kunsten in 1873, acted as secretary to the American Commissioner for a World's Fair in Vienna, and then moved to Rome, where he took life classes at the Academy of Saint Luke and prepared this picture for the Brussels salon of 1875. It was the first time that his work was shown in a major exhibition. The picture itself is a far-fetched contrivance. A water seller plying his trade in the street would ordinarily walk with an animal skin full of water slung over his back.[2] By contrast, this water seller is shown with crystal glasses and a gilded pitcher. He is extravagantly dressed, and his demeanor is almost haughty.

Like most of Millet's pictures, this one does not tell much of a story, nor does it convey a weighty message.[3] It is a set piece about surfaces, colors, and textures.[4] Turbans and tassels provide the structure, and the overarching tent is a subdued echo of the extravagant silken headgear of the water seller. Driving the painting is the contrast between the sheer opacity of the man's black skin and the transparent clarity of the glasses of water. The painting is also about color and light in the shade of a tent that shields a sun so intense that it bleaches out the architectural setting beyond. The man's skin seems to glow in the darkness of that space, and the water seller's attribute, his pitcher, is almost heraldic: gold luster afloat on a milky green glaze. Such display suggests that Millet is trying to prove that he can paint.[5]

Having argued for an aesthetic reading of this picture, the fact remains that the painting depicts a black-skinned person in close and objectified proximity to the viewer. How are we to relate such a picture to traditions of race representation that were current in America in the late nineteenth century—African-Americans as singing and dancing "primitives," subjugated field workers, or domestic slaves?[6] Millet's painting of the water seller has little to do with such racial slurring. The picture was akin to a graduation exercise, conducted in Europe and preceding any firsthand experience of the Orient. It is not about the Orient nor about race relations in America; rather, it presents beauty with reference to race, perhaps even projecting an alternative to the prevailing stereotypes of the era.

1. Some reproductions of these drawings are unpaginated supplements to the text of Sharpey-Schafer 1984.
2. Witness, for example, a vendor who sold refreshment to the passersby at the 1893 Columbian Exposition in Buel's *Magic City* album (see cat. no. 45).
3. Millet was criticized for his weak anecdotes and the narrative ambiguity of his genre scenes. See Weinberg 1977b, 9–10.
4. There is debate about the exact title and date when this picture was first exhibited. It is reproduced as *The Yellow Silk Turban* by the painter's granddaughter in Sharpey-Schafer 1984. H. Barbara Weinberg states that *Turkish Water Seller* was exhibited at the Brussels salon in 1875 in Weinberg 1977b, 4. Gerald Ackerman notes that "some scholars think that this is the work exhibited at the Salon de Brussels in 1878 under the title of the *Turkish Water Seller*, even though the subject is neither a Turk nor a salesperson, but rather a black servant." Ackerman 1994a, 130.
5. Sharpey-Schafer 1984, 51. This painting predates his trip as a war correspondent to the Orient in 1877–78. According to his granddaughter, he brought back from the trip a great deal of Orientalia, stuff that transformed his apartment into "an Aladdin's cave of treasures." Among the objects described there is reference to "a very brilliant yellow silk turban"; it is conceivable that this is the headgear that the figure wears in the painting, acquired at an earlier date.
6. See Judith Wilson, "Lifting the Veil: Henry O. Tanner's *The Banjo Lesson* and *The Thankful Poor*," in Calo 1998, 211. See also Boime 1990.

28 FRANCIS DAVID MILLET
American, 1846–1912

Turkish Water Seller

1874
Oil on canvas, 40 × 28 inches (101.6 × 71.1 cm)
Signed, lower left: F. D. Millet, 1874
Private collection

1. Gerald Ackerman terms those painters who painted the Orient without benefit of firsthand travel experience "Pseudo-Orientalists." Ackerman 1994a, 11. I have opted to use "Armchair Orientalists" to characterize the sedentary but heartfelt character of a form of Orientalism inspired by literature, translated and otherwise.
2. For an introduction to the *Thousand and One Nights*, see Irwin 1994.
3. For more on their individual renditions, see ibid., 23–35.

*A*rtists who went to the Orient and painted what they saw were not representative of the population at large. Most people only dreamed of the Orient, inspired by the exotic tales that proliferated in magazines and books in the nineteenth century.[1] The single most formative collection of stories, of course, was *The Arabian Nights*, or the *Thousand and One Nights*, a huge compendium of oral literature that was assembled into written form over the centuries, subject to emendation, addition, deletion, and all manner of other capricious adjustments. Indeed, *The Arabian Nights* has been termed "a book without authors" in recognition of its complex emergence from the larger literary and social traditions of the Arab world.[2]

By the turn of the century, Americans had access to a variety of versions and editions of *The Arabian Nights*, including the translations by Edward William Lane (1838–41), John Payne (1882–84), and Richard Burton (1885–88).[3] Predictably, the editorial choices made by these different translators had considerable impact on American perceptions of the stories. Lane conceived his translation for family reading, expurgating or rewriting anything inappropriate for youthful ears. He deleted entirely all that he deemed obscene, along with anything else that he thought was tedious. In the process,

29 R OBERT S WAIN G IFFORD
American, 1840–1905

The Roc's Egg
1874
Watercolor on paper, 14¹¹⁄₁₆ × 10¾ inches
(37.3 × 27.3 cm)
Signed, lower left: R. Swain Gifford / '79
Farnsworth Art Museum, Rockland, Maine.
Gift of Mrs. Dorothy Hayes, 1959

30 JOHN LAFARGE
American, 1835–1910

Fisherman and the Genie
1868
Engraving, 6¾ × 5⅜ inches (17.1 × 13.6 cm)
Preservation Society of Newport County,
Newport, Rhode Island

31 JOHN LAFARGE

The Giant
1869
Engraving, 7 × 5½ inches (17.8 × 14 cm)
Signed, lower left: JHF 1869
Preservation Society of Newport County,
Newport, Rhode Island

4. Ibid., 33–35.
5. In the late twentieth century, the erotic content of the
tales is still often emphasized. See, for example, a full-
page advertisement by Easton Press for a new edition of
Burton's translation, which was featured in the *New York
Times Book Review* on 26 February 1995. The ad copy
read, "The complete Arabian Nights, Uncut! Uncen-
sored! Extraordinary! . . . All in all this is the world's
greatest treasury of exotica and esoterica—containing,
too, everything you wanted to know about harems,
eunuchs, aphrodisiacs and topics beyond imagining.
Victorians would almost kill for a peek at these pages!"
6. A good example of this abridged genre is Burnside n.d.

he left out most of the poetry and some very good stories. Burton, on the other hand, included everything and embroidered a lot in his comprehensive translation. He was a man of many prejudices, and he was more than a little preoccupied with the scatologi-cal and the prurient. These tastes permeate the extensive notes appended to his transla-tion.[4] Given such diverse approaches, *The Arabian Nights* has had a varied reputation over time, ranging from innocent to mildly titillating to positively racy.[5]

The Arabian Nights begins with the tale of Shariyar, a mythical king who discovers his wife's infidelity with a kitchen servant and has her put to death. Thereafter, in order to avoid similar experiences, he commandeers a virgin for his bed every night and has each of them beheaded the next morning. After this practice had gone on awhile, the vizier's daughter Scheherazade volunteers to go to the king, and begins a clever strategy of telling him an entrancing story every night to stave off her pending execution. This goes on for a thousand and one nights, at which point Shariyar relents and accepts Scheherazade as his wife. Thus, *The Arabian Nights* involves stories within stories, lead-ing the reader further and further into an enchanted world. Among the most famous are "The Story of the Fisherman," "Aladdin and the Magic Lamp," "Sindbad the Sailor," and "Ali Baba and the Forty Thieves."

So domesticated did the tales become that Americans often encountered *The Ara-bian Nights* in piecemeal fashion, without acknowledgment of a translator or original source. Thus a dozen or so stories would be "arranged" by someone and perhaps sup-plemented with illustrations in a handsome volume for a home audience. In such col-lections, the tale of Scheherazade and the hapless virgins might become an unexplained marital displeasure between a king and his queen, who resorts to entertaining her hus-band with good stories to avoid execution.[6]

In this sanitized guise, the stories enjoyed considerable popularity. Harriet Beecher Stowe, proper and puritanical author of *Uncle Tom's Cabin* and many other "edifying"

32 HENRY SIDDONS MOWBRAY
American, 1858–1928

The Calenders
1889
Oil on canvas, 9¼ × 18⅛ inches (23.5 × 46 cm)
Signed, upper right: H. Siddons Mowbray
The Detroit Institute of Arts. Founders Society
Purchase, Beatrice W. Rogers Fund

7. Stowe 1873, vii–viii.

8. Unfortunately, there has been no study of illustrated versions of *The Arabian Nights*.

9. *Riverside Magazine for Young People*, 2, no. 19 (July 1868), frontispiece.

10. *Riverside Magazine for Young People*, 2, no. 24 (December 1868), frontispiece.

11. These illustrations were perhaps a money-making venture for him at a time when his professional prospects were obscure. For a chronology of La Farge's life and reproduction of representative works, see Newport 1989. See also Weinberg 1977a.

12. Yarnall 1995, 144.

volumes, deemed *The Arabian Nights* quite wholesome and even uplifting, and included selections in her *Library of Famous Fiction Embracing the Nine Standard Masterpieces of Imaginative Literature* (1873). According to Stowe, such tales, and similarly imaginative literature in general, gave "a start to the imagination, such a powerful impulse to the soul." These stories were acceptable and treasured entertainment "even in the strictest households," and they provided magical escape from prosaic existence for children and adults alike.[7]

Imagine their impact if they were also illustrated.[8] Having the bizarre and inconceivable stories visualized, thereby granting them more palpable reality, must have been a treat indeed. R. Swain Gifford managed this effect in a beautiful drawing *The Roc's Egg* (cat. no. 29), an episode from the cycle of stories of Sindbad the Sailor, an enterprising adventurer who acquired great riches during the course of his many voyages. At one point, he bought a ship and took aboard several foreign merchants and their belongings. Stopping at an island, they came across the egg of a roc (a legendary bird of prey of great size and strength), which they roasted and ate. The parent birds, understandably enraged, dropped huge stones down on the ship in revenge and sank it. Gifford enhances the magical quality of this tale by devoting most of the drawing to the huge egg surrounded by the dwarfed travelers.

The *Riverside Magazine for Young People* included illustrations of *Fisherman and the Genie* (cat. no. 30)[9] and *The Giant* (cat. no. 31)[10] executed by John La Farge, an artist who traveled to Japan but never to the Levant or North Africa, and became known later in life primarily for his murals and stained-glass windows.[11] La Farge turned to a wide variety of sources to create the appropriate imagery for these fanciful tales. In the *Fisherman and the Genie*, the artist combined elements from a Japanese print and an altarpiece by Titian, and set the scene on his favorite beach near Newport, Rhode Island. For *The Giant*, he used a similar melange of diverse source materials that range from Japanese prints to French Romantic paintings, assembling the scenario effectively in his own backyard.[12]

The Arabian Nights also served as inspiration for paintings that were entirely divorced from any formal narrative context. H. Siddons Mowbray, known primarily for

33 HENRY SIDDONS MOWBRAY

Rose Harvest

1887

Oil on canvas, 14 × 20 inches (35.6 × 50.8 cm)

Signed, lower right: H. SIDDONS MOWBRAY 87

Mint Museum of Art, Charlotte, North Carolina.

Museum Purchase: Exchange Funds from the Gift

of Mrs. John White Alexander

mural paintings from later in his career, drew on *The Arabian Nights* to compose evocative and beautiful easel paintings (cat. nos. 32, 33).[13] His exotic imagery did not always derive from translated literature. One of his loveliest paintings, *Rose Harvest* (cat. no. 33), likely illustrates an episode from Thomas Moore's *Lalla Rookh,* a work that enjoyed considerable popularity in the late nineteenth century.[14] Ultimately, however, the source of the story and the authenticity with which it rendered the Orient were of little consequence; the flights of fancy that they engendered were the important point. As with Vedder's rendition of the *Rubáiyát* (see cat. no. 17), the exotic raw material was often manipulated to reach creative and idiosyncratic ends.

The popularity of oriental tales and travelogues attracted shrewd entrepreneurs. Bayard Taylor (see cat. no. 1) was one who had traveled to the Orient and came back to tell others of his adventures, fueling a successful career on the lecture circuit. Others saw the potential profits to be made from armchair Orientalists and adjusted the formula of oriental tales for profit. An advertisement for Colonel Thomas W. Knox's book *Backsheesh! or Life and Adventures in the Orient* (cat. no. 34) is indicative of the competitive market in such Orientalia. As the broadside indicates, the book was to be sold only by subscription and is described as being "designed and engraved principally in London, Paris, and New York, from photographs and original sketches at a cost of over ten thousand dollars." The advertisement trumpets a royal octave volume of over seven hundred pages, nearly 250 splendid illustrations, and forty-eight magnificent full-page engravings. The publishers bemoaned the "barefaced tricks" of "desperate people" who had already tried to abscond with Colonel Knox's stories and reputation in publishing their own "small and inferior works," but this was to be the "real thing."

13. Owens 1980, 82–89.

14. For diverse manifestations of the popularity of *Lalla Rookh,* see Bolger 1980, 31.

34 *Broadside for "Backsheesh! or Life and Adventures in the Orient"*

1875

Letterpress, 11 × 8½ inches (27.9 × 21.6 cm)

Chapin Library, Williams College, Williamstown, Massachusetts. 1940 Chapin Library Americana Fund

The real thing was a collection of short, humorous anecdotes of human foibles and frailties set in the Orient. "Backsheesh," which loosely translates as "gift," signifies the requests for money that travelers often encountered in the Orient. As the broadside explains, "A little 'backsheesh' put where it would do the most good, revealed to the author of the present volume many strange and wonderful sights, and what he saw, heard, and did, and the adventures of himself and companions—one a jolly judge, the other an original genius known as the 'Doubter'—are graphically and humorously portrayed by pen and pencil in the fascinating pages of Backsheesh!"

Backsheesh!, The Arabian Nights, and other oriental tales fed the seemingly insatiable desire of Armchair Orientalists for escape and fantasy and provided the standards against which subsequent travel experiences were often gauged. It was a potent and cumulative folklore—part translated literature and part sheer fabrication—and it exerted a formative impact on American public opinion.

A Studio Orientalist

Including William Merritt Chase in an exhibition on American Orientalism requires justification. Chase trained in Munich, he never traveled to the Orient, and exotic subject matter did not figure prominently in his oeuvre. Despite these basic facts, however, he epitomizes what might be termed a studio Orientalist, one whose notions of the Orient imbued his diverse personal spaces with an entrepreneurial touch of the exotic.

Chase used oriental imagery early in his career as an opportunity to hone his technical skills and demonstrate his talents. *Moorish Warrior* (cat. no. 35) is a product of his student years,[1] likely painted for a patron in Munich in 1878. Assembling the artifacts lying about his studio into an arrangement evocative of his imagined Orient, Chase conjured up a warrior examining a sword blade as the painting's hero. Everything in the picture is calculated to demonstrate the artist's growing virtuosity. The highlights of bunched velvet, the glitter of diverse metals, and the density of a pile carpet suggest a reprise of academic lessons well learned. The warrior's cross-legged pose is masterfully rendered and then promptly camouflaged by the piles of almost luminous drapery around his knees; here the softness of velvet is contrasted with the crisper stuff of the man's shirt, and tassels hang free over the sheen of a silken turban. Ultimately, however, it is the sheer density of the setting that captivates, evoking the stereotypical indolence and luxury of the Orient.

The viewer is surely meant to ogle the blackness of the man's skin, for wherever it is exposed the surroundings provide contrast—a white scarf around the neck, a white cuff on the sleeve, a white border on the carpet insure that we notice the difference. And we are invited to imagine ownership of the objects and interaction with the hero. The overriding artifice of it all is constant reminder that it is a performance piece and a bit of bravura at that. It is about art, not about ethnography, and the viewer is meant to applaud.

The objects that Chase arranges in this evocative still life are the stereotypical accoutrements of artist studios and exotic domestic interiors of late-nineteenth-century America. Chase himself later used such artifacts to concoct an exotic ambience for his space in the Tenth Street Studio building (p. 30, fig. 12), and Frederic Church assembled similar objects in his Persianate home and studio on the Hudson, Olana (cat. no. 36). But what was accomplished by this density of exotic artifacts?

In the case of the flamboyant urban artist Chase, an elaborate studio was part of a calculated strategy of self-promotion, "the ultimate marketing tool" in the competitive art market of late-nineteenth-century New York.[2] It was a place to invite potential clients, challenge students, and generally conduct the business of being a charismatic and cosmopolitan artist in the modern world. The studio took on an allure all its own, eliciting desires for exotic experience and antiquarian acquisition.[3] The studio itself inspired a whole series of portraits—depictions of the space and its accoutrements, sometimes including beautifully dressed people.[4] Most importantly, however, it was the

1. Gallati 1995, 20–22.
2. Blaugrund 1997, 105–29.
3. Burns 1993, 209–39.
4. Ibid., figs. 66, 67, 69, 70, 72, 76.
5. Ibid., figs. 60, 62.

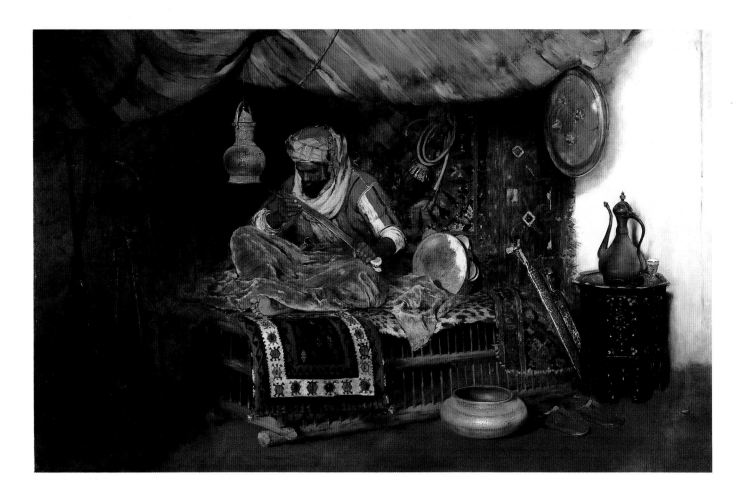

35 WILLIAM MERRITT
CHASE
American, 1849–1916

The Moorish Warrior
1878
Oil on canvas
58⅞ × 93⅝ inches (148.2 × 237.8 cm)
Signed, lower right: W. M. Chase
Brooklyn Museum of Art. Gift of John R. H. Blum
and A. Augustus Healy Fund

grand setting for Chase's own self, dressed in red fez, perhaps a flowing cape.[5] Thus, Chase used a studio brand of Orientalism to project an image of worldly charm and exotic sophistication, luring in clients and consolidating his position in the public eye. This was Orientalism calculated to elicit desire and, as such, it anticipated the diverse Orientalisms to come in the department store culture of modern America.

Trophies of Travel

Frederic Church's fascination with the Orient developed in two phases. The first was both adventurous and pious, based on the direct experience of the Levant and Syria during the first four months of 1868. This phase is represented in this exhibition by *Jerusalem from the Mount of Olives* (cat. no. 2) and *Sunrise in Syria* (cat. no. 3), paintings that suggest the complex matrix of Protestant conviction and Manifest Destiny that informed his work.

The second phase, overlapping rather than following the first, was more derivative and synthetic. During this period, Church became primarily a collector, designer, and architect, and was completely preoccupied by the design and furnishing of "Olana," his mansion high above the Hudson River. Church traced his primary inspiration for this project to Persia and admitted the difficulties of implementing his fantasy: "Having undertaken to get my architecture from Persia, where I have never been—nor any of my friends either—I am obliged to imagine Persian architecture—to embody it on paper and explain it to a lot of mechanics whose ideal of architecture is wrapped up in felicitous recollections of a successful brick school house or meeting house or jail."[1]

The result is extraordinary: an idiosyncratic and grand aerie overlooking carefully composed vistas and the Hudson. With its eclectic furnishings and exotic surface effects (cat. no. 36A), Olana epitomized the tastes and visual priorities associated with the Aesthetic Movement that was sweeping the United States.[2] For Church and others of his era, a country home was ideally a vehicle of self-presentation, a manifestation of individuality.[3] He described it as the "center of the universe" and filled it with artifacts from all over the world. In effect, the world was at his fingertips, and he was the proprietor. Church could paint the Orient on canvas, and he could also orchestrate it on his own property.

Church's enthusiasm for collecting exotic artifacts and arranging them around himself in a flattering fashion anticipated the growing materialism and commodity fetishism that would come in ensuing decades. As consumers began to sample the varied wares of department stores, and museums sprang up to house certifiable objets d'art, Americans acquired new ways by which to order and classify the material culture around them. Church appreciated diverse objects and attached value to them according to idiosyncratic tastes and symbolic priorities. When he was in the Middle East, he acquired "rugs— armour—stuffs—curiosities . . . old clothes (Turkish) stones from a house in Damascus, Arab spears—beads from Jerusalem—stones from Petra and 10,000 other things," filling fifteen crates.[4] It was diverse and exotic but to the modern eye of "little intrinsic value."[5] At Olana, Church proceeded to assemble it all very purposefully—along with a wide variety of other things acquired through dealers in the United States—by means of unifying colors, textures, and forms. In the process, he created a veritable museum of world cultures.

Church's "trophies of travel"[6] reflect the spectrum of his affections. Rocks he collected derived their dignity solely from their provenance as relics of the Holy Land (cat.

1. Quoted in James Anthony Ryan, "Frederic Church's Olana: Architecture and Landscape as Art," in Kelly 1989, 136–37.

2. Roger Stein, "Artifact as Ideology," in Burke et al. 1986, 24–25.

3. This notion follows the dictates of Albert Jackson Downing, the dean of country home design. See Johnson 1996, 16.

4. Quoted and described in Ryan 1989, 141 (see note 1 above).

5. Ibid.

6. This phrase appeared in the New York *Daily Evening Transcript*, 3 December 1869.

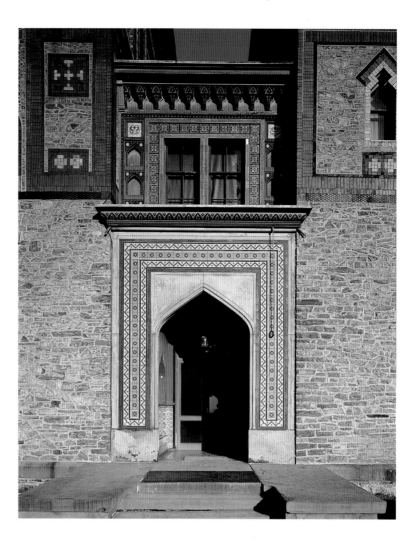

36A Frederic Edwin Church
American, 1826–1900

Olana
1870–72, studio wing added 1889–91
New York State Office of Parks, Recreation and
Historic Preservation. Olana State Historic Site

no. 36B). Bringing them home enabled Church to recall and relive his pilgrim experience despite his distance from sacred topography. Similarly, he and his wife Isabel assembled a reliquary herbarium, *Wildflowers of the Holy Land* (cat. no. 36C), which contains samples of various grasses, reeds, and modest flowers arranged artfully and labeled by place, not by flower type.[7] Included therein are plants from Petra and surrounding sites, Askelon and the Plains of Sharon, Olivet, Bethany, the Mosque of Aksa, the Golden Gate of Solomon, Mount Zion, the City Walls of Jerusalem, Nazareth, Beirut, and Damascus. One page, displaying a radiant plant labeled "Star of Bethlehem" bears a striking resemblance to Church's painting of the same title. Although now faded with time, it is clear that these clippings were chosen not as significant floral samples but rather as humble bits of symbolism assembled for their associative or inspirational value. Bound reverentially in cedar of Lebanon, it was a reliquary, not a botanical manual.

That flowers might evoke strong sentiments or symbolize larger truths was a common conviction at this time, and in assembling such symbolic souvenirs, the Churches were typical tourists. Flowers from the Holy Land, cedars of Lebanon, olive oil, soil from Jerusalem—these were the icons of Protestant America. Indeed, the enthusiasm for the flora, fauna, and physicality of the sacred landscape had considerable market potential. It inspired Robert Morris, an active Freemason, to finance a trip to the Holy Land by subscriptions from fellow Freemasons for "Holy Land Cabinets" that would include 150 sacred specimens (such as dirt from Gethsemane or water from the Dead Sea), complete with descriptions and relevant biblical verses. Such physical evidence enabled a sedentary believer or homebound tourist to maintain direct contact with the holy and to reenact the sacred stories in the mind's eye, supplemented by the touch and

7. Karen Zukowski, curator of Olana, has correlated the place names in the herbarium with the travel itinerary of the Churches and has determined that Frederic Church must have brought home samples of flowers from places his wife did not see, although they visited many of the sites together. In her estimation, however, the album was actually assembled by Isabel.

8. Davis 1996, 49–51. Ella Pell (see cat. no. 13) notes at various points in her diary that she or her sister gave such presents to friends and acquaintances back home.

9. *Picturesque Palestine, Sinai and Egypt* (1880) was later reprinted as Charles W. Wilson, *Jerusalem: The Holy City.* On John Woodward as an Orientalist, see Ackerman 1994a, 258–65. On the *Picturesque America* series, see Rainey 1994.

10. Scarce 1976. On the Persian ceramics at Olana, see Wilcoxen 1990.

11. The phrase is from Miller 1993.

36B *"Trophies of Travel" collected by Frederic Church*
New York State Office of Parks, Recreation and
Historic Preservation. Olana State Historic Site

36C *"Wildflowers of the Holy Land,"
compiled by Frederic and Isabel
Church*
New York State Office of Parks, Recreation and
Historic Preservation. Olana State Historic Site

smell of material evidence.[8] Similar sentiments were pictorially evoked in the illustra-
tions of *Picturesque Palestine* (a volume of the immensely popular series that began with
Picturesque America) in which, for example, John Woodward's illustration of the Upper
Pool of Siloam is captioned with a mention of the mosses and ferns and framed with
tendrils of the maidenhair fern.[9]

 If some of Church's collecting was reverential in character, he also acquired aestheti-
cally significant works of indigenous craftsmanship. Over time, he accumulated, for
example, a collection of items by Ali Mohammad Isfahani, a Persian ceramist active in
Tehran in the 1870s and 1880s, whose work incorporates traditional Persian elements
but also exhibits evidence of European influence (cat. no. 36D).[10] Acquisition of multiple
works by a known artist suggests the increasing commercialization of such cross-
cultural exchange and indicates that Church's system of values ranged from the reliquary

36 D *Persian Ceramics and Other Artifacts at Olana*

New York State Office of Parks, Recreation and Historic Preservation. Olana State Historic Site

to the curatorial. Cumulatively these materials indicate the diverse associations undergirding the burgeoning cult of the authentic or unique object—the premise of modern museums and the seduction of consumer culture.

When he furnished his house with these items, Church chose what became the archetypal accoutrements of the Orientalized interior—the taboret table, the ewer, carpets, weaponry (cat. no. 36E). The artfulness of his arrangement echoed contemporaneous artists' studios in New York and the paintings that were created therein. In this environment, Church lived a life punctuated by daily Bible readings in the parlor and tableaux vivants in the court hall. The costumes he had collected (cat. no. 36F) allowed him to animate the stage set that he created, bringing the Orient to life within his own home (see p. 34, fig. 13).

Thus, Church composed the world around himself, enjoying the role of the creator and domesticating the Orient by means of image and object. Seen in conjunction with his own paintings, the memorabilia from the Holy Land and ceramics from Tehran all contributed to a larger evocation of the Orient in architectural form. A visit to this extraordinary house leaves little doubt that the real and imagined Orient was the most important province in Church's empire of the eye.[11]

36 E *Interior at Olana*
New York State Office of Parks, Recreation and
Historic Preservation. Olana State Historic Site

36 F *Studio at Olana*
New York State Office of Parks, Recreation and
Historic Preservation. Olana State Historic Site

Orientalism and the Aesthetic Movement

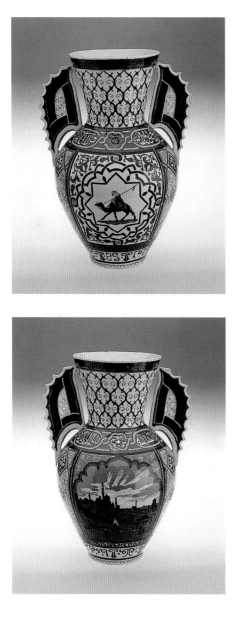

37 Cordelia A. Plimpton
American, 1830–1886

Alhambra Vase
1881
Earthenware, 16½ × 12¹³⁄₁₆ × 10⅛ inches
(41.9 × 32.5 × 25.7 cm)
Cincinnati Art Museum. Gift of the Women's Art
Museum Association

\mathcal{D}iverse modes of Orientalism are manifest in the objects crafted in metal, ceramics, and wood that are included in this exhibition. Individually, these objects are superior examples of American craft, exemplifying dominant trends in their respective media. They demonstrate the vitality and ferment in the decorative arts scene, and the multifaceted enterprise called the Aesthetic Movement, which was dedicated to the reinvigoration of American craft and the generation of a superior language of design.[1] Collectively, they also suggest the diverse ways that Orientalism intersected with the Aesthetic Movement to produce exquisite works of art resonant with American desire and aspiration.

During this period of experimentation in the world of decorative arts, objects were appreciated without detailed reference to their original function or source. Rather they were seen as works of cross-culturally transcendent beauty. Tracing the roots of the Aesthetic Movement in the English reform movement, Roger Stein has noted that individual motifs or designs were disengaged from their original contexts to be transformed by American designers into American creations.[2] While such borrowing may be deemed a cocky or cavalier act of appropriation, this mode of Orientalism was essentially one of aesthetic inspiration and aspiration, made possible by the ongoing ascendancy of the American dollar.

Decorative arts of this sort can be viewed as manifestations of Orientalism in various ways. The most inclusive mode of cross-cultural allusion is the stylistic one. All of the decorative arts objects included in this show (cat. nos. 37–41) exhibit varying degrees of stylistic resonance with the Islamic artistic tradition by means of material, form, or surface ornament. A revealing example of this aesthetic homage is a vase designed by L. F. Plimpton and executed by Mrs. C. A. Plimpton, a member of the Cincinnati Pottery Club (cat. no. 37). It is a rendition of an Alhambra vase, a distinctive type of ovoid storage jar with winged handles made in Spain from the thirteenth to the fifteenth century.[3] The American work differs from the basic prototype somewhat in profile but shares a similar combination of simple materials and sumptuous surface effect.[4] Fields of pattern and cartouches of calligraphy closely evoke the Muslim examples, but the pictoral scenes that occupy the large zones on either side of the body depart radically from the banded and non-figural decoration favored by Muslim potters. For an American audience, such departures would further enhance the exotic feeling of these pieces, for they represent images of a stereotypical Orient—a dramatically backlit cityscape with domes and minarets and, on the other side, a desert expanse with camels and nomads.

This vase, evoking the Orient in its form and decoration, also advanced the cause of the "art pottery" movement by using simple, indigenous materials to create a dramatic and sophisticated work of art. Those materials, in fact, carried an ideological significance of their own, as they were of the very earth of the New World.[5] The vase was exhibited to

38 TIFFANY AND COMPANY

Saracenic Tea Service

C. 1888

Silver, width of teapot 11 inches (27.9 cm)

The Metropolitan Museum of Art, New York. Gift of a Friend of the Museum, 1897

1. Burke et al. 1986.

2. Ibid., 25.

3. Dodds 1992, 354–57.

4. Sweetman 1988, 231–32.

5. Ibid., 232.

6. Barber 1893, 281–83.

7. "The Genius of American Silversmiths," *The Jeweler's Circular and Horological Review* 36, no. 7 (16 March 1898): 1.

8. Kisluk-Grosheide 1994, 166.

considerable acclaim at the World's Columbian Exposition of 1893, where it demonstrated the vitality and creativity of American craftsmen.[6]

Not all Orientalizing decorative arts stand in such close proximity to the traditions to which they allude. Tiffany and Company's "Saracenic Tea Service" (cat. no. 38), for example, evokes the Islamic tradition with its name but relatively little else. Each article of the four-piece set was handcrafted from a single piece of silver, then gilded, etched, and enameled in red, blue, white, or yellow to achieve a luxurious surface effect. Exhibiting neither stylistic debt nor functional reference (coffee was the oriental drink of distinction), the tea service borrows from many styles with minimal connection to the Islamic world. Despite its ambiguous stylistic heritage, the service was described in 1898 as "one of the most artistic silver sets ever produced by the hands of an American silversmith."[7] Intended solely for exhibition purposes, the makers agreed never to duplicate it.

The fact that technical virtuosity itself seems to have had an oriental connotation is also suggested by a rosewood secretary exhibited at the Columbian Exposition of 1893 (cat. no. 39). Clearly intended to display the expertise and accomplishment of the furniture maker, this marvel of craftsmanship exhibits the full gamut of woodworking skills and inlay techniques, conjuring up an ambience of luxury and sophistication that seems otherworldly in its refinement. This stunning work of art was not modeled on an Islamic prototype but rather epitomized the late-nineteenth-century aesthetic of exotic interiors, in which wall surfaces were transformed into cabinets of curiosities for the display of artifacts from all over the world.

From just such a setting came a delicately carved satinwood table, vaguely reminiscent of the *mashrabiyya* screens gracing the windowed balconies of the Orient (cat. no. 40). Attributed to Tiffany's firm Associated Artists, this table stood at the center of a Moorish smoking room in the mansion of Henry Gurdon Marquand.[8] Smoking rooms in this style, *de rigueur* among the wealthy classes, often exhibited carved niches and arabesque wall decorations and served as settings for collections of Islamic artifacts. As ensembles, these rooms extended the connection between smoking and the Orient and

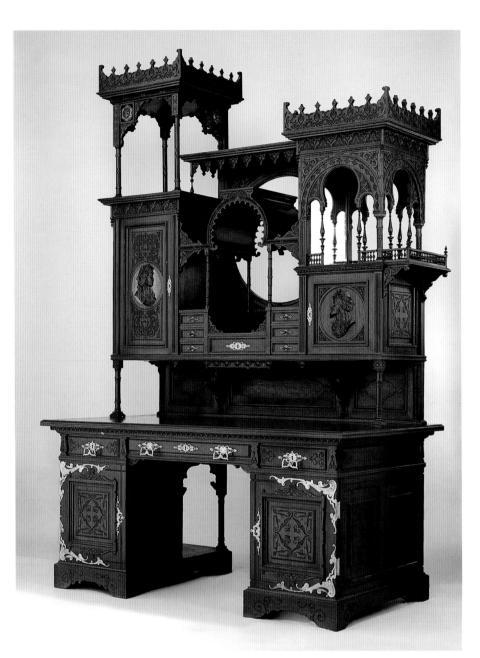

39 *Secretary*
1880
Rosewood and oak, 94 × 65 × 32½ inches
(238.8 × 165.1 × 82.6 cm)
Collection of Margaret Caldwell and Carlo
Florentino

40 LOUIS COMFORT
TIFFANY
American, 1848–1933

Moorish Desk
c. 1885
From the Henry G. Marquand House,
New York
Satinwood, brass, pewter, and leather,
25⅝ × 36 × 24⅜ inches (65 × 91.4 × 61.9 cm)
Los Angeles County Museum of Art. Gift of the
1995 Collectors Committee

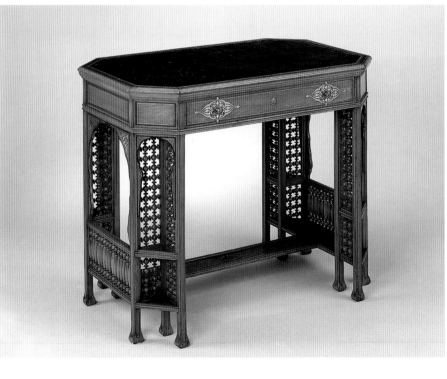

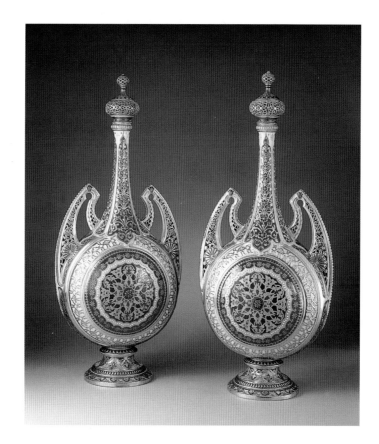

41 CROWN DERBY

Pair of Bottles
C. 1890
Ceramic, enamel and gilt, 18½ × 8½ × 5¼
inches (47 × 21.6 × 13.3 cm) each
Los Angeles County Museum of Art. Gift of
Irving Mills

provided a venue for male escapism, even as they epitomized practices of cross-cultural consumer delight. Thus, while individual works of art might have served as objects of contemplation and beauty in their own right, they also served as relics or tributary accoutrements in larger webs of symbolism, evocation, and aesthetic impact.

The desire to incorporate the Orient into one's everyday life was facilitated by the burgeoning import business, of which Tiffany and Company was the premiere American provider. Such entrepreneurial ventures acquired materials directly from the Orient but also imported goods of western fabrication that were intended to approximate oriental originals (cat. no. 41). As time went on, the taste for exotic interiors spread from the mansions of the newly wealthy to more modest middle-class homes.[9] This desire was fomented and fed by the burgeoning mail-order business and by large department stores like Sears, Roebuck and Company and Wanamaker. Through such enterprising intermediaries, the average middle-class American had access to the basic accoutrements for a Turkish corner that fit their budgets and space requirements.[10]

If the Orient was incorporated into the American home by means of artifacts, how did those objects enhance the domestic setting? In the grand mansions of the elite, where each room might evoke a different artistic or cultural tradition, the world was rendered in microcosm to revolve flatteringly around the self-indulgent proprietor. For Frederic Church, touches of the Orient at Olana were evidence of a sophisticated philosophical commitment to a distinctive aesthetic vision (see cat. no. 36). For the average consumer, they perhaps served more licentious agendas. In artists' studios and shop windows, there was clearly an erotic charge to Orientalizing decor, conjuring up the sensuous pleasures of the harem with luxuriant fabrics and cozy, seductive spaces to drum up business and stimulate consumer desire.[11] Orientalism in the realm of design and consumption clearly had many faces.

9. See, for example, the shop window designed by
L. Frank Baum in Burns 1993, figs. 10.16 and 10.17.
10. Lange 1990, 30–35.
11. Burns 1993, 232ff.

The Near East and the Wild West

*C*harles M. Russell, the quintessential painter of the American West, perhaps more than anyone else represents the extent to which the Wild West and the Near East merged in the American notion of the exotic, providing inspiration and fantasy for nineteenth-century citizens of the New World.[1] In effect, his Orient was the West.[2] He never traveled to the Orient, but instead spent time in Montana, learning about the wildlife and native populations, and then worked eleven years as a cowboy, absorbing the details and the ambience of that rugged life. Thereafter, he built a successful career as a painter, illustrator, and sculptor of the western frontier.

Russell was well aware of the fact that his life was different than that of other painters of exotic subject matter. In fact, he spoofed himself by drawing two views of his studio— one "as Mother thought" it might look and a second as his studio really was. In the former, the artist sits chatting urbanely with a grandly dressed woman in an exotically furnished studio, rather like that of William Merritt Chase. On the easel, a painting in progress depicts an oriental scene replete with palm trees and water carriers.[3] In the latter, the western artist is seen in a bare, crude room scrambling to capture the quality of one of his rough-hewn subjects. There are no niceties here, nor are there any excuses about life on the frontier. But there was a sense, in both cases, of the artist rendering that which was different, and exhibiting his talents in the process.

Like Russell's representations of artist studios, his *Keeoma* (cat. no. 42) reveals an awareness of larger artistic traditions. The painting is clearly a self-conscious effort to adapt the trope of the odalisque to Native American subject matter. It employs all the stereotypical elements of such imagery, including a languid female with accommodating demeanor, ethnographically pertinent backdrop, and, of course, the ever-ready pipe. The details are simply adjusted to evoke a Native American setting rather than an oriental harem. Such a scene could only be contrived with some effort, and Russell accomplished it by having his wife dress and pose in the appropriate garb.[4] He was clearly engaging art history in this picture, and he was also making a laconic comment about the tastes and values of collectors back East.

Russell was playing with conventions in painting *Keeoma*, but he was also commenting implicitly on the state of affairs in the United States. As his contemporary and fellow western artist Frederic Remington said, "The West is no longer the West of picturesque and stirring events. Romance and adventure have been beaten down in the rush of civilization."[5] Russell was situating himself on the frontier, for better or worse. For painters and purchasers of such exotica, there was a feeling of nostalgia, as well as a sense of implacable "progress," as that frontier disappeared and the native populations were forcibly subdued. Thus, Orientalism was a way of seeing the larger world, sometimes with recourse to formula and stereotype, at a moment when America's relationships with other cultures were rapidly changing.

1. Dippie 1987, 81–105.
2. He actually painted the Orient from his mind's eye a few times. Ibid., figs. 80–82.
3. Ibid., fig. 79.
4. Renner 1966, no. C-11.
5. Quoted in Maxwell 1907, 395–96.

42 CHARLES M. RUSSELL

American, 1864–1926

Keeoma

1896

Oil on academy board, 18½ × 24½ inches

(47 × 62.2 cm)

Signed, lower left: C. M. Russell 1896

Amon Carter Museum, Fort Worth, Texas

A Means to an End

Would it be possible to grow up in late-nineteenth-century Philadelphia with the name Jean-Léon Gérôme Ferris and not become a painter of oriental scenes, especially if you came from a family of artists and were sent to France to study with Bouguereau and Gérôme? Even on his way to Paris in 1884, Ferris made a stopover in Morocco. He returned again in 1888 and for the next ten years painted oriental imagery, exhibiting such scenes at the Pennsylvania Academy of the Fine Arts in 1887, 1888, and 1889. What he really wanted to do, however, was to follow Gérôme's advice and become a painter of American history. But there was no money in it, so, to support himself, he painted oriental genre scenes.

Ultimately, Ferris did paint sober and momentous episodes from American history, making a living by retaining the paintings himself and disseminating the images in the form of art reproductions for calendars, fine art prints, and magazine covers. Over the years he painted around seventy scenes from American history, the complete collection of which was put on display in Independence Hall in Philadelphia from 1913 to 1930. His was a shrewd appraisal of the marketplace, and it secured for him an unrivaled spot in the history of American art.[1]

As a stepping-stone toward that accomplishment, Ferris's Orientalist phase reveals much about Orientalist painting and the milieu in which it flourished. First, it suggests that, to a degree, Orientalism was simply a pedagogical contrivance that served to situate the human body in diverse poses among a wide array of exotic accoutrements, varied colors, and disparate textures. Painting an odalisque, for example, might be deemed a useful academic exercise, the successful completion of which qualified the student to tackle more challenging compositions. (By his own account, some of Ferris's Orientalist paintings were "practically only studies in technique from the living model simply to acquire facility of execution, with no subject worthy of mention.")[2] Second, the salability of such images is telling. In contrast to the ambitious history paintings for which Ferris could find no patron, there was an active market for Orientalism. Timely and therapeutic, it provided a vent for American ideological aspirations as well as an outlet for unspoken desires, even as it granted the owner a veneer of worldly sophistication.

A painting like *The Favorite* (cat. no. 43) must have found a ready buyer. It utilizes many of the stereotypical trappings that odalisque paintings employ—an attenuated ewer on an inlaid taboret table, a fur rug, and a languid lady. There are admittedly incongruities in this painting, such as the fact that a woman would not have worn this type of hat, but such ethnographic niceties presumably did not matter much. In effect, the buyer acquired an exotic still-life painting. Amongst the bric-a-brac, the reclining woman was just one more bibelot arranged in a pleasing manner to conform to the Orientalist expectations of a late-nineteenth-century aesthete.

1. Mitnick 1985.
2. On Ferris as Orientalist, see Ackerman 1994a, 82, which also reproduces another odalisque picture, *The Afternoon Siesta.*

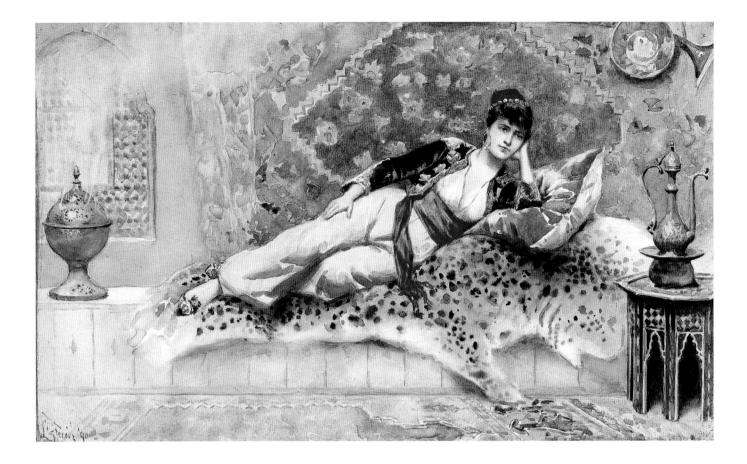

43 Jean-Léon Gérôme Ferris

American, 1863–1930

The Favorite

1890

Watercolor on paper, 11 × 18 inches

(27.9 × 45.7 cm)

Signed, lower left: L. G. Ferris 90

Private collection, Morristown, New Jersey

Links with the Past

\mathscr{I}n 1870, when Frederic Church was working on *Jerusalem from the Mount of Olives* (cat. no. 2), Eric Pape was born in San Francisco. By the time Church died in 1900, Pape had already passed through his Orientalist phase and gone on to establish a career as a teacher and illustrator.[1] Weeks would die three years later and Bridgman was casting about for new subjects. Orientalism, as a genre of painting, was on the wane, but Pape used his experiences in the Orient, as others had before him, as a stepping-stone to other interests.

In the late 1880s, the young Pape spent five years abroad. He trained at the Académie Julian and perhaps at the École des Beaux-Arts; he lived for a year with German peasants, painting their daily life; and he spent two years in Egypt, traveling extensively and periodically selling his sketches to other travelers. He was not a timorous tourist. Indeed, he went to considerable lengths to pursue his fascination with the Pyramids, sleeping one night atop the great pyramid in Giza, secured by ropes so that he would not roll off. In a fictionalized account of his Egyptian adventures, written by his friend and fellow painter Walter Launt Palmer, Pape is said to have disappeared into the desert in search of the gravity-defying metal that purportedly enabled the ancient Egyptians to move the large stones used in building the Pyramids.[2]

If he was prone to youthful enthusiasms, Pape was also capable of hard work. By 1893, at the age of twenty-three, he had honed his technical skills sufficiently to exhibit works in the Paris Salon as well as the World's Columbian Exposition in Chicago.[3] In both cases, he contributed very large pictures that drew inspiration from his Egyptian experiences, and in both cases, his fascination with ancient monuments was subsumed in larger themes. The Salon picture, entitled *The Two Great Eras,* depicted the Holy Family on the flight into Egypt in the lee of the moonlit Sphinx.[4] The Chicago picture, *The Site of Ancient Memphis* (cat. no. 44), shows a simple shepherd kneeling in the grass, surrounded by his grazing flock, with the Pyramids in the hazy distance. Both of these images addressed the passage of time, utilizing ancient monuments to situate an imagined event in the larger continuum of history.

The latter picture, however, is an enigmatic one. In it, ancient Egypt serves as a picturesque and evocative setting for the familiar theme of a shepherd tending his flock. Antiquity is evoked by the extraordinary gilt frame, the title of the painting, and the mirage-like depiction of the necropolis of Sakkāra, which is generally associated with ancient Memphis. In a sense, this is simply a peasant painting exoticized; Pape executed other pictures in this vein during his years abroad. However, this painting suggests something more. A shepherd has laid down his staff among the wildflowers and looks upward beyond the frame. Light falls on his face, and he appears transfixed. It is not clear what has immobilized him, but given the subject of Pape's other major painting, it is plausible to suppose that the picture depicts an allegorical or religious event, perhaps alluding to the revelation of Christianity.

1. Ackerman 1994a, 277.

2. Palmer 1894, 718–28.

3. Carr et al. 1993, 298.

4. For analysis of comparable imagery by Luc-Olivier Merson in the Museum of Fine Arts, Boston, see Eric M. Zafran, "The Virgin and the Sphinx: Merson's *Rest on the Flight into Egypt,*" in Fort 1983, 29–37.

5. Bancroft 1893, 872.

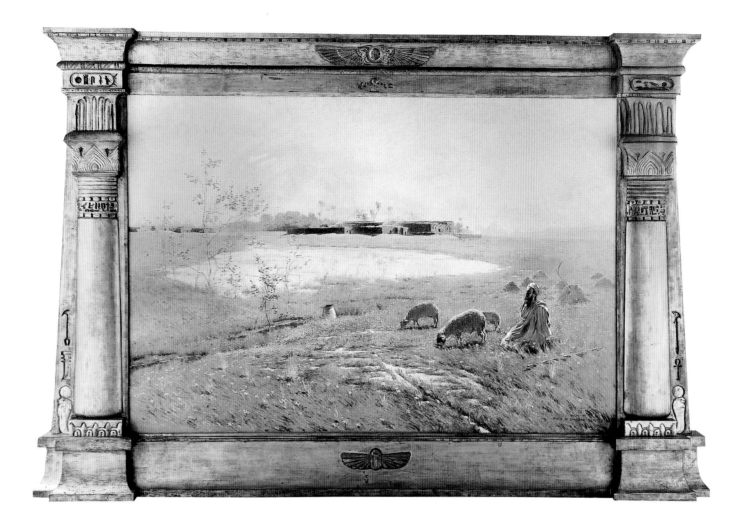

44 ERIC PAPE
American, 1870–1938

Site of Ancient Memphis
1891
Oil on canvas, 44¾ × 67½ inches
(113.7 × 171.5 cm)
Signed, inscribed, and dated lower right:
Pape / PYR'S DE SAKKĀRA EGYPTE 91
Private collection, courtesy of Spanierman Gallery,
LLC, New York

The Site of Ancient Memphis may also have had a topical connotation for Pape. Hubert Howe Bancroft discussed Memphis in *The Book of the Fair,* a two-volume description of the Columbian Exposition. In the *rathaus* of the Old Vienna exhibit on the Midway, a few chambers were fitted out as a museum of the Hellenistic period to display encaustic portraits recently exhumed from Egyptian mausoleums. According to Bancroft, the pictures came from the tombs of Ruijat in Memphis, where Alexander was thought to have left artists behind after his conquest of Egypt in 320 B.C.[5] These images excited considerable interest at the time and appear to have linked Memphis with great accomplishments in painting. Given the fact that Pape was presenting his work at the Columbian Exposition to establish his professional stature as a painter, one wonders whether he sought to affiliate himself with the venerable tradition that the Memphis finds represented.

The Magic City

The World's Columbian Exposition of 1893 extended America's belief in Manifest Destiny to the realization of a New Jerusalem, a magical "White City" conjured on the shores of Lake Michigan (cat. no. 45A).[1] Celebrating extravagant material prosperity and technological accomplishment during a major economic depression, the fair heralded the era of mass consumption, coupling America's inevitable and unquestioned primacy with the future potential of foreign markets. America seemed poised on the brink of economic and cultural conquest.[2]

The fair was a utopian fashioning of national identity as well as an effort to proclaim America's preeminence, among other things as the producer of the world's greatest art. This self-laudatory campaign was a complicated undertaking, as there was no unanimity about which artists should be represented or what constituted "good" art. The major point of contention was described as "French Notions" versus "Real American Art,"[3] and in that battle, for example, the cosmopolitan William Merritt Chase (cat. no. 35) was vilified for acting to exclude the works of the quintessentially American artist Frederic Remington. Orientalist paintings by Bridgman (cat. no. 7), Mowbray (cat. no. 33), and Pape (cat. no. 44) were exhibited and occasioned no vigorous comment. The paintings were safe, formal, and somewhat artificial in their evocation of exotic people in remote places.

The Orient that was perceived as "the real thing" was situated in various exhibits along the Midway Plaisance, the avenue of entertainment and ethnography that extended outward from the White City. Along that boulevard, dominated by the Ferris wheel (cat. no. 45B), one might encounter people from different parts of the Orient wearing distinctive dress and engaged in a variety of activities deemed to be representative of their cultures. These exhibits were posed in architectural settings evocative of the home country. Much of this display revolved around the dense and opulent array of exotic artifacts, not unlike the extravagances of American department stores.

In retrospect, the Moorish Palace was a particularly bizarre case of consumerism and cross-cultural myopia. Hubert Howe Bancroft, the author of one of the most elaborate illustrated accounts of the fair, enumerated the rugs, tiles, bronzes, swords, and other works of art that could be purchased from "turbaned Moors," then described an extensive assemblage of wax figures (made in Paris) that incongruously juxtaposed Moors, European rulers, and historic Americans. Thus provided with "a clear idea of a people which once played no mean part in the history of the world," the visitor, if so inclined, could "become so entangled in an ingenious labyrinth of optical illusions as to imagine a swart-visaged Berber in every corner."[4] Thus demonized and commodified, Moorish culture was packaged for American consumption.

Among the most popular of these Midway exhibits was a display called the "Streets of Cairo," where diverse races and cultures, conjurers, astrologers, snake charmers and dancers were all concentrated within the ostensible verisimilitude of a Cairo street. Bancroft described the presentation with a predictable appreciation for the artifacts and

1. This description and other revealing rhetoric is addressed by Robert Rydell, "Rediscovering the 1893 Chicago World's Columbian Exposition," in Carr et al. 1993, 29.

2. Ibid., passim.

3. For a study of American art at the fair, see Carr et al. 1993, 86ff.

4. Bancroft 1893, 858.

5. Ibid., 865.

a concomitant condescension toward the people. He recounted the daily staging of a wedding procession thus:

> *The oriental band brays in honor of the event, which is succeeded by a parade of donkeys and half-naked wrestlers, while swordsmen with scimitars and shields indulge in special contests of skill. Jesters, mounted upon camels and fantastically dressed, slap each others' faces, and do as would their brothers at Barnum's or Forepaugh's circus, while after all comes the central figure amid the commotion— the coy bride, hidden under a rose-colored canopy, preceded by her bridesmaids and an unladen camel gorgeously caparisoned.[5]*

Descriptions of the Algerian and Tunisian villages were dedicated primarily to the exotic furnishings as well as to the concert hall and the dancing girls to be seen therein:

> *[They are] beauties in their way, though with strongly marked features and some-what too plump of outline. Their attire is modest and not without elements of the picturesque; for the Algerian dancing girl wears clothes, much more of them at least*

45A *"A Panoramic View from the Northeast"*
From James W. Buel, *The Magic City*
(St. Louis: Historical Publishing Co., 1893)
Private collection

A PANORAMIC VIEW FROM THE NORTHEAST.—A very charming sight is presented in the above photograph, taking in a very large section of the Fair grounds and picturing with great distinctness the Merchants' Tailoring Building, in the foreground, and the massive Woman's Building. The former was 94 feet square, of a Grecian temple style, and as hand-somely finished in the interior as its beautiful exterior appearance might indicate. The walls were splendidly frescoed with eight scenes, representing as many periods in dress evolution and reform, and the details were more elaborate than are to be seen in any permanent structure of the present time. The steps leading into the water, beautiful bridges on either side, and embowered with trees, the building was a model of picturesqueness and magnificent repose, a suggestion of the Phidian age of architectural splendor.

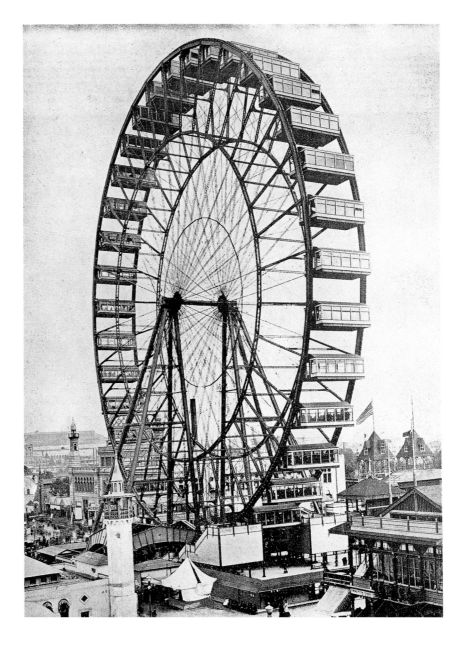

45B *"The Mammoth Ferris Wheel"*
From James W. Buel, *The Magic City*
(St. Louis: Historical Publishing Co., 1893)
Private collection

than the Parisian coryphée, and here is no unseemly display of tightly hosiered
limb. . . . As the orchestra warms to its work, her figure appears to tremble and
undulate as though in an ecstasy of delight; for the motion is rather of the body than
of the feet, yet agile and far more graceful than the pirouetting of a premiere.[6]

All in all, the Orient as seen at the Midway was a conflicted and confusing array of deracinated cultural practices and spectacular artifacts, much of it overseen by so-called concessionaires. The Turkish Village, for example, was "arranged in attractive style" by a man named Robert Levy, who represented the firm of Saadullah, Suhami and Co., Constantinople.[7] Such individuals presumably stood to gain considerably from their efforts. Bancroft (not an altogether unimpeachable source) reported that most of the people who worked on the Midway took home sizable sums of money: the Turks made from two to three hundred dollars apiece, the dancing girls at least five hundred, and the donkey boys "a larger amount."[8]

The overarching agenda of the fair organizers, however, was the celebration of American accomplishment. At this multifaceted event, a national self-image was communally fabricated and witnessed by millions of people.[9] The Cairo street was the most popular exhibit, with admissions there exceeding 2.25 million people, while some 1.5

million visitors rode the Ferris wheel.[10] Even larger numbers experienced the fair by means of pictures taken by official fair photographers using tripods and large-plate cameras, as well as by avid amateurs armed with the newly developed and more portable hand cameras. Indeed, the degree to which photography permeated the Columbian Exposition distinguished it from prior events of similar magnitude.[11]

Many of the photographs of the fair were commercially produced and marketed in albums or collections. J. W. Buel's *The Magic City: A Massive Portfolio of Original Photographic Views of the Great World's Fair and Its Treasures of Art, including a Vivid Representation of the Famous Midway Plaisance* sought to reproduce the fair "in Splendid Realism, as it was seen by millions of visitors." By means of three hundred magnificent photographic views accompanied by extensive captions, it claimed to record not the "mummified remains of the Fair" but rather to preserve intact "the entire Exposition as fresh for all time as a rose bathing in the morning dew."[12]

The author of the text, James William Buel, was trained in law but made a career of writing edifying books for the general public.[13] In his introduction to *The Magic City*, he adapted an Orientalist conceit, claiming that even a genie's power could not rival the accomplishments of American technology and progress manifest at the fair. Voicing familiar utopian themes and convictions about America's Manifest Destiny and the country's entitlement to a certain kind of "progress," Buel announced grandly, "we cannot fail to discern a manifestation of beneficence, that divine benevolence, charity and goodness which is leading us surely towards a happier, higher and more righteous condition."[14]

The organization of the album departed markedly from anything resembling a walking tour of the fair. Instead, images of the White City were interspersed with images of the Midway Plaisance, the sequence presumably calculated to generate conversation, rumination, or entertainment. That the editors viewed the layout as a mode of didactic commentary is suggested in the first few pages of the album, most of which are given over to the most impressive panoramic views of the main buildings of the fair. Having just viewed the Woman's Building and the Art Palace, for example, the reader turns the page to encounter "Dahomey Cannibals," who, according to the caption, "afforded a remarkable contrast, the extreme of barbarity in contact with the highest types of civilization." On the opposite page is a grand view of the Government Building.

Similarly, a photograph captioned "The Cowboy" (cat. no. 45C), showing Alexander Proctor's heroic sculpture set on the west lagoon of the White City, was not paired with a photograph of its companion piece, "Proctor's Statue of an Indian," to approximate their actual disposition at the fair, but instead was placed alongside "Joseph and His Boom-de-ay Donkey" (cat. no. 45D), a popular attraction of the Streets of Cairo exhibit on the Midway. Both pictures depict equestrian figures, but while one is a heroic archetype, the other is an object of derision. The captions of the two photographs further contrasted the "great spirit and strength" of the statue and the "singularly comical traits" of Joseph and Boom-de-ay. Clearly, the viewer was being instructed in the indisputable hierarchy of things: American know-how was superior to that of the rest of the world, and her culture was more advanced.

The album's pedagogical character extended to anthropological concerns as well. Characters from the Midway, for example, were included in gallery shots as "types," each one identified to represent their homeland or ethnic identity. Consistent with the essentializing taxonomies of the era, these "representative" figures were deemed sufficient to provide the viewer a complete travel experience: "A visit to the Midway was like a trip around the world." Grouped together on one page were "A Javanese girl, plump and

6. Ibid., 877.

7. Ibid., 855.

8. Ibid., 883.

9. Numbers vary; Rydell cites a figure of some twenty million in Carr et al. 1993, 21.

10. Bancroft 1893, 881.

11. Brown 1994.

12. Buel 1894, intro.

13. The author's character is perhaps most vividly revealed in *Buel's Manual of Self Help: A Book of Practical Counsel, Encouraging Advice, and Invaluable Information* (1894), which addressed matters ranging from astronomy and parliamentary law to courtship and miscellaneous diseases.

14. Buel 1894, intro.

45C *"The Cowboy"*
From James W. Buel, *The Magic City*
(St. Louis: Historical Publishing Co., 1893)
Private collection

45D *"Joseph and His Boom-de-ay Donkey"*
From James W. Buel, *The Magic City*
(St. Louis: Historical Publishing Co., 1893)
Private collection

45E *"An Odalisque from the Seraglio"*
From James W. Buel, *The Magic City*
(St. Louis: Historical Publishing Co., 1893)
Private collection

45F *"Three Dancing Girls from Egypt"*
From James W. Buel, *The Magic City*
(St. Louis: Historical Publishing Co., 1893)
Private collection

pretty; an Algerian girl; a girl from Nazareth; a Japanese lady; a Moorish ballet girl and an old lady who distinguished herself by walking all the way from New York to Chicago, to attend the Fair."

Buel's descriptions of oriental women are candid and opinionated, revealing middle-class taste and demonstrating the extent to which Midway exhibits were artificially packaged to conform to western expectations and standards. "An Odalisque from the Seraglio" (cat. no. 45E), which pictured a woman posed before a formulaic backdrop of palm trees and pyramids, clasping her hands in a contrived stance and looking winsomely beyond the picture frame, was captioned thus:

> She was heralded by the Algerian Concessionaire as an Odalisque, fresh from the Seraglio, and the Sultan's favorite. This was rhetorical, even if not true, so she was accepted as a beauty and invested with a mystery that made her a very interesting personage. She danced in the Algerian theatre, and was for a while exceedingly popular but she was less fascinating to young men visitors to the Fair than Fatima, of the Persian theatre, who, while not so pretty, was more lithesome and executed the dance du ventre *with a wild abandon that called for repression by the authorities.*

Such a description suggests collusion between an enterprising concessionaire and a gullible audience with a taste for mystery. Buel, moreover, was aware that eroticism was beginning to subsume beauty as a means to attract public attention, as is evident in his commentary on "Three Dancing Girls From Egypt" (cat. no. 45F):

> Writers of Oriental stories have created the impression among the uninformed that houris of the East are sylph-like and beautiful; but close contact reveals them as we behold them here, destitute of animation, formless as badly-stuffed animals,

45G *"A Performance in the Egyptian Theatre"*
From James W. Buel, *The Magic City*
(St. Louis: Historical Publishing Co., 1893)
Private collection

as homely as owls, and graceless as stall-fed bovines. But truth compels us to add
that the dancing girls in the Midway were not the best types of their race either in
form or character, and that their abdominal muscles were the only portions of
anatomy or mind which showed any cultivation, while these, to their shame, were
displayed to serve the basest uses.

The sanctimonious tone of this dismissal hints at the anxieties that underlay American responses to the hoochy-coochy. Elsewhere, Buel focuses his attack on the belly dance itself, describing it as "a suggestively lascivious contorting of the abdominal muscles, which is extremely ungraceful and almost shockingly disgusting. Curiosity prompted many to view the performance, but very few remained more than five minutes before this was fully satisfied." Such a description provided the reader with the full range of fair experiences, framing those that were more dissonant with American social norms in appropriate tones of outraged propriety.

The photograph that Buel describes, titled "A Performance in the Egyptian Theatre" (cat. no. 45G), depicts the dancers and musicians on the stage, an empty theater reflected in the mirrors hanging behind them. This was surely an official photograph taken when the fair was closed, as were others in the Buel album. Such institutional or commercial photography packaged the fair conveniently—to serve as experience for those who did not attend and as memory for those who did—but opportunities for more informal pictures were also available for amateur photographers. Those who owned cameras and were willing to pay the fees to photograph within the fairgrounds enjoyed easy access to film and darkroom space. It was even possible to rent a camera at the fair, courtesy of Eastman Kodak and other companies.[15] As a result, many amateur photographers hastened to record the hilarity of their friends and relatives riding camels down the Streets of Cairo. Alternatively, personalized pictures of the fair could be provided by enterprising entrepreneurs: one concession stand advertised, "Have your picture taken on a donkey . . . a suitable souvenir."[16] The immediacy of such images was particularly effective in

15. Brown 1994, 95–96.
16. Ibid., fig. 5.16.
17. Compare the ostensible "truth" of Orientalist paintings and the role of photography therein. See Williams 1993–94, 121–29.
18. For a correlation between the development of photography and the emergence of mass culture, see Jowett 1982, 216–17.

8953. Doing Midway in a Sedan Chair, World's Columbian Exposition.

46 *Doing Midway in a Sedan Chair, World's Columbian Exposition*
1893
Stereograph, 3½ × 7 inches (8.9 × 17.8 cm)
Chapin Library, Williams College, Williamstown, Massachusetts

stereographic format, well suited to convivial parlor entertainments in its approximation of virtual reality. A stereograph of a woman alighting from a sedan chair drawn by a man wearing a fez (cat. no. 46) would have brought the fair experience home as an interactive reality when viewed through a stereoscope.

In effect, photography served to record, with technologically superior accuracy, a performed Orient as it was both enacted and experienced.[17] Moreover, the mechanical reproduction of these images amplified their impact, disseminating their supposed truths to present and future generations. Visualized so "truthfully" and witnessed so widely, a stereotypical Orient became institutionalized in American culture. Photographic coverage of the fair thus inaugurated the metastasizing potential of mass-produced Orientalism.[18]

The beginning of the twentieth century in America witnessed the rapid emergence of the advertising industry and a corresponding explosion of visually assertive invitations to purchase mass-produced consumer products. In the early phases of this art form, emphasis was placed on bold wording that would explain why a particular product was worth buying or why it was superior to the alternatives. Gradually however, there was a shift toward making the product seem desirable by visual rather than verbal means, conjuring an enticing aura or setting for the item that the buyer would find appealing.[1]

A late-nineteenth-century newspaper ad of the discursive type typically employed a variety of typefaces to catch the reader's eye. One such example announced the "Greatest Discovery on Earth: ORIENTAL BEAUTY HERB, How Turkish Houris and Parisian Ladies preserve their Beauty."[2] With more than four paragraphs of text and a lively narrative, the ad copy offered the ladies of America the most jealously guarded secret of the Turkish harems, a "precious herb which has remained in mystery, discovered and presented to the Sultana of Osman I by a dervish." This restorative tonic, taken internally, "brightens the eyes, removes sallowness, premature wrinkles, pimples, tan moth patches, freckles, and other defects which mar beauty. . . . Its use also conduces to a full bust and makes the flesh firm and hard." It had, moreover, the imprimatur of Dr. Paul Lucas, physician to the king of France, who interviewed the widow of Hasan Pacha in Turkey about its wonders. Such windy text deployed the cachet of the Orient as well as France in an effort to herald a product "for sale by all druggists."

47 *Orient Delights Trade Sign*
C. 1920
Housepaint on plywood, 36 × 72 inches
(91.4 × 182.9 cm)
National Museum of American Art, Smithsonian
Institution, Washington, D.C. Gift of Herbert
Waide Hamphill, Jr. and museum purchase made
possible by Ralph Cross Johnson

48 MAXFIELD PARRISH

American, 1870–1966

Rubáiyát

1917
Lithograph, 13¼ × 35½ inches
(33.7 × 90.2 cm) framed
Inscribed, lower right: Copyright 1917,
C. A. Crane, Cleveland
Private collection, courtesy the American
Illustrators Gallery, New York

49 MAXFIELD PARRISH

"Garden of Allah" Candy Box

1918
Wood, 5 × 14½ × 8¾ inches (12.7 × 36.8
× 22.2 cm)
Private collection, courtesy the American
Illustrators Gallery, New York

This advertisement extended the triadic entanglement between the United States, France, and the Orient that undergirded American Orientalism, and capitalized on the titillating potential of the harem, a stock metaphor of western constructions of the erotic exotic. As the advertising industry became increasingly refined and visually aggressive, however, techniques of Orientalist enticement were fabricated to suit the needs of diverse and distinctly American products. New technological developments, particularly those in the field of lithography, brought vivid and evocative imagery within the reach of advertisers, and the general association between luxurious indulgences and oriental splendor was often the key.

A large trade sign for a candy factory in Hoboken, New Jersey, combined the domed silhouette of a Turkish mosque with the candy name, Orient Delights, and glossed the composition simply "Orient's Most Famous Sweets" to suggest that the consumer would be transported and delighted by the experience of eating this candy (cat. no. 47).[3] This linkage between sweetmeats and idyllic oriental pleasures was used in even more colorful form by Maxfield Parrish, who was hired by Crane's Chocolates to decorate candy boxes during the second decade of the twentieth century. Drawing on the *Rubáiyát of Omar Khayyám* and *The Garden of Allah*, he designed images that situated the consumption of candy in lush and exotic garden settings (cat. nos. 48, 49).

The indulgence most consistently coupled with oriental imagery, however, was tobacco. The link between sweet smoke and the Orient was often alluded to in paintings as well as exotic furnishings in the later nineteenth century (see cat. nos. 6, 40), and it was a small step to utilizing this connection to market tobacco products. Freestanding

1. Lears 1984, 369–88.
2. *Adams (Mass.) Transcript*, 8 October 1882, 3.
3. Hartigan 1990, cat. no. 6.

50 Attributed to William Demuth and Company, New York

Cigar Store Sultan
1875
Wood and polychrome, 86 ½ × 26 inches
(219.7 × 66 cm)
Private collection

trade figures of sultans and sultanas (cat. nos. 50, 51), personifying the Turkish source of aromatic tobaccos, lured customers off the street with their exotic and commanding presence on the sidewalk.[4]

These carved wooden figures, reaching the height of their popularity in the latter half of the nineteenth century, were produced by a small coterie of apprenticeship-trained craftsmen, primarily in major coastal cities.[5] After about 1860, such figures were disseminated nationally by means of the catalogues of a few large tobacco distributors and displayed prominently at major expositions and industrial fairs, including the World's Columbian Exposition in Chicago in 1893.

During this period, domestically grown tobacco was used primarily for chewing or pipe-smoking, and cigarettes were rather uncommon. Typically hand-rolled from Turkish leaf, they were seen as a foreign luxury, combining European sophistication and oriental panache.[6] New strains of domestically grown tobacco and the development of

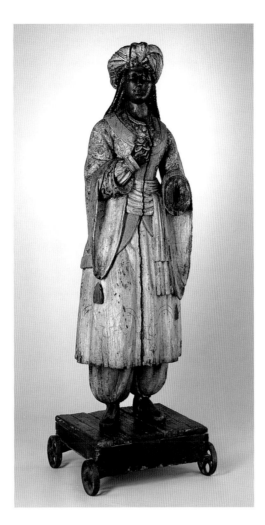

51 *Trade Figure Sultana*
1860
Wood and polychrome, height 61 inches
(154.9 cm)
Shelburne Museum, Shelburne Vermont

52 *Box of Salome Cigarettes*
1920–25
Tobacco and paper, 4 × 5 inches
(10.2 × 12.7 cm)
Duke Homestead, Durham, North Carolina

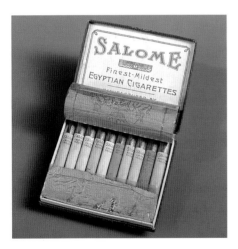

4. Fried 1970, Turk no. 40 and fig. 212.

5. Sessions 1997, 471–77.

6. Heimann 1960, 221.

7. The best and most synthetic overview of these developments is Smith 1990, 15–21.

8. Congdon-Martin 1996, 8–9.

9. The critical breakthrough for tin signage and packaging was the introduction of commercially viable methods of lithography on tin, transpiring in the last decades of the nineteenth century. See Congdon-Martin 1992, 4–5.

James Albert Bonsack's mechanical cigarette-rolling machine, however, revolutionized the cigarette business in the last two decades of the nineteenth century. Once the machinery was perfected, the mechanization of the rolling process radically increased cigarette production, inspiring cigarette manufacturers to transpose the product from an elite indulgence to a mass-market enjoyment. All the tools of the fledgling advertising trade were marshaled to the purpose, including the use of premiums as advertising gimmicks, colorful packaging, and alluring brand names.[7]

Over the course of the 1890s, James B. Duke of Durham, North Carolina, consolidated 60 percent of the domestic tobacco industry in an unprecedented corporate structure known as the American Tobacco Company, a monopolistic trust that was finally broken up in 1913.[8] Within this extraordinary conglomerate, there were in actuality three kinds of cigarettes on the market: pure Turkish blends, pure domestic blends, and blends of Virginia and Turkish leaf. This functional standardization made distinctive packaging and brand names critical to successful sales. Oriental names were frequently used to grant a particular brand of cigarettes a bold visual appearance and to capitalize on exotic allure. Fatima brand, the cheapest of the Turkish blends, was initially packaged with little pictorial enhancement. Eventually, however, it was widely marketed with a coquettish harem girl peeking out from behind a diaphanous veil to entice buyers into self-indulgence. Such imagery appeared in full-page magazine ads and was also applied to tin counter signs for "point of purchase" reinforcement (cat. nos. 53, 54).[9]

Imagery evoking romance and exotic ethnic types comprised many oriental cigarette logos. Signage for Mogul brand exhibited a half-length figure in turban staring imperiously out at the consumer (cat. no. 55). Omar cigarettes, by contrast, employed a

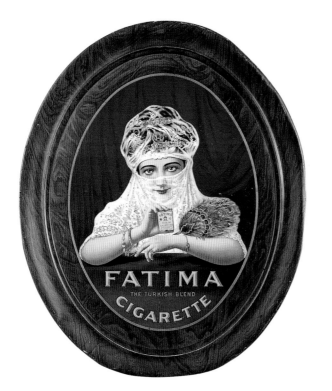

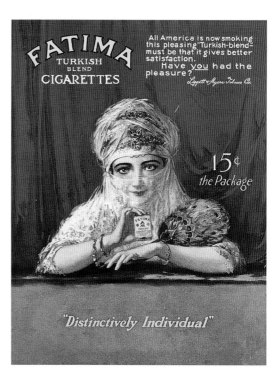

53 *Fatima Cigarettes Advertising Sign*

1890–1920

Tin, 23 × 19 inches (58.4 × 48.3 cm)

Duke Homestead, Durham, North Carolina

54 *Fatima Cigarettes Magazine Advertisement*

c. 1910

Lithograph, 14 × 10⅝ inches (35.6 × 27 cm)

Private collection

romantic vignette featuring a rotund sultan and a lithe houri in a moonlit garden setting (cat. no. 56). The image is captioned with a quote from Omar: "Yon rising Moon that looks for us again— / How oft hereafter will she wax and wane." These advertisements had sufficient public appeal that the American Tobacco Company placed a small notice on the back: "The Omar Painting (shown on the reverse page) in Full Color, 7 × 10¼, on heavy plate paper, without advertising and ready for framing, will be sent to any address in U.S. on receipt of 10 cents in stamps."[10] This is the point of power—an image that advertises and an image that pleases, and an image that can serve as art in middle-class homes. In this manner, an Orient of stereotypical form infiltrated popular culture and became institutionalized.

While representations of this sort were the imaginative fabrications of graphic artists, other advertisements were generated differently. When the tobacco trust was broken up and the various cigarette brands were apportioned to the constituent entities, R. J. Reynolds was allotted no established brands and instead infiltrated the competitive cigarette market with a new brand, Camel. Launched with a national advertising campaign and priced below Turkish blends, Camels quickly dominated the market. The distinctive camel logo was based originally on a dromedary that passed through Winston-Salem with Barnum and Bailey's circus, and it has enjoyed extraordinary longevity with minimal change up to the present day.[11]

In retrospect, the orientalizing trend in cigarette advertisements seems to have coincided largely with the lifetime of the American Tobacco Company. Many brands did not survive the disruption of the Turkish tobacco industry and world markets during World War I, and the taste for orientalia waned. Salome cigarettes (cat. no. 52) a short-lived brand launched in the mid-1920s and aimed at the new female market, did not utilize pictorial imagery at all, perhaps in acknowledgment of the prickly quandaries posed by women smoking.[12] Meanwhile, by 1921 Camel comprised virtually one half of the cigarettes smoked in America, and the advertising emphasis had shifted away from Orien-

10. This follows a lengthy description of the superior qualities of the cigarette.

11. Congdon-Martin 1996, 8–9, 23.

12. On the marketing of cigarettes to women in the early twentieth century, see Smith 1990, 22–23.

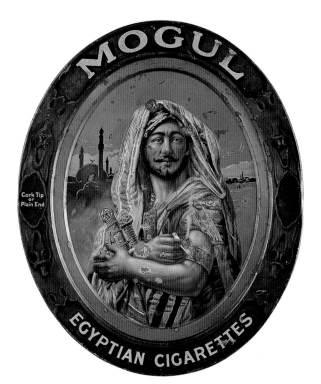

55 *Mogul Cigarettes Advertising Sign*
1890–1920
Tin, 23 × 19 inches (58.4 × 48.3 cm)
Duke Homestead, Durham, North Carolina

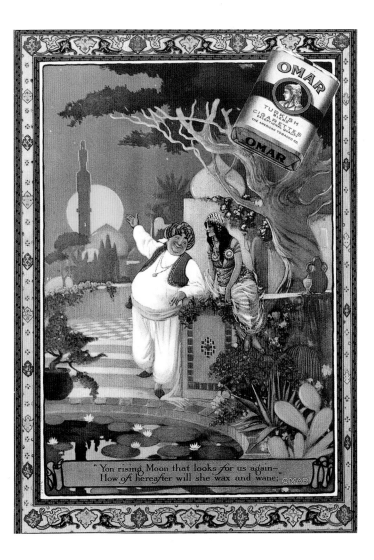

56 *Omar Cigarettes Advertisement*
Early 20th century
Lithograph, 12 × 10⅝ inches (30.5 × 27 cm)
Private collection

57 MAXFIELD PARRISH

American, 1870–1966

*Lamp Seller of Bagdad
Calendar Top*

1922

Lithograph, 31 × 21¼ inches (78.7 × 54 cm)
framed

Inscribed, lower left: Copyright 1922, Edison
Lamp Works of General Electric Company;
lower center: "The Lamp Seller of Bagdad";
lower right: MP

Private collection, courtesy the American Illustrators Gallery, New York

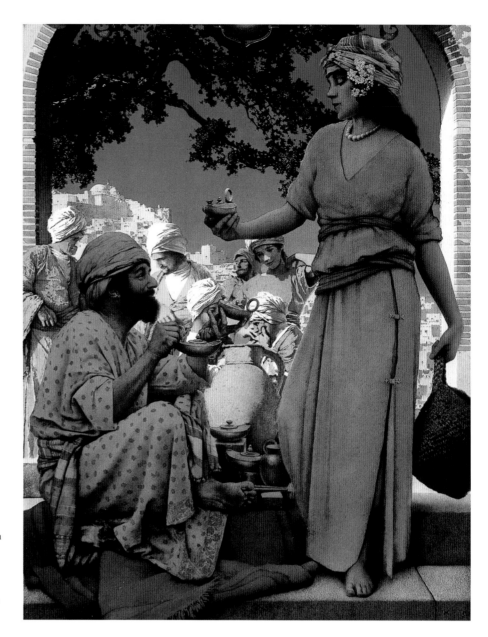

talism (a camel in a desert setting) to masculinity ("The Man in the Camel Ad").[13]

In general, Orientalist advertisements of the early twentieth century bore little relationship to the prior traditions of Orientalist painting. Instead, they utilized a vocabulary of stereotype and fantasy that was not confined to those who had the wherewithal to purchase fine art. The work of Maxfield Parrish, encompassing book illustrations, fine art prints, and advertisements with Orientalist themes, exemplifies this phenomenon. His *Lamp Seller of Bagdad* (cat. no. 57) reiterated the familiar theme of the Orient as a foil for America's technological sophistication, but Parrish romanticized the imagery in an unprecedented way for commercial purpose. Drawn entirely from the artist's imagination to serve particular marketing needs, images such as *The Lamp Seller of Bagdad* and *The Rubáiyát* (cat. no. 48) were also circulated as independent fine art prints.[15]

Vivid and evocative, these representations were widely disseminated by the mechanisms of the modern marketplace, thereby consolidating a spectacularized Orient in the public eye. The diachronic sweep of American visual Orientalism thus suggests that as "high art" Orientalism waned, mass-produced imagery emerged, reflecting and extending popular convictions along new lines.

13. Ruth M. Bennett's four-stanza poem, "The Man in the Camel Ad," was reproduced in a large format suitable for framing. See Congdon-Martin 1996, 41 and 51, on the decidedly masculine tone of the advertising in the 1920s.

14. Ludwig 1973, 32–34. Parrish's earliest sustained exercise in Orientalist imagery—a series of illustrations for *The Arabian Nights*, first appeared in serial format in *Collier's* (*The National Weekly*) from April 1906 to November 1907 and was published in book form in 1909.

15. On the genesis of this image as advertisement and wall art, see Ludwig 1973, 131–34.

With the insight of a cartoonist,[1] John Sloan captured the dominant theme of Orientalism in American popular culture in the early twentieth century. His 1913 painting *Movies* (cat. no. 58) depicted an urban street with a brightly lit marquee reading, "A Romance of the Harem," thus Orientalizing the unprecedented and sexually charged freedoms of New York nightlife. Whether on silent screen or Broadway, in song or dance, such Orientalism provided the American public with the style and the storylines to explore heightened sensuality.

This ventilation of American desire took place in the industrialized environments of the early twentieth century, when horse-drawn carriages were being replaced by automobiles, when pipes were exchanged for cigarettes, and when the Ziegfeld Follies were

58 **JOHN SLOAN**
American, 1871–1951

Movies

1913
Oil on canvas, 19⅞ × 24 inches (50.5 × 61 cm)
Signed, lower right: John Sloan
Toledo Museum of Art

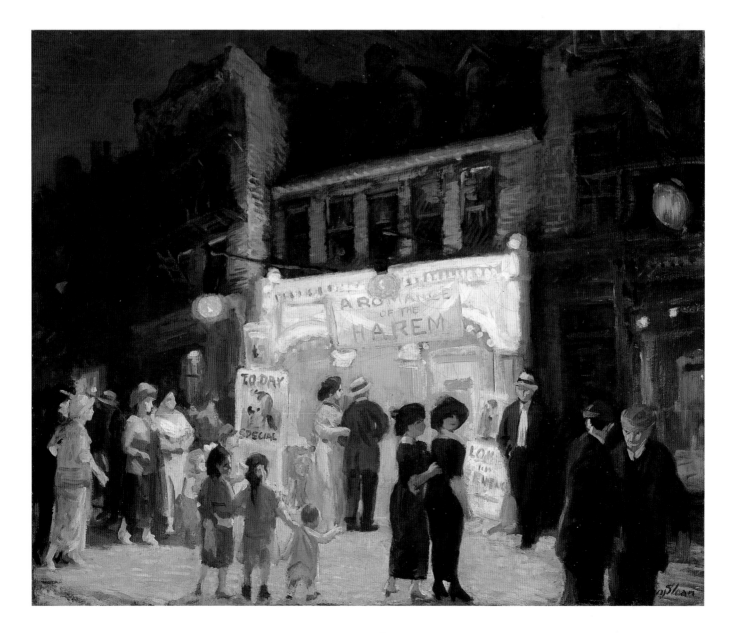

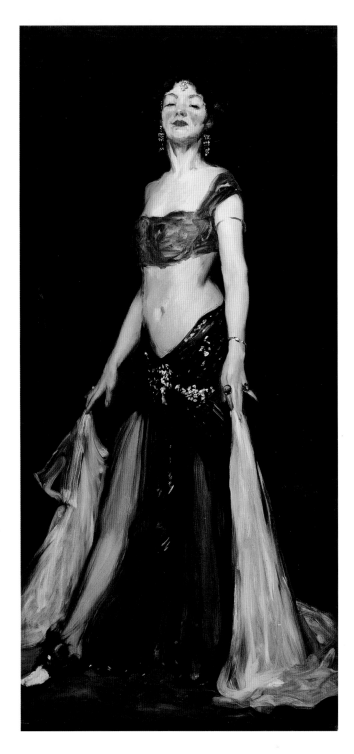

59 ROBERT HENRI
American, 1865–1929

Salome

1909
Oil on canvas, 77 × 27 inches (195.6 × 68.6 cm)
Signed, lower left: Robert Henri
Mead Art Museum, Amherst College, Amherst,
Massachusetts. Purchase

1. Sloan in fact began his artistic life in this capacity,
whereas many of his Ash-can School colleagues were
artist-journalists. Two useful sources on early-twenti-
eth-century painting and the Ash-can School are Perl-
man 1979 and Zurier, Snyder, and Mecklenburg 1995.
2. Florenz Ziegfeld (1867–1932) produced the first Follies
in 1907; this song and dance revue was staged annually
throughout the period in question. The standard
monograph is Farnsworth 1956.
3. On the connection between cooch, burlesque, and
sexual display on stage, see Allen 1991, 225–36.
4. On Henri's portraits of standing women, see Perlman
1979, 95.
5. Allen 1991, 245–46.

launched for the enjoyment of the American public.[2] Painters were shifting their focus
from the ideal to the real, from traditional paintings of landscape and allegorical figural
compositions to grittier depictions of life in and around urban America. Emblematic of
this change was Robert Henri's displacement of William Merritt Chase (cat. no. 35) as the
preeminent teacher in the New York School of Art. Both were inspiring and gifted teach-
ers, but the studio Orientalist Chase was a retrograde aesthete compared to the streetwise
and challenging Henri. The transfer of power from the former to the latter reveals the
larger shift from cosmopolitan and worldly propriety to an unblinkered focus on the
domestic front. In the world of boxers and prostitutes that Henri and Sloan painted, the
Orient as Chase created it was wholly irrelevant. In their world, Orientalism had been
reduced to harem envy; it was democratized and not particularly proper.

The story began on stage, with the hoochy-coochy and burlesque.[3] At the outset, the

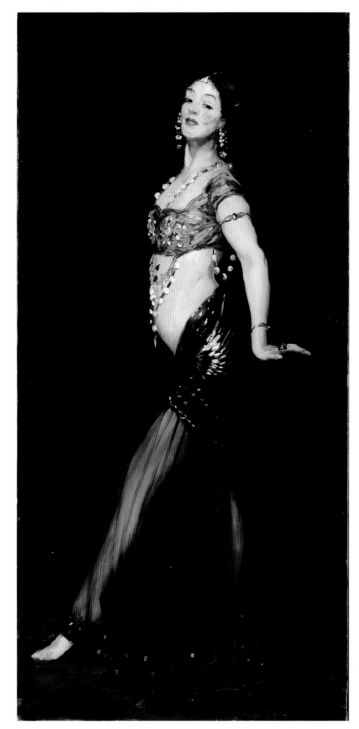

60 ROBERT HENRI

Salome

1909

Oil on canvas, 77½ × 37 inches (196. 9 × 94 cm)

Collection of the John and Mable Ringling Museum
of Art, Sarasota. The State Art Museum of Florida

theme was the dancing girl, and the archetype was Salome—the biblical girl who
danced for King Herod and was rewarded with the head of John the Baptist. Henri
painted her with minimal story line: brazen, vital, and without John the Baptist's head
(cat. nos. 59, 60),[4] and countless aspiring dancers tried to master her dance of the seven
veils. Popular tunes of the era suggested a mix of titillation and anxiety about Salome:
Irving Berlin wrote in 1909, "Sadie Cohen left her happy home to become an actress
lady. On the stage she became the rage as the only real Salomy baby." Her sweetheart
rushes to defend her honor but is appalled by what he finds: "Don't do that dance, I tell
you. Sadie, that's not a business for a lady. Oy, Oy, Oy, where's your clothes?" Eventually,
the spectacle of a sexual female was packaged for middle-class consumers in the form of
the Ziegfeld Follies, a manifestation of the widespread desire to "show things off" that
permeated consumer culture.[5]

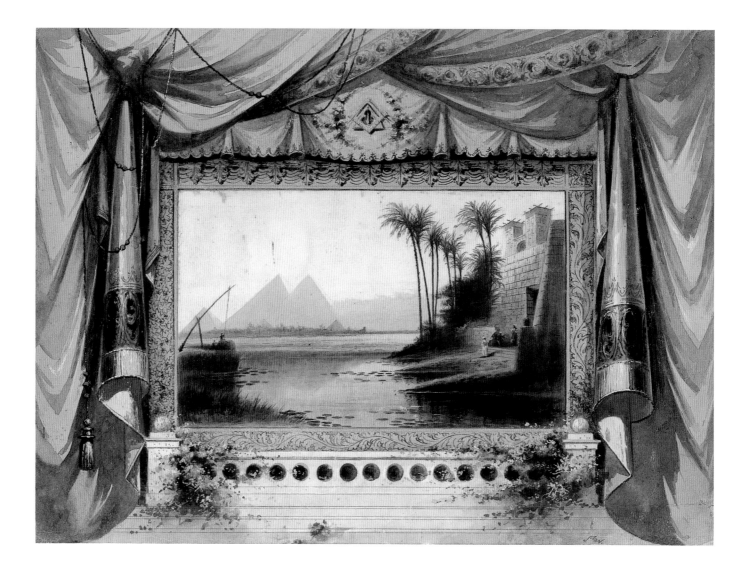

61 John Z. Wood

Masonic Drop Sketch

1900

Opaque watercolor on paper, 14⅝ × 22⁷⁄₁₆
inches (37.1 × 57 cm)

Twin City Scenic Company Collection, Performing
Arts Archives. University of Minnesota Libraries,
Twin Cities

In the early decades of the twentieth century, songwriters worked hard to keep up with the enormous demand for catchy tunes, and producers concocted vaudeville shows that circulated nationally. To accommodate a production of oriental theme, a local theater or opera house might acquire a stock backdrop of appropriate and evocative subject matter: a formulaic rendition of a Nilotic landscape or a stereotypical exotic interior (cat. nos. 61, 62). These settings could be deployed as needed for the staging of a wide variety of dramatic performances.[6]

Trendsetters in big cities might opt to mount grander extravaganzas, seeking to provide theatergoers with a truly "authentic" experience of the Orient. No expense was spared in the case of *The Garden of Allah*, Leibler and Company's stage production of Robert Hichens's novel (see pp. 43–45). For two years prior to the play's opening in 1911, the technical staff was busy preparing what came to be an extraordinary success that recounted a romance in the desert between a free-spirited Englishwoman and an apostate priest. As explained in the souvenir booklet that accompanied the play, this staging process entailed weeks of research in "the heart of the Desert of Sahara," during which photographs and sketches were taken, and costumes and other properties were acquired that would help to convey "the illusion of the East" on stage. Leaders of "electrical and mechanical ingenuity" were enlisted, "real Arabs" were imported for crowd scenes, and scenic artists were given free rein. The result was "the most magnificent spectacle that had ever been offered American or any other audiences."

The booklet also provided a plot synopsis and a selection of research and produc-

6. On stock scenery and theater functioning, see Brockman et al. 1987, esp. 83–93.

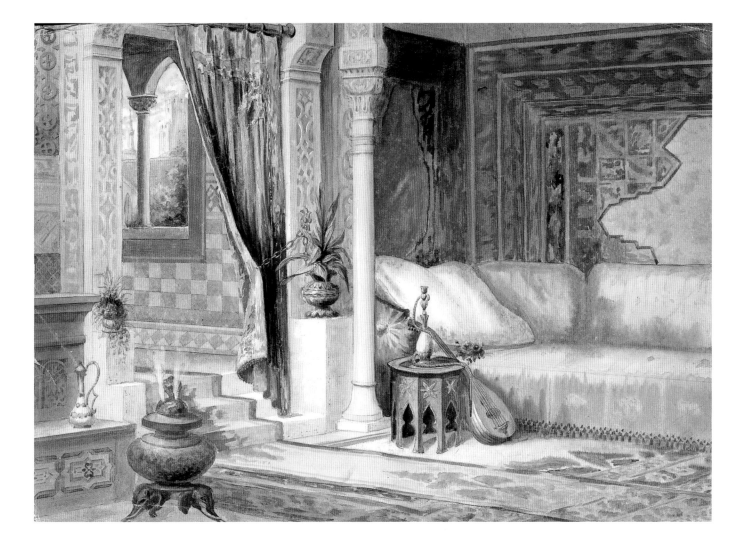

62 "Turkish Room" Theater Curtain Sketch

C. 1900
Watercolor on paper, 16¾ × 23¼ inches
(42.5 × 59.1 cm)
Twin City Scenic Company Collection, Performing
Arts Archives. University of Minnesota Libraries,
Twin Cities

tion photographs. In extravagant rhetoric, it voiced all of the themes that imbued early-twentieth-century Orientalism with its conflicted character of repressed and unleashed desires. The play opens with a scene entitled "The Spirit of the Desert," in which "An attempt has been made to visualize this Intangible Spirit in three of its phases: its Vastness, its Element, and Prayer." It is this atmosphere that is evoked in the cover design of the souvenir booklet (cat. no. 63). In fact, the desert plays such a prominent role that it becomes virtually a member of the cast: "She [the heroine, Domini] thought of the desert as a soul that need to strive no more, having attained. And she, like the Arabs, called it always in her heart the Garden of Allah. For in this wonderful calm, bright as the child's idea of heaven, clear as a crystal with a sunbeam caught in it, silent as a prayer that will be answered silently, God seemed to draw very near to his wandering children. In the desert was the still, small voice, and the still, small voice was the Lord."

In this charged desert setting, the story unfolds around newly discovered emotions—sexual as well as spiritual. The sexual passion that is awakened in the heroine, Domini, is conveyed in an indirect and displaced way by means of an intense scene in a "dancing house," in which Domini watches the hero, Boris Androvsky, gaze at an Algerian dancer: "The dancing woman had observed him, and presently she began slowly to wriggle towards him between the rows of Arabs, fixing her eyes upon him and parting her scarlet lips in a greedy smile. . . . A dark flush rose on his face and even flooded his forehead to his low-growing hair. . . . She lifted her arms above her head, half closed her eyes, assumed an expression of languid ecstasy and slowly shuddered . . . the gaudy siren

63 ASA CASSIDY

"The Garden of Allah" Souvenir Book

1911
12½ × 9½ inches (31.8 × 24.1 cm)
The Shubert Archive, New York

64 FRANK GUBA

American, 1867–1938

Pairpoint Glass Lamp with "Garden of Allah" Design

1891–1900
Metal and glass, height 23 inches (58.4 cm)
Old Dartmouth Historical Society–New Bedford
Whaling Museum, New Bedford, Massachusetts.
Gift of Billy and Becky Hitt

65 G. W. Peters

Omar the Tentmaker Poster
1914
Lithograph, 41 × 28 inches (104.1 × 71.1 cm)
Billy Rose Theatre Collection, The New York Public
Library for the Performing Arts, Astor, Lenox and
Tilden Foundations

7. A photograph illustrating the epilogue in the souvenir
book shows her looking wistfully over the wall while a
small boy listens to a lovelorn flutist in the foreground.
8. *New Jersey Journal,* 14 January 1914, n.p.
9. Various publicity shots and newspaper coverage of
the production are available in the Theatre Collection
of the New York Public Library for the Performing Arts,
Astor, Lenox and Tilden Foundations. The quote comes
from an unsourced article in the Robinson Locke Col-
lection, vol. 390, dated 24 January 1914.
10. "My Turkish Opal from Constantinople" and "In My
Harem" may share a topical reference to contemporary cir-
cumstance or they may simply reflect overlapping modes
of hostility to non-Anglo ethnic groups in early-twentieth-
century America. I am grateful to Charles Kennedy for a
copy of his typescript, "Salome and the Sheik: Kitsch as
Kitsch Can," presented at MESA 1998 Annual Meetings.

curved almost into an arch before him. The musicians blew their hautboys and beat their
tom-toms more violently, and all things, Domini thought, were filled with a sense of cli-
max." At the end of the play, Domini is left with a child and no lover, looking out over
the sands of the Garden of Allah from an idyllic garden.[7]

While *The Garden of Allah* was perhaps the most extravagant rendition of romance
in the desert, other plays exhibited a similar preoccupation with passion in oriental
guise. In the 1914 production *Omar the Tentmaker,* the "legend of the *Rubáiyát* is made
real"; it was deemed spectacular, atmospheric, poetic, authentic, and somehow related
to Edward Fitzgerald's translation of the fabled Persian poet Omar Khayyám.[8] Given the
non-narrative character of that text, this would have entailed considerable creativity on
the part of the producers. A poster advertising the play (cat. no. 65) encapsulates the
fabricated plot with a depiction of the passionate hero, played by Guy Bates Post, climb-
ing up to the barred window of a sequestered woman. It is a suggestive and overheated

66 *Arabian Nights Intermezzo*

1918

Music and lyrics by M. David and
William Hewitt

Sheet music, 11 × 9 inches (27.9 × 22.9 cm)

Whiteman Collection, Williams College Archives,
Williamstown, Massachusetts

67 *In My Harem*

1913

Music and lyrics by Irving Berlin

Sheet music, 11 × 9 inches (27.9 × 22.9 cm)

Whiteman Collection, Williams College Archives,
Williamstown, Massachusetts

11. Michalek 1989, 3.

12. A poster of this otherwise lost film exists in a private
collection in Santa Fe, New Mexico.

13. J. Stuart Blackton directed a version of *Salome* in
1908; J. Gordon Edwards directed Theda Bara in a 1918
version; Charles Bryant directed Alla Nazimova in a
1923 version.

14. Bernstein and Studlar 1997, 3–4.

image drawn directly from publicity shots of the play itself. Newspaper coverage at the time put a finer point on it: the *Rubáiyát* was deemed "hedonism, pure and simple."[9]

Popular music of the day explicitly echoed the themes of romance in the desert and harem envy as well. For example, the cover of the sheet music for David and Hewitt's "Arabian Nights Intermezzo" (cat. no. 66) depicts a desert caravan and an ambience similar to that of *The Garden of Allah*. Irving Berlin composed "In My Harem" in 1913 (cat. no. 67): "Down in Turkey-urkey, when the Turks were called away to war, A Turk asked Patrick if he wouldn't watch his harem. Pat said 'With pleasure, I will cover every track. . . . don't you hurry back.'" "My Turkish Opal from Constantinople" (cat. no. 68) recounts a similar tale: "An Irish Turk named Pat McGurk was sent to the Turkish war. . . . they called upon the sultan but the sultan turned them down, so they captured all the harems in Constantinople town. A girl whose name was Opal danced her way into Pat's heart. Said he, 'I'd like to steal you and then this land depart. Be my little Turkish opal from Constantinople. I'll be your little Irish emerald and we'll have a wedding grand. I'll build a little hut in clover with shamrocks all over. You'll be Missus McGurk and a regular Turk in Ireland.'"[10] Similar rhetoric occurred in the wake of World War I. In a song by Alex Gerber and Abner Silver, an American narrator glibly announces that when the spoils of war are divided, for his part, he wants the sultan's harem. After all, "he's past 83, and his thousand wives need a fellow like me" (p. 49, fig. 23).

The material evidence of the burgeoning entertainment industry suggests that, in the realm of popular culture, the Orient had been consolidated into a few stock tropes, foremost among them the romance of the desert and a fascination with harems. Silent movies were perhaps the most effective agent of this reductionist trend, reifying the stereotypes for an ever broader audience. This process began as early as 1893, when

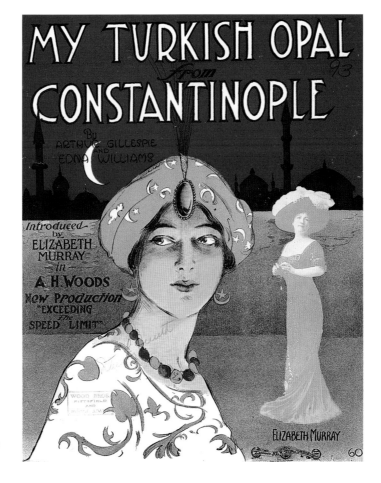

68 *My Turkish Opal from Constantinople*

1912

Music and lyrics by Arthur Gillespie and
Edna Williams

Sheet music, 10⅝ × 13½ inches (27 × 34.3 cm)

Chapin Library, Williams College, Williamstown,
Massachusetts. Gift of the Smith Club of Berkshire
County

Thomas Edison founded his film studio in West Orange, New Jersey. Among his first productions was *The Dance of the Seven Veils.*[11] Every year between 1910 and 1920, a handful of romantic or action films set in North Africa were made, including a rendition of *The Garden of Allah*[12] and multiple versions of *Salome.*[13] The 1920s saw the release of such major hits as *The Sheik,* a romantic melodrama starring Rudolph Valentino, and *The Thief of Baghdad,* an Arabian Nights fantasy that featured dazzling special effects. So institutionalized was this genre that Paramount even released a parody, *She's a Sheik,* in which all of the prevailing clichés were trotted out and lampooned.[14] Ultimately, the entertainment industry proved to be the key agent of dissemination for twentieth-century American Orientalism. It served to visualize and then institutionalize stereotypes, eventually projecting them even beyond American horizons into the cultures that they presumed to depict.

The Playground of the Masons

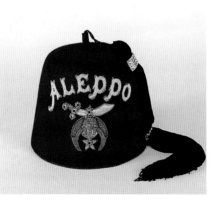

69 *Shriner Fez*

1920

Felt, metal, and rhinestones

Museum of Our National Heritage, Lexington, Massachusetts. Harvey B. Legee Collection of Shrine and Fraternal Material

During the period that this exhibition covers, 1870 to 1930, the Ancient Order of the Nobles of the Mystic Shrine grew from an inchoate idea in the mind of one Scottish Rite Freemason to a nationwide institution of some half a million devotees. Its arcane rituals were housed in elaborate "mosques" in the major cities of the United States, and its members donned elaborate "Arabic" dress in order to initiate new members to the tenets of Shrinedom. That so many middle-class citizens were willing to invest considerable monetary and social capital in Orientalist playacting is extraordinary; that it was conducted on such a grand and communal scale borders on the bizarre. How did members explain such activities, and what was the nature of the organization's debt to the Orient?

Predictably, the history of a secret fraternal order like the Shrine is obscure, but the traditional foundation myth, recounted from an official source, is as follows: The cofounders—Billy Florence, a famous actor, and Dr. Walter Fleming, a noted physician and surgeon with a talent for juggling and magic tricks—were both said to be "passing good showmen."[1] At the end of the Civil War, when Scottish Rite Freemasonry was emerging from a period of chaos and flagging enrollment, many Masons were eager to consolidate and augment membership. Fleming concocted the idea for an elite new fraternal order and enlisted Florence to collaborate for a "touch of glamour." The format and the character of this new order, however, remained unclear.

Some months later, in 1870, Florence was in Marseille, France, and was invited to attend a party given by an Arab diplomat, that took the form of an elaborately staged musical comedy, at the end of which the guests became members of a secret society. Florence seized upon this experience as the perfect raw material for Fleming's projected fraternal order, made copious notes and drawings, and obtained a copy of the script from his host (none of this material is extant).[2] Florence ostensibly witnessed the ritual twice more—once in Algiers and again in Cairo—and returned to New York, his collected exotica in hand. Thereafter, the myth was established that the American order was an offshoot of an Ancient Arabic Order of Nobles of the Mystic Shrine that had been founded in Mecca by Ali, the son-in-law of the prophet Muhammad.

Fleming, a shrewd promoter, leaked the claim that he had personally been granted official permission to launch the shrine in North America by a man named Rizk Allah Hassoon Effendee, who had allegedly brought a copy of the original ritual from the Archives of the Order in Aleppo to London in 1860. Other publicity releases intimated that the initiation rites were stringent and grueling but that successful initiates would be permitted to wear a distinguishing emblem to set them apart from others—the fez (cat. no. 69). Fraternal appetites were whetted, and the foundation was laid for the extraordinary efflorescence of the Nobles of the Mystic Shrine in America.

When it came to composing the ritual itself, other people were consulted. Noted Masonic ritualists Charles T. McClenachan and William S. Patterson (who was also said to be conversant in Arabic) contributed along with Albert L. Rawson, a scholar and

1. Saunders 1976, 4–7. I am citing this source, for present purposes, because it reveals as much in its rhetorical style as it does in its content. For original documents and a more sober presentation of "facts," see Melish et al. 1921.

2. Melish et al. 1921, 25–26, includes some original documents.

3. Bancroft 1893, 855–57.

4. Saunders 1976, 3.

5. Ibid., 8.

Annual Outing
of Aleppo Temple
Ancient Arabic Order, Nobles of the Mystic Shrine, Oasis of Boston, Massachusetts

STAG PARTY
(NOBLES ONLY)

The Date **August 15th** 1923

The Place — Hampton Beach, N. H.

The Time — 10.30 A.M.
(Daylight Time), North Station,
Boston & Maine Railroad. Arriving
at Hampton at 12 O'Clock Noon.
Trolley Cars to the Bake. After the Bake, Parade to the Beach.
CIGARS AND SOUVENIRS—See the Steward, Henry B. Perkins, at the Bake.

At the Beach:

BAND CONCERTS BASEBALL
 PATROL *vs.* DEGREE STAFF
FIELD SPORTS Umpire: Benjamin Orinoco

 WATER SPORTS
Judges: See Ben James
Director Don Sisson, Harry Fleming,
Ralph Godfrey

Trolleys leave Beach in time to take Train for Boston and Way Stations at 9.30 and 10.30 P.M., Daylight Saving.
Train Stops at Lynn, Salem, and Newburyport.

 { By Train $7.00
The Price { By Auto 6.00
 Send for Tickets to R. W. Rowell.

N.B.— If you are going on the Outing, we must have your reservation on
or before August 12th. This is imperative. We must notify the Caterer on
that date how many to prepare for. Ticket Sale Closes August 12.

A Meeting for the Election of Candidates for the Order and Con-
ferring the Degree will be held in Talbot Hall, Mechanics
Building, Huntington Avenue, at 9 A.M., Daylight time, on day of Outing.
CANDIDATES REPORT AT 8 O'CLOCK, DAYLIGHT TIME

BASEBALL DAY
Monday **JULY 30** Monday
Fenway Park
Cleveland vs. Red Sox
GAME STARTS 3.15 P.M.

Compliments of IF RAINY, THE NEXT
Red Sox Management AFTERNOON

Your Card Admits You Aleppo Drum Corps
 will furnish music
WEAR YOUR FEZ

70 *Shriner Announcement*
1923
Printed card, 12¼ × 27¾ inches (31.1 × 70.5 cm)
Museum of Our National Heritage, Lexington,
Massachusetts. Harvey B. Legee Collection of
Shrine and Fraternal Material

Mason who provided abstruse Arabic background for the mysterious rites. While this oriental veneer gradually grew to include the use of the Arabic calendar, exotic mosque names and architectural forms, pilgrimage rhetoric, and some basic Arabic phrases—the standard greeting was "As Salaam Aleikum!" (Peace be with you)—the extent to which Arabic language or custom actually permeated ritual practice remains unclear.

The precise nature of the Shrine's debt to the Orient must have come into sharper focus during the World's Columbian Exposition in 1893, when Shriners of Chicago's Medina Temple participated in the dedication ceremony for the mosque in the Turkish Village on the Midway Plaisance. The mosque was erected by special permission of the Ottoman government and was dedicated with appropriate ceremony. When the call to prayer was sounded, three thousand people participated, led by a military band. According to Hubert Howe Bancroft's *Book of the Fair*, the majority of the participants were "of the Caucasian race" and members of the Ancient Arabic Order of the Nobles of the Mystic Shrine, which was purported to have flourished in Turkey many years before it gained a foothold in the United States: "The ceremony was the briefest—merely a recitation of passages from the ritual, in which the Muezzin and his brethren were the prominent figures, the congregation responding with frequent prostrations, and devout exclamations of 'Allah!' A banquet followed in an adjoining hall; a handsome Damascus blade was presented to the Medina temple by the concessionaire, and the celebration was at an end."[3]

While it is unclear who initiated this ceremony and what impact it had on the participants, such contact was not the norm. In fact, periodically throughout the history of the order, efforts have been made to rationalize and explain its oriental character and to demonstrate that it is "as American as apple pie."[4] At one point in 1894 (and perhaps in response to the events of 1893), leaders of the order admitted that "From an academic standpoint our Shrine and our Ritual would be held in ridicule by the savant, or even the progressive student of Arabic learning. . . . To revise the ritual to make it conform to Arabic nomenclature customs, practices and ideals would deprive it of all that has made it so amusing to many thousands of admiring followers. . . . Noble Fleming gave the Shrine such harmless humor in his conception of his ritual we would not mar his work through cold conformation to Arabic or any other customs."[5] In 1921, the official Committee on

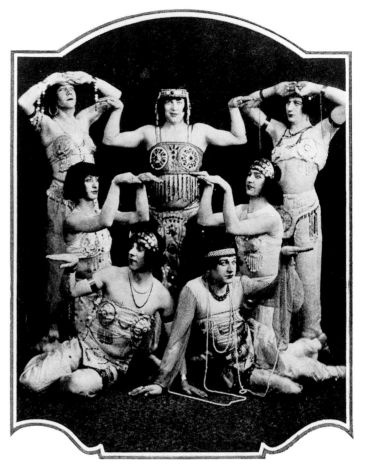

71A, B *Images from the Commemorative Volume of the Pilgrimage to Washington*

1923

Courtesy of the Livingston Masonic Library, New York

6. Ibid.

7. Melish et al. 1921, 10.

8. By 1892, membership had reached 23,000; by 1918 it had risen to more than 250,000, and by 1922 Shrine rosters numbered over 500,000. "The Mystic Shrine," *Los Angeles Freemason* 11, no. 8 (May 1907): 257.

History for the Shrine explained that the oriental paraphernalia, signs, tokens, and the like were used for "histrionic rather than for esoteric or historical purposes."[6]

Florence and his theatricality were credited with the dramatic character of the order, replete with extravagant jewels, costumes, picturesque desert settings, and a spare religion: "It is not difficult to see why one as skilled as he was should have selected the picturesque jewels and costumes of the Orientals. The jeweled costumes, the picturesque Arab with his tent, and the holy city of Mecca, together with all that surrounded it and the religion which it typified, naturally appealed to the actor. To him the whole world was a stage and all the people actors. He hit upon an exceedingly picturesque and attractive feature. The Ritual is evidently the free translation of a beautiful and ancient order or religion and this, in truth, is about all that can be said of its antiquity."[7] Apparently, the Orientalism was critical but not for reasons of verisimilitude; informed members harbored few delusions about its authenticity.

If the Shrine was an elaborate Orientalist contrivance, the excellent banquet fare and "the jovial time, the screeching farce, camels, ropes, sands, branding irons, vats of boiling water, goats, all fast and furious" were cited as explanation for the exploding membership.[8] Colorful announcements of Shrine events pictorialized what literally or metaphorically transpired behind closed doors (cat. no. 70). Initiates bore the brunt of all manner of practical jokes, and even imperial potentates were made to look ridiculous with photographs of their heads superimposed on cartooned bodies. In some cases, role playing entailed raucous transgressive behavior, even to the extent of cross-dressing (cat. no. 71B).

The lampooning was not confined to rituals or pictures but also permeated written documents that the Shrine published in conjunction with their initiations and pilgrim-

THE GARDEN OF ALLAH

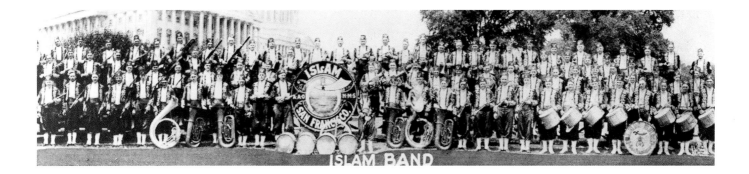

71C, D *Images from the*
Commemorative Volume
of the Pilgrimage to
Washington

1923

Courtesy of the Livingston Masonic
Library, New York

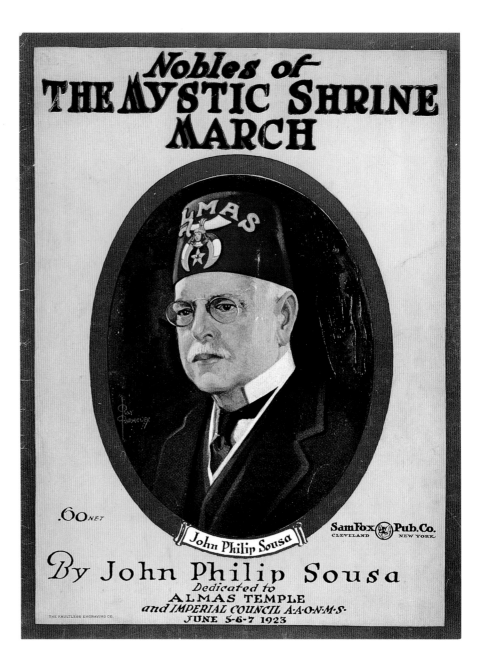

72 *Nobles of the Mystic Shrine March*

1923
Music by John Philip Sousa
Sheet music, 12¼ × 9¼ inches (31.1 × 23.5 cm)
Courtesy of the Livingston Masonic Library,
New York

9. Saunders 1976, 6; Melish et al. 1921, 11.

10. Melish et al. 1921, 12.

11. My analysis of the Shrine's Orientalism follows Will
Moore's "American Shriners' Mosques, 1904–1929: The
Golden Age," a lecture presented at National Masonic
Expo, Minneapolis, Minnesota, 5 October 1996.

12. The Chancellor Robert R. Livingston Masonic
Library of Grand Lodge, 1996 Annual Report, 14, 16.

13. Saunders 1976, 9. The fez is generally associated with
nineteenth-century dress reform in the Ottoman
Empire and the attire of government bureaucrats. On
the various Shriner accoutrements and their symbol-
ism, see Melish et al. 1921, 37–39.

ages. In the commemorative volume produced in the wake of the 1923 pilgrimage to
Washington D.C. (cat. nos. 71A–D), for example, stories in the mode of the *Arabian
Nights* are recounted, including one called "That Affair of the Camel's Milk" (told at two
a.m. on the 1002nd Night). The author wryly concludes, "So this verily is bunk? Well,
whadya know about that?" As the self-styled playground of Masons, the Shrine and its
rituals were clearly designed to be impressive but also amusing to the participants;[9] that
it effectively linked the Orient with comic relief is an insidious subtext, the impact of
which is difficult to gauge.

The Orientalism of Shrine rhetoric was important in a number of ways. Some of
those reasons are hinted at in the official history:

> *It is a well known psychological fact that most men never lose their boyhood fac-
> ulty of dreaming or projecting themselves into strange and mysterious lands and
> performing mighty feats and doing wonders with ease and facility. And of all the
> lands of mystery, magic, glamour, charm and delight, none excels that of ancient
> Arabia. Beautiful, strange, colorful, a land of mystery, peculiar customs, yet one of*

73 *Shriner Jewel*
c. 1900
Metal and tiger claw, 4⅛ × 3½ inches
(8.9 × 10.5 cm)
Museum of Our National Heritage, Lexington,
Massachusetts. Harvey B. Legee Collection of
Shrine and Fraternal Material

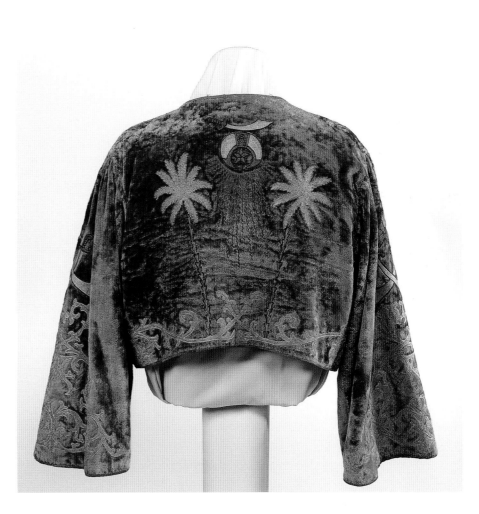

74 *Shriner Jacket*
c. 1900
Velour
Museum of Our National Heritage, Lexington,
Massachusetts. Gift of Grant B. Romer

**75 Shriner Commemorative
Miniature**
1923
Gold-plated lead with enamel, 2½ × 3½ inches
(6.4 × 8.9 cm)
Collection of Ace Architects, Oakland, California

76 Shriner Scimitar
c. 1900
Aluminum, length 23½ inches (59.7 cm)
Museum of Our National Heritage, Lexington,
Massachusetts. Gift of Mrs. Mary Ceaser

*pomp, ceremony, majesty and glory, the ancient courts and civilization of Arabia
have stirred the imagination and haunted the dreams of millions.*[10]

Invoking tropes of mystery, magic, and escapism, such an explanation acknowledges the
peculiarly masculine character of the Shrine's Orientalism and suggests that it was cru-
cial precisely because of the sense of geographical, cultural, and chronological "other-
ness." The Orient in this romanticized guise was both timeless and effortless, thus
providing respite from the drudgery of prosaic reality.[11]

The elaborate oriental regalia was also critical to the success of this fraternal society,
for it facilitated the shedding of workaday personae and granted the wearers new identi-
ties in which self-indulgence and frivolity were acknowledged and even licensed. Secret
rituals were conducted in elaborate pseudo-oriental regalia (cat. no. 74),[12] and even pub-
lic activities were elaborately costumed events. These trappings were not flimsy
emblems but impressive and even conspicuously luxurious symbols of alternative reali-
ties. The jewel of the order (cat. no. 73) is a crescent, ideally made from the claws of a
Bengal tiger, united at their bases in a gold setting and mounted with a sphinx, pyra-
mid, urn, and star. The jewel bore the Arabic motto "Quwwat wa ghadab," generally
translated as "Strength and Fury." The fez, headgear that Shriners associated with both
Arab and Turkish dress,[13] was adorned with the temple name and gilt tassel (cat. no. 69)
and was vested with particular honor, distinguishing as it did members of the Shrine
from other Masonic orders. Thus the elaborate accoutrements were consonant with the
lapsed self-control that Shrine rites entailed and echoed the increasingly materialistic
priorities of consumer society.

In effect, the Shrine offered a socially acceptable venue for self-indulgence, masquer-
ade, and playacting that contravened social norms. When the elaborately garbed
Shriners "parked their camels with Uncle Sam'l" in the grand pilgrimage to Washington
D.C. and marched to the tunes of John Philip Sousa (cat. no. 72), the Shrine even
allowed them to map the nation's capital around their own Orientalized power (cat.
nos. 71, 75, 77, 78). It is perhaps no wonder, then, that Shrinedom was deemed a gratify-
ing experience. The Order worked precisely because of its Orientalism, for the stereo-
typical Orient represented elaborate spectacle and no obligations, both of which
released men from sober and burdensome responsibilities in other sectors of their lives.

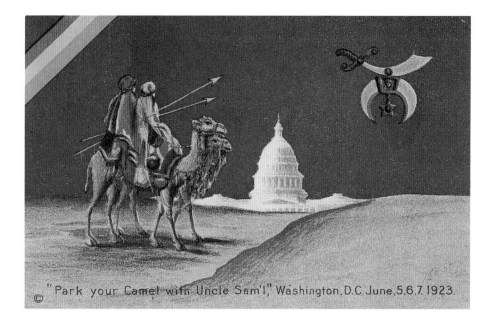

77 *Park Your Camel with Uncle Sam'l*

1923

Postcard, 3½ × 5½ inches (8.9 × 14 cm)

Museum of Our National Heritage, Lexington, Massachusetts

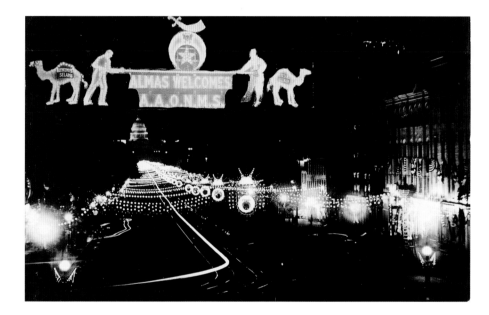

78 *Pennsylvania Avenue, Washington, D.C.*

1923

Postcard, 3½ × 5½ inches (8.9 × 14 cm)

Museum of Our National Heritage, Lexington, Massachusetts

The Modern Master of the Magic Carpet

*L*owell Thomas—newscaster, foreign correspondent, explorer, and business executive—was an Orientalist in the mode of Bayard Taylor (cat. no. 1), bringing the Orient home with a consummate sense of showmanship. Speaking to packed lecture halls all over the world, he presented "With Allenby in Palestine and Lawrence in Arabia" in the form of a two-hour monologue accompanied by colored slides. His audio-visual techniques were state of the art, his rhetorical skills were well honed, and he was largely responsible for creating the myth of Lawrence of Arabia in American popular culture (see pp. 100–107).

Thomas's 1919 travelogue performance at Covent Garden in London, as described in his autobiography, was quintessential Orientalism, complete with palm trees and incense: "The curtain opened on the Nile set, the moon faintly illuminating distant pyramids. Our dancer glided on stage in a brief Oriental dance of the seven veils. Fran [Thomas's wife] had set to music the Mohammedan call to prayer and, from the wings, a lyric tenor sent this haunting, high-pitched melody sailing away to the farthest reaches of the theatre. Two minutes later, I stepped into the spotlight and began to speak."[1]

His monologue was more than a little seductive: "I would like to have you close your eyes for a moment, and try and forget that you are here in this theatre, and come with me on a magic carpet, out to the land of history, mystery and romance."[2] The lecture was accompanied by 285 lantern slides, projected for the audience by means of three different machines (one and a half tons of special equipment); in an extraordinarily taxing engineering feat, these pictures were shown and replaced in rapid sequence, interrupted by thirty short film segments, some of which had been shot from an airplane.[3]

Miraculously, it all worked; the audience loved it and they treated Thomas to a ten-minute ovation, thus inaugurating a demanding schedule of nearly nonstop performances that pushed him to the point of total exhaustion in a short time. When he finally did collapse, the doctor obliged him to remain in bed every minute of the day that he was not onstage. With his customary eloquence, he described this grueling life as "half invalid, half theatrical athlete."[4]

Such a description does little justice to the care and planning that Thomas invested in the creation of his travelogues. His lantern slides, culled from a corpus of almost a thousand pictures taken by photojournalist and collaborator Harry Chase, were hand-tinted by the miniaturist Augusta Heyder. He frequently adjusted his text to suit different audiences, inserting references to local sites and personalities, and he devoted considerable care to publicity materials and advance planning. He was particularly intent on using the title "The Lowell Thomas Travelogues," describing it as a "trademark which must be burned into the mind of every man, woman and child, Pekinese dog and Shetland pony from Lands End to John O'Groats."[5]

The posters designed to promote the Thomas Travelogues are also evidence of a master publicist at work. Dale Carnegie was instrumental in convincing him that bold

1. Thomas 1976, 201.

2. Thomas 1922a.

3. Keith 1998, 20–22.

4. Thomas 1976, 207.

5. Keith 1998, 25.

6. During the time he was advising Thomas, Carnegie spelled his name "Carnagey."

7. Dale Carnegie to Lowell Thomas from Cranston's Kenilworth Hotel, Great Russell Street, n.d., Lowell Thomas Archives, Marist College.

8. Keith 1998, 24.

9. "Lowell Thomas Creator of 'With Allenby in Palestine and Lawrence in Arabia' / The Modern Master of the Magic Carpet," publicity brochure, Lowell Thomas Archives, Marist College.

10. Thomas 1922a, 1.

11. See note 9.

12. Keith 1998, 31–32.

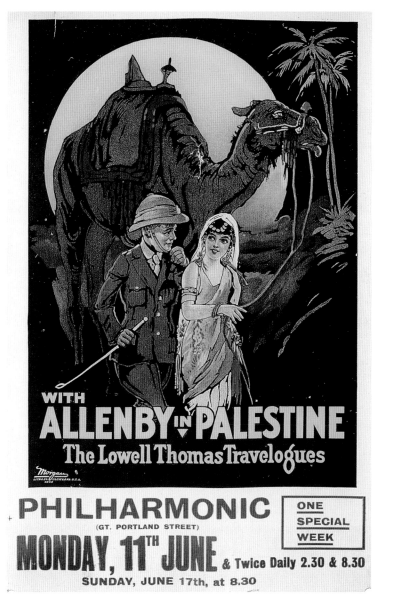

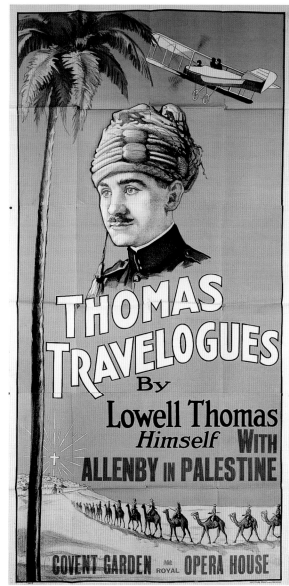

79 *Lowell Thomas Travelogues Poster*

1923
Lithograph, 22 × 14 inches (55.9 × 35.6 cm)
Lowell Thomas Archives, Marist College,
Poughkeepsie, New York

80 *Lowell Thomas Travelogues Poster*

1921
Lithograph, 84 × 42 inches (213.4 × 106.7 cm)
Lowell Thomas Archives, Marist College,
Poughkeepsie, New York

illustration was the key.[6] In one of their many exchanges, Carnegie exhorts him vigorously: "No matter how well known you are, it is absolutely essential to have lithographs to announce your arrival in town. If I had the full say so, I would hire two men who did nothing else all day long but put out billing and tack up tack cards. I would make it look like a Barnum and Bailey Circus were coming to town. . . . we ought to have billing that will catch attention. . . . The only way to do that is to use pictures."[7] Carnegie personally commissioned sketches for posters, which he sent along for approval.

The posters were bold and colorful. Thomas considered them carefully, and, in reference to one that depicts a soldier approaching a girl who leads a camel silhouetted against the moon (cat. no. 79), he corrected the initial sketches, suggesting the substitution of a British soldier for the "Kanuck," and changing the soldier's cap for a sun helmet.[8] Each of the posters strikes a different note, deploying familiar tropes of caravans and Christianity (cat. no. 80) and romance and conquest in the desert (cat. no. 81).

He extended the romanticized rhetoric in brochures accompanying his lectures, presenting himself and his collaborators in the guise of the *Arabian Nights*. He was billed as "The Modern Master of the Magic Carpet" and his slide artist as "Miss Aladdin."[9] Allenby's campaigns in Palestine were described as "the last and greatest Crusade,"[10] and Allenby himself was declared a Christian conqueror, likened to Richard the Lionhearted.

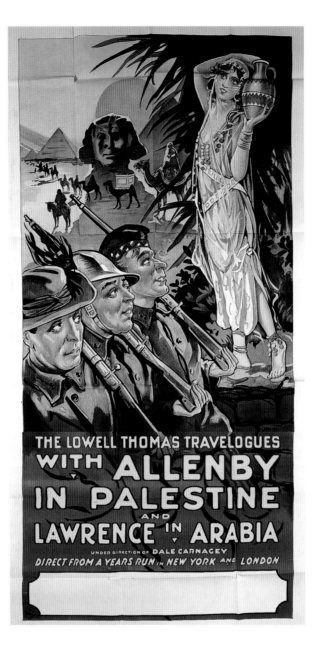

81 *Lowell Thomas Travelogues Poster*

1921

Lithograph, 84 × 42 inches (213.4 × 106.7 cm)

Lowell Thomas Archives, Marist College,

Poughkeepsie, New York

Lawrence was "the uncrowned King of Arabia," and his story was "a tale of wild adventure—colorful as the *Arabian Nights,* poetic as the *Rubáiyát.* It is not a story of war and slaughter but of a human being endowed with God-given powers."[11]

In general, Orientalism served Thomas well, and he enjoyed extraordinary popularity. His expertise went largely unquestioned, although at least one member of the audience wrote to protest the show's disgraceful treatment of Islam, and another accused Thomas of being on the payroll of brewers of alcoholic beverages.[12] All in all, however, Thomas managed to gauge his audiences perfectly, packaging the Orient in a form that was accessible, entertaining, and conformed to all the comfortable stereotypes. His lectures, in turn, perpetuated and extended those convictions with reference to current events, thereby consolidating Orientalism in popular culture.

Orientalism in Fashion

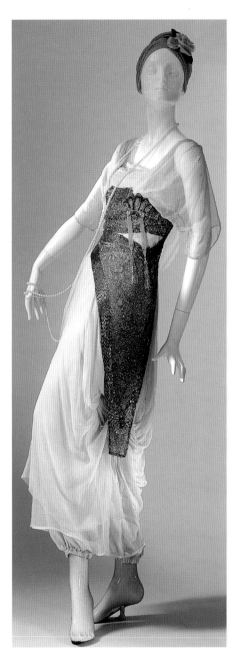

82 JEANNE HALLÉE

French, active early 20th century

Jupe-Culotte Evening Dress

C. 1911

Silk charmeuse harem trousers; silk chiffon
sleeves and overskirt; tulle scarf, cummer-
bund, and overskirt with bead embroidery
and a beaded tassel ornament

Courtesy The Costume Institute, The Metropolitan
Museum of Art. Purchase, Isabel Shults Gift, 1981

From head to toe, a woman fashionably dressed in Orientalist taste (during its
height in 1910), sported a turban, perhaps ornamented with a jeweled aigrette;
a wrap-front tunic, cut either as the bodice of a dress or as a kind of loose-fitting jacket;
flowing pants gathered in at the cuffs, a skirt fashioned similarly, or the combination
thereof called a jupe-culotte (cat. no. 82). On her feet were shoes with upturned toes
(cat. no. 86). Colors reminiscent of the most glorious plumage sparkled with metallic
thread or fabric. From her wrist hung a beaded bag ornamented with tassels (cat. no.
83), perhaps made in the design of a magic carpet; inside were such necessities as a ciga-
rette case or vanity items, crafted in precious metals, enameled, and set with stones of
clashing colors. Her earrings were long and dangling, and her preferred jewels were
pearls—ropes and ropes of them. Sautoirs of beads often reached the knees, culminat-
ing in tassels (cat. no. 84). Over her shoulders she threw a wrap, perhaps a burnous or
a caftan, falling in supple folds, its cowl weighted with yet another tassel. Dressed thus
en élégante, she went to dinner, or to dance the tango or perhaps to see the latest opera
or ballet come alive.

This was a look that perfectly suited fashion at a crossroads. The Victorian age had
left the sexes cemented in rigid roles that were easily discernible in their dress—men in
the drab yet freeing uniform of business, and women in an almost literal gilded cage of
whalebone and steel, brocade and lace. For most of the nineteenth century, Orientalism
had provided fashion with occasional decorative flourishes and a favorite form of fancy
dress. Its most far-reaching influence proved to be an "anti-fashion" look, based on a
Turkish model, that was adopted by women seeking to advance women's rights. Perhaps
the earliest example in this country is that of Frances Wright—author, abolitionist, and
utopian—who was known as early as the 1830s for wearing Turkish trousers.[1] Thus,
there was a precedent for equating such a look with reform when, in 1851, a small group
of suffragists, including Elizabeth Cady Stanton and Amelia Bloomer, adopted a uni-
form consisting of voluminous pantaloons worn under a knee-length dress with a fitted
bodice and full skirt. Bloomer's newspaper *The Lily* published illustrations of this type
of ensemble along with letters from satisfied wearers, doctors, and other interested par-
ties. "Bloomers," as the trousers came to be known, eventually became so controversial
that their original wearers began to feel that they diverted attention from the matters
that most concerned them, and so they stopped wearing them.[2] However, the practical
bloomer remained in use for physical labor, and, increasingly, for sports.

Traditionally, high fashion, as epitomized by the Paris *haute couture,* was a matter of
society's sartorial requirements realized with exquisite workmanship. In 1910, however,
many new factors came into play. In June, the Ballets Russes performed *Scheherazade* at
the Paris Opera, with sets and costumes by Léon Bakst. Its effect on the world of design
was immediate. Those who attended the production or saw Bakst's watercolor sketches
reproduced in such luxurious journals as *Art et Decoration* were dazzled by the daring

color combinations and swirling profusion of patterns. Since the Belle Epoch could be said to have been defined by delicate, subtle tints, such a use of color was seen as groundbreaking. Typically, couturier Paul Poiret gave himself credit for bringing about the change: "Nuances of nymph's thigh, lilacs, swooning mauves, tender blue hortensias, niles, maizes, straws, all that was soft, washed-out, and insipid, was held in honour. I threw into this sheepcote a few rough wolves; reds, greens, violets, royal blues, that made all the rest sing aloud."[3] Couture was not the only métier to embrace novelties in color: jewelers such as Cartier were inspired by the East as interpreted by Bakst and began combining not just sapphires and emeralds but amethysts, coral, lapis, opal, and turquoise, in addition to enamels. After the decades-long reign of diamonds set in platinum in designs as fine as lace, this was a radical departure.[4]

Although color and pattern were what people talked about, they serve to obscure the most daring aspect of Bakst's costume designs: the sheerness (not to mention scantiness) of the materials. Even in drawings published in 1911, nipples can be seen through sheer silk bodices, and thighs were visible in harem trousers. Midriffs, both male and female, were bared altogether. While some of this transparency made its way into high fashion—in particular, the sheer skirts over harem trousers in the jupe-culottes—its real influence had to do with fluidity and the adoption of a natural, as opposed to corseted, figure. During the decades leading up to 1910, the corseted upper body common during most of the nineteenth century had been supplanted by a figure confined from the neck to the knees in steel and whalebone. Ironically, Poiret, who claimed to have single-handedly banished the corset, was to reverse this configuration, freeing the bust, waist, hips, and thighs, but hobbling the ankles.

Its sensuality aside, part of the allure of Orientalized attire was its blurring of gender boundaries. Men in fancy dress draped themselves in pearl necklaces; women in harem pants revealed that they had two legs. The world couldn't help being stunned by the idea of pants on women when, six months after *Scheherazade* opened, women in trousers made the news. Coverage in the *New York Times* wavered between descriptions of aeroplane or suffragette costumes (usually featuring bloomers under princess-cut dresses) and more social reports of jupe-culotte sightings at the Plaza for tea. At the end of 1910 came the first bulletin from Paris that Poiret was about to bring out bifurcated skirts. One person interviewed, a dressmaker, said, "The idea of this new skirt is not to popularize trousers for women, but to add a little touch of Orientalism to their dress."[5]

83 *French Evening Bag in Persian Taste*

1910S
Faceted steel beads in shades of gold, metallic blue, rose, green, and black
Museum of the City of New York. Gift of Mr. and Mrs. Alexander Slater

84 *Sautoir*

1920S
Pearl, lapis, and gold
Private collection, New York

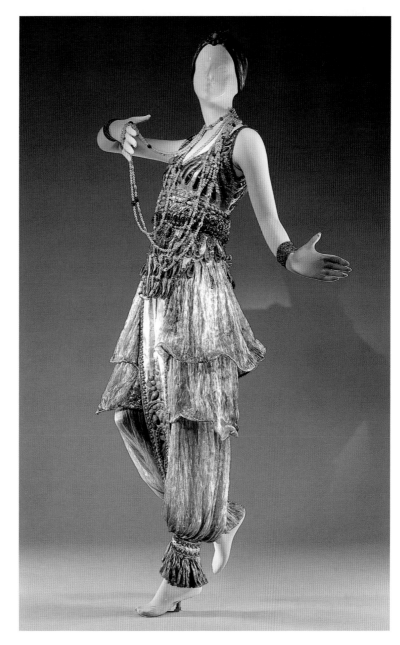

85 PAUL POIRET
French, 1879–1944

"1002nd Night" Dress Ensemble with Turban

C. 1911

Silver lamé and green gauze dress with harem pants and wired panniers; trimmed with blue and green foil, gold metal beads, and faceted celluloid beads in shades of blue, green, red, and yellow

Courtesy The Costume Institute, The Metropolitan Museum of Art, New York. Purchase, Irene Lewisohn Trust Gift, 1983

1. Neville-Sington 1998, 110.

2. Bloomer 1975, x.

3. Poiret 1931, 93.

4. Untracht 1997, 403, describes Bakst's *Scheherazade* and its effect on jewelry: "A master at creating mood through color and pattern, Bakst's work often reflected his ongoing interest in ethnic cultural models, in this case, Indian and Persian concepts. The result was a riotous fantasy of sumptuous 'orientalist' sensuality, to a large extent well researched and authentic."

5. "Pantaloon Skirt Here," *New York Times*, 26 December 1910.

6. Ibid.

7. *Vogue*, 1 April 1911, 57.

The skirt, as described in the cable dispatch, was "an exact reproduction of the dress worn by Turkish women, minus the veil."[6] By the beginning of the new year, fashion magazines were showing the look. The April issue of *Vogue* featured both photographs of the new styles (the most tailored and suffragist-suitable, curiously, was exotic Poiret's) and photographs of Persian fancy dress as worn at a costume ball in Chicago. Perhaps to deflect criticism that *Vogue* was promoting pants for women, the caption for a particular jupe-culotte read, "One could scarcely apply 'trouser' to this creation of Margaine Lacroix, [it's] really a modest bag through which the feet are thrust in the interest of locomotion."[7] Even as the controversy over the jupe-culotte waned (they were made, and worn, but in such small numbers as to make the evening dress by Jeanne Hallée particularly rare), a precedent had been set: for the next fifteen years, most of the pants ensembles shown by couturiers would have an oriental flair.

The taste for things Near Eastern continued to gain momentum. Events such as Poiret's renowned fete, the "1002 Nights," held in May 1911, fanned the flame. According to Janet Flanner, Paris correspondent for the *New Yorker*, "three hundred guests stayed to see the dawn come up in his garden in the Faubourg Saint-Honoré. Black slaves served dishes at tables seventy-five feet long. Paler female slaves lay feigning sleep on an

86 NELLE BABANI
French, active 1920s

Platform Shoes

1920s
Red suede tambour embroidered in gold and
sewn with ivory braid
Courtesy Sandy Schreier

87 *Evening Gowns Illustrated in
"La Gazette du Bon Ton"*
January 1914
Private collection, New York

immense golden staircase erected beneath the trees. In one salon lay Mme. Poiret, dressed in aigrettes. De Max, the actor, in another, recited poems, his costume shivering with the shaking of thousands of pearls. Among electric blossoms, live parrots were chained to the bushes; their companions were monkeys and cockatoos. Rug merchants, beggars, and sweetmeat sellers, hired to whine, strolled among the crowd."[8] So precise was the Arabian Nights dress code, that those arriving in mere evening dress, or even in Chinese mantles, were taken to the first floor and outfitted in more appropriate garb (cat. no. 85).[9] Poiret went on to create influential costumes for a play, *Le Minaret*, in 1913. Along with turbans and harem pants, these designs featured tunics with wired hems. Enough versions of his similarly styled dress, "Le Sorbet," exist today to indicate that even at its most exaggerated, Poiret's Orient was popular.

The early-twentieth-century women who adopted this look wore it as a definition of who they were, attempting to place themselves outside society. While the height of fashion, it was also definitely daring, and those who took it up tended to be women of unusual accomplishment. The noted art collector Peggy Guggenheim had herself photographed by Man Ray wearing a sinuous Poiret gown with a metallic gold harem hem. Rita de Acosta Lydig's appreciation of fashion was on the connoisseur level; her museum quality laces were made into tunics by the Callot Soeurs to wear with harem pants. Natasha Rambova, Hollywood costumer (and Mrs. Rudolph Valentino), briefly ran her own New York couture house specializing in exotic clothes often made from antique Persian textiles. Aline Bernstein, costume designer and muse to Thomas Wolfe, donated exotic dresses by Babani and Jessie Franklin Turner to the Costume Institute,[10] of which she was a pivotal early patron. Dancer Isadora Duncan wore Babani and Fortuny designs, even while performing. Other fans included poets, actresses, and writers.

Perhaps most devout was Gertrude Vanderbilt Whitney—heiress, wife, and mother, as well as artist, patron, and museum founder. Multiple photographs of her in varia-

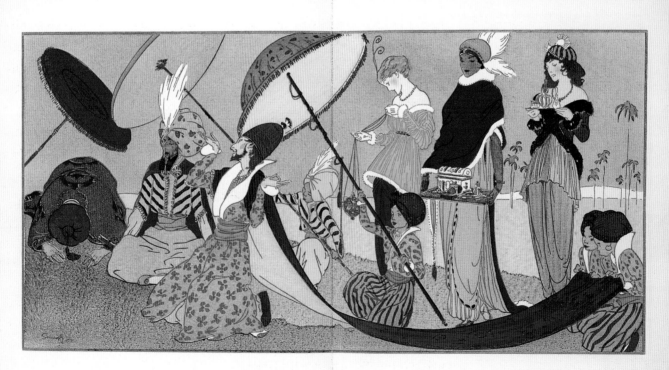

L'ENCENS, LE CINNAME ET LA MYRRHE
Robes du soir

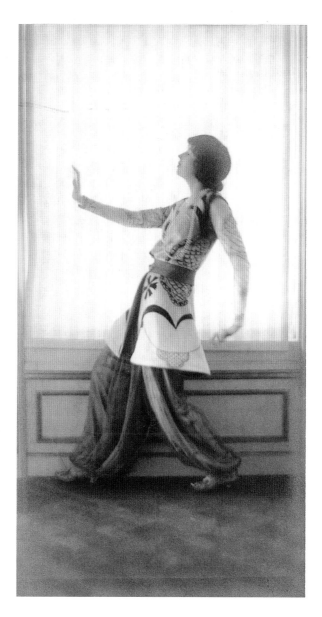

88 Baron Adolf de Meyer

Austrian, active United States,
1868–1949

*Gertrude Vanderbilt Whitney
Wearing a Bakst Tunic and
Harem Trousers*

c. 1913

Gelatin silver print, 9 × 4½ inches
(22.9 × 11.4 cm)

Courtesy Emily Irving

tions on the same theme show that Near Eastern fancy dress was a favorite of hers during the first decade of the century. In 1911, she was buying clothes from Poiret. In 1912, she was buying pantalons and blouses as separate items from Nicole Groult, Poiret's sister. In 1913, she commissioned from Bakst an ensemble consisting of a flared tunic with an oversized Persian design and harem trousers. That she saw herself, in this ensemble, as an artistic entity is supported by the number of times and media in which she was portrayed wearing it. She was photographed by Baron de Meyer (cat. no. 88), sculpted in silver by Emanuele de Rosales, painted life size by Howard Cushing in the mural he installed in her Long Island studio, and drawn, in an exuberant pose suggestive of a dancer taking a bow, by John Singer Sargent. In 1916, Robert Henri painted her, lying in an almost odalisque style on a sofa, wearing Chinese pajamas. A 1919 photograph in *Vogue* shows Whitney in an elaborate evening dress with Persian details. Just as she was maturing as an artist, showing her work to acclaim, and enjoying a real place in the artistic world, she went from wearing these clothes for fancy dress to actual dress. That she considered this way of dress part of her artistic, "downtown" self, as opposed to her wealthy, socially connected, uptown self, is revealed in her choice to keep her Henri portrait at her studio and not in her house.

After World War I, this style lingered as an exotic air of otherwise increasingly modern clothes—the little chemise dress of the 1920s serving as a blank canvas for surface

8. Flanner 1972, 151.

9. Poiret 1931, 189.

10. See Martin and Koda 1994, 62, 68.

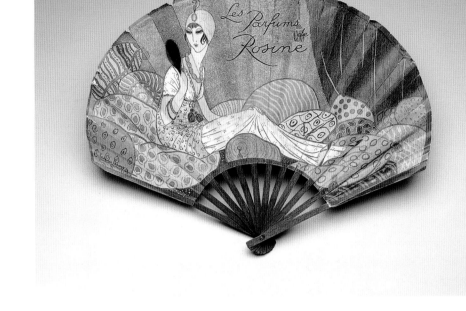

89 PAUL POIRET

Advertising Fan
C. 1911
Printed paper
Courtesy Sandy Schreier

90 BLACK, STARR & FROST

Vanity Case
C. 1925
Gold polychrome enameled with a scene
from a Persian garden
Private collection, New York

ornament, the bolder the better. Such a streamlined silhouette cried out for a greater emphasis on accessories; openly smoking and wearing cosmetics created a demand for attractive cigarette and vanity cases (one example [cat. no. 90] combines a powder compact and a lipstick in a pendant brooch). A hint of the East became a marketing asset as, throughout the 1920s, the fashion magazines ran advertisements for scents, evening bags in small Persian brocades, jewels, and *objets vertu*. To promote his perfumes in the 1920s Poiret relied on the imagery that had created his reputation; his advertising fan (cat. no. 89) features a Georges Lepage odalisque, dressed by Poiret, circa 1911.

Ultimately, the biggest difference between clothing of the East and West has to do with the cut. The burnous, to use one example, is rectangular, and can be laid flat. When a flat garment is put on a rounded figure, the result is that the fabric hangs in soft folds. Most western clothes had been cut in shaped pieces to fit the (corset-molded) form. During the teens, Orientalizing garments let loose onto fashion not just an acceptable (i.e., feminine-seeming) way for women to wear pants but a new, more supple, silhouette, which evolved into the nearly flat, almost rectangular chemise of the roaring twenties. Thus it followed that ancient, basic forms of dress gave western fashion its first real modernity.

"Academy of Design" 1874
"The Academy of Design, Some of the Gems of the Present Exhibition, The Hanging Committee's Work." *New York Herald Tribune*, 20 April 1874.

Ackerman 1986a
Ackerman, Gerald. "Gérôme's Oriental Paintings and the Western Genre Tradition." *Arts Magazine* 60, no. 7 (March 1986): 75–80.

Ackerman 1986b
Ackerman, Gerald. *The Life and Work of Jean-Léon Gérôme, with a Catalogue Raisonné.* London: P. Wilson Publishers; New York: Sotheby's Publications, Harper & Row, 1986.

Ackerman 1994a
Ackerman, Gerald. *American Orientalists.* Paris: ACR Edition, 1994.

Ackerman 1994b
Ackerman, Gerald. *British Orientalists.* Paris: ACR Edition, 1994.

Ackerman and Ettinghausen 1972
Ackerman, Gerald, and Richard Ettinghausen. *Jean-Léon Gérôme (1824–1904).* Exh. cat. Dayton: Dayton Art Institute, 1972.

Adams 1997
Adams, Bluford. *E Pluribus Barnum: The Great Showman and the Making of American Culture,* Minneapolis: University of Minnesota Press, 1997.

Ahmet Mithat 1890
Ahmet Mithat [Ahmed Mithad Efendi]. *Avrupa'da Bir Cevelan.* Istanbul: Tercüman-ı Hakikat, 1890.

Ahmet Mithat 1994
Ahmet Mithat [Ahmed Mithad Efendi]. *Fatma Aliye: Biyografi.* 1911. Reprint, Istanbul: Sel Yayıncılık, 1994.

al-Faruqi 1985
al-Faruqi, Lois Lamya'. *Islam and Art.* Islamabad: National Hijra Council, 1985.

Allen 1984
Allen, William. "The Abdul Hamid II Collection." *History of Photography* 8, no. 2 (April–June 1984): 119–45.

Allen 1991
Allen, Robert C. *Horrible Prettiness: Burlesque and American Culture.* Chapel Hill: University of North Carolina Press, 1991.

American Art Association 1905
[Edwin Lord Weeks]: Catalogue of Very Important Finished Pictures, Studies, Sketches and Original Drawings. To Be Sold at Unrestricted Public Sale by Order of His Widow at the American Art Galleries, Mar. 15–16, and at Mendelssohn Hall, Mar. 17. New York: American Art Association, 1905.

"American Painters" 1877
"American Painters—Robert Swain Gifford." *Art Journal,* n.s., no. 34 (October 1877): 310–12.

Ames 1988
Ames, Kenneth. "The Decorative Arts of the Gilded Age." In *1888: Frederick Layton and His World.* Exh. cat. Milwaukee: Milwaukee Art Museum, 1988.

Arberry 1952
Arberry, Arthur John, ed. and trans. *Omar Khayyám: A New Version Based upon Recent Discoveries.* New Haven: Yale University Press, 1952.

Atkinson 1974
Atkinson, Brooks. *Broadway.* Rev. ed. New York: Macmillan, 1974.

Avery 1993
Avery, Kevin J. *Church's Great Picture "The Heart of the Andes."* Exh. cat. New York: Metropolitan Museum of Art, 1993.

Baedeker 1878
Baedeker, Karl. *Handbook for Travellers.* Leipzig: K. Baedeker; London: Dulau, 1878.

Bancroft 1893
Bancroft, Hubert Howe. *The Book of the Fair.* Chicago: Bancroft, 1893.

Barber 1893
Barber, E. A. *The Pottery and Porcelain of the United States.* New York: G. P. Putnam's Sons, 1893.

Barnby 1979
Barnby, H. G. *The Prisoners of Algiers: An Account of the Forgotten American-Algerian War, 1785–1797.* 1966. Reprint, London: Oxford University Press, 1979.

Bederman 1995
Bederman, Gail. *Manliness and Civilization: A Cultural History of Gender and Race in the United States, 1880–1917.* Chicago: University of Chicago Press, 1995.

Benjamin et al. 1997
Benjamin, Roger, et al. *Orientalism: Delacroix to Klee.* Exh. cat. Sydney: Art Gallery of New South Wales, 1997.

Bernstein and Studlar 1997
Bernstein, Matthew, and Gaylyn Studlar, eds. *Visions of the East: Orientalism in Film.* New Brunswick: Rutgers University Press, 1997.

Blaugrund 1997
Blaugrund, Annette. *The Tenth Street Studio Building: Artist-Entrepreneurs from the Hudson River School to the American Impressionists.* Southampton: Parrish Art Museum; Seattle: University of Washington Press, 1997.

Bloom 1948
Bloom, Sol. *The Autobiography of Sol Bloom.* New York: G. P. Putnam's Sons, 1948.

Bloomer 1975
Bloomer, Dexter C. *Life and Writings of Amelia Bloomer.* 1895. New York: Schocken Books, 1975.

Board of Managers 1894
Board of Managers. *Lists of Books Sent by Home and Foreign Committees to the Library of the Woman's Building.* Chicago: World's Columbian Exposition, 1894.

Boime 1983
Boime, Albert. "Gérôme and the Bourgeois Artist's Burden." *Arts Magazine* 57, no. 5 (January 1983): 67–68, 72.

Boime 1990
Boime, Albert. *The Art of Exclusion: Representing Blacks in the Nineteenth Century.* Washington, D.C.: Smithsonian Institution Press, 1990.

Boime 1991
Boime, Albert. *The Magisterial Gaze: Manifest Destiny and American Landscape Painting, c. 1830–1865.* Washington, D.C.: Smithsonian Institution Press, 1991.

Bolger 1980
Bolger, Doreen, ed. *American Paintings in the Metropolitan Museum of Art.* Vol. 3, *A Catalogue of Works by Artists Born between 1846 and 1864.* Princeton: Princeton University Press, 1980.

Bridgman 1890
Bridgman, Frederick Arthur. *Winters in Algeria.* New York: Harper and Brothers, 1890.

Bridgman 1898
Bridgman, Frederick Arthur. *L'Amarchie dans l'art.* Paris: Société Français d'Éditions d'Art, 1898.

Broadley 1981
Broadley, Hugh. "Voyage of the *Sesostris*: Elihu Vedder in Egypt." *Phoebus* 3 (1981): 39–51.

Brockman et al. 1987
Brockman, C. Lance, et al. *The Twin City Scenic Collection: Popular Entertainment, 1895–1929.* Exh. cat. Minneapolis: University Art Museum, University of Minnesota, 1987.

Brockman 1996
Brockman, C. Lance. *Theatre of the Fraternity: Staging the Ritual Space of the Scottish Rite of Freemasonry, 1896–1929.* Minneapolis: Frederick R. Weisman Art Museum, University of Minnesota, 1996.

Broun 1989
Broun, Elizabeth. *Albert Pinkham Ryder.* Exh. cat. Washington, D.C.: Published for the National Museum of American Art by the Smithsonian Institution Press, 1989.

Brown 1987
Brown, Dorothy M. *Setting a Course: American Women in the 1920s.* Boston: Twayne, 1987.

Brown 1994
Brown, Julie K. *Contesting Images: Photography and the World's Columbian Exposition.* Tucson: University of Arizona Press, 1994.

Browne 1989
Browne, Nick. "Orientalism as an Ideological Form: American Film Theory in the Silent Period." *Wide Angle* 11, no. 4 (1989): 22–31.

Brownlow 1990
Brownlow, Kevin. *Behind the Mask of Innocence.* New York: Knopf, 1990.

Bryant 1991
Bryant, Keith L. *William Merritt Chase, a Genteel Bohemian.* Columbia: University of Missouri Press, 1991.

Buel 1894
Buel, James W. *The Magic City.* St. Louis: Historical Publishing Co., 1894.

Burke et al. 1986
Burke, Doreen Bolger, et al. *In Pursuit of Beauty: Americans and the Aesthetic Movement*. New York: Metropolitan Museum of Art and Rizzoli, 1986.

Burns 1993
Burns, Sarah. "The Price of Beauty: Art, Commerce, and the Late Nineteenth-Century American Studio Interior." In *American Iconology: New Approaches to Nineteenth-Century Art and Literature*, ed. David C. Miller. New Haven: Yale University Press, 1993.

Burns 1996
Burns, Sarah. *Inventing the Modern Artist: Art and Culture in Gilded Age America*. New Haven: Yale University Press, 1996.

Burnside n.d.
Burnside, Helen Marion, comp. *The Arabian Nights*. London, Paris, and New York: Raphael Tuck and Sons, n.d.

Çaha 1996
Çaha, Ömer. *Sivil Kadın: Türkiye'de Sivil Toplum ve Kadın*. Ankara: Vadi Yayınları, 1996.

Callow 1967
Callow, James T. *Kindred Spirits: Knickerbocker Writers and American Artists, 1807–1855*. Chapel Hill: University of North Carolina Press, 1967.

Calo 1998
Calo, Mary Ann, ed. *Critical Issues in American Art: A Book of Readings*. Boulder, Colo.: Westview Press, 1998.

Card 1994
Card, James. *Seductive Cinema: The Art of Silent Film*. New York: Knopf, 1994.

Carnes 1990
Carnes, Mark C. "Middle Class Men and the Solace of Fraternal Ritual." In *Meanings for Manhood: Constructions of Masculinity in Victorian America*, ed. Mark C. Carnes and Clyde Griffen. Chicago: University of Chicago Press, 1990.

Carr et al. 1993
Carr, Carolyn Kinder, et al. *Revisiting the White City: American Art at the 1893 World's Fair*. Washington, D.C.: National Museum of American Art and National Portrait Gallery, Smithsonian Institution, 1993.

Carrithers 1982
Carrithers, David. "Montesquieu, Jefferson, and the Fundamentals of Eighteenth-Century Republican Theory." *The French American Review* 6 (Fall 1982): 160–88.

Çelik 1992
Çelik, Zeynep. *Displaying the Orient: Architecture of Islam at Nineteenth-Century World's Fairs*. Berkeley: University of California Press, 1992.

Çelik 1996
Çelik, Zeynep. "Colonialism, Orientalism, and the Canon." *Art Bulletin* 78, no. 2 (June 1996): 202–5.

Çelik 1997
Çelik, Zeynep. *Urban Forms and Colonial Confrontations: Algiers under French Rule*. Berkeley: University of California Press, 1997.

Çelik forthcoming
Çelik, Zeynep. "Speaking Back to Orientalist Discourse." In *Orientalism's Interloculors: Rewriting the Colonial Discourse*, ed. Jill Beaulieu and Mary Roberts. Durham: Duke University Press, forthcoming.

Çelik and Kinney 1990
Çelik, Zeynep, and Kinney, Leila. "Ethnography and Exhibitionism at the Expositions Universelles." *Assemblage* 13 (December 1990): 35–60.

Chadwick 1990
Chadwick, Whitney. *Women, Art, and Society*. London: Thames and Hudson, 1990.

Chen 1996
Chen, Constance M. *"The Sex Side of Life": Mary Ware Dennett's Pioneering Battle for Birth Control and Sex Education*. New York: New Press, 1996.

Chesler 1992
Chesler, Ellen. *Woman of Valor: Margaret Sanger and the Birth Control Movement in America*. New York: Simon and Schuster, 1992.

"Church's Pictures" 1869
"Church's Pictures of the Orient." *Chicago Tribune*, 12 December 1869.

Cikovsky 1970
Cikovsky, Nicolai Jr. *Sanford Robinson Gifford, 1823–1880*. Exh. cat. Austin: University of Texas Art Museum, 1970.

Codell and Macleod 1998
Codell, Julie F., and Dianne Sachko Macleod, eds. *Orientalism Transposed: The Impact of the Colonies on British Culture*. Aldershot, England, and Brookfield, Vt.: Ashgate, 1998.

Cohan and Hark 1993
Cohan, Steven and Ina Rae Hark, eds. *Screening the Male: Exploring Masculinities in Hollywood Cinema*. London and New York: Routledge, 1993.

Conforti 1981–82
Conforti, Michael P. "Orientalism on the Upper Mississippi: The Work of John S. Bradstreet." *Minneapolis Institute of Arts Bulletin* 65 (1981–82): 2–35.

Congdon-Martin 1992
Congdon-Martin, Douglas. *Tobacco Tins: A Collector's Guide*. Atglen, Pa.: Schiffer Publishing, 1992.

Congdon-Martin 1996
Congdon-Martin, Douglas. *Camel Cigarette Collectibles: The Early Years, 1913–1963*. Atglen, Pa.: Schiffer Publishing, 1996.

Conrads 1990
Conrads, Margaret. *American Paintings and Sculpture at the Sterling and Francine Clark Art Institute*. New York: Hudson Hills Press, 1990.

Cowling 1989
Cowling, Mary. *The Artist as Anthropologist: The Representation of Type and Character in Victorian Art*. Cambridge and New York: Cambridge University Press, 1989.

Crabitès 1938
Crabitès, Pierre. *Americans in the Egyptian Army*. London: G. Routledge & Sons, 1938.

Craven 1976
Craven, Wayne. "Samuel Colman (1832–1920): Rediscovered Painter of Far-away Places." *American Art Journal* 8, no. 1 (May 1976): 16–37.

Croutier 1989
Croutier, Alev Lytle. *Harem: The World behind the Veil*. New York: Abbeville Press, 1989.

Crunden 1993
Crunden, Robert M. *American Salons: Encounters with European Modernism, 1885–1917*. New York: Oxford University Press, 1993.

Curl 1994
Curl, James Stevens. *Egyptomania: The Egyptian Revival, a Recurring Theme in the History of Taste*. Manchester, England: Manchester University Press, 1994.

Cutler 1995
Cutler, Laurence S., and Judy Goffman Cutler. *Maxfield Parrish: A Retrospective*. San Francisco: Pomegranate Artbooks, 1995.

Daniels 1990
Daniels, Roger. *Coming to America: A History of Immigration and Ethnicity in American Life*. New York: Harper Collins, 1990.

Davis 1996
Davis, John. *The Landscape of Belief: Encountering the Holy Land in Nineteenth-Century American Art and Culture*. Princeton: Princeton University Press, 1996.

Dawson 1991
Dawson, Graham. "The Blond Bedouin." In *Manful Assertions: Masculinities in Britain since 1800*, ed. Michael Roper and John Tosh. London and New York: Routledge, 1991.

De Groot 1989
De Groot, Joanna. "'Sex' and 'Race': The Construction of Language and Image in the Nineteenth Century." In *Sexuality and Subordination: Interdisciplinary Studies of Gender in the Nineteenth Century*, ed. Susan Mendus and Jane Rendall. London and New York: Routledge, 1989.

De Kay 1987
De Kay, Charles. *The Art Work of Louis C. Tiffany*. 1914. Reprint, with a new foreword by J. Alastair Duncan. Poughkeepsie, N.Y.: Apollo, 1987.

Dijkstra 1986
Dijkstra, Bram. *Idols of Perversity: Fantasies of Feminine Evil in Fin-de-Siècle Culture*. New York: Oxford University Press, 1986.

Dippie 1987
Dippie, Brian W. *Looking at Russell*. Fort Worth: Amon Carter Museum, 1987.

Dodds 1992
Dodds, Jerrilynn D., ed. *al-Andalus: The Art of Islamic Spain*. Exh. cat. New York: Metropolitan Museum of Art, 1992.

Dream City 1893
The Dream City. St. Louis: N. D. Thompson Publishing Co., 1893.

Dubbert 1980
Dubbert, Joe. "Progressivism and the Masculinity Crisis." In *The American Man*, ed. Elizabeth H. Pleck and Joseph H. Pleck. Englewood Cliffs: Prentice-Hall, 1980.

Duncan 1989
Duncan, Alastair, et al. *Masterworks of Louis Comfort Tiffany*. Exh. cat. New York: Harry N. Abrams, 1989.

Duncan 1992
Duncan, Alastair. *Louis Comfort Tiffany*. New York: Harry N. Abrams in association with the National Museum of American Art, Smithsonian Institution, 1992.

Eagle 1894
Eagle, Mary Kavanaugh Oldham, ed. *The Congress of Women Held in the Woman's Building, World's Columbian Exposition*. 2 vols. Chicago: W. B. Conkey, Philadelphia, 1894.

Edgerton 1923
Edgerton, Joseph. *Across the Burning Sands to the National Homecoming: The Pilgrimage 1923. The Official Story by Word and Picture of the Imperial Council Session of the AAONMS at Washington, D.C.* Washington, D.C., 1923.

Erenberg 1981
Erenberg, Lewis A. *Steppin' Out: New York Nightlife and the Transformation of American Culture, 1890–1930*. Westport: Greenwood Press, 1981.

Everson 1978
Everson, William K. *American Silent Film*. New York: Oxford University Press, 1978.

Farnsworth 1956
Farnsworth, Marjorie. *The Ziegfeld Follies*. New York: Putnam, 1956.

Fatma Aliye Hanım 1993
Fatma Aliye Hanım. *Nisvan-ı Islam*. Ed. Mübeccel Kızıltan. Istanbul: Mutlu Yayıncılık, 1993.

Ferber and Gallati 1998
Ferber, Linda S., and Barbara Dayer Gallati. *Masters of Color and Light: Homer, Sargent, and the American Watercolor Movement.* Exh. cat. Washington, D.C.: Brooklyn Museum of Art in association with Smithsonian Institution Press, 1998.

Fetvaci 1996
Fetvaci, Emine. "An Orientalist Reconsidered: Osman Hamdi." Senior thesis, Williams College, 1996.

Fink 1990
Fink, Lois Marie. *American Art at the Nineteenth-Century Paris Salons.* Washington, D.C.: National Museum of American Art, Smithsonian Institution; Cambridge: Cambridge University Press, 1990.

Fink and Taylor 1978
Fink, Lois Marie, and Joshua C. Taylor. *Academy: The Academic Tradition in American Art.* Chicago: University of Chicago Press, 1978.

Finnie 1967
Finnie, David H. *Pioneers East: The Early American Experience in the Middle East.* Cambridge: Harvard University Press, 1967.

Flanner 1975
Flanner, Janet. *Paris Was Yesterday, 1925–1939.* Ed. Irving Drutman. New York: Viking, 1975.

Fort 1983
Fort, Ilene Susan. *Picturing the Middle East: A Hundred Years of European Orientalism.* Exh. cat. New York: Dahesh Museum, 1983.

Fort 1990
Fort, Ilene Susan. *Frederick A. Bridgman and the American Fascination with the Near East.* Ann Arbor: UMI, 1990.

Fox and Lears 1983
Fox, Richard Wightman, and T. J. Jackson Lears, eds. *The Culture of Consumption: Critical Essays in American History, 1880–1980.* New York: Pantheon Books, 1983.

Frelinghuysen 1998
Frelinghuysen, Alice Cooney. *Louis Comfort Tiffany at the Metropolitan Museum of Art.* New York: Metropolitan Museum of Art, 1998.

Fried 1970
Fried, Frederick. *Artists in Wood: American Carvers of Cigar-Store Indians, Show Figures, and Circus Wagons.* New York: C. N. Potter, 1970.

Friedman 1981
Friedman, John Block, *The Monstrous Races in Medieval Art and Thought.* Cambridge: Harvard University Press, 1981.

Friedman 1991
Friedman, Lester D., ed. *Unspeakable Images: Ethnicity and the American Cinema.* Urbana: University of Illinois Press, 1991.

Friedman 1995
Friedman, Thomas L. *From Beirut to Jerusalem.* Updated with a new chapter. New York: Anchor Books, Doubleday, 1995.

Fussell 1975
Fussell, Paul. *The Great War and Modern Memory.* Oxford: Oxford University Press, 1975.

Gallati 1995
Gallati, Barbara Dayer. *William Merritt Chase.* New York: Harry N. Abrams in association with the National Museum of American Art, Smithsonian Institution, 1995.

Ganely and Paddock 1976
Ganely, Kathleen Duff, and Leslie Paddock. *The Art of Edwin Lord Weeks (1849–1903).* Exh. cat. Durham, N.H.: University Art Galleries, University of New Hampshire, 1976.

Germaner and Inankur 1989
Germaner, Semra, and Zeynep Inankur. *Orientalism and Turkey.* Istanbul: Turkey Cultural Service Foundation, 1989.

Gifford Papers
Robert Swain Gifford Papers, 1722–1968. Old Dartmouth Historical Society, New Bedford Whaling Museum Library, New Bedford, Mass.

Gifford 1869
Letters-Journal of Sanford Robinson Gifford. Archives of American Art, Washington, D.C.

Green 1982
Green, Vivien M. "Hiram Powers' Greek Slave: Emblem of Freedom." *American Art Journal* 14 (Autumn 1982): 31–39.

Grossman 1994
Grossman, James R., ed. *The Frontier in American Culture.* Exh. cat. Chicago: Newberry Library; Berkeley: University of California Press, 1994.

Gunning 1991
Gunning, Tom. *D. W. Griffith and the Origins of American Narrative Film: The Early Years at Biograph.* Urbana: University of Illinois Press, 1991.

Hall 1974
Hall, Elton W. *R. Swain Gifford, 1840–1905.* Exh. cat. New Bedford: Old Dartmouth Historical Society, 1974.

Hambidge 1928
Hambidge, Gove. "He Was with Lawrence of Arabia." *New York Herald Tribune,* 25 November 1928.

Hamilton 1994
Hamilton, John. *Material Culture of the American Freemasons.* Lexington: Museum of Our National Heritage, 1994.

Hansen 1986
Hansen, Miriam. "Pleasure, Ambivalence, Identification: Valentino and Female Spectatorship." *Cinema Journal* 25, no. 4 (Summer 1986): 6–32.

Hansen 1991
Hansen, Miriam. *Babel and Babylon: Spectatorship in American Silent Film.* Cambridge: Harvard University Press, 1991.

Hardin 1996
Hardin, Jennifer. *The Lure of Egypt: Land of the Pharaohs Revisited.* St. Petersburg, Fla.: Museum of Fine Arts, 1996.

Hartigan 1990
Hartigan, Lynda Roscoe, et al. *Made with Passion: The Hemphill Folk Art Collection in the National Museum of American Art.* Exh. cat. Washington, D.C.: Published for the National Museum of American Art by the Smithsonian Institution Press, 1990.

Heimann 1960
Heimann, Robert. *Tobacco and Americans.* New York: McGraw-Hill, 1960.

Hesseltine and Wolf 1961
Hesseltine, William B., and Hazel C. Wolf. *The Blue and the Gray on the Nile.* Chicago: University of Chicago Press, 1961.

Hichens 1907
Hichens, Robert Smythe. *The Garden of Allah.* New York: F. A. Stokes, 1907.

Higham 1955
Higham, John. *Strangers in the Land: Patterns of American Nativism, 1860–1925.* New Brunswick: Rutgers University Press, 1955.

Hobsbawm 1989
Hobsbawm, Eric. *The Age of Empire: 1875–1914.* New York: Vintage, 1989.

Hodson 1995
Hodson, Joel C. *Lawrence of Arabia and American Culture: The Making of a Transatlantic Legend.* Westport: Greenwood Press, 1995.

Homer and Goodrich 1989
Homer, William Innes, and Lloyd Goodrich. *Albert Pinkham Ryder, Painter of Dreams.* New York: Harry N. Abrams, 1989.

Honour 1989
Honour, Hugh. *Slaves and Liberators.* Vol. 4, part 1 of *The Image of the Black in Western Art.* Houston: Menil Foundation; Cambridge: Harvard University Press, 1989.

Hopper 1877
Hopper, Lucy. "The Paris Salon of 1877, III." *Art Journal* 3 (September 1877): 283.

Hull 1921
Hull, E. M. *The Sheik.* 1919. New York: Small, A. L. Burt, 1921.

Hull 1925
Hull, E. M. *The Sons of the Sheik.* Boston: Small, Maynard, 1925.

Hussain, Olson, and Qureshi 1984
Hussain, Asaf, Robert Olson, and Jamil Qureshi, eds. *Orientalism, Islam and Islamists.* Brattleboro: Amana Books, 1984.

Hyman 1976
Hyman, Linda. "*The Greek Slave* by Hiram Powers: High Art as Popular Culture." *Art Journal* 35, no. 3 (Spring 1976): 216–23.

Irving 1829
"Memorandum of Washington Irving of Sunnyside, Alhambra, Spain, 1829." Unpublished manuscript. Beinecke Rare Book and Manuscript Library, Yale University, New Haven, Conn.

Irving 1832
Irving, Washington. *The Alhambra.* Philadelphia: Carey and Lea, 1832.

Irwin 1994
Irwin, Robert. *The Arabian Nights: A Companion.* London: Allen Lane, 1994.

Jacobson 1998
Jacobson, Matthew Frye. *Whiteness of a Different Color: European Immigrants and the Alchemy of Race.* Cambridge: Harvard University Press, 1998.

Johnson 1996
Johnson, Kyle. "Frederic Church's Near Eastern Paintings and American Imperialism: The Restless, Unsatisfied Genius of Our People." Unpublished manuscript, 1996.

Jones 1955
Jones, Ernest. *The Life and Work of Sigmund Freud.* New York: Basic Books, 1955.

Jowett 1982
Jowett, Garth S. "The Emergence of Mass Society: The Standardization of American Culture, 1830–1920." *Prospects* 7 (1982): 207–28.

Kabbani 1986
Kabbani, Rana. *Europe's Myths of the Orient.* Bloomington: Indiana University Press, 1986.

Karp and Lavine 1991
Karp, Ivan, and Steven D. Lavine, eds. *Exhibiting Cultures: The Poetics and Politics of Museum Display.* Washington, D.C.: Smithsonian Institution Press, 1991.

Kearney 1975
Kearney, Helen McCready. "American Images of the Middle East, 1824–1924: A Century of Antipathy." Ph.D. diss., University of Rochester, 1975.

Kelly 1989
Kelly, Franklin, et al. *Frederic Edwin Church.* Exh. cat. Washington: National Gallery of Art, 1989.

Kendall 1979
Kendall, Elizabeth. *Where She Danced.* New York: Knopf, 1979.

Kimmel 1987
Kimmel, Michael S. "Men's Responses to Feminism at the Turn of the Century." *Gender and Society* 1 (September 1987): 261–83.

King 1983
King, Philip J. *American Archaeology in the Mideast: A History of the American Schools of Oriental Research*. Philadelphia: American Schools of Oriental Research, 1983.

Kinzer 1984
Kinzer, Suzanne. "Prostitutes in the Art of John Sloan." *Prospects* 9 (1984): 231–54.

Kisluk-Grosheide 1994
Kisluk-Grosheide, Danielle O. "The Marquand Mansion." *Metropolitan Museum Journal* 29 (1994): 151–81.

Kızıltan 1990
Kızıltan, Mübeccel. "Öncü Bir Kadın Yazar: Fatma Aliye Hanım." *Journal of Turkish Studies* 114 (1990): 283–323.

Kızıltan and Gençtürk 1993
Kızıltan, Mübeccel, and Tülay Gençtürk. *Atatürk Kitaplığı, Fatma Aliye Hanım Evrakı Katalogu-I*. Istanbul: Büyük Sehir Belediyesi Kültür Işleri, 1993.

Knickerbocker 1853
"Orientalism." *The Knickerbocker* 41, no. 6 (June 1853): 479–96.

Kuklick 1996
Kuklick, Bruce. *Puritans in Babylon: The Ancient Near East and American Intellectual Life, 1880–1930*. Princeton: Princeton University Press, 1996.

Lange 1990
Lange, Amanda. "The Islamic Taste in American Domestic Interiors, 1860–1910." M.A. thesis, University of Delaware, 1990.

Leach 1993
Leach, William. *Land of Desire: Merchants, Power and the Rise of a New American Culture*. New York: Pantheon Books, 1993.

Lears 1981
Lears, T. J. Jackson. *No Place of Grace: Antimodernism and the Transformation of American Culture, 1880–1920*. New York: Pantheon Books, 1981.

Lears 1984
Lears, T. J. Jackson. "Some Versions of Fantasy: Toward a Cultural History of American Advertising, 1880–1930." *Prospects* 9 (1984): 349–406.

Lears 1994
Lears, T. J. Jackson. *Fables of Abundance: A Cultural History of Advertising in America*. New York: Basic Books, 1994.

Lee 1911
Lee, Joseph E. "Play as an Antidote to Civilization." *Playground*, July 1911.

Lewis 1996
Lewis, Reina. *Gendering Orientalism: Race, Femininity, and Representation*. London and New York: Routledge, 1996.

Little 1947
Little, K. L. *Negroes in Britain: A Study of Racial Relations in English Society*. London: Keagan, Paul, Trench, Trubner and Co., 1947.

Little 1997
Little, Carl. *Winslow Homer: His Art, His Light, His Landscapes*. Cobb: First Glance Books, 1997.

Lubin 1994
Lubin, David M. *Picturing a Nation: Art and Social Change in Nineteenth-Century America*. New Haven: Yale University Press, 1994.

Ludwig 1973
Ludwig, Coy L. *Maxfield Parrish*. New York: Watson-Guptill, 1973.

Mackenzie 1995
Mackenzie, John M. *Orientalism: History, Theory, and the Arts*. Manchester: Manchester University Press, 1995.

Maddox and Baz 1983
Maddox, Kenneth W., and Douglas Baz. *In Search of the Picturesque: Nineteenth-Century Images of Industry Along the Hudson River Valley*. Exh. cat. Annandale-on-Hudson: Bard College, 1983.

Marr 1998
Marr, Timothy. *Imagining Ishmael: Studies of Islamic Orientalism in America from the Puritans to Melville*. Ann Arbor: UMI, 1998.

Martin and Koda 1994
Martin, Richard, and Harold Koda. *Orientalism: Visions of the East in Western Dress*. Exh. cat. New York: Metropolitan Museum of Art, 1994.

Maxwell 1907
Maxwell, Perriton. "Frederic Remington—Most Typical of American Artists." *Pearson's Magazine* 18 (October 1907): 395–96.

May 1983
May, Lary. *Screening Out the Past: The Birth of Mass Culture and the Motion Picture Industry*. Oxford: Oxford University Press, 1980. Reprint, Chicago: University of Chicago Press, 1983.

Mazo 1977
Mazo, Joseph H. *Prime Movers: The Makers of Modern Dance in America*. New York: Morrow, 1977.

McArthur 1984
McArthur, Benjamin. *Actors and American Culture, 1880–1920*. Philadelphia: Temple University Press, 1984.

McCoy 1966
McCoy, Garnet. "Visits, Parties, and Cats in the Hall: The Tenth Street Studio Building and Its Inmates in the Nineteenth Century." *Archives of American Art* 6, no. 1 (January 1966): 8.

McEvilley 1992
McEvilley, Thomas. *Art and Otherness: Crisis in Cultural Identity*. Kingston: Documentext/McPherson, 1992.

McKennon 1972
McKennon, Joe. *A Pictorial History of the American Carnival*. Sarasota: Carnival Publishers of Sarasota, 1972.

Melish et al. 1921
Melish, William B., et al. *The History of the Imperial Council, Ancient Arabic Order Nobles of the Mystic Shrine for North America, 1872–1921*. Cincinnati: Imperial Council, Nobles of the Mystic Shrine, 1921.

Melman 1988
Melman, Billie. *Women and the Popular Imagination in the Twenties: Flappers and Nymphs*. London: Macmillan, 1988.

Mendus and Rendall 1989
Mendus, Susan, and Jane Rendall, eds. *Sexuality and Subordination: Interdisciplinary Studies of Gender in the Nineteenth Century*. London: Routledge, 1989.

Meyers 1997
Meyers, Eric M., ed. *The Oxford Encyclopedia of Archaeology in the Near East*. 5 vols. New York: Oxford University Press, 1997.

Michalek 1989
Michalek, Laurence. "The Arab in American Cinema: A Century of Otherness." *Cineaste* 17, no. 1 (1989): 3–10.

Miller 1993
Miller, Angela L. *The Empire of the Eye: Landscape Representation and American Cultural Politics, 1825–1875*. Ithaca: Cornell University Press, 1993.

Mitchell 1988
Mitchell, Timothy. *Colonising Egypt*. Cambridge: Cambridge University Press, 1988.

Mitnick 1985
Mitnick, Barbara J. *Jean Leon Gerome Ferris, 1863–1930: American Painter Historian*. Exh. cat. Laurel, Miss.: Lauren Rogers Museum of Art, 1985.

Moran 1880
Moran, J. "New York Art Studios, III." *Art Journal*, n.s., no. 61 (January 1880): 1–4.

Mosby 1991
Mosby, Dewey F., et al. *Henry Ossawa Tanner*. Exh. cat. Philadelphia: Philadelphia Museum of Art; New York: Rizzoli, 1991.

Moure 1973
Moure, Nancy Dustin Wall. "Five Eastern Artists Out West." *American Art Journal* 5, no. 2 (November 1973): 15–31.

Mulvey 1975
Mulvey, Laura. "Visual and Narrative Cinema." *Screen* 16, no. 3 (Spring 1975): 6–18.

Munsterberg 1988
Munsterberg, Marjorie. "Naked or Nude? A Battle among French Critics of the Mid-Nineteenth Century." *Arts Magazine* 62, no. 8 (April 1988): 40–47.

Musser and Nelson 1991
Musser, Charles, and Carol Nelson. *High Class Moving Pictures: Lyman H. Howe and the Forgotten Era of Traveling Exhibition, 1880–1920*. Princeton: Princeton University Press, 1991.

Naff 1985
Naff, Alixa. *Becoming American: The Early Arab Immigrant Experience*. Carbondale: Southern Illinois University Press, 1985.

Naylor 1981
Naylor, David. *American Picture Palaces: The Architecture of Fantasy*. New York: Van Nostrand Reinhold, 1981.

Naylor 1987
Naylor, David. *Great American Movie Theaters*. Washington, D.C.: Preservation Press, 1987.

Necipo0lu 1995
Necipoglu, Gülru. *The Topkapı Scroll: Geometry and Ornament in Islamic Architecture*. Santa Monica: Getty Center for the History of Art and the Humanities, 1995.

Neville-Sington 1998
Neville-Sington, Pamela. *Fanny Trollope: The Life and Adventure of a Clever Woman*. New York: Viking, 1998.

Newport 1989
John La Farge, an American Master (1835–1910). Exh. cat. Newport, R.I.: Newport Gallery of American Art, 1989.

New York 1996
Picturing the Middle East: A Hundred Years of European Orientalism. A Symposium. New York: Dahesh Museum, 1996.

Nochlin 1983
Nochlin, Linda. "The Imaginary Orient." *Art in America* 71, no. 5 (May 1983): 118–31, 186–91.

Owens 1980
Owens, Gwendolyn. "H. Siddons Mowbray, Easel Painter." *Art and Antiques* (August 1980): 82–89.

Palmer 1894
Palmer, Walter Launt. "The Mantle of Osiris." *Scribner's Magazine* 16, no. 6 (December 1894): 718–28.

Pappas 1985
Pappas, Paul Constantine. *The United States and the Greek War for Independence, 1821–1828*. Boulder: East European Monographs, 1985.

Paris and Ottawa 1994
Egyptomania: Egypt in Western Art, 1730–1930. Exh. cat. Paris: Réunion des Musées Nationaux; Ottawa: National Gallery of Canada, 1994.

Parisot 1985
Parisot, Jeannette. *Johnny Come Lately: A Short History of the Condom*. Trans. Philip Mairet. London: Journeyman, 1985.

Parry 1988
Parry, Ellwood C. *The Art of Thomas Cole: Ambition and Imagination*. Newark: University of Delaware Press, 1988.

Pell 1872–78
Pell, Ella Ferris. Journal, 1872–78. 4 vols. Collection of Fort Ticonderoga. Ticonderoga, N.Y.

Peltre 1998
Peltre, Christine. *Orientalism in Art*. Trans. John Goodman. New York: Abbeville, 1998.

Perlman 1979
Perlman, Bennard. *Painters of the Ashcan School: The Immortal Eight*. New York: Dover, 1979.

Poiret 1931
Poiret, Paul. *King of Fashion: The Autobiography of Paul Poiret*. Trans. Stephen Haden Guest. Philadelphia and London: J. B. Lippincott, 1931.

Powell 1971
Powell, Philip. *Tree of Hate: Propaganda and Prejudices Affecting United States Relations with the Hispanic World*. New York: Random House, 1971.

Prown et al. 1992
Prown, Jules David, et al. *Discovered Lands, Invented Pasts: Transforming Visions of the American West*. Exh. cat. New Haven: Yale University Press; Yale University Art Gallery, 1992.

Pyne 1996
Pyne, Kathleen. *Art and the Higher Life: Painting and Evolutionary Thought in Late Nineteenth-Century America*. Austin: University of Texas Press, 1996.

Rai 1998
Rai, Amit. "'Thus Spoke the Subaltern . . .': Postcolonial Criticism and the Scene of Desire." In *The Psychoanalysis of Race*, ed. Christopher Lane. New York: Columbia University Press, 1998.

Rainey 1994
Rainey, Sue. *Creating Picturesque America: A Monument to the National and Cultural Landscape*. Nashville: Vanderbilt University Press, 1994.

Ramsaye 1964
Ramsaye, Terry. *A Million and One Nights: A History of the Motion Picture*. London: F. Cass, 1964.

Read 1932
Read, Bernard E. "Ambergris, Translation and Notes from Old Chinese Literature." *Chinese Medical Journal* 46 (1932): 473–88.

Reed 1984
Reed, James. *The Birth Control Movement and American Society: From Private Vice to Public Virtue*. Princeton: Princeton University Press, 1984.

Renner 1966
Renner, Frederic G. *Charles M. Russell, Paintings, Drawings, and Sculpture in the Amon G. Carter Collection: A Descriptive Catalogue*. Austin: University of Texas Press, 1966.

Reynolds 1977
Reynolds, Donald. "The 'Unveiled Soul': Hiram Powers's Embodiment of the Ideal." *Art Bulletin* 59, no. 3 (September 1977): 394–414.

Reynolds 1979
Reynolds, Gary. *Louis Comfort Tiffany: The Paintings*. Exh. cat. New York: Grey Art Gallery and Study Center, New York University, 1979.

Rich 1986
Rich, Paul B. *Race and Empire in British Politics*. Cambridge: Cambridge University Press, 1986.

Riis 1971
Riis, Jacob A. *How the Other Half Lives: Studies Among the Tenements of New York*. 1892. Reprint, New York: Dover Publications, 1971.

Robert 1949
Robert, Joseph C. *The Story of Tobacco in America*. New York: Knopf, 1949.

Rydell 1984
Rydell, Robert W. *All the World's a Fair: Visions of Empire at American International Expositions, 1876–1916*. Chicago: University of Chicago Press, 1984.

Said 1978
Said, Edward W. *Orientalism*. New York: Pantheon Books, 1978.

Said 1995
Said, Edward W. "East Isn't East: The Impending End of the Age of Orientalism." *Times Literary Supplement*, 3 February 1995.

Saunders 1976
Saunders, George M. *A Short History of the Shrine*. Chicago: Ancient Arabic Order of the Nobles of the Mystic Shrine for North America, 1976.

Scarce 1976
Scarce, Jennifer M. "Ali Mohammed Isfahani, Tilemaker of Tehran." *Oriental Art*, n.s., 22 no. 3 (Autumn 1976): 278–88.

Schneider and Schneider 1994
Schneider, Dorothy, and Carl J. Schneider. *American Women in the Progressive Era, 1900–20*. New York: Anchor Books, 1994.

Schueller 1998
Schueller, Malini Johar. *U.S. Orientalisms: Race, Nation, and Gender in Literature, 1790–1890*. Ann Arbor: University of Michigan Press, 1998.

Scobie 1972
Scobie, Edward. *Black Britannia: A History of Blacks in Britain*. Chicago: Johnson Publishing Company, 1972.

Scott 1980
Scott, Donald M. "The Popular Lecture and the Creation of a Public in Mid-Nineteenth Century America." *Journal of American History* 66, no. 4 (March 1980): 791–809.

Scott 1983
Scott, Donald M. "Print and the Public Lecture System, 1840–1860." In *Printing and Society in Early America*, ed. William L. Joyce et al. Worcester: American Antiquarian Society, 1983.

Sears 1989
Sears, John F. *Sacred Places: American Tourist Attractions in the Nineteenth Century*. New York: Oxford University Press, 1989.

Sessions 1997
Sessions, Ralph. "Ship Carvers and the New York City Shop Figure Style." *Antiques* 151, no. 3 (March 1997): 471–77.

Sha'ban 1991
Sha'ban, Fuad. *Islam and Arabs in Early American Thought: Roots of Orientalism in America*, Durham: Acorn Press, 1991.

Sharpey-Schafer 1984
Sharpey-Schafer, Joyce A. *Soldier of Fortune: F. D. Millet, 1846–1912*. Utica, N.Y.: J. Sharpey-Schafer, 1984.

Shinn 1881
Shinn, Edward. "Frederick A. Bridgman." *Art Amateur* 4 (March 1881): 71.

Shohat and Stam 1994
Shohat, Ella, and Robert Stam. *Unthinking Eurocentrism: Multiculturalism and the Media*. New York: Routledge, 1994.

Simpson 1997
Simpson, Marc. *Uncanny Spectacle: The Public Career of the Young John Singer Sargent*. Exh. cat. New Haven: Yale University Press; Williamstown, Mass.: Sterling and Francine Clark Art Institute, 1997.

Smith 1990
Smith, Jane Webb. *Smoke Signals: Cigarettes, Advertising and the American Way of Life*. Richmond: The Valentine Museum; Chapel Hill, University of North Carolina Press, 1990.

Smith-Rosenberg 1985
Smith-Rosenberg, Carroll. *Disorderly Conduct: Visions of Gender in Victorian America*. New York: Knopf, 1985.

Smyth 1896
Smyth, Albert H. *Bayard Taylor*. Boston: Houghton, Mifflin, 1896.

Snitow, Stansell, and Thompson 1983
Snitow, Ann, Christine Stansell, and Sharon Thompson, eds. *Powers of Desire: The Politics of Sexuality*. New York: Monthly Review Press, 1983.

Sobel 1956
Sobel, Bernard. *A Pictorial History of Burlesque*. New York: Putnam, 1956.

Steele 1985
Steele, Valerie. *Fashion and Eroticism: Ideals of Feminine Beauty from the Victorian Era to the Jazz Age*. New York: Oxford University Press, 1985.

Stoddard 1859
Stoddard, Richard Henry. *The Life, Travels and Books of Alexander Von Humboldt*. New York: Rudd and Carlton, 1859.

Stoller 1957
Stoller, Leonard. "Ambergris and the Whale: Facts and Fables." *Givandanian* (September 1957): 3–7.

Stowe 1873
Stowe, Harriet Beecher. Introduction to *A Library of Famous Fiction, Embracing the Nine Standard Masterpieces of Imaginative Literature*. New York: J. B. Ford, 1873.

Strahan 1881
Strahan, Edward. "Frederick A. Bridgman." *Harper's Magazine*, October 1881, 70–71.

Studlar 1993
Studlar, Gaylyn. "Valentino, 'Optic Intoxication,' and Dance Madness." In *Screening the Male: Exploring Masculinities in Hollywood Cinema*, ed. Steven Cohan and Ina Rae Hark. London and New York: Routledge, 1993.

Studlar 1996
Studlar, Gaylyn. *This Mad Masquerade: Stardom and Masculinity in the Jazz Age*. New York: Columbia University Press, 1996.

Sullivan 1981
Sullivan, Edward. "Mariano Fortuny y Marsal and Orientalism in Nineteenth-Century Spain." *Arts Magazine* 55, no. 8 (April 1981): 96–101.

Sweeney 1992
Sweeney, J. Gray. "Racism, Nationalism and Nostalgia in Cowboy Art." *Oxford Art Journal* 15, no. 1 (1992): 67–80.

Sweetman 1988
Sweetman, John. *The Oriental Obsession: Islamic Inspiration in British and American Art and Architecture, 1500–1920*. Cambridge: Cambridge University Press, 1988.

Tabili 1993
Tabili, Laura. *"We Ask for British Justice": Workers and Racial Difference in Late Imperial Britain*. London: Routledge, 1993.

Tatham 1983
Tatham, David. "Thomas Hicks at Trenton Falls." *American Art Journal* 15, no. 4 (Autumn 1983): 5–20.

Taube 1996
Taube, Isabel. "The Orient as Aesthetic Inspiration and Found Beauty in the Works of Louis Comfort Tiffany." Unpublished manuscript, 1996.

Taylor 1855
Taylor, Bayard. *The Lands of the Saracen.* New York: G. P. Putnam, 1855.

Taylor and Scudder 1884
Taylor, Marie Hansen, and Horace E. Scudder, eds. *Life and Letters of Bayard Taylor.* 2 vols. Boston: Houghton, Mifflin, and Co., 1884.

Thomas 1922a
Thomas, Lowell. "With Allenby in Palestine and Lawrence in Arabia." Unpublished manuscript, 1922. Lowell Thomas Collection. Marist College, Poughkeepsie, New York.

Thomas 1922b
Thomas, Lowell. Letter to Calvin Fentress, 22 February 1922. Lowell Thomas Collection, Marist College, Poughkeepsie, New York.

Thomas 1924
Thomas, Lowell. *With Lawrence in Arabia.* New York and London: Century, 1924.

Thomas 1927
Thomas, Lowell. *The Boys' Life of Colonel Lawrence.* New York and London: Century, 1927.

Thomas 1976
Thomas, Lowell. *Good Evening Everybody: From Cripple Creek to Samarkand.* New York: William Morrow, 1976.

Thompson 1871
Thompson, Joseph P. "Concluding Appeal." *Palestine Exploration Society* 1 (July 1871): 36.

Thompson 1984
Thompson, D. Dodge. "American Artists in North Africa and the Middle East, 1797–1914." *The Magazine Antiques* 126, no. 2 (August 1984): 303–12.

Thompson 1985
Thompson, D. Dodge. "Edwin Lord Weeks, American Painter of India." *The Magazine Antiques* 128, no. 2 (August 1985): 246–58.

Thomson 1987
Thomson, Ann. *Barbary and Enlightenment: European Attitudes towards the Maghreb in the Eighteenth Century.* New York: Brill, 1987.

Tibawi 1966
Tibawi, Abdul Latif. *American Interests in Syria, 1800–1901: A Study of Educational, Literary and Religious Work.* Oxford: Clarendon Press, 1966.

Tilley 1985
Tilley, Nannie May. *The R. J. Reynolds Tobacco Company.* Chapel Hill: University of North Carolina Press, 1985.

Tomsich 1971
Tomsich, John. *A Genteel Endeavor: American Culture and Politics in the Gilded Age.* Stanford: Stanford University Press, 1971.

Tripp 1938
Tripp, William Henry. *"There Goes Flukes": The Story of New Bedford's Last Whaler.* New Bedford, Mass.: Reynolds Printing, 1938.

Truman 1893
Truman, Benjamin Cummings. *History of the World's Fair, Being a Complete and Authentic Description of the Columbian Exposition from Its Inception.* Philadelphia: Standard Publishing Co., 1893.

Tufts 1987
Tufts, Eleanor. *American Women Artists, 1830–1930.* Exh. cat. Washington, D.C.: International Exhibitions Foundation for the National Museum of Women in the Arts, 1987.

Twain 1872
Twain, Mark. *The Innocents Abroad, or The New Pilgrims' Progress.* London: G. Routledge and Sons, 1872.

Untracht 1997
Untracht, Oppi. *Traditional Jewelry of India.* New York: Harry N. Abrams, 1997.

Urry 1990
Urry, John. *The Tourist Gaze: Leisure and Travel in Contemporary Societies.* London and Newbury Park: Sage Publications, 1990.

Vanishing White City 1894
The Vanishing White City. Chicago: Peacock Publishing Company, 1894.

Vogel 1993
Vogel, Lester Irwin. *To See a Promised Land: Americans and the Holy Land in the Nineteenth Century.* University Park: Pennsylvania State University Press, 1993.

Walker 1967
Walker, Alexander. *The Celluloid Sacrifice: Aspects of Sex in the Movies.* New York: Hawthorn Books, 1967.

Weber 1982
Weber, David. *The Mexican Frontier, 1821–1846: The American Southwest under Mexico.* Albuquerque: University of New Mexico Press, 1982.

Weeks 1896
Weeks, Edwin Lord. *From the Black Sea to India.* New York: Charles Scribner's Sons, 1896.

Weeks 1901
Weeks, Edwin Lord. "Two Centres of Moorish Art." *Scribner's Magazine* 29 (1901): 433–52.

Weidman 1985
Weidman, Jeffrey. *William Rimmer, a Yankee Michelangelo.* Exh. cat. Hanover, N.H.: Distributed for the Brockton Art Museum/Fuller Memorial by University Press of New England, 1985.

Weimann 1981
Weimann, Jeanne Madeline. *The Fair Women.* Chicago: Academy Chicago, 1981.

Weinberg 1977a
Weinberg, H. Barbara. *The Decorative Work of John La Farge.* New York: Garland, 1977.

Weinberg 1977b
Weinberg, H. Barbara. "The Career of Francis David Millet." *Archives of American Art Journal* 17, no. 1 (1977): 4.

Weinberg 1984
Weinberg, H. Barbara. *The American Pupils of Jean-Léon Gérôme.* Fort Worth: Amon Carter Museum, 1984.

Weinberg 1991
Weinberg, H. Barbara. *The Lure of Paris: Nineteenth-Century American Painters and Their French Teachers.* New York: Abbeville, 1991.

Weiss 1987
Weiss, Ila. *Poetic Landscape: The Art and Experience of Sanford R. Gifford.* Newark, Del.: University of Delaware Press; Cranbury, N.J.: Associated University Presses, 1987.

Wilcoxen 1990
Wilcoxen, Charlotte. "A Group of Persian Pottery in a Classic Tradition." *Ars Ceramica* 7 (1990): 48–53.

Williams 1993–94
Williams, Caroline. "Jean-Léon Gérôme: A Case Study of an Orientalist Painter." In *Fantasy or Ethnography? Irony and Collusion in Subaltern Representation: Papers in Comparative Studies* 8 (1993–94): 117–48.

Wilmerding 1989
Wilmerding, John, ed. *American Light: The Luminist Movement, 1850–1875.* Princeton: Princeton University Press, 1989.

Wollen 1987
Wollen, Peter. "Fashion/Orientalism/The Body." *New Formations* 4 (Spring 1987): 10–12.

Yarnall 1995
Yarnall, James L. *John La Farge in Paradise: The Painter and His Muse.* Newport, R.I.: William Vareika Fine Arts, 1995.

Zurier, Snyder, and Mecklenburg 1995
Zurier, Rebecca, Robert W. Snyder, and Virginia M. Mecklenburg. *Metropolitan Lives: The Ashcan Artists and Their New York.* Washington, D.C.: National Museum of American Art; New York: Norton, 1995.

Tlemcen, 158, 161

tobacco, 18, 201–7; advertising for, 42 (fig. 18), 43 (fig. 19), 46, 202 (cat. no. 50), 203 (cat. nos. 51, 52), 204 (cat. nos. 53, 54); and the Orient, 18, 42–43, 183–85, 201–3; and smoking rooms, 15, 42, 183–85, 201; Turkish, 202–4; *see also* cigarettes; pipes

Todd, Charles, 140, 143

Todd, Evie, 140, 141; (with Ella Pell) *Our Winter in Egypt and Nubia*, 142 (cat. nos. 12A–C)

tourism, 4, 8, 16, 19, 21, 25–26, 93, 107, 120n.2, 141; to Holy Land, 4, 8–9, 30, 62, 126, 148, 178; *see also* travels under *individual artists*

Traveler's Club, 25, 55n.44

travel literature, 21, 93, 120, 122, 143, 157–58, 159, 173; *see also* armchair Orientalism; Taylor, Bayard; tourism

Troye, Edward, 4, 56n.79

Turkey, 9, 13, 15, 18–21, 23, 32, 36, 49, 54n.15, 67, 77–97, 120, 140, 200, 202; and tobacco, 202–4; *see also* Arab revolt; Istanbul; Ottoman Empire

Turner, Jessie Franklin, 230

Twain, Mark, 8–9, 65

Valentino, Rudolph, 15, 49, 51, 98, 99–100, 112–14, 116, 120, 215, 230

Vanderbilt family, 40

Vanderlyn, John, *Ariadne Asleep on the Island of Naxos*, 59

vaudeville, 46, 210

Vedder, Elihu, 149–51; *Egyptian Nile*, 151 (cat. no. 18);

Rubáiyát of Omar Khayyám, 149–50 (cat. nos. 17A–C), 173; *Questioner of the Sphinx*, 149; travels of, 25, 148, 151

Weeks, Edwin Lord, 27, 59, 67, 72–73, 137–39, 145, 190; as academic painter, 152; *The Arab Gunsmith*, 67, 68 (fig. 5), 70; *Blacksmith's Shop at Tangiers*, 69 (fig. 6), 70; *Interior of the Mosque at Cordova*, 68–69, 137, 138 (cat. no. 10), 139; travels of, 25, 67, 137

Weinberg, Barbara, 55n.61

West, American, and the Orient, 34–35, 54n.8, 186, 195

Whichelo, C. John M., 64; *Destruction of Jerusalem*, 62 (fig. 1)

White, Thomas Edward Mulligan, *Quittacus Club Members in Costumes from North Africa*, 159 (cat. no. 23)

White, Willis T., *Uncle Gus Was Sultan for a Day*, 49 (fig. 24)

Whitney, Gloria Vanderbilt, 230–31, 231 (cat. no. 88)

Williams, Edna, "My Turkish Opal from Constantinople," 214, 215 (cat. no. 68)

Wilson, Charles W., *Jerusalem: the Holy City*, 178n.9

Wolfe, Thomas, 230

women: image of, 14, 70–74, 81–84, 89–95, 105, 109, 114, 131, 132, 135, 197; and smoking, 204, 204n.12, 232; status of, 22, 23, 32–33, 37–38, 41, 44, 45, 50, 105, 106–7, 227, 230; treatment of, 22, 32–33, 55, 70, 72, 144–45, 159; *see also* Algeria, women of; Bridgman, Frederick Arthur, portrayal of women; gender roles; gender relationships; Islamic culture, women and; men; Ottoman Empire, women in; sexuality

women artists, 75n.48, 144–45

women Orientalists. *See* Pell, Ella Ferris

World's Columbian Exposition, 15, 16, 17, 36–40, 49, 51, 77–93, 96, 131, 168n.2, 191, 192–99, 202; Algerian village, 193; art exhibited at, 36, 38, 183, 190, 191, 192, 195; Art Palace, 195; Cairo, Streets of, 36, 192–95, 198; Damascus, Camp of, 78, 80 (fig. 6); Damascus, Palace of, 78, 80 (fig. 50); Ferris wheel, 17, 192, 194 (cat. no. 45b), 195; Midway Plaisance, 17, 36–39, 78–79, 92, 191, 192–97; Moorish Palace, 192; Ottoman Pavilion, 77, 78 (figs. 1, 2), 86; Ottoman representation in, 77–93, 96; Transportation Building, 7 (fig. 2), 77; Tunisian village, 193; Turkish village, 78, 194, 217; White City, 36–39, 78, 192, 195; Woman's Building, 38, 78, 92, 96, 195; Woman's Library, 92; *see also* hoochy-coochy dancing, dancing girls

Wood, John Z., *Masonic Drop Sketch*, 210 (cat. no. 61)

Woodward, John, 179

World War I, 48–49, 53, 99–101, 110–11, 113, 116, 204, 214, 231

Wright, Frances, 227

Wright, Frank Lloyd, 6

Wright, Mary Page, 92–93

Ziegfeld, Florenz, 46, 207, 208n.2, 209

Zola, Emile, 128

Zukowski, Karen, 178n.7

PHOTOGRAPHY CREDITS

Permission to reproduce illustrations is provided by courtesy of the owners as listed in the captions. Additional photography credits are as follows.

Courtesy of Ace Architects, Oakland, California (cat. no. 75); Michael Agee (p. 64 [fig. 2]); Courtesy the American Illustrators Gallery, New York (p. 45 [fig. 20], cat. nos. 48, 49, 57]; Amon Carter Museum, Fort Worth, Texas (cat. no. 42); © 1999, The Art Institute of Chicago, All Rights Reserved (p. 39 [fig. 17]); David Behl (cat. nos. 84, 87, 88, 90); Courtesy of Berry-Hill Galleries, Inc. (p. 70 [fig. 7], cat. no. 16); David Bohl (cat. nos. 69, 70, 73, 74, 76–78); Brooklyn Museum of Art (cat. nos. 8, 26, 35); Steven Caton (pp. 102 [figs. 1, 2], 103 [figs. 3, 4], 105 [fig. 5]); Zeynep Çelik (pp. 78 [figs. 1, 2], 79 [figs. 3, 4], 80 [figs. 5, 6], 81 [fig. 7], 83 [fig. 10], 84 [fig. 11]); © Christie's Images, Long Island City, New York (p. 65 [fig. 3]); Cincinnati Art Museum (cat. no. 37); John W. Corbett (cat. nos. 30, 31); Corbis, New York (pp. 29 [fig. 8], 51 [fig. 25], 52 [fig. 26], 98, 113 [fig. 6]); George C. Cox, p. 32 [fig. 12]); Reproduced with the permission of Elizabeth Cumbler (p. 58, cat. no. 7); The Dayton Art Institute (p. 82 [fig. 8]); © The Detroit Institute of Arts (cat. no. 32); Fine Arts Museums of San Francisco (cat. no. 19); Fort Ticonderoga Museum, Ticonderoga, New York (cat. nos. 11, 13); Frances Lehman Loeb Art Center, Vassar College, Poughkeepsie, New York (cat. nos. 12A–C); Courtesy of Thomas A. Gray (p. 43 [fig. 19]); The Haggin

Museum, Stockton, California (p. 13 [fig. 3]); Photographic Services, © President and Fellows of Harvard College, Harvard University, Cambridge, Massachusetts (pp. 5 [fig. 1], 15 [fig. 5, photo Michael Nedzweski]); Helga Photo Studios (cat. nos. 28, 83); R. H. Hensleigh (cat. nos. 86, 89); © 1992 Images from the Past, Bennington, Vermont (p. 49 [fig. 24]); Collections of the John and Mable Ringling Museum of Art, The State Art Museum of Florida (cat. no. 60); © Kennedy Galleries, Inc., New York (cat. nos. 3, 18); Suna Kiraç, Istanbul (p. 14 [fig. 4]); Ralph Lieberman (pp. 30 [fig. 10], 31 [fig. 11], 34 [fig. 13], 67 [fig. 4], cat. nos. 36A–F); Courtesy of the Livingston Masonic Library, New York (cat. nos. 71A–D, 72); Lowell Thomas Archives, Marist College, Poughkeepsie, New York (cat. nos. 79–81); Mead Art Museum, Amherst College, Amherst, Massachusetts (cat. no. 59); © The Metropolitan Museum of Art, New York (cat. nos. 27, 38, 82, 85); Courtesy of William D. Moore, Enfield, New Hampshire (p. 48 [fig. 22]); © 1998 Museum Associates, Los Angeles County Museum of Art. All Rights Reserved (cat. nos. 40, 41); Courtesy, Museum of Fine Arts, Boston. Reproduced with permission. © 1999 Museum of Fine Arts, Boston. All Rights Reserved (p. 12 [fig. 1]); © Museum of the City of New York (p. 22 [fig. 6]); National Gallery of Art Library, Washington, D.C. (p. 63 [fig. 1]); National Museum of American Art, Smithsonian Institution, Washington, D.C. (p. 29 [fig. 9], cat. nos. 20, 47); National Portrait Gallery, Smithsonian Institution,

Washington, D.C. (cat. no. 1); The Nelson-Atkins Museum of Art, Kansas City, Missouri. © 1999 The Nelson Gallery Foundation. All Reproduction Rights Reserved (p. 2, cat. no. 2); © Collection of The New-York Historical Society (p. 42 [fig. 18]); New York Public Library, Astor, Lenox and Tilden Foundations, photo Robert D. Rubic (cat. nos. 25, 65); New York State Office of Parks, Recreation and Historic Preservation (p. 34 [fig. 13]); The Pennsylvania Academy of the Fine Arts, Philadelphia (cat. no. 15); © Photo RMN, Paris (pp. 12 [fig. 2, photo Jean Schormans], 82 [fig. 9, photo Hervé Lewandowski]); Prints and Photographs Division, Library of Congress, Washington, D.C. (pp. 83 [fig. 10], 84 [fig. 11], 85 [figs. 12, 13], 86 [fig. 14], 87 [fig. 15], 88 [figs. 16, 17], 89 [fig. 18], 90 [figs. 19, 20], 91 [figs. 21, 22]); The Shubert Archive, New York (cat. no. 63); Courtesy of Spanierman Gallery, LLC, New York (cat. nos. 6, 44); © Sterling and Francine Clark Art Institute, Williamstown, Massachusetts (pp. ii, 7 [fig. 2], 10, 35 [figs. 14, 15], 37 [fig. 16], 49 [fig. 23], 76, cat. nos. 4, 5, 9, 14, 17A–C, 21A–C, 23, 24, 29, 33, 34, 39, 43, 45A–E, 46, 50–56, 64, 66–68); Toledo Museum of Art, Ohio (cat. no. 58); University of Minnesota Libraries, Twin Cities (cat. nos. 61, 62); Courtesy Vance-Jordan Fine Art, New York (pp. 68 [fig. 5], 69 [fig. 6]); The Walters Art Gallery, Baltimore (p. xiv, cat. no. 10); Yale University Art Gallery, New Haven, Connecticut (p. 23 [fig. 7]); All rights reserved (pp. 118–19, cat. no. 22)